P9-CJY-932

Folk Art in American Life

Folk Art
in American

ROBERT BISHOP and JACQUELINE MARX ATKINS

with the assistance of
Henry Niemann
and Patricia Coblentz

Life

VIKING
STUDIO
BOOKS

in association with
Museum of American Folk Art
New York

VIKING STUDIO BOOKS

Published by the Penguin Group
Penguin Books USA Inc., 375 Hudson Street,
New York, New York, 10014, U.S.A.

Penguin Books Ltd, 27 Wrights Lane,
London W8 5TZ, England

Penguin Books Australia Ltd, Ringwood,
Victoria, Australia

Penguin Books Canada Ltd, 2801 John Street,
Markham, Ontario, Canada L3R 1B4

Penguin Books (N.Z.) Ltd, 182-90 Wairau Road,
Auckland 10, New Zealand

Penguin Books Ltd, Registered Offices:
Harmondsworth, Middlesex, England

First published by Viking Studio Books, an imprint of Penguin
Books USA Inc.

First printing, October 1995
10 9 8 7 6 5 4 3 2 1

Copyright © Estate of Robert Bishop and Jacqueline M. Atkins 1995
All rights reserved

Library of Congress Catalog Card Number: 95-60164

Book designed by Design Oasis
Printed and bound by Dai Nippon Printing Co., Hong Kong, Ltd.

Without limiting the rights under copyright reserved above, no part
of this publication may be reproduced, stored in or introduced into a
retrieval system, or transmitted, in any form, or by any means (elec-
tronic, mechanical, photocopying, recording, or otherwise), without
the prior written permission of both the copyright owner and the
publisher of the book.

ISBN: 0-670-85717-3

FOLK ART IN AMERICAN LIFE
is dedicated to Jean Lipman
and to the memory of Nina Fletcher Little,
for their books and articles on the subject
and their renowned collections
have been of immense importance to our understanding
and appreciation of American folk art.

IN MEMORIAM

Robert Bishop
and
Henry Niemann

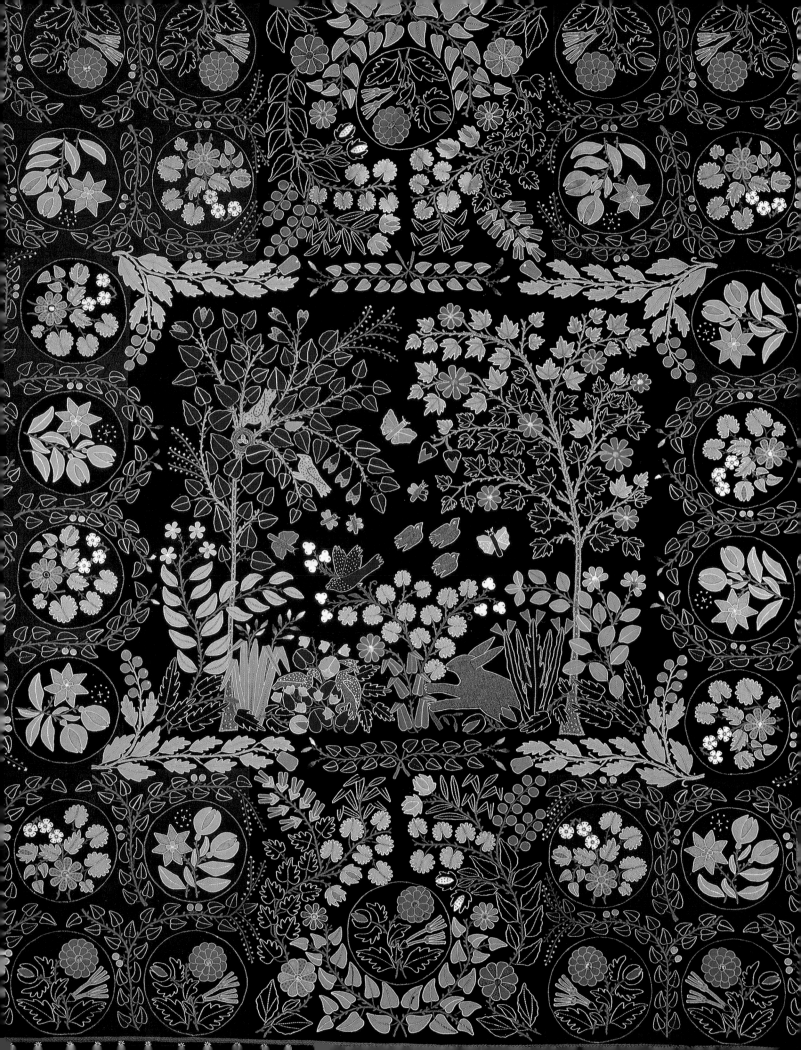

Table of Contents

Acknowledgments

Every book has its share of behind-the-scenes players, each of whom has his or her role in contributing to the final product. In an overview book such as this one, covering a variety of areas and a multitude of objects, these players are especially important, for the need to draw from the broadest possible range of expertise is obvious. All those whom I contacted in the process of completing this book were more than generous in giving of their time and in sharing their knowledge, and their help is gratefully acknowledged.

I am particularly indebted to the staff of the Museum of American Folk Art, New York City, especially to Gerard Wertkin, Director of the Museum, for his ongoing encouragement and support of this book, and to Janey Fire, Photographic Services, and Stacy Hollander, Curator, for their advice and help in locating images and information. Ann Marie Reilly, Registrar, also provided welcome assistance, and Lee Kogan, Director of the Museum's Folk Art Institute, was always there as a much-needed sounding board for problems and ideas.

Numerous curators, historians, dealers, and collectors have all helped in the compilation of this book. Many of them have worked with me directly; others, some of whose names I do not know, worked with Robert Bishop in the initial development of the book. To all of these people, both known and unknown, I extend my sincere thanks for the part you played in making the idea a reality, and especially to the following: Catherine Grosfils, Abby Aldrich Rockefeller Folk Art Center, Williamsburg, Virginia; Kate and Joel Kopp, America Hurrah Antiques, New York City; Robert Ampf; Marna Anderson, New Paltz, New York; Martha Downey, Bishop Hill State Historic Site, Bishop Hill, Illinois; Cynthia Carlson; Lucy Danziger; David L. Davies; Ralph Esmerian; Barbara Rothermel, Everhart Museum, Scranton, Pennsylvania; John Ollman, Janet Fleisher Gallery, Philadelphia, Pennsylvania; Robert D. Farwell, Fruitlands Museums, Harvard, Massachusetts; Kurt Gitter and Alice Yelen; Cathleen Latendresse, Henry Ford Museum & Greenfield Village, Dearborn, Michigan; John Wright, Historical Society of Old Newburyport, Newburyport, Massachusetts; Jolie Kelter and Michael Malcé, Kelter-Malcé Antiques, New York City; Deanne Levison; Roger Manley; Nicole Messinger; Beatrice Epstein, The Metropolitan Museum of Art, New York City; Johanna Metzgar, Museum of Early Southern Decorative Arts, Winston-Salem, North Carolina; George Meyer; Kathy Stocking, New York State Historical Society, Cooperstown, New York; Barbara Bernard, National Gallery of Art, Washington, D.C.; Lisa A. Compton, Old Colony Historical Society, Taunton, Massachusetts; Patrick Bell and Edwin Hild, Olde Hope Antiques, Inc., New Hope, Pennsylvania; Robert Peacock; Roger Ricco/Frank Maresca, New York City; Luise Ross and Robert Manly, Luise Ross Gallery, New York City; David Schorsch, David A. Schorsch Company, New York City; Dennis Moyer, Schwenkfelder Library, Pennsburg, Pennsylvania; Stephen Score, Boston, Massachusetts; Julie Liepold and Nancy Druckman, Sotheby's, New York City; Cipora and Philip Schwartz; James D. Schwartz; Seymour Rosen, SPACES, Los Angeles, California; Todd Strand, State Historical Society of North Dakota, Fargo, North Dakota; Bill Steltzer, Winterthur Museum, Winterthur, Delaware; Blanche Greenstein and Thomas K. Woodard, Thos. K. Woodard: American Antiques & Quilts, New York City; and Shelly Zegart, Louisville, Kentucky.

Special thanks and recognition are due to Cyril I. Nelson for his commitment to this book and his dedication to seeing it reach fruition, and not least for his positive encouragement at times when I seemed to reach a writing impasse. His sound judgment and many constructive suggestions have all played their very fruitful part in the final shape of the book.

To my husband, Edward G. Atkins, I extend my love and appreciation for his patience, and support, for his ability to motivate and stimulate, and not least for his willingness to take on such chores as walking the dog and washing the dishes when I was in a writing frenzy and found it hard to leave the computer!

Foreword

The works of art that brighten the pages of this handsome volume were created in America in the seventeenth, eighteenth, nineteenth, and twentieth centuries. As a field of collecting and scholarly inquiry, however, American folk art is much younger, having its beginnings only seventy or eighty years ago. Until then, the paintings and sculpture, furniture and textiles presented so splendidly in *Folk Art in American Life* would have been understood, if at all, as objects of utility, or household decoration, or personal fancy rather than as works of art, "folk" or otherwise.

In its beginnings, the field of American folk art was characterized more by aspiration than by coherence. The first generation of collectors, who gave shape to the field in the 1920s, rarely articulated a clear or consistent approach to the objects that they collected. The most prominent of them were themselves artists; they were more interested in seeking out in the earlier vernacular traditions of America a paradigm for a new American art. For these modernists, working in the aftermath of the 1913 Armory Show, it was the formal aesthetic qualities of the objects that they called "folk art" that most interested them. In these attributes they discerned the American spirit in its essentials—a simple, almost austere directness, an engagingly straightforward honesty. Their own artwork was influenced by the flat picture planes and tonalities, geometric patterning and angularity, and the tendency to abstraction of the earlier works. By and large, however, the objects themselves and the circumstances of their creation were little understood.

The "folk-art craze" of the 1920s and 1930s proved to be a more lasting phenomenon than its proponents might have imagined. Major museums presented exhibitions of American folk art and tens of thousands of Americans were introduced to a previously overlooked chapter in the history of American culture. By mid-century, however, some thoughtful observers began to express doubts about the field's underlying presumptions. In particular, they questioned the appropriateness of a fine-arts model or critical framework for understanding objects that were created outside the traditions of the art academy.

As more became known about the richly gifted artisans and amateurs who produced works that previously were seen as anonymous, the full diversity of the contexts in which they created, their widely varied sources and techniques, the disparate methods of transmission and training and the differing community traditions that they represented, the very notion of American folk art as a coherent field was challenged. A highly charged and occasionally rancorous literature began to develop over issues of classification and terminology, with some theorists holding to a more limited, class-based definition of folk art. The term itself, it was argued, was a translation of the German *Volkskunst*, which in Europe referred only to the tradition-bound household arts of peasant communities.

Notwithstanding the raging of these debates, the proponents of American folk art continued to study, collect, and exhibit the objects comprising the field, however arbitrary the classification sometimes appeared, confident that these objects deserved the consideration given to mainstream art. As a result, scores of artists and the stylistic characteristics of their work were identified, local and regional decorative traditions were explored, and a body of increasingly reliable information about sources, materials, working methods, and community contexts was developed. No one could doubt the significance of this growth of knowledge. Furthermore, these developing insights demonstrated that the field, however diverse and elusive its definitions, had shed light on a highly important aspect of the American heritage and warranted the serious consideration of scholars.

It was in affirmation of these developments and a commitment to fostering public appreciation of the field that the Museum of American Folk Art was founded in 1961. Almost from its inception as an institution, the Museum took a broad view of the subject, embracing rather than excluding many classes of objects. Moreover, the Museum saw itself not only as the institutional home of the earlier folk-art traditions but of the

work of twentieth-century self-taught artists, as well. No one more fully represented the very broad-based approach of the Museum than its Director from 1977 to 1991, Robert Bishop, under whose leadership the Museum experienced very substantial growth and development.

Even before he came to the Museum, Robert Bishop exemplified this embracing approach to folk art. His doctoral work at the University of Michigan considered the paintings of John Blunt, a nineteenth-century New England ornamental and portrait painter, but his interests, as his many publications attest, were nearly encyclopedic. I have written elsewhere of Robert Bishop's "restless eye"; he encouraged the exploration of almost every expression of art outside the mainstream and incorporated it into the exhibitions and programs of the Museum. He was drawn, for example, to the bold, idiosyncratic, sometimes obsessive, often visionary works of twentieth-century self-taught artists, some of whom are represented in this book.

To a very large extent *Folk Art in American Life* represents the culmination of Robert Bishop's work, although, following his death in 1991, it fell to an accomplished colleague, Jacqueline Atkins, to complete it. I am delighted that Robert Bishop's editor, Cyril I. Nelson, persevered in his efforts to see the volume published and am grateful to Jacqueline Atkins for undertaking a very challenging project. *Folk Art in American Life* serves as a summary of Robert Bishop's contributions to a field to which he devoted his highly creative working life and punctuates a fascinating period in the history of American folk art. Today, the Museum of American Folk Art and the field that it represents may be developing in new and different directions; indeed, I believe that Robert Bishop would have had it no other way. His contributions, however, are secure. They are richly celebrated in this colorful, compelling volume.

GERARD C. WERTKIN
Director
Museum of American Folk Art, New York

Note to the Reader

Although chronology was a significant organizing principle in establishing the order of the images shown in this book, conceptual unity was an equally important guiding force. Thus, for the most part, objects are grouped first by conceptual category in relation to the text and then chronologically within the category. In a few cases, in order to underscore a point or provide a comparison, objects are not given in strict chronological sequence. Other factors used as organizing principles included subject or function, geography, materials and construction, and whether the work was the product of a specific cultural, religious, or ethnic tradition.

Dimensions of all objects are given in the following order in the captions: height, width, and depth (if appropriate). All dimensions are in inches, unless otherwise noted, and represent the widest and the tallest points. In a few cases, because an object has changed hands several times and could no longer be located for measurement, no dimensions are given; for this same reason, some pieces have only one dimension given. In these latter instances, the measurement includes a notation of whether the size given refers to height, width, or depth.

Preface

The development of this book has a long and somewhat convoluted history. It began around 1984 as the brainchild of Dr. Robert Bishop, then Director of the Museum of American Folk Art in New York City, who felt that a general survey book that helped to place folk art within the context of American life—and especially highlighting the contributions of the many immigrant populations that made up the American scene over the years—would be a helpful and valuable addition to the then-existing knowledge base in American folk art. Eventually he developed a proposal and presented it to his editor and friend, Cyril I. Nelson. The proposal was accepted, and Bob, with the help of Pat Coblentz, his long-time assistant and co-author with Bob of *A Gallery of American Weathervanes and Whirligigs* (New York: E.P. Dutton, 1981) and *American Decorative Arts: 360 Years of Creative Design* (New York: Harry N. Abrams, 1982), began serious work on the book. This work, however, coincided with a spurt of exciting developments at the Museum, which included the establishment of the Eva and Morris Field Gallery at Lincoln Center, a new location for the Museum's offices, and plans for building permanent housing for the Museum that would not only house the present collection and activities adequately but also would allow for future expansion. The demands on Bob's time for these pressing and crucial projects were great, and, when Pat Coblentz found it necessary to relocate from New York, Bob was regretfully forced to set the book aside for the moment. Later assistance by Henry Niemann, a close friend and an instructor in the New York University graduate folk-art program and the Museum's own Folk Art Institute, provided additional research and organization and helped to move the book ahead somewhat, but Bob, intent on maintaining the Museum as a major cultural player within New York City, was still unable to devote the time that he knew was needed to tie the various pieces of the manuscript together.

I met Robert Bishop first in 1987, after enrolling in the Folk Art Institute. In 1988, while completing work on the Certificate program of the Institute, the Museum staff asked me to make use of my editorial and publishing experience by writing the text for *Memories of Childhood,* a compilation of the winning quilts from the Great American Quilt Festival 2; this was followed, in 1990, by *Discover America/Friends Sharing America*, a similar compilation for the Great American Quilt Festival 3, and by work as general editor for the *Museum of American Folk Art Encyclopedia of Twentieth-Century Folk Art and Artists* (Charles and Jan Rosenak, compilers; New York: Abbeville Press in conjunction with the Museum of American Folk Art, 1990). By this time, Bob and I had gotten to know each other well, and we found much in common besides our love of folk art; we had both come to New York initially with the bright lights of Broadway in our eyes and then moved from stagestruck to the creative delights of publishing—albeit in different arenas—although Bob's long-standing and extensive knowledge of the decorative and folk arts allowed him to move quickly from the editorial to the directorial forum. We even discovered that we lived only three blocks apart in the Chelsea section of New York City!

Suffice it to say that as we grew to know each other better, with mutual respect for each other's talents, Bob told me about *Folk Art in American Life* and of his difficulties in completing it; his work on the book was further complicated by illness, and all his available (and by no means negligible) energy was being expended on seeing through some of his many and ambitious plans for the Museum. In late 1990, he asked me if I would be able to work on the book with him and complete it; although I agreed to do so, it was understood that several other obligations would prevent me from doing so until well into 1991 or even 1992. Between November of 1990 and July of 1991, we were able to hold a number of conversations about the content and direction of the book, and in that period Bob turned over to me all his files, materials collected, and records for *Folk Art in American Life*. In early September of 1991, I accompanied my husband, who had won a Fulbright research fellowship, to Japan, but planned to devote my time on

our return in the spring of 1992 to completing the book with Bob's input. Fate, however, cruelly intervened; Bob's illness grew worse, and he died later in September of 1991.

While this so easily might have been the end of the story, it was not. Cy Nelson, friend and editor, had remained staunch in his belief in the book in spite of its many setbacks, and he took it upon himself to see that the book would be completed, cutting slowly but effectively through the legal morass and complexities of estates, permissions, and necessary sign-offs until, late in 1993, all legal technicalities had been satisfied and we could proceed with the book.

By this time, nearly ten years after the book was first conceived, much of Bob's original research had been superseded, and many of the original images intended to be included were no longer new, so it was obviously necessary to make changes in the structure of the book. Luckily, however, Bob and I had discussed these difficulties to some extent and developed contingency plans that would allow updating and some conceptual changes while maintaining a significant degree of faithfulness to his original idea. For example, although originally the book was intended to cover folk art in all areas of the United States, we had decided to limit the coverage of the book to east of the Mississippi generally and, principally, to the Northeast, East, and Mid- and North Atlantic regions—that is, to those areas that had first shaped the face of what was, for many years, perceived as American folk art. In addition, we decided to focus only on the folk arts developed by the early colonists and their successors rather than also include the development of the arts of the indigenous Indian populations—important work worthy of a study of its own. Although exclusionary choices such as these were extremely difficult—even painful—to make, we finally came to the conclusion that the physical limitations of the book itself—this was not to be an encyclopedia, after all—called for a more comprehensive coverage of a smaller area than minimal coverage of a comprehensive area.

Yet, for all our discussions, I was left with many unanswered questions and little guidance about the direction Bob would have taken in certain areas, and so the book necessarily reflects a great deal of my own outlook and philosophy as well as Bob's. I like to think, however, that in such instances our instincts would have led us to similar conclusions—if not initially, at least after an evening of spirited argument—and that my interpretations here would have ultimately met with his approval and support.

Now, at last, *Folk Art in American Life* is reaching its long-intended audience. It has been a long and winding road, with, perhaps, more than its share of stops and starts, but one that Bob Bishop, with his ever-present pluck, determination, and exuberant approach to adversity, would have relished. I hope that he would also relish this final product of what he started, and that I have done justice to both his ideas and my own.

JACQUELINE M. ATKINS
New York City, January 1995

Introduction

"Art happens—no home is safe from it."
—James Abbott McNeill Whistler

"Democratic nations will habitually prefer the useful to the beautiful, and they will require that the beautiful will be useful."
—Alexis de Tocqueville

Folk artists, whether of yesterday or today, are the ongoing celebrants of the American experience and spirit. They are the frequently unacknowledged documenters of the way life is lived as well as the creators of a richly diverse realm of objects—known under the umbrella term of folk art—that have exemplified the importance of the art of the everyday as a part of American life. Although their tangible work may be appreciated on aesthetics alone, they are, often unknowingly, social historians whose text flows powerfully through paint, wood, stone, metal, clay, and fabric to provide a vivid look at the content of American life and beliefs.

In the eighty-odd years that folk art has been recognized as an American artistic tradition, it has captured a large part of the public's imagination as well as that of curators, collectors, art historians, and other scholars. Folk art encompasses a wide variety of artistic forms as well as many utilitarian objects that have been imbued by their makers with an aesthetic that takes them far beyond the functions for which they were originally intended. It is this, in part, that provides the fascination of folk art—the recognition of the irrepressible urge of the human spirit to create, to decorate, embellish, innovate, to bring beauty in so many ways, shapes, and forms into every aspect of daily life—and it is this that the folk artist has done, often with extraordinary vision and skill, enlivening along the way not only his or her own life but also the lives of all those who eventually come in contact with the work.

The amount of work that has been left to us by earlier folk artists is perhaps only a small indication of all that was done, for time and change have undoubtedly played their parts in the loss of many pieces. What is extant today, however, is enough to give us a sense of the importance of art in everyday life from the earliest years of colonial settlement in this country, even at a time when the majority of the tasks of the day were still dedicated to basic survival—to housing, feeding, and clothing one's self and family. Whether or not, at the time of their making, the results were intended or recognized by the creator as art, lives at that time, and our lives today, were and are thereby the richer for it.

Many of the folk artists of earlier centuries whose work we now admire are anonymous; some of their names will never be known, others will gradually be discovered through dedicated and painstaking research. Yet, although their names may be unknown today, whether the artists created only for their own pleasure to satisfy some elementary need within themselves, or whether they worked for an audience of intimates, or whether they used their skills to support themselves, it should be remembered that their work was not anonymous when it was first made. Family, friends, and employers knew very well who made the work; it was art made by the people and for the people—and it was appreciated as such.

Some folk-art scholars have viewed folk art only as a premodern artifact. Mary Black, for example, observed: "The genesis, rise, and disappearance of folk art is closely connected with the events of the nineteenth century when the disappearance of the old ways left rural folk everywhere with an unused surplus of time and energy. People were free to invent and make simple things for their own pleasure in each household and village, until the rise of industrial production toward the end of the nineteenth century decreased the interest in and need for homemade goods. Folk art occupies the brief interval between court and commercial taste."[1] This point of view, with all its limitations, was indeed prevalent among a whole generation of folk-art scholars who preferred to believe that, by the end of the nineteenth century, folk art was, for all intents and purposes, no more. Although this general idea still remains popular with some—and it is true that the creation of many types of paintings and objects were preindustrial phenomena and could not flourish in nor cope with the rapidly changing demands and tastes of the late-nineteenth and twentieth centuries—most contemporary scholars now recognize the

continuance of a larger and more inclusive folk-art tradition, with its expression reflected in a myriad of new modes at the same time that some small pockets of cohesive ethnic groups, isolated by choice or by accident, also continue to sustain a few of the folk traditions of the eighteenth and nineteenth centuries well into the twentieth.

Today, the new folk art that has emerged has brought with it a new breed of folk artists, although some similarities to those who have gone before remain. Those producing this art are at work in cities, small towns, hamlets, isolated rural areas—today, as yesterday, geography poses no barrier to the need for expression and the will to carry out that need. Much of their work is now based predominantly upon individual preoccupation and personal vision—some highly internalized, some an idealized reflection of a desire for what was or what could be—although some aspects of this work remain as records of and commentary on the contemporary social and cultural scene. Religion, celebration of self, lifestyle, social injustice, history, politics, and patriotism are but a few of the inspirational sources that motivate folk artists today; and yet, like many of the folk artists of earlier times, they also find inspiration and motivation in the popular media of the day. At one time this took the form of book plates, engravings, and mezzotints—today it is more likely to be magazines, television, and film. The source, however, in no way lessens the impact or the power of the image on the artist—a television sound bite that fires a Howard Finster makes his work no less valid than the biblical images that inspired Edward Hicks, or the English mezzotints that sparked a creative glow in the breast of many an American schoolgirl of the nineteenth century.

Although inspiration and motivation may still flow in many cases from similar fountains, the folk art produced today is significantly different from that of earlier years. The folk painting of America in the twentieth century is brushed with broader strokes, nearly each one unique; contemporary folk sculpture is much the same, no longer finding its primary grounding in function but in form, but neither does the latter exclude the former. Giant environmental gardens, often several acres in size, are sometimes bizarre personal monuments on a grand scale—private creations of stunning beauty that speak to the soul—and stretch the dimensions of the folk environment far beyond nineteenth-century conceptions, while the ambitious creations of today's needleworkers enrich our lives with their beauty, skill, and ingenuity. Just as in past years, the lines between craft, folk art, and (for want of a better word) "academic" or "mainstream" art are sometimes blurred, but this blurring of boundaries is a part of what folk art is all about, for folk artists have never been loath to push the parameters of their art.

Folk art can now be seen as a broadly inclusive field, especially in this century, but not every work—be it painting, carving, metalwork, textile or other needlework, or ceramic—done by an unsophisticated eye or untrained hand does or should qualify as folk art, just as not every so-called "country" item should be so classified. There have been many pages written, symposia held, debates recorded on what folk art is (or is not), and there is no intent here to try to condense and repeat what is so easily accessible elsewhere in the literature.[2] Too often has the argument broken down into statements of exclusionary listings; for example, although folk art can be appreciated from a point of view of aesthetic qualities alone, the context in which a piece was created has meaning as well, and to consider either aesthetics or context alone, one without the other, is to ignore a part of the meaning of the work. One, in essence, enhances the other. Folk art (like any work of art) was—and still is—never made in a vacuum; the personal, social, and cultural environments surrounding the creation of a piece each play a part in shaping the final form, and thus cannot be totally separated from it. From this point of view, a careful review of the representative objects shown in the following pages will, it is hoped, present a coherent visual conception of folk art and its place in American life through the years.

This book presents a broad sampling of the wealth and variety of American folk art from the late seventeenth century through the late twentieth century. Its scope includes objects from many diverse subject areas, from paintings to household furnishings of many kinds to textiles to sculpture to environments. Although certain broad groupings have been established—paintings, household items, textiles, sculpture, and so forth—in order to provide a somewhat coherent framework for discussion, in a book such as this one, where the range of material to be discussed is extensive and pieces are often representative of more than one idea, it is sometimes difficult to determine in just which category a particular object is best located. It is, therefore, almost inevitable that some categories will overlap. A painted overmantel, for example, may be discussed with equal ease from the point of view of its function, or for the painting techniques used, or for what it depicts. Thus, several painted overmantels are found in Chapter One: Portrait of America, which comprises the face of America—its people, places, landscape, beliefs, and so forth—as seen in paintings by folk artists, while other overmantels are included in Chapter Two: House and

Home, which is representative of specific expressions of folk art within the broadly defined home environment. These latter examples could just as easily have been included in Chapter One, or vice versa. Likewise with weathervanes—by the somewhat ample categories in which this book is arranged, they would have been equally comfortable in Chapter Four: Carvers, Metalworkers, and Artful Eccentrics, which deals primarily with three-dimensional sculptural forms, or in House and Home; here, the decision on where to place them was based more on form than function, and so they appear in Chapter Four. Thus, the placement of objects within a category should not be seen as gospel, or as the final word. Regard it, rather, as a provisional framework, one within which the reader is encouraged to make his or her own comparisons and connections and, perhaps, to create a personal organizational pattern that can facilitate further development and study.

Likewise, the choice of objects to be included was often difficult. The idea underlying the choices was not to provide complete and comprehensive coverage of subjects, artists, regions, periods, or media—an impossible task, in any event—but rather to show a range of representative objects that would provide a sense of scope showing how folk art has permeated and enhanced American life, from bedroom to barroom, from kitchen to cradle, from park to prairie, from graveyard to barnyard, from ship to shore, from colonial days until today. Although each object pictured was chosen as representative of a particular genre, each also has played its part within the context of American life at the time it was created.

The universe of objects from which to choose is extraordinarily and gratifyingly rich—sometimes even frustratingly so, because the choices to be made are then that much more difficult. In many cases, any one of an extensive array of examples could have been used to make the intended point. Although many of the pieces included here are well known, numerous others are not; at times, prominent icons in the field have been bypassed in favor of showing a lesser known but no less potent work, not because the one was thought to be more important than the other, but rather to expand the range of images available for study in the literature. Aesthetics certainly played a part in the selection of many pieces, but, although of significant importance, it was not the sole criterion on which a choice was based; artist, region, and social and cultural context also had to be considered in order to present a selection of images representative of the scope of the book. In those cases where the artists or makers of works are known, for the most part only one work by a given artist has been included, again as part of an effort to provide as broad and representative a spectrum as possible rather than focusing too narrowly on the output of any one individual, however worthy that body of work may be.

In spite of the many hundreds (if not thousands) of possible images reviewed and considered for inclusion, and the input and recommendations of a number of knowledgeable people, the final choices were, of course, necessarily subjective. While not everyone will agree wholeheartedly with the material ultimately included (or omitted), it is hoped that what is shown in this book will provide a firm sense of the range of achievement of American folk artists and of the importance of their work within the context of American life.

It should be noted that several of the pieces included here, both because of the volatility of the folk-art field and the time involved in developing a book such as this, have changed hands and new owners could not always be located. Because these pieces were deemed important enough to retain, they have been included here under the names of the former owners or with a notation that the present whereabouts are unknown; it is to be hoped that this publication will, perhaps, once more bring these works to light so that future researchers may have the correct information. Also, although every attempt was made to ensure accuracy, it is inevitable that some problems will surface in a volume that covers as much territory as this one does. If misattributions or incorrect descriptions have occurred, apologies are in order, with the understanding that the information available was, to the best of our knowledge, accurate at the time the object was selected for inclusion in the book. Ongoing research will continue to expand the knowledge available on many of these objects, and if old data is invalidated and discarded in the course of discovering and verifying the new, it is indeed a significant part of the growth process that will ultimately be to the benefit of all of us who labor in and love the folk-art universe.

Finally, while the text herein provides context and background as well as information on the artists (when known), it is the tangible object itself that counts, that crosses the boundary from the merely decorative, functional, or eccentric and takes on the mantle that we call art. When all is said and done, what the reader needs to do is look—look with the mind, with the eye, and with the heart. Let the objects themselves speak to the intellect, to the senses, to the spirit; this, then, is where the final understanding of folk art resides.

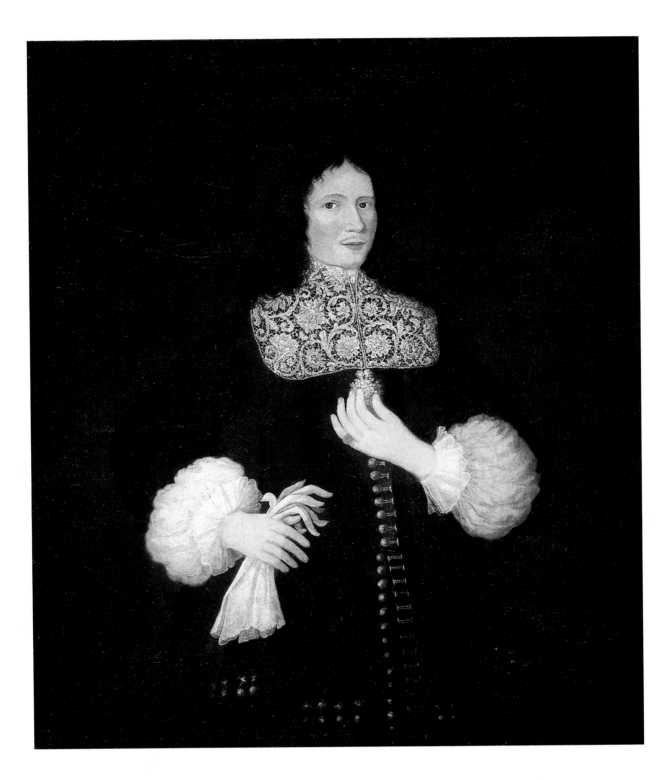

1. *John Freake;* artist unknown; Boston, Massachusetts; c. 1674; oil on canvas; 42$\frac{1}{2}$" x 36$\frac{3}{4}$". John Freake was a prosperous Boston attorney and merchant who, in 1674, commissioned this painting of himself and another of his wife, Elizabeth Freake, with their baby daughter, Mary. The two paintings, both owned by the Worcester Art Museum, are among the handsomest of all of the New England portraits painted in the latter half of the seventeenth century and display a conscious effort on the part of the artist to establish accurate spatial relationships, a new idea at the time, for until the mid-century most portraits were judged by the rendering of the face for depth of characterization. In the portraits, the Freakes are elaborately, even lavishly (and, in her case, colorfully) dressed, providing a striking visual statement of their prosperity. In addition to the luxurious lace collar and silver buttons trimming his outfit, John Freake also wears a large gold ring, a display of decoration and wealth that is obviously at odds with the traditional view of Puritan New England's ascetic lifestyle and shunning of ostentatious clothing and ornament. Not long after sitting for this portrait, John Freake died in an explosion in Boston Harbor. (Worcester Art Museum, Worcester, Massachusetts; Sarah C. Garver Fund)

1

Portrait of America

American folk painters have served as important and often unacknowledged documenters of the people, places, and events that shaped this country. Their work, crammed full of information about everyday lives, has provided an invaluable visual history that helps to breathe life and vitality into the written accounts of the times, a portrait of America that allows us today to gain some better insight and understanding into the lives, interests, and activities of our forebears as well as a new perspective on our own times. Most of these artists were self-taught or had only the most minimal training, yet whatever their technical limitations, they were able to capture the essence of their subject—be it people or places, private or public, religious or lay, dreams or reality—and leave it recorded in paint for others to read as one more helpful piece in putting together a complete picture of our past.

The European colonists that came to the New World brought with them more than the desire to settle new lands or find new riches or share in a new religious and social freedom. They also brought with them the traditions and other cultural trappings of their homelands, including artistic traditions. It was these traditions that provided the underpinnings of what developed into folk painting in America, leaving as a still-developing legacy an exuberant portrait of the many faces of a country as it passed from its infancy to a full-blown maturity.

Portraiture developed as the first and most important mode of artistic expression in the small colonial towns of the New World in the seventeenth century. There has been a marked predilection throughout the course of history to preserve likenesses of one's self and one's family for future generations—a self-generated immortality as it were—and, as the colonial population consolidated their foothold in their new world and began to realize

the fruits of their labors, they found themselves no less immune to this impulse than their ancestors. The eighteenth century saw an increasing demand for such work, and there seemed to be no lack of artists—both trained and otherwise—willing to satisfy this need.

American folk portraiture developed first in New England, where population, commerce, and wealth were initially centered, then spread south and, later, westward, following the pioneer migration and subsequent development of new and prosperous population centers. The folk painters of the seventeenth century in both New England and the South were very often English, coming to the New World for a host of reasons, not the least of them a hope to garner fortune and, perhaps, fame. Their technical abilities, while not always the best, satisfied a clientele that, because of its geographical and cultural isolation, was perhaps somewhat less demanding than its European counterpart. These artists often relied on British mezzotints and engravings for such elements of their portraits as costume, background, and pose, although faces were often presented in a boldly realistic manner. These immigrant artists, and later their native counterparts, became known as limners; many of them still remain anonymous today, identified only by their sitter's name or by an area in which they were known to have worked (see, for example, figs. 2 and 5).

By the late-eighteenth and early-nineteenth centuries—what might be called the golden age of folk portraiture—many folk painters, most of whom were self-taught, had developed a competence that earned them national and international reputations. Benjamin West (1738–1820), John Singleton Copley (1735–1815), and other well-known academic painters had actually begun their careers as naïve artists; they then developed their techniques through a combination of personal

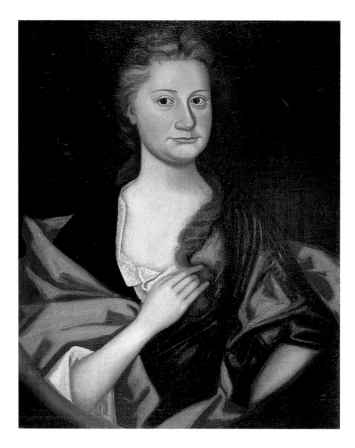

2. *Catherine Adams;* Frost-Pepperill limner; New England; 1715–1725; oil on canvas; 27" x 22". The sitter for this portrait is known, but little is known about the painter. Although other works have been attributed to the same hand, no clue to the painter's identity has as yet been found. Several of the unknown limners from the seventeenth and early-eighteenth centuries who created bodies of work large enough so that attributions to one or another could be made apparently traveled extensively, for paintings that can be linked stylistically to the same artist have been found in such diverse sites as Portsmouth, New Hampshire; Boston, Massachusetts; Newport, Rhode Island; Albany, New York; and at several locations in Virginia. In this painting, the classic pose and the stylized drapery of the clothing indicate that the artist, like others of the time, may have used an English engraving as a model, with an appropriate personalization of features to fit the sitter. (Richard Love Gallery, Chicago, Illinois)

experimentation and later formal training, in the process moving away from characteristic folk techniques and into the mainstream of American art at the time. Most folk painters, however, due to a variety of economic, cultural, and social constraints, were unable to obtain the training afforded men like West and Copley and failed to attain similar status and recognition. Still, they created an art that, while usually lacking virtuoso technical competence, demonstrates a basic and important power of observation, a cohesive sense of design, and a vision that defies convention. The early folk art of America was brushed with a penetrating insight that was as valued in its time as now.

By the late-eighteenth century, Baltimore was a flourishing port city and Boston and New York City had already become major urban centers with sizeable populations. Many of the inhabitants of these burgeoning towns desired to have their likenesses taken but could not afford the best-known academic artists of the time. While the cities could support a few well-paid professional artists, most artists found it necessary to supplement their incomes in a variety of ways and counted portrait painting, furniture decoration, painting hatchments and other accessories, sign and coach painting, and mural painting among their accomplishments. A detailed look at the career of John S. Blunt (1798–1835)

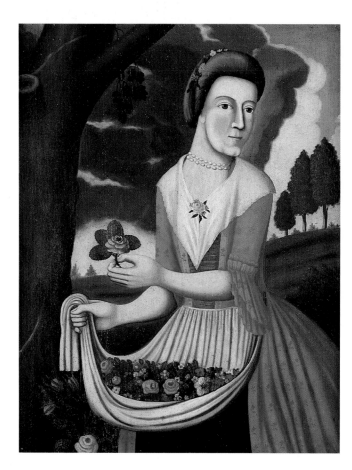

3. *Woman Gathering Roses;* artist unknown; probably Hudson River Valley, New York State; probably c. 1740; oil on panel; dimensions unavailable. This painting exhibits several of the qualities associated with the unknown limners of the Hudson River Valley, many of whom worked in a painting style that was broad, flat, often colorful, and decorative. The pose of the unidentified but distinctive woman in this fascinating portrait was, as is the case with many early American paintings, probably borrowed from an English mezzotint. (Photograph courtesy Peter Tillou and America Hurrah Antiques, New York City)

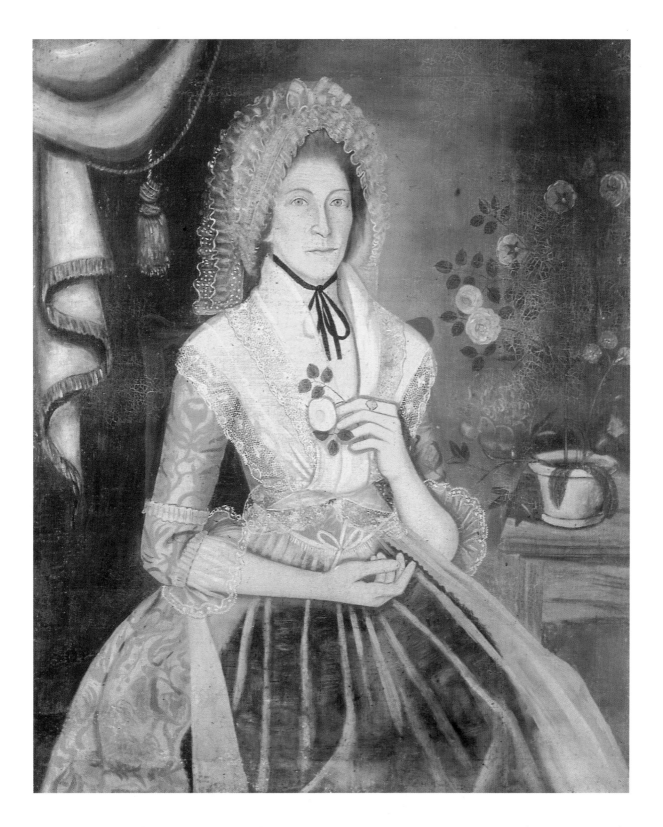

4. *Mary Kimberly Thomas (Mrs. James Blakeslee) Reynolds;* attributed to Reuben Moulthrop (1763–1814); West Haven, Connecticut; c. 1789; oil on canvas; 45" x 36". Mary Kimberly Thomas married James Blakeslee Reynolds in 1788, and it is thought that their portraits, of which this is one, were painted shortly thereafter. Like numerous painters throughout the seventeenth, eighteenth, and nineteenth centuries, Moulthrop included a stylized drapery on one side, which made the execution of the background of the picture substantially easier. This portrait and the companion one of James Reynolds also provide some indication of household furnishings and decor. Although Moulthrop was best known as a modeler in wax, he shows himself capable of great delicacy in his handling of painted face and form in this elegant portrait. (Museum of American Folk Art, New York; Anonymous gift)

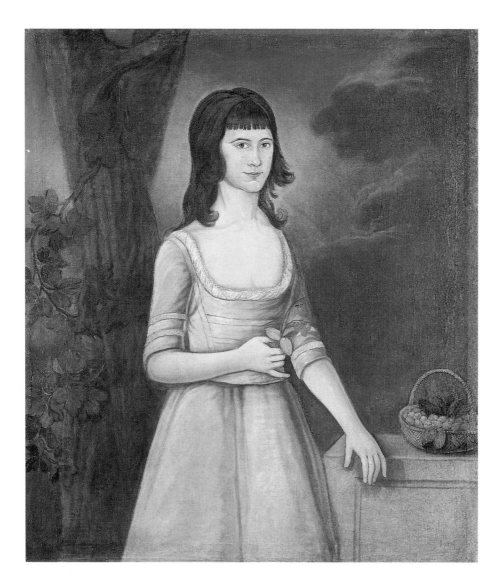

5. *Jane Payne;* Payne Limner; Goochland County, Virginia; c. 1791; oil on canvas; 41³/₄" x 35⁵/₈". This portrait is one of a group of ten depicting various members of the Archer Payne family, each personalized by some accessory such as fruit (like the basket of strawberries here), animals, or objects (a fan, for example, or a gun). Few such large family groupings remain today, and those from the South are extremely rare. With the exception of two of the sitters, all of the subjects are shown out of doors, probably on the grounds of New Market, the Payne family plantation in Goochland County, Virginia. Photograph courtesy Sotheby's. (Private collection)

will provide a perspective that is indicative of the myriad of small activities by which a folk painter could earn his living.

John Blunt was born in Portsmouth, New Hampshire. By 1821 he was listed in the Portsmouth directory as an "Ornamental and Portrait Painter," and on December 31, 1822, he advertised in the *New Hampshire Gazette* that he did "profiles, profile miniature pictures, landscapes and ornamental paintings." (See fig. 9 for an example of Blunt's portraiture.) He announced a new venture in the *Portsmouth Journal* on April 2, 1825:

> Drawing and Painting School. The subscriber proposes to open a school for the instruction of young ladies and gentlemen in the arts of drawing and painting. The following branches will be taught: oil painting on canvas and glass, water colors, and with crayons. The school will commence about the first of May provided a sufficient number of scholars can be obtained to warrant the undertaking. Terms

made known on application of John S. Blunt. Painting in its various branches attended to as usual.

In an 1827 advertisement Blunt announced that he would execute "THE FOLLOWING BRANCHES, VIZ. Portrait and Miniature Painting, Military Standard do. Sign Painting, Plain and Ornamented, Landscape and Marine Painting, Masonic and Fancy do. Ships Ornaments Gilded and Painted, Oil and Burnish Gilding, Bronzing, &c &c." Blunt apparently was frequently patronized by members of the Masons, a fraternal order that was quite extensive and powerful, for in his ledger he recorded many entries similar to the following for the decoration of Masonic paraphernalia: "May 26, 1826: DeWitt Clinton Encampment to painting 10 Aprons and Sashes, $12.50"; "July 3, 1826: Washington Chapter to painting banner, $11.00"; "July 3, 1826: St. John's Lodge to All-seeing Eye and Painting do. $2.25."[1]

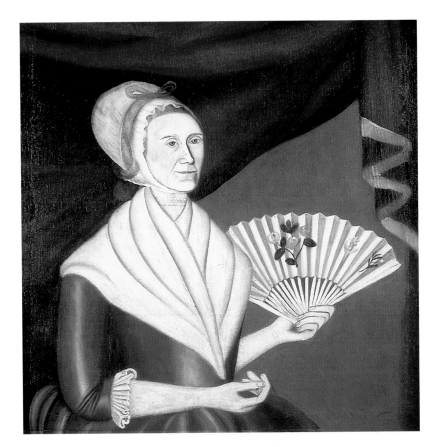

6. *Phebe King (Mrs. Caleb) Turner;* Dr. Rufus Hathaway (1770–1822); Taunton, Massachusetts; 1791; oil on canvas; 34½" x 33". The compelling subject of this arresting portrait was the wife of the Reverend Caleb Turner. Several paintings by Hathaway show his female subjects holding an ornamental fan as a prop, and side drapery was a commonly included convention in portraits. Hathaway is thought to have been born in Freetown, Massachusetts; early in the 1790s he began his career as an itinerant artist and worked in and around Bristol, Rhode Island, and Taunton and Duxbury, Massachusetts. In 1795, he settled in Duxbury, where he married Judith Winsor, the subject of one of his portraits. Upon urging by his father-in-law, a prominent merchant who did not approve of art as a profession, Hathaway studied medicine. He ultimately became a highly respected physician and practiced for twenty-seven years, gradually giving up painting as the demands of his practice grew. There are no known paintings by him after the first decade of the nineteenth century. (From the collection of the Old Colony Historical Society, Taunton, Massachusetts)

7. *James Prince and Son William;* John Brewster, Jr. (1766–1854); Newburyport, Massachusetts; 1801; oil on canvas; 60⅜" x 60½". James Prince, a prosperous merchant and prominent community member (he is known to have entertained both Washington and Lafayette at his home), is shown here with his nine-year-old son. The artist, who stayed with the Prince family in 1801–1802, painted at least three other portraits of family members. John Brewster, Jr., born in Connecticut, was a deaf mute. He developed an aptitude for portraiture at an early age and is said to have studied with the prominent Connecticut artist, the Reverend Joseph Steward. Upon the marriage of his younger brother, Royal Brewster, the artist followed him to Maine, where he settled in Buxton. Although physically handicapped, Brewster traveled extensively and frequently advertised in newspapers throughout New York, Connecticut, and northern New England that he was available to do "Portrait work and miniatures." When the Connecticut Asylum for the Deaf and Dumb was established in Hartford in 1817, Brewster enrolled in the opening class and remained there for several years studying lip reading and speech; he then returned to Maine to continue his career. (Historical Society of Old Newbury, Newburyport, Massachusetts)

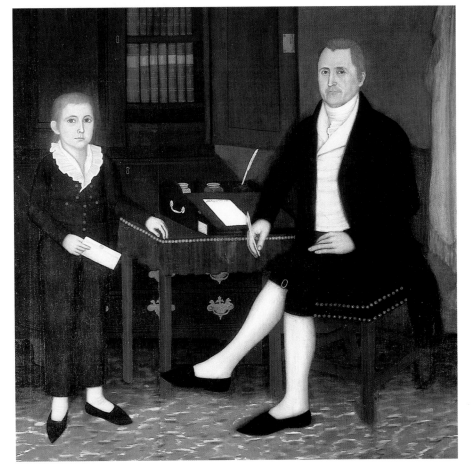

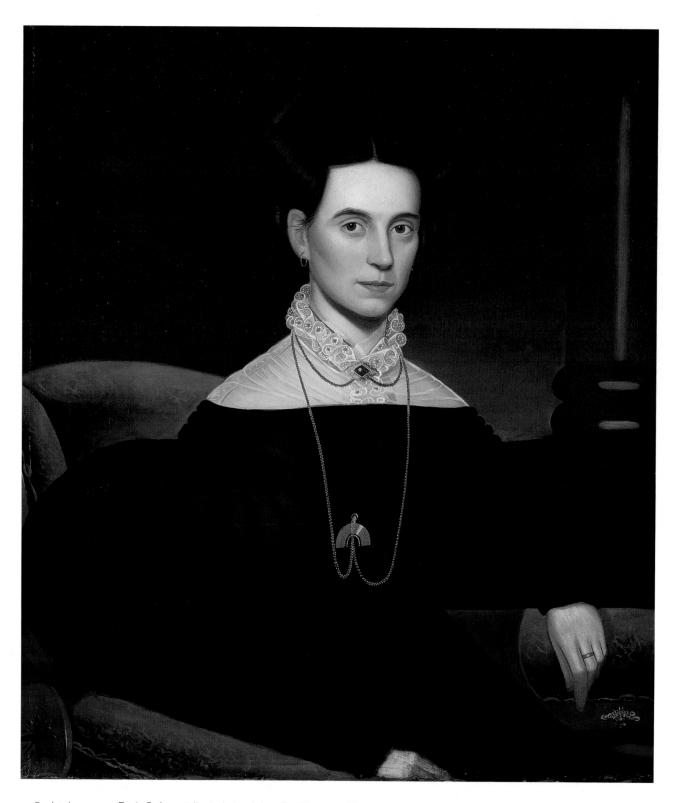

8. *Lady on a Red Sofa;* attributed to John S. Blunt (1798–1835); New England; c. 1833; oil on canvas; 32³/₄" x 28¹/₄". John Blunt was a versatile artist who was born in Portsmouth, New Hampshire, in 1798. By 1821 he was listed in the Portsmouth directory as an "Ornamental and Portrait Painter"; he also painted landscapes, seascapes, ship portraits, and genre pictures as well as decorative pieces for several Masonic lodges in and around Portsmouth. In 1831, Blunt moved to Boston, and, until his untimely death at sea in 1835, appears to have worked as an itinerant painter throughout much of the New England coastal area during the summer months. The dramatic coloring and bold brushstrokes that characterize his portrait work create vibrant compositions of unusual elegance and beauty. Photograph courtesy Sotheby's. (Private collection)

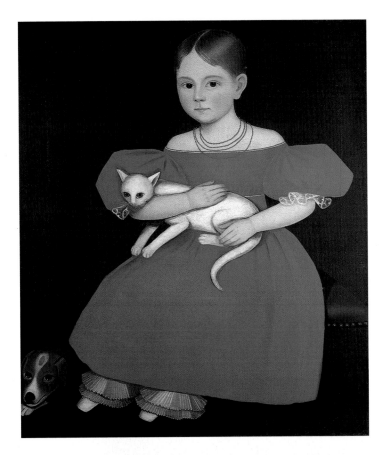

9. *Girl in Red Dress with Cat and Dog;* Ammi Phillips (1788–1865); vicinity of Amenia, Dutchess County, New York; 1830–1835; oil on canvas; 30" x 25". Ammi Phillips, one of the most important folk portraitists of the nineteenth century and an extremely prolific artist to whom about five hundred works are now attributed, was born in Colebrook, Connecticut. Most of his work was done in western Massachusetts and Connecticut and in bordering areas of New York State, and, like many of the itinerant painters of this period, he seldom signed or dated his work. Phillips had an astoundingly wide range of styles during his fifty-plus years as an itinerant painter. At one time, certain portions of his body of work were attributed to "The Border Limner" and others to "The Kent Limner"; it was only after a signed portrait was found and tied to the work of The Kent Limner that the full range of his work could be appreciated. Not unlike many early folk painters, Phillips developed formula methods and poses that he used at certain periods in his career, although he did make alterations to suit the individual sitter. He is known to have painted several other portraits of young girls in similar red dresses, but this charming depiction is the only one in which the subject holds a white cat. The plain background, strong contrast between the light and dark elements, and rather awkwardly articulated figure is characteristic of his work. (Museum of American Folk Art, New York; Promised anonymous gift. P2.1984.1)

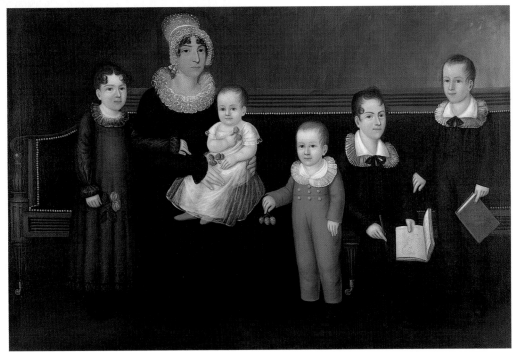

10. *Mrs. Thomas Everette and Her Children Mary, Rebecca, John, Thomas, and Joseph;* Joshua Johnson (1765–1830); Baltimore, Maryland; 1818; oil on canvas; 38⅞" x 55³/₁₆". Joshua Johnson is perhaps the best-known and best documented of several black artists who earned a reputation for their skillful portraits during the Federal period. His exceptional talent brought him commissions from some of the South's most prominent families, and the sensitivity shown in his work makes his popularity understandable. Mr. Everette, a successful Baltimore merchant, died shortly before this portrait was painted. (Collection of the Maryland Historical Society, Baltimore, Maryland)

A typical page from John Blunt's account book indicates a great variety of painterly tasks. On August 8 he painted a pair of signs for $3.50 for the Robert Foster, Jr., Co. (Robert Foster is identified in the 1821 *Portsmouth Directory* as a printer and bookseller); lettered a coffin plate for Samuel M. Docham, for which he charged 25 cents; and charged Ann Folsom $4.20 for mending three chairs and painting a set of eight. On August 24 he repainted letters for Robert Foster, Jr., Co. at a cost of 20 cents, and on the same day charged the town of Portsmouth $3.34 for painting a guideboard and board. On August 29 Blunt painted parts of a small carriage for John Trundy, charging him 12 cents, and on September 3 he earned $1.75 by painting a sign for Nathaniel O. Ham, a watchmaker.

On September 4 Blunt charged Langley Boardman $1.75 for staining a bedstead rose, and on September 16 he painted a small coffin plate, earning $1.00. The entry for September 21 deserves note, for it expands the spectrum of Blunt's artistic endeavors. On that date he charged $1.00 for painting five dozen tin boxes for Joshua Hubbard, a druggist; the boxes probably were apothecary containers. Throughout New England painted and decorated tin was an acceptable alternative to imported French tole, and nearly every home had at least one document box decorated with painted flowers or other designs; Blunt probably decorated this type of tin as well. Folk artists could indeed be said to be jacks-of-all-trades!

Joshua Johnson (1765–1830) of Baltimore, Maryland, was one artist, however, who made his living almost entirely by his portraits. He is the earliest and perhaps the best-known of several black artists who painted portraits during the Federal period, and he was extraordinarily successful in gaining commissions to paint many prominent Baltimore families (fig. 10). A "free householder of color," he was listed as a portrait painter or limner in the Baltimore directory from 1796 to 1824 and he was not shy of his talent, as an advertisement of his skills shows:

> As a self-taught genius, deriving from nature and industry his knowledge of Art: and having experienced many insuperable obstacles in the pursuit of his studies; it is highly gratifying to him to make assurances of his ability to execute all commands, with an effect, and in a style that must give satisfaction.[2]

Unlike Johnson, who was able to carve out a niche for himself in one place, most artists found it necessary to adopt an itinerant lifestyle and journeyed from

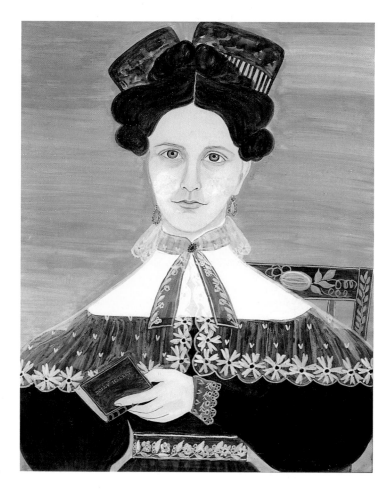

11. *Dolly Hackett;* Ruth Whittier Shute (1803–1882) and Dr. Samuel Addison Shute (1803–1836); New England; 1830–1832; watercolor on paper; 23³/₄" x 19". Dr. Shute and his wife Ruth, who signed themselves "R.W. and S.A. Shute," are a rare example of a collaborative conjugal team. Dr. Shute practiced medicine as well as portrait painting, and he and Mrs. Shute traveled throughout New England and upstate New York plying their trades. It is thought that Mrs. Shute did most of the drawing and Dr. Shute the painting. Mrs. Shute is also known to have executed a number of portraits on her own in a similar style. This handsome watercolor is a glowing and particularly fine example of the exuberant brush technique, strong color, and decorative detail that are typical of their joint work. (Fruitlands Museum, Harvard, Massachusetts)

colony to colony and city to city in search of patrons. Some traveled great distances to gain commissions, from Portsmouth, New Hampshire, to Boston Massachusetts, to Albany at the head of the Hudson River and New York City at its mouth, and even into the southern reaches of the colonies. These artists traveled primarily by ship, for land transportation was far from easy. Such travels required a substantial commitment of time and energy, yet the rewards must have seemed worthwhile for this hardy group to forsake family and friends for lengthy periods in order to further their chosen profession. As these artists journeyed about the country in

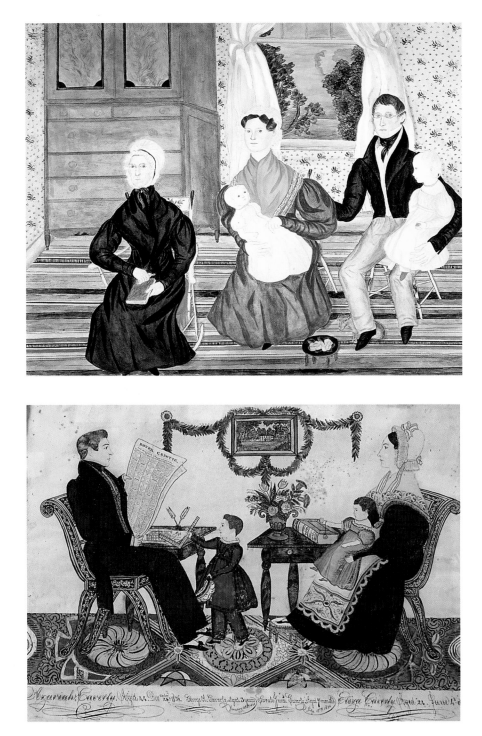

12. (LEFT) *The Talcott Family;* Deborah Goldsmith (1808–1836); Hamilton, New York; 1832; watercolor on paper, 18" x 21⁷/₁₆". Deborah Goldsmith was born at North Brookfield, New York, and taught herself to paint. She took up professional portrait painting when she was in her early twenties in order to support her elderly parents and traveled throughout central New York state in search of work. Some of her paintings, as in the one here, show detailed interiors, providing documentation of the homes of the time as well as of the sitters. In 1832, Goldsmith married George Addison Throop, whom she had met while painting him and his family's portraits. They corresponded for nearly a year and, after he had made his feelings clear to her, she responded with unusual honesty:

> Some things I want to remind you of, that you may weigh them well. . . . Your religious sentiments and mine are different. Do you think that this difference will ever be the cause of unpleasant feelings? Your age and mine differ, I do not know your age exactly, but I believe I am nearly two years older than you. . . . has this ever been an objection in your mind? And another thing which I expect you already know is, my teeth are partly artificial. Nature gave me as many teeth as She usually gives her children, but not as durable ones as some are blessed with. Some people think it is wrong to have anything artificial, but I will let that subject go.[1]

She no longer sought painting commissions after her marriage, but she did paint members of her immediate family, including her daughter. (Abby Aldrich Rockefeller Folk Art Center, Williamsburg, Virginia)

13. (ABOVE) *The Azariah Caverly Family;* attributed to Joseph H. Davis (active 1832–1838); Stafford, New Hampshire; c. 1836; watercolor, pencil, and ink on paper; 13⁷/₁₆" x 17³/₄". This painting is inscribed "Azariah Caverly. Aged 44. December 28th 1836. George A. Caverly. Aged 3 yrs. January 28th 1836. Sarah June. Aged 7 mths. July 15 1836. Eliza Caverly. Aged 24. June 4th 1835." Few personal details are known about Joseph H. Davis, sometimes called the "Left-Hand Painter," yet his sitters are often known because of his habit of inscribing the sitter's age and/or birth date on his paintings as seen here. His paintings are noteworthy not only for his style but also for the more subtle information about the sitters and the domestic details that they show. In this one, Mr. Caverly is shown with a newspaper (the *Dover Gazette*) in his hands and an architectural drawing and quill pens on the table near him, and his son holds a ruler; although his profession is not known, Davis may have been indicating that Mr. Caverly was an architect or builder. A garlanded landscape painting similar to ones seen in several other of Davis's paintings hangs over the table, indicating that this was a popular mode of decoration of the time. Dated works by Joseph H. Davis range between 1832 and 1838, and he is known to have painted in both New Hampshire and Maine. (New York State Historical Association, Cooperstown, New York)

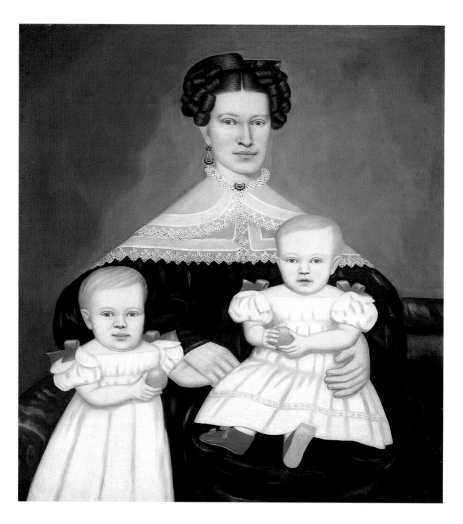

14. *Mrs. Paul Smith Palmer and Her Twins;* Erastus Salisbury Field (1805–1900). Massachusetts; 1835–1838; oil on canvas; 38 1/2" x 34". The Palmer twins, Charles and Emma, are clothed and coiffed identically in this painting, and even the pieces of fruit they hold do not give a clue to their gender. They died soon after this portrait was painted. Erastus Salisbury Field was a formula painter and many of his pictures are virtually identical in composition, in the palette used, and in the placing of the figure or figures on the canvas. Like many New England artists, Field found it difficult to obtain painting commissions after the popular acceptance of the inexpensive daguerreotype. He attempted to adapt to this changing fashion in portraiture and became one of the first folk painters to use photography; his advertisements indicated that he would either paint a portrait or take a photograph, which he also offered to embellish with paint if the client so wished. Although there was little demand for such work, he continued to paint until his death, eventually giving up portraits in favor of painting religious and genre pictures and landscapes, as well as historical and biblical scenes based upon prints and other published sources. (© 1994 Board of Trustees, National Gallery of Art, Washington, D.C.; Gift of Edgar William and Bernice Chrysler Garbisch)

their never-ending quest for portrait commissions, they occasionally attempted to establish themselves as painting and drawing masters and gave lessons to local residents who desired to further their own artistic ambitions. Early newspapers abound with advertisements announcing the arrival of an artist in a town and the subsequent opportunity for local citizens, as this one indicates: "Wm. Birchall Tetley . . . Continues Painting Portraits in oyl or miniature, as usual, Teaches Ladies and Gentlemen drawing and painting in crayons or water colours."[3]

Although the obstacles facing any woman who wished to practice within the academic tradition were substantial, women had a place within the folk-art tradition from its earliest days. That their numbers were more limited initially than those of men is true. The constraints of caring for large families and the time required to fulfill all the needs of a household in an era when much of what a family had—from every scrap of clothing to the food on the table—was often only what family members could make or raise themselves, put severe limits on what else a woman might be able to accomplish, but some,

nevertheless, overcame these not-insubstantial restrictions. Some women who turned to portraiture did paintings only of their family members and friends; others painted for payment or in-kind contributions in order to supplement their family's income—and in some cases to provide the only income. A hardy few took on the itinerant-limner's life, giving it up once they married and had children. Deborah Goldsmith (1808–1836), for example, had an active career as an itinerant portraitist for several years until she married at the age of twenty-four (fig. 12). During her husband's periodic lengthy stays in the South for his health, Ruth Henshaw Bascom (1772–1848) traveled extensively, staying with relatives throughout the Northeast and doing her pastel profiles, sometimes accepting payment, sometimes not, for her work (fig. 19). Eunice Griswold Holcombe Pinney (1770–1849), a middle-class wife and mother, took up painting as a mature woman for the enjoyment of it, and her copious output, much of which is based on prints, reflects an educated and literate woman, familiar with the literature of her time (fig. 60). Mary Ann Willson (active 1810–1825) sold her colorful paintings of biblical scenes,

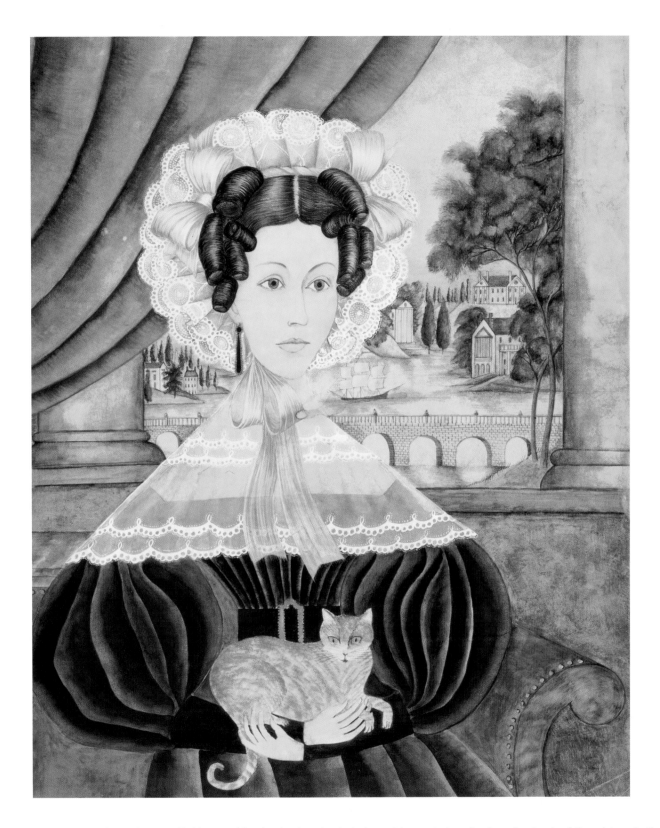

15. *Mrs. Keyser;* artist unknown; Baltimore, Maryland; dated December 1, 1834; watercolor on paper; 23" x 18". This extraordinary watercolor has many of the typical characteristics of nineteenth-century American folk portraits. In this case, the conventions—a sharply delineated shape, bold patterning in clothing and draperies, and an intriguing vista through the window—work together to provide a delightful and charming presentation of a lovely lady and her pet. Inscribed on the back of the picture is the address "20 N. Eutaw Street." The original framer's label indicates that it was made by "M. Barret & Bros. Carvers & Gilders No. 82 Howard Street, corner Saratoga, Baltimore; Looking glasses, portrait and picture frames and gilt work in all its variety, also plain and fancy wood frames and importers of French and German looking glass plates, fine engravings." (Private collection)

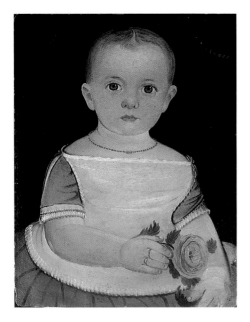

16. *Young Girl with a Rose;* William Matthew Prior (1806–1873); probably Boston, Massachusetts; 1849; oil on academy board; 16" x 12". Signed and dated on back: W M PRIOR 1849. This charming and unusually sensitive portrait of an unidentified baby girl is typical of William Matthew Prior, a versatile and productive artist whose work ranged from naïve portraiture, such as seen here, to the near-academic (see also fig. 24). A native of Maine, where he did his earliest work, he later moved to Boston and spent over thirty years of his life there, a sojourn broken by several tours of New England as an itinerant painter. Prior's versatility and productivity exerted a strong influence on the contemporary artists with whom he had some contact. Prior, Sturtevant J. Hamblin (his brother-in-law and also a portrait painter), and several others who painted in stylistically similar manners and whose work is often difficult to separate, have often been collectively termed the "Prior-Hamblin School," although the artists did not actually work together. (Photograph courtesy America Hurrah Antiques, New York City)

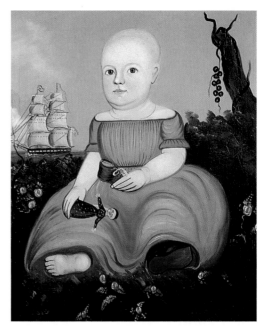

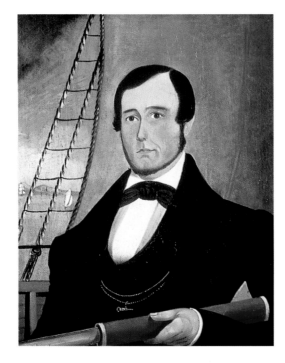

18. *Portrait of an Unidentified Child;* Prior-Hamblin School; probably Massachusetts or Maine; 1835–1845; oil on canvas; 26³/₄" x 21³/₄". Many symbolic elements in this painting—the dead tree, the leafless branch, the departing ship—indicate that the painting was possibly done as a postmortem work, a not-unusual occurrence at a time when child mortality was high. Ongoing research indicates that this painting, once thought to be the work of William Matthew Prior, may instead be by a relative, George Hartwell, who was one of five artists identified as working in the style of Prior and his brother-in-law, Sturtevant Hamblin. (Museum of American Folk Art, New York; Gift of Robert Bishop. 1992.10.1)

17. *Portrait of an Unidentified Sea Captain;* Prior-Hamblin School; Massachusetts or Maine; 1835–1845; oil on canvas; 27¹/₈" x 22¹/₄". This painting was long attributed to Sturtevant J. Hamblin, the brother-in-law of William Prior, but more recent research shows traits that are also associated with George Hartwell, another artist in the so-called "Prior-Hamblin School" of painters whose work is often difficult to tell apart. The inclusion of items having special meaning for the sitter—in this case, a telescope, a sail and rigging as a backdrop, and ships in the background—were common adjuncts in folk portraits, helping to personalize the work further. A painting nearly identical to this one is in the Colby College Museum of Art, Waterville, Maine. (Museum of American Folk Art, New York; Gift of Robert Bishop. 1992.10.2)

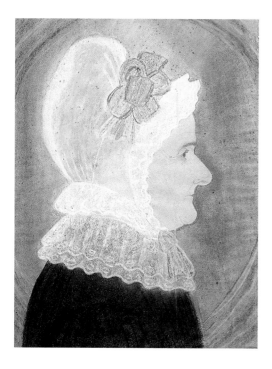

19. *Profile of an Old Lady;* Ruth Henshaw Bascom (1772–1848); Brattleboro, Vermont; c. 1837; pastel on paper; 18" x 13". Ruth Henshaw, born in Leicester, Massachusetts, was the oldest of ten children. Starting in 1789, she maintained a journal for the next fifty-seven years and in it recorded making over 1400 portraits for money, services in kind, or as tokens of affection for family and friends. In 1806, she married the Reverend Ezekiel Bascom and took on the roles of wife, mother, church-record keeper, librarian, teacher, and hat maker, in addition to her avocation as an artist. Her journal first notes making portraits in 1819; her last portraits were done in 1846. For several years, while her husband was ill and had to spend much of his time in the milder climate of the South, she traveled extensively throughout New England visiting family and friends and doing portraits. During this period, she reached a peak of productivity; she notes having done 170 profiles in 1829. Her earliest works are "cut" profiles, a popular art form of the time in which the artist first traced a life-size shadow profile from the sitter and then filled in the features and color without the sitter present; the profile was then cut out and pasted on another sheet of paper and the background done. Bascom's later works, of which this sensitive portrait of a member of the Chamberlin family of Brattleboro is a fine example, were drawn the same way but finished on the same piece of paper rather than being cut out. Bascom kept in touch with many of her subjects and would alter their portraits to show aging or change their clothing to reflect new styles; she even repaired the portraits if they were damaged. Today, 185 of her portraits are known. (Ex-collection Howard and Jean Lipman; present whereabouts unknown)

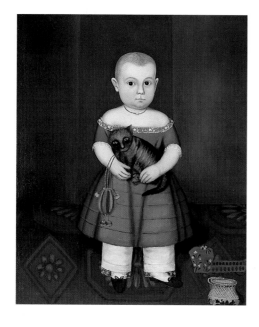

20. *Child with a Cat;* attributed to Joseph Whiting Stock (1815–1855); Chicopee, Massachusetts; 1830–1840; oil on canvas, 33" x 27". Joseph Whiting Stock, born in Springfield, Massachusetts, was crippled in a childhood accident and began painting at the suggestion of his doctor. His early portraits were enthusiastically received, and he soon began to pursue his craft seriously. In spite of his handicap—and with the aid of a wheelchair designed by another friendly doctor—he traveled as far as Connecticut and Rhode Island as well as elsewhere in Massachusetts to carry out commissions. Stock was an impressively prolific artist; a journal that he kept from 1832 to 1846 lists over 900 portraits, along with the prices charged and the dates they were done. His best-known works are his portraits of children, which often have a visual appeal not always present in his likenesses of adults. Like many portrait painters, he often included personal objects associated with the sitter in the composition; here, the pet cat, a tasseled purse, a doll's cradle, and the decorated basket all add homey and individualized touches to this charming child's portrait. (America Hurrah Antiques, New York City)

birds and flowers, and portraits for 25 cents each to help pay for the necessities of life for herself and her companion, a Miss Brundage (fig. 45).

Throughout the first half of the nineteenth century the folk artist caught the many faces of an optimistic, self-confident expanding nation, and there were countless portrait artists who earned their living as itinerants, traveling from town to town and recording the likenesses of all who could afford their artistry. Ammi Phillips (1788–1865; fig. 9), Ruth (1803–1882) and Samuel (1803–1836) Shute (fig. 11), Erastus Salisbury Field (1805–1900; fig. 14), William Matthew Prior (1806–1873; fig. 16), Joseph Whiting Stock (1815–1855; fig. 20), and Joseph H. Davis (active 1832–1838; fig. 13) are but a few of the better known.

Prior began his career in Bath, Maine; he later moved to Portland, Maine, a bustling seaport with a substantial population, finally settling in 1841 in Boston, Massachusetts, where he established his now-famous "Painting Garret." There he painted with several relatives, includ-

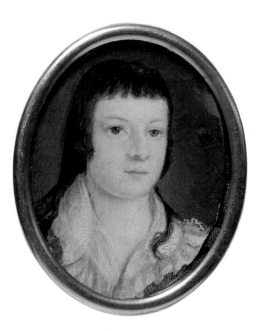

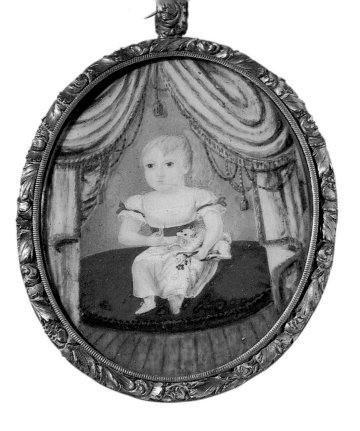

21. *Miniature: Portrait of a Young Boy;* attributed to Joseph Steward (1753–1822); New England; early nineteenth century; oil on ivory; 1⅝" x 1¼". Many artists who painted large-scale works also painted miniatures. These small paintings had an obvious appeal; they could be executed much more rapidly than a large oil on canvas and, because they sold for considerably less, the demand was high. The materials were also easily obtainable and transportable. This attractive miniature is thought to have been painted by Joseph Steward, a multifaceted man who was at one time or another a clergyman, artist, and museum proprietor. Steward began his career as a portrait painter in 1788 in Connecticut; he is thought to have had some lessons with the artist John Trumbull, and he himself is known to have taught John Brewster, Jr., and Sarah Perkins, among others. Photograph courtesy Sotheby's. (Private collection)

22. *Miniature: Portrait of a Child on a Cushion;* artist unknown; 1825–1840; New England; oil on ivory; oval, 2¾" x 2⅛". This delicately painted portrait of an unidentified child was quite possibly done posthumously, for plaited hair is preserved on the reverse side of the miniature. (Museum of American Folk Art, New York; Gift of Howard and Jean Lipman in memory of Joyce Hill. 1989.2.1)

23. *Miniature: Portrait of an Unidentified Gentleman;* attributed to Isaac Sheffield (1807–1845); probably New London, Connecticut; c. 1838; watercolor on ivory; 3¾" x 3½". Miniatures were symbols of a rising middle class that could now command the niceties of life; they were often worn as lockets or brooches or exchanged as tokens of esteem. They were at their peak of popularity from about 1750 until the mid-1800s. The introduction of the daguerreotype in 1839, which put the cost of an identical likeness within reach of the general public, rapidly forced the miniaturist out of business. (Museum of American Folk Art, New York; Purchase in honor of Joyce Hill, 1984.16.1)

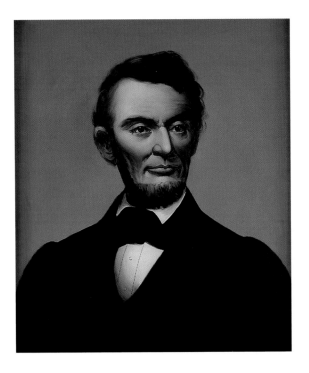

24. *Reverse-Painting on Glass: Abraham Lincoln;* William Matthew Prior (1806–1873); East Boston, Massachusetts; 1865–1870; oil-base paint on glass, wood backing; 23¹/₂" x 19¹/₂". In the latter years of the eighteenth century and well into the nineteenth reverse-paintings on glass were quite popular, and William Matthew Prior became well known in his later years for his work in this medium. Prior is known to have done reverse-glass portraits of George and Martha Washington, Lafayette, and Garibaldi, in addition to Abraham Lincoln; they were handsome as well as appealing to the American public's enthusiasm for depictions of political heroes. This portrait is accompanied by a similar likeness of George Washington. (Museum of American Folk Art, New York. 1985.18.1)

ing Sturtevant J. Hamblin, his brother-in-law and also a portrait painter, and George Hartwell, among others; members of this group painted in stylistically similar manners and are often collectively termed the "Prior-Hamblin School" (see, for example, figs. 17 and 18). Prior is an excellent example of the folk-portraitist's versatility; he adapted his technique to a potential sitter's financial means. A small, flat likeness "without shade" included a frame and glass and could be had for about one dollar. For more affluent subjects, he would provide a surprisingly realistic portrait at a price that might be as high as twenty-five dollars.

Prior also did reverse painting on glass, a technique that was well-established and popular by the mid-eighteenth century. His likenesses in this medium of the American Founding Fathers, such as George Washington, were exhibited at the Boston Athenaeum, where they were most enthusiastically received by a public that "marveled" at his special skills. No examples of reverse-painting on glass from the mid-eighteenth century have

been positively identified, but a careful survey of newspapers of the period indicates that many artists practiced this difficult technique, which was used in the late-eighteenth and early-nineteenth centuries to paint decorative scenes on the glass panels used on clock cases. It was revived in the second and third quarters of the nineteenth century and became especially popular when combined with crumpled foil to create the colorful and sparkling decorative pieces known as tinsel painting (fig. 25). Art manuals and instruction books divulging the secrets of reverse-painting on glass (as well as many other painting techniques) were readily available. Perhaps the most popular book relating to this technique was *The Artist's Assistant in Drawing, Perspective, Etching, Engraving, Mezzotinto Scraping, Painting on Glass, in Crayons, in Water Colours, and on Silks and Satins, the Art of Japanning, etc.* by Carrington Bowles. Records indicate that this book was included in several American libraries

25. *Tinsel Painting: Vase of Flowers;* artist unknown; United States; c. 1860; reverse-painting on glass, foil, wood backing; 17³/₈" x 14". Tinsel paintings became quite popular in the second half of the nineteenth century, especially in the northeastern United States. The reverse-painted glass was backed with crinkled foil, which glittered through the translucent paint. Many women's periodicals, such as Godey's Lady's Book, included instructions and designs to encourage women to create their own tinsel pictures at home. The composition of this work bears a strong resemblance to the theorem paintings so popular among schoolgirls and housewives earlier in the century. (Museum of American Folk Art, New York; Gift of Mr. and Mrs. Day Krolik, Jr. 1979.3.3)

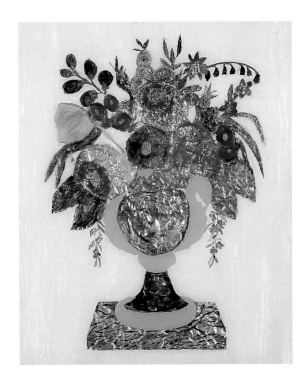

soon after its first release in 1750, and that it went through as many as six editions.

Most portraits of the eighteenth and nineteenth centuries were executed in oil on canvas, but several of the best-known folk painters preferred to use wooden panels that they prepared themselves, thus eliminating a large cash outlay for supplies; other artists worked on paper. Some, like Prior, executed reverse portraits on glass. Painters of miniatures often used ivory because it gave a luminous quality to these tiny portraits that were then mounted in brooches, lockets, pins, and other articles of personal adornment. Watercolors were also produced throughout this period, and pastel portraits such as those by Ruth Henshaw Bascom enjoyed a great popularity with both artists and sitters because they could be executed in a comparatively short period of time. They also did not require an extensive drying time, as did oils, and were easier to use than watercolor. Silhouette portraits cut with scissors were also immensely popular and inexpensive, easily executed personal records; some were further embellished with watercolors.

In September 1839, a momentous event occurred in Paris that ultimately would completely change the life of the itinerant portraitist and even have some impact on lesser-known academic portraitists—the age of photography was born. Louis-Jacques-Mande Daguerre (1787–1851) presented his method of producing the daguerreotype and the process quickly reached the American shores, introduced by Samuel F. B. Morse, an academic painter of some note as well as

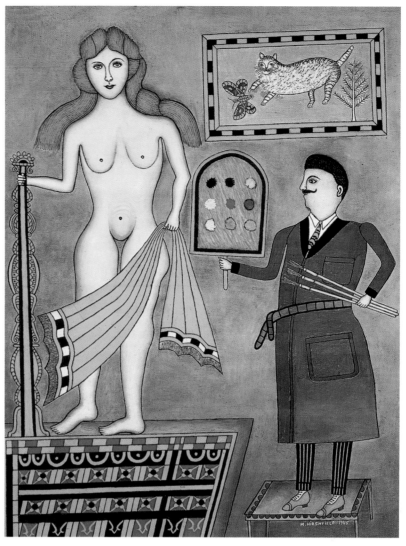

the inventor of the telegraph. Portrait galleries sprang into existence overnight it seemed, and the products of the Daguerrean camera must have begun to create economic hardship for the folk painter almost immediately. Just as were many of the folk portraitists, many

26. *Self Portrait: John Kane (c. 1860–1934)*; Pittsburgh, Pennsylvania; 1929; oil on canvas over composition board; 36¹/₈" x 27¹/₈". John Kane was born in Edinburgh, Scotland, and emigrated to America in 1880. Like many other American folk artists in the twentieth century, Kane held many jobs before he became recognized as a painter—miner, carpenter, steelworker, housepainter, and construction foreman. As he said: "I liked to work and I did not care how hard it was. I think I rather enjoyed using my hard muscles." After losing a leg in an accident, he became a railroad watchman and painter of freight cars; it was at this time that he "became in love with paint." He put this love to good use in depictions of scenes of his native land and his adopted country and city, Pittsburgh. This extraordinary painting by Kane is one of the most powerful portraits of the twentieth century. (The Museum of Modern Art, New York; Abby Aldrich Rockefeller Fund. Photograph © 1995 The Museum of Modern Art, New York)

27. *The Artist and His Model*; Morris Hirschfield (1872–1946); Brooklyn, New York; 1945; oil on canvas; 44" x 34". Born in Poland, Morris Hirschfield emigrated to the United States at the age of eighteen and became a successful manufacturer of carpet slippers. He had shown an aptitude for art from a young age—when he was twelve he made a wood carving for his synagogue that created such a furor the rabbi asked his father to hide it so that prayers could be said—but he did not begin to paint until after his retirement in 1937. Although his initial attempts were discouraging, he persevered and by 1939 was included in the exhibition of "Contemporary Unknown American Painters" at The Museum of Modern Art in New York. Hirschfield's style is lively and distinctive, full of pattern and color, and women were among his favorite subjects. (Collection of David L. Davies)

daguerreotype operators were itinerant, visiting towns, renting rooms, and creating portraits for the local citizens. As one advertisement noted, a Mr. Stevenson "would inform the citizens of Washington and the District that he has taken rooms at Mrs. Cummings' on Penn. Ave. a few doors from the Capitol where he is prepared to take miniature likenesses by the Daguerreotype every fair day from, 10 A.M. till 4 P.M."[4] Sometimes the daguerreotypes were tinted by hand, making them even more like miniature paintings. Some folk-portrait painters abandoned their field for photography while others, such as Erastus Salisbury Field, attempted to bridge the gap and offered both painted and daguerreotype portraits—and even daguerreotypes with color added. Field's daguerreotypes lacked the spark of his earlier work and he met with little success in this area, however. Discouraged, Field turned more and more to historical and religious art and, although he created several superb and ultimately influential paintings in these genres, his ability was not truly recognized until well into this century.

Within a generation new photographic techniques were introduced, the cost of photographic portraiture became less expensive, and the demand for the folk-painter's work all but disappeared. Artistic approximations held no allure when a "true as life" photograph could be had at a fraction of the cost, and so portrait painting returned to the realm of the professional mainstream painter, once again a luxury. In the twentieth century, folk portraiture has had a revival of sorts, but the contemporary folk artist does portraits for pleasure rather than for pay and is just as likely to portray him or herself as anyone else (see, for example, figs. 26 and 29).

Along with portraits of themselves and their families, Americans developed a taste for depictions of the land around them, especially once it had, to a certain extent, been "tamed" and was no longer a subtly threatening reminder of the vastness and dangers of the wilderness that the early colonists had encountered. Landscape paintings began to appear in small numbers during the first decades of the eighteenth century, the majority of which were done on such utilitarian objects as fireboards and overmantels, popular household adjuncts among both the Dutch and English settlers. The Dutch,

especially, brought with them to the Hudson Valley a true love of genre painting that flourished wherever they settled.

Although many of these paintings were of local scenes, or even of the house for which the painting was done (see, for example, figure 31), "landskip" painters often used prints, engravings, and lithographs as design sources. They also had available to them a wealth of books giving painting and drawing techniques and designs, among the most popular being *The Graphice, or the Most Ancient and Excellent Art of Limning,* written by Henry Peachem and published in London in 1612, Carrington Bowles's *The Artist's Assistant* (as noted earlier), and in 1810, *Hints to Young Practitioners in the Study of Landscape Painting,* written by J. W. Alston and published in London. These all provided visual encyclopedias for the beginning artist who lacked access to formal training and were extensively used. One of the earliest American publications to deal with landscape painting was *The School of Wisdom or Repository of the Most Valuable Curiosities of Art,* published at New Brunswick, New Jersey, in 1727. This was a pocket instructor in which amateur artists were introduced to the mysteries of drawing, water and oil colors, etching, engraving, gilding, staining glass, marble, wood, bone, horn, ivory, paper, parchment, and so forth.

Landscapes, farmscapes, housescapes, and cityscapes—a true panorama of the American scene—became even more popular in the nineteenth century (figs. 32–36), and many paintings of the time showing interiors of houses often show a landscape on the wall, indicating that they were, along with portraits, a fashionable mode of decoration (see, for example, the landscape hanging on the wall in the watercolor by Joseph H. Davis, fig. 13). Some wealthy businessmen even had their workplaces documented, just as they would their families and their homes. After Washington's death, Mount Vernon became an especially favored subject for a landscape painting, combining as it did patriotic sentiment and a romanticized landscape; many such paintings were based on popular prints of the time and were done by schoolgirls (see fig. 53).

By the mid-eighteenth century some of the artists who had chosen to paint the landscape began as well to view the sea as an appropriate topic for decorative

painting. The first artists who attempted to paint the sea tended to focus their attention upon the harbors, perhaps because of their vital importance to the economy of the coastal cities and towns in terms of shipbuilding, shipping, and fishing. Almost all such views include a healthy component of ships of all types, underscoring the commercial aspect of the harbor scenes (see, for example, fig. 83). Very few marine views from the early eighteenth century are known, but the custom of including an emblematic seascape visible though an open window in the background of portraits was a well-established conceit of the time.

Eventually, painters broadened their horizons and no longer concerned themselves exclusively with the shore. By the mid-eighteenth century paintings of large bodies of water populated with sprightly sailing ships were being created, and, as the Romantic style developed during the first decades of the nineteenth century, some American artists turned their backs on the shore to record the turbulent and often dangerous open sea (fig. 38). Woodcuts, engravings, and mezzotints provided marine artists with sources of design that they boldly copied and, on occasion, adapted. From this point onward, the innovative American painter looked upon the recording of the sea as a great adventure. The awe of the sea as captured by earlier painters gradually disappeared, and by the late nineteenth and twentieth centuries the fascination with the sea had been transferred from the water to the vessels that rode the crests of its waves (figs. 39, 42).

Religion has always been a major source of inspiration for the artist, folk or otherwise. It has also been one of the most powerful influences on American culture since its beginning, as so many groups came here in search of religious freedom. Religion was thus a dominant force in life and left its imprint in art. For some artists painting was a means of expressing simple religious beliefs; for others, it was intended as an evangelical tool; and for yet others, the artists believed that a message was being transmitted from a higher being and should be shared. These same motivations are no less valid today in the religiously inspired art made by many twentieth-century folk artists (see, for example, figs. 46, 70, and 73).

In the seventeenth through nineteenth centuries, prints and engravings were important design sources, and many European religious engravings influenced local artists (fig. 45). In the Hudson River Valley particularly, Dutch settlers living between New York City and Albany commissioned an extensive body of religious art from itinerant artists, adorning their walls with numerous religious paintings based on woodblock illustrations

29. *Self-Portrait;* Mattie Lou O'Kelley (b. 1908); Decatur, Georgia; 1978; oil on canvas; 44" x 31½". Born in Maysville, Georgia, Mattie Lou O'Kelley remembers childhood on her father's farm as the best time of her life. She lived there until her father died in 1943 and the farm was sold; she then moved into Maysville and held a series of jobs over the next twenty-five years. On her retirement in 1968 she started painting—"I had always wanted to paint, now I had the time." The majority of her work comprises memory paintings that lovingly depict life in the rural area where she grew up (see, for example, fig. 75). This self-portrait reflects an introspective moment perhaps typical of the spirit and lifestyle of rural folk artists who often have worked in cultural isolation, and it recalls a verse from her autobiographical poem:
 Now my one-room house has only me,
 I never roam,
 No lessons have I, but I paint
 and paint
 And stay at home.
(Museum of American Folk Art, New York; Gift of the artist. 1990.6.1)

28. (OPPOSITE PAGE) *Portrait of Frank Peters;* Joseph P. Aulisio (1910–1974); Stroudsburg, Pennsylvania; 1965; oil on masonite; 28" x 20". Frank Peters was a tailor in a cleaning establishment owned by Joseph Aulisio in Old Forge, Pennsylvania. Aulisio, who began to paint when he was about fifty, used many of the traditional elements associated with folk portraits—the full front pose, a personal accessory to tell something about the sitter (in this case, a tape measure), and a plain background—in this striking painting that seems to capture the sitter's inner soul. The artist, who painted about thirty pictures of people and places in Pennsylvania, once said, "I always dreamed of becoming an artist and writer. . . . I paint because I love it." (Museum of American Folk Art, New York; Gift of Arnold B. Fuchs. 1978.8.1)

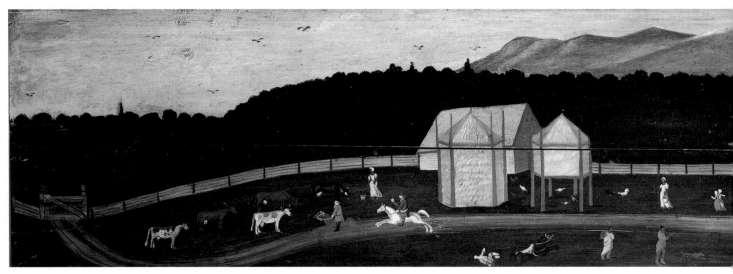

30. (TOP) *Overmantel;* artist unknown; Morattico, Richmond County, Virginia; c. 1715; oil on wood; 20¹/₁₆" x 91³/₄". Many Southern landowners regarded the decorative painted overmantel as a status symbol, and this handsome and lively painting graced one of the fireplaces in the elaborate and elegant Virginia mansion built by Charles Grymes in 1715. English lifestyles and fashions still exerted a strong influence on the Southern colonies in the first half of the eighteenth century, and a panel painted about 1690 that is thought to have served as the inspiration for this piece was found in Wilsley House, Cranbrook, Kent, England. (Courtesy Winterthur Museum, Winterthur, Delaware)

31. (ABOVE), 31a. (OPPOSITE PAGE, BOTTOM) *Van Bergen Overmantel;* attributed to John Heaten (active 1730–1745); New York; 1732–1733; oil on wood; 15¹/₄" x 87¹/₂". This overmantel from the Marten Van Bergen homestead in Leeds, Greene County, New York, is one of the earliest American landscapes extant, and it was saved and reused when the original house (seen in the painting) was demolished to make way for a new one. Rich in detail, it offers a comprehensive view of the Van Bergen farm, complete with its inhabitants and livestock, as well as a panorama of the nearby Catskill Mountains. Because the artist included so much careful detail, the painting serves as an excellent record of both early Hudson River architecture and the activities of a flourishing farm of the early eighteenth century. (New York State Historical Association, Cooperstown, New York)

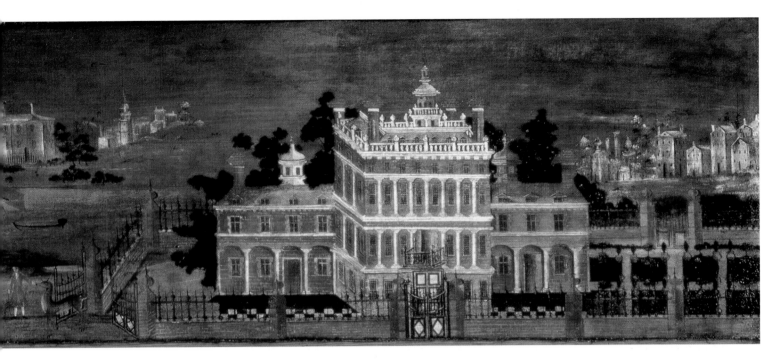

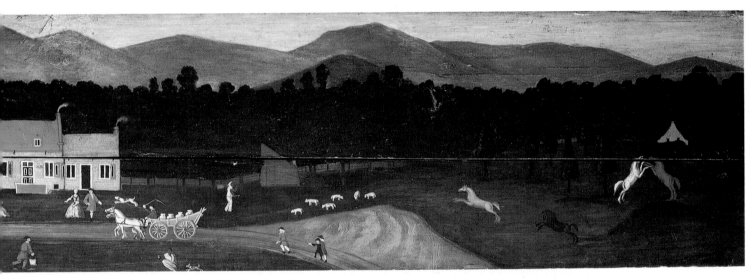

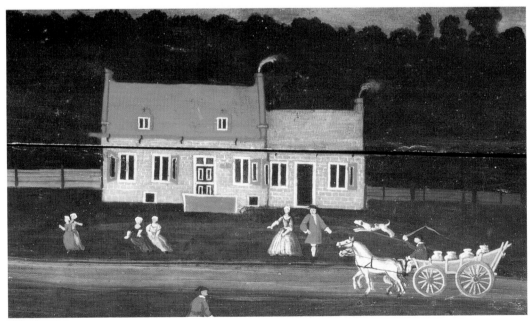

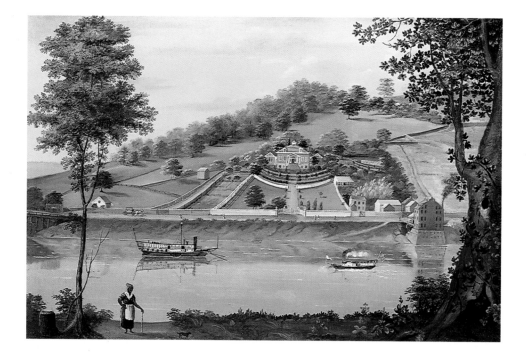

32. *The Steamboat Washington;* artist unknown; Ohio; c. 1820; oil on canvas; 19¾" x 28½". Although the nominal subject of this early painting from the Midwest is the steamboat, the elegant mansion on the far side of the river is the true focal point. The painting also gives a good sense of how Ohio, which had been part of the western frontier of the United States not so many years earlier, had become quite domesticated. (Private collection)

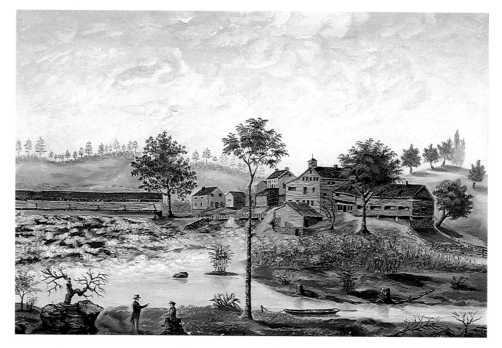

33. *Mill on the Brandywine;* artist unknown; Pennsylvania; 1830–1850; oil on canvas; 13½" x 19⅝". Folk artists frequently recorded the buildings that were important in their or their clients' lives. Possibly the painter of this piece lived or worked near the mill depicted, or was a relative of the owner. It is also possible that the proud owner of this obviously successful mill commissioned the painting to enhance his own importance. (Private collection)

from Bibles brought from Holland. Many of these crude but vital pictures appear to have been executed by itinerant English painters and other visiting portrait painters of the day, whatever their nationality.

The Shaker religion was brought to America from England in 1774 by Mother Ann Lee (1736–1784), who established communities initially in several places in New York and Massachusetts. The material culture of the Shakers was very simple; they did not believe in superfluous decoration—every article they made had a

purpose, and ostentation was frowned on; as one of their elders once said: "The beautiful is absurd and abnormal. It has no business with us."[5]

In 1837, a wave of revivalism swept the Shakers, promoting the belief that they had drifted too far from their roots of simplicity and spirituality. While this revival was still in process, many "gifts" were received from the spirit world—messages were said to have come not only from Mother Ann but also from other departed Shakers, angels, even George Washington, and, sometimes, from

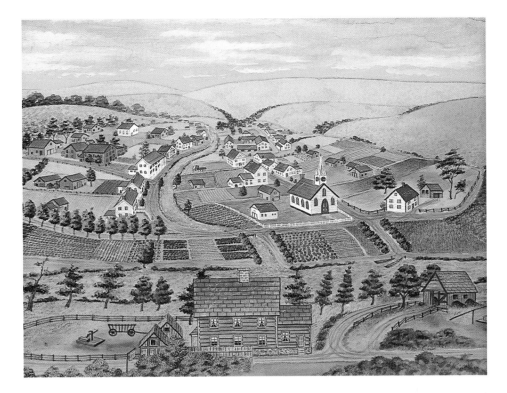

34. *View West from Easton, Pennsylvania;* Adam Doyle; Pennsylvania; c. 1850; watercolor on paper; 13⅞" x 17¼". By the middle of the century inexpensive lithograph landscapes were often used as sales premiums and helped to awaken an interest in landscape painting among the general public that almost reached fever pitch. Both fine and folk artists experimented with new ways of depicting the world they lived in, and, among those in rural areas, views such as this example were immensely popular. They gave a sense of consequence to the upwardly mobile population, in essence giving substance and importance to familiar surroundings. (Present whereabouts unknown)

the Holy Father and his counterpart, Holy Mother Wisdom (the Shakers believed in a mother/father Godhead). A series of drawings began to appear in Shaker communities in this period. They were usually done by women members of the community who believed that they were simply the means by which messages about heavenly life were being communicated to the group. Several dozen drawings were done from about 1845 to 1855, and often the same person received more than one vision, for example, Hannah Cohoon (fig. 44). These pieces were often quite beautiful, filled with color and decorative motifs such as flowers and musical instruments; it was almost as if what was denied in earthly life existed in heavenly life. The elements in the drawings often had specific meanings—the tree of life, for example, which appears in several drawings, represented many things: (1) part of the vision calling Shakers to America, (2) a symbol of the unity of the Church, and (3) a life-affirming symbol at a time when converts to the religion were dropping off. The drawings were not openly displayed in Shaker buildings—they went against the credo of simplicity—but they nevertheless were treasured and preserved as a reflection of faith. By 1860, the revivalist spirit among the Shakers had dissipated; as the revival ended, so, too, did the production of drawings.

Pennsylvania, settled toward the end of the seventeenth century by colonists led by William Penn, was known for its policy of religious freedom and soon began to attract a large multinational group of immigrants that made it, like New York, its sister colony to the north, a prototype of the American melting pot. Penn received a charter to establish a colony in the New World in 1682 in payment of a debt owed his father by King Charles II of England. Penn was a Quaker, and he came to look on his planned colony as a "holy experiment," where religious and personal freedoms might flourish. In an attempt to encourage colonists to settle in the rural areas of Pennsylvania, Penn's agents visited the Rhineland area of Germany during the latter part of the seventeenth century and attracted many religiously persecuted Protestants to the New World. These early settlers, inaccurately referred to as Pennsylvania Dutch (derived from *Deutsch,* meaning German) were often members of the Lutheran or Reformed churches. The Amish and the Mennonites, also disenfranchised religious groups from Switzerland, came as well.

Fraktur was a native art brought to America by these German Protestant religious groups that settled in Pennsylvania. Its proper name is *fraktur schriften.* or "fraktur writing." The term *fraktur* was coined in 1898 by Dr. Henry Mercer, founder of Mercer Museum in Bucks County, Pennsylvania, and refers to the "fractured" script on medieval manuscripts. It is a type of manuscript illumination and was used in the making of the decorated handwritten documents that record births, marriages, deaths, and other significant life events within the Pennsylvania German communities. One of the most common types of *fraktur* was the birth and baptismal certificate (figs. 47 and 51), or *Geburts und Taufschein,* a docu-

ment required by law in the old country. These highly ornamented, hand-drawn and colored records were usually created by an educated elite—schoolmasters or clergymen. *Vorschriften,* or writing models, were also created by these skilled men for their pupils, and many of them are inscribed with the names of the instructors and their hopeful students. *Haus-Segen,* or house blessings, another type of *fraktur,* reminded the family of the ever-present spirit of the Almighty in the home. Some of the earliest examples of *fraktur* in this country were done by nuns and other brethren of the community at Ephrata, Lancaster County, Pennsylvania, a cloistered community founded by Conrad Beissel in 1728.

Numerous *fraktur* from the second half of the eighteenth century have come to light in recent years, but few have been as impressive as those executed in 1784 by Ludwig Denig of Chambersburg, Pennsylvania. These include an album of biblical scenes, quotations from the Bible, *fraktur* writings, and several pieces of music. Little is known about the personal life of Denig, but his simple, straightforward watercolors are permeated with religious fervor and speak directly to the viewer's basic sensibilities (figs. 43).

Fraktur makers often had more technical training than many other folk artists and were frequently skilled draftsmen and colorists. Most practitioners were men, although women were not excluded from *fraktur* training. The work of many *fraktur* artists was sold or commissioned, which helped to supplement the incomes of the teachers and ministers, and they rarely signed their work, making attribution difficult.

Fraktur usually blended pictorial elements with a text and were beautifully lettered and decorated. The decorative elements were sometimes primitive, almost always symbolic—a combination of Christian and pagan beliefs—and sometimes abstract. Traditional motifs abound in *fraktur.* Unicorns, stags, decoratively drawn mermaids, heraldic lions, and an endless variety of birds, including the dove, the peacock, the distelfink, and the

35. *Residence of C.N. Wolters, Cohoes, N.Y.;* artist unknown; New York; c. 1850; watercolor on paper; 23" x 29". For most of the nineteenth century America remained agrarian. The measure of one's success was the acreage of fertile land and the usefulness and handsomeness of the buildings erected upon it. Many landowners chose to have their homesteads documented in what may be called "property portraits" in order to have a permanent and visible record of their wealth and good husbandry. The unknown Mr. Wolters must have been especially proud of this handsome domain, captured so successfully for posterity in this painting. Photograph courtesy Thos. K. Woodard: American Antiques & Quilts, New York City. (Private collection)

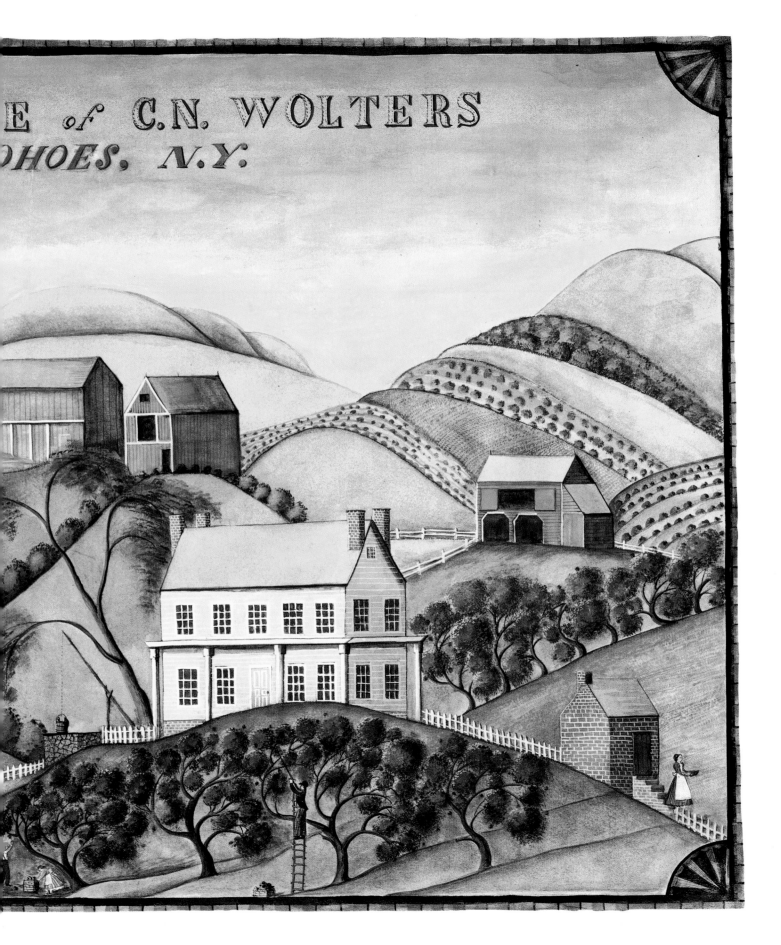

36. *The White House at Sunset;* artist unknown; Pennsylvania; c. 1855; oil on canvas; 12³/₄" x 17³/₄". Although somewhat primitive in its handling of form, this painting is remarkable for its sensitive palette, the use and degree of shading through the sky, and the depiction of reflected light. It is a fine representative of the popular landscapes/ housescapes of the period. (Museum of American Folk Art, New York; Gift of Robert Bishop and Cyril I. Nelson. 1992.10.14)

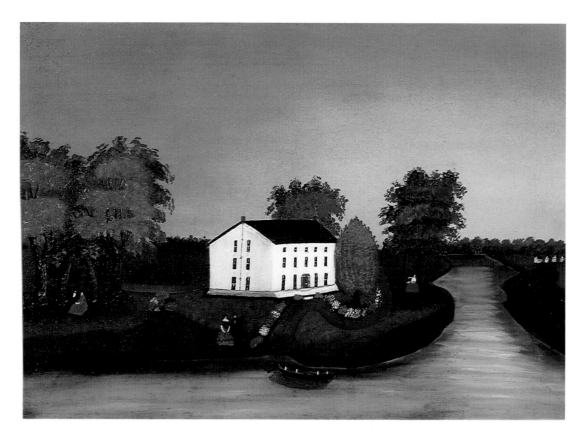

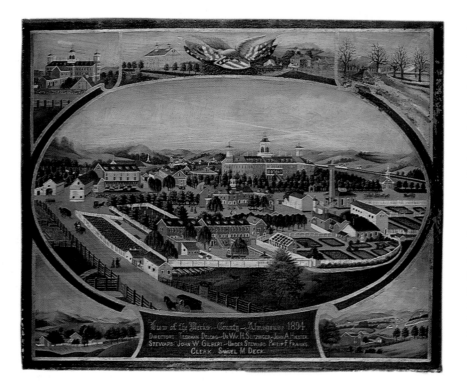

37. *View of the Berks County Almshouse;* Louis Mader; Pennsylvania; 1894; oil on tin; dimensions unavailable. Charles C. Hofmann (1821–1882), John Rasmussen (d. 1895), and Louis Mader are known as the Pennsylvania almshouse painters for their depictions of the extensive Berks County almshouse where each spent some time. These paintings are thought to have been commissioned, probably by employees or trustees of the almshouse. Mader was admitted to the almshouse for intemperance just three years before Rasmussen's death there, and he painted a number of views of the institution and its environs. In this composition, Mader appears to have used an 1879 painting by Hofmann as his source of inspiration. All known examples of Mader's and Rasmussen's work are painted on tin, which provides a smooth, hard surface ideal for the detailed work in which these artists excelled. (Present whereabouts unknown)

38. (OPPOSITE PAGE) *Sailor's Cutwork;* Frederick Williams; Portsmouth, Virginia; 1835; cutwork, pinpricking, watercolor and ink on paper; dimensions unavailable. In the eighteenth and much of the first half of the nineteenth centuries it was easier to travel by ship than by any other form of transportation. The sea also was the means of livelihood for many Americans, be they fishermen, sailors, whalers, merchants, shipbuilders, or shipowners. It is not surprising, then, that folk artists frequently included ships and the sea in their art. This quite astonishing combination of cutwork and painting commemorates in almost biblical terms the loss of a ship at sea. Photograph courtesy America Hurrah Antiques, New York City. (Private collection)

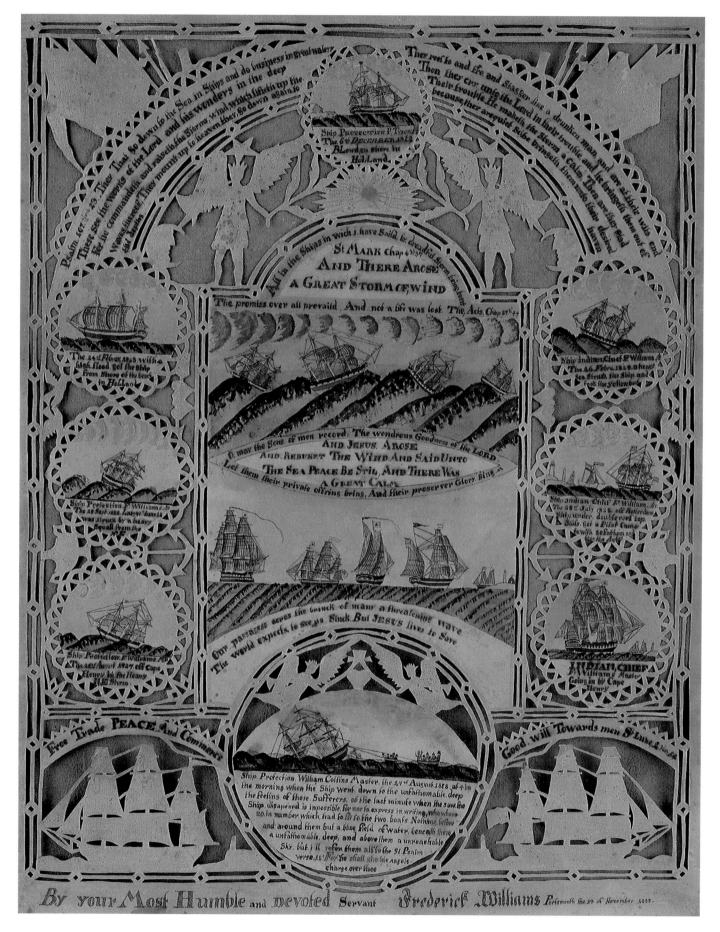

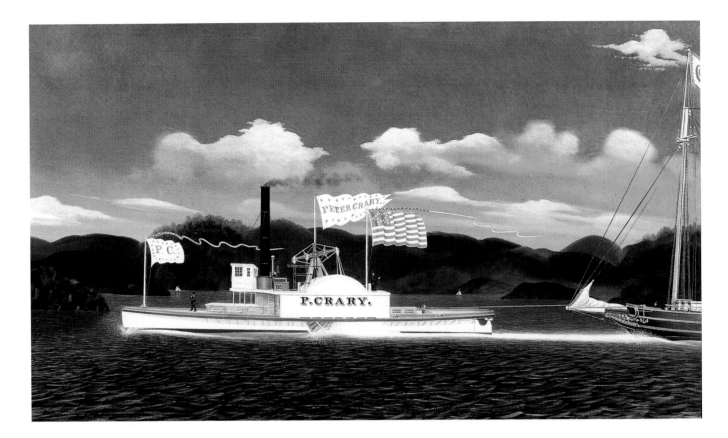

parrot, appear in a vast number of these ink and watercolor creations (fig. 48). These symbols were also often painted on the decorated furniture from this area (see, for example, fig. 99). The symbols became more contemporary and secular later in the nineteenth century.

The dates on *fraktur* documents do not always mean the date the work was done, as some families or communities might wait to record life events until an artist who could make a *fraktur* certificate was available. Sometimes, to expedite the work, the decorative parts of a *fraktur* might be completed in advance, with the appropriate inscriptions filled in later. Most *fraktur* were made between 1760 and 1850, with the peak period

39. *The Hudson River Towboat P. Crary;* James Bard (1815–1897); New York City; 1858; oil on canvas; 29" x 50". Signed and dated on the lower right: "Drawn and painted by James Bard, 162 Perry St., N.Y. 1858." The P. Crary, built as a towboat (the job it is performing in this painting), was later used to ferry immigrants from Ellis Island in New York harbor to Manhattan. James Bard and his twin brother John were fascinated by boats from their youth. Self-taught artists, they collaborated on hundreds of splendidly detailed, luminous paintings of ships until John's death in 1856. James continued to depict both steam and sailing vessels until his own death some forty years later. (America Hurrah Antiques, New York City)

40. *Homeward Bound;* R. Johnson; New York; c. 1960; oil on window shade; approximately 29" x 43". Johnson, who emigrated to New York from Sweden, was a merchant seaman. His love of his trade is reflected in the nautical paintings that recall his sixty years of sailing to all parts of the world. Note the inscription on this painting that describes the full catch of cod and halibut from the Grand Banks. His frames, crafted from rope and often trimmed with sailor's knots, become integral parts of the paintings. Photograph courtesy America Hurrah Antiques, New York City. (Private collection)

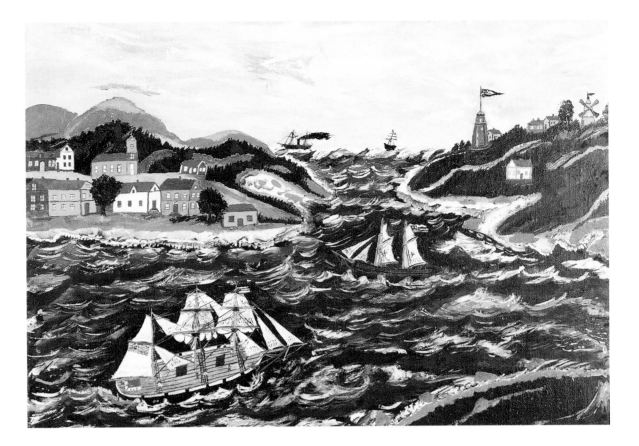

being from about 1800 to 1835. Schools in German communities throughout Pennsylvania continued to teach manuscript illumination and *fraktur* writing well into the nineteenth century; in fact, many of them were still instructing their pupils in this ancient craft at the time of the establishment of the American school system in the 1850s. Just as the daguerreotype changed the face of folk portraiture and the future of the itinerant artist, so, too, did the printing press ultimately force the *fraktur*-maker from his profession. From the second quarter of the nineteenth century forward, printed certificates, intended to be colored by the purchaser and filled in as required, were mass-produced. Hand-executed examples were simply too time-consuming and expensive to com-

41. (TOP) *Harbor Scene on Cape Cod;* artist unknown; Massachusetts; 1890–1900; oil on canvas; 23" x 31¾". Careful scrutiny of details can sometimes provide clues helpful in dating a painting. For example, a ship in the background of this piece has sails as well as a smokestack; because such dual-powered vessels began to disappear around 1900, this lively and colorful composition was probably completed before that date. (Museum of American Folk Art, New York; Gift of Robert Bishop. 1992.10.11)

42. *The Titanic;* James Crane (1877–1974); Ellsworth, Maine; c. 1968; oil on cloth with paper collage; 20" x 28". Although James Crane was well known in Ellsworth for his attempt to build an airship based on "bird-motion flight," he is recognized more widely for his maritime paintings. A fisherman in his youth, he depicted the sea and its disasters when he turned to painting in his later years. He painted several versions of the Titanic and also built a rough model of it in his yard, next to his airship that never flew. Crane's paintings often show his subject from several perspectives, as in this one, where the top deck is seen from overhead and the rest of the ship from the side. (Museum of American Folk Art, New York; Gift of Robert Bishop. 1985.37.1)

pete, and so the traditions that nurtured the German *fraktur* artist waned.

The most celebrated of all Pennsylvania folk painters is Edward Hicks (1780–1849), who was born in the village of Attleborough (now Langhorne), Bucks County, Pennsylvania. He was the son of a Quaker father and an Episcopalian mother who died when he was an infant. Because of severe financial losses, Hicks's father was unable to support young Edward and placed him with another Quaker family, the Twinings, for his upbringing (see fig. 82). At thirteen years of age Edward Hicks entered an apprenticeship with a coachmaker; soon after the turn of the nineteenth century he became a partner in a Milford, Pennsylvania, coachmaking and painting business and in time painted street signs and shop and tavern signs. A jack-of-all-trades like so many folk artists, he also executed decorative paintings on furniture, fireboards, and even clock faces. Eventually, his success was such that he required assistance, and when writing his memoirs, he noted: "I am now employing four hands, besides myself, in coach, sign and ornamental painting, and still more in repairing and finishing carriages, and I think I should find no difficulty in doubling my business."[6] Hicks was also a deeply religious man and was accepted into the Quaker ministry.

Hicks was devoted to painting historical and religious scenes, and, like other American folk painters, he relied on prints and biblical illustrations as a chief source of inspiration. He frequently repeated a composition that pleased him, and he seems never to have tired of the idea that the wild beast and civilized man could peacefully coexist in God's world. This idea was expressed best in his paintings of *The Peaceable Kingdom*, and he executed nearly one hundred versions of this subject during his career (fig. 52). Painting ultimately became an obsession with Hicks. Once, in a Quaker meeting, he exhorted the congregation about the importance of art in life; the conservative parishioners then appointed a committee to express condemnation of his testimony—for them, the idea of the constant pursuit of beauty was akin to consorting with the devil.

During the opening years of the nineteenth century, the rising and prosperous middle class took great pride in their success and began actively to educate their daughters as well as their sons. Girls were sent to academies and seminaries where they would gain the trappings of distinction and gentility through a curriculum that leaned heavily toward the polite arts of needlework, music, dancing, writing, and painting. A tremendous number of paintings were turned out by girls in the academies as well as when they returned home, and the results changed the look of the interiors of homes.

43. *Pilate's Mouth Proclaims Innocence;* Ludwig Denig; Chambersburg, Pennsylvania; 1784; each page, 6½" x 8½". Ludwig Denig's unique *fraktur* album contains fifty-nine biblical and scriptural scenes, over one hundred pages of script, and several pages of music. His intense and colorful depictions of events in the life of Christ are permeated with religious fervor, and each scene is described in detail. The translation of a part of the text that accompanies this painting is as follows: "Here is pictured the presentation of Jesus Christ before the worldly judge, Pontius Pilate, and the accusers. For early in the morning the entire multitude arose and led him before Pilate and began to accuse him, saying: Of this man we find that he alienates the people and says that he is Christ, a king, and forbids paying taxes to Caesar." Photograph courtesy Museum of American Folk Art, New York. (Private collection)

Needlework was initially the favored medium for "fancy pieces" to brighten the home (see figs. 142, 143, 144), but, as watercolor paints became available in solid form, they were preferred for convenience (and fashion) and eventually replaced needlework altogether. The influence of stitchery was strong, however, and many paintings continued to simulate the look of needlework—short, stitch-like strokes of the brush, and paper pinpricked to resemble fabric (see, for example, figs. 54 and 61). Theorem painting, a technique taught in the academies after about 1812, was also very popular (figs. 57, 58, 59). Although stencils were used, theorems required considerable skill to do them properly, and many girls created quite wonderful pieces that managed to transcend formulaic compositions. The stenciling techniques used in theorems were also used to decorate furniture, tinware, and bedcovers, to name a few other possibilities.

The topics for other schoolgirl paintings encompassed a broad range: scenes from popular novels or classical literature, national heroes, history, Shakespeare, or

44. *A Little Basket of Beautiful Apples*; Hannah Cohoon (1788–1864); Hancock, Massachusetts; 1856; ink and watercolor; 10¹/₈" x 8³/₁₆". The text at the top of the painting, one of several gift drawings done by Hannah Cohoon, reads "Come, come my beloved/ And sympathize with me/ Receive this little basket/ And the blessing so free." The inscription on the bottom says: "Sabbath. P.M. June 29th 1856. I saw Judith Collins bringing a little basket full of beautiful apples for the Ministry, from Brother Calvin Harlow and Mother Sarah Harrison. It is their blessing and the chain around the pail represents the combination of their blessing. I noticed in particular as she brought them to me the ends of the stems looked fresh as though they were just picked by the stems and set into the basket one by one. Seen and painted in the City of Peace, by Hannah Cohoon." (Hancock Shaker Village, Pittsfield, Massachusetts)

45. *The Prodigal Son Wasted His Substance;* Mary Ann Willson (active 1810–1825); Greene County, New York; c. 1815; ink and watercolor on paper; 15" x 12⁵/₁₆". Little is known of the life of Mary Ann Willson and her "romantic attachment," a Miss Brundage. They are said to have lived on a small farm in New York, which Brundage farmed while Willson created lively and colorful paintings on a variety of subjects—biblical scenes, portraits, flowers, and birds—to supplement their income. Several of her works were clearly inspired by engravings of the period. This painting, one of a group of four depicting scenes from the parable of the Prodigal Son, was probably based on an engraving and etching from a similar series attributed to Cornelius Tiebout from the last decade of the eighteenth century. Willson used large, flat areas of color in her work and created her own rules for perspective and form. (© 1995 Board of Trustees, National Gallery of Art, Washington, D.C.; Gift of Edgar William and Bernice Chrysler Garbisch)

the Bible; landscapes and still lifes also remained perennial favorites (figs. 54 and 56). At this same time, the French and English Romantic movements reached the American shores, and idealized pictures, moody, moonlit landscapes, and romantic story paintings emanated from the girls' schools in astonishing numbers. Delicate watercolors with incredible detail, romantic landscapes with mysterious castles, elegant grisaille paintings, and mourning/memorial paintings were all part of this manifestation, and paintings depicting such idealized moral personifications such as Hope, Virtue, and Charity were popular as well. The number of romantic topics and compositions testified to the extent and strength of the Romantic movement in this country. In addition, a renewed interest in religious concerns flourished as a result of the Second Great Awakening, a period of religious revival that was sweeping the country at the time and led to the creation of untold numbers of watercolor and needlework pictures based on biblical subjects (fig. 55).

Both the Second Great Awakening and the Romantic movement played parts in the emphasis on the themes of death, dying, and resurrection in the early nineteenth century, and the popular mourning/memorial needlework pictures (see fig. 145) and paintings (figs. 60, 61) of the time may have fed off this trend to some extent—or vice versa, for the ubiquitous mementoes of death and one's all-too-frail mortality might well keep one concerned about the state of one's everlasting soul. Some mourning pieces were made specifically to memorialize public figures and to express the esteem and respect in which they were held. Innumerable memorials were created in the years following the death of Washington in 1799—indeed, his death may be said to have given a spurt to the trend. However, mourning pictures seem to have been made as much for their stark beauty and classical themes as to memorialize someone, famous or otherwise. In fact, when one schoolgirl asked her older sister for a suggestion for a needlework subject, she was told to do a mourning piece because the sister thought it "handsomer than Landscapes." Their popularity simply as subject matter is additionally indicated by those

mourning pictures that appear to be premature, as the ubiquitous tomb will carry the name of the artist for herself or a still-living member of her family (with the death dates left blank, or course); these paintings also capture the artist's romanticized vision of the despair that would occur on such an untimely death. Not all, however, were so enamored of these sometimes lugubrious and hardly cheerful depictions that hung on parlor walls; Mark Twain, via Huckleberry Finn, noted that he "didn't somehow seem to take" to such dark decoration—"they was too black, mostly"—and that "because, if ever I was down a little, they always gave me the fan-tods."

Like theorem paintings, mourning and memorial paintings and needlework pictures, which were done almost exclusively by schoolgirls and women, had a certain formulaic aspect to them; they incorporate a number of symbolic elements and motifs that add additional subtle messages to the obvious topic. The burial urn stood for the spirit of the departed; the mourning figure(s) represented heroic death; the willow tree, mourning and the cleansing waters of Christian grace; the evergreens, Resurrection and life everlasting; the oak and elm trees, strength, prominence, and dignity; ferns bespoke humility; a broken tree or broken flower, life cut short; a departing ship, a completed journey; a village, the temporary environment on earth, and so on. All mourning pictures contain several, if not all, of these symbols. Many of the memorial pictures also used stencils for certain elements of the composition, while others were based on engravings.

The academies and seminaries that taught painting and drawing put some stress on copying prints, engravings, and well-known paintings, and most had files of prints that the girls could use as sources of inspiration. Again, books such as *The Artist's Assistant* and Rufus Porter's *A Select Collection of Approved Genuine, Secret, and Modern Receipts, Valuable and Curious Arts, as Practiced by the Best Artists of the Present Age* (1810) were helpful. Girls and women could also learn to paint and draw by taking private lessons or attending drawing schools—many of them run by itinerant artists such as those discussed earlier.

47. *Birth and Baptismal Certificate for Martin Andres;* John Spangenberg, "The Easton Bible Artist"; dated 1788; New Jersey or Pennsylvania; watercolor and ink on paper; 13" x 15½". John Spangenberg, a schoolteacher and *fraktur* artist from Easton, Pennsylvania, followed the practice of many schoolmasters and supplemented his teaching salary by creating decorated written documents as well as less-ornate writings. The lively and colorful borders on his *fraktur* often depict musicians and ladies and gentlemen in addition to the more usual floral motifs. This *fraktur* as well as others commissioned by Bernard and Mary Andres, Martin's parents, for their children, are unusual in that they are written in English rather than German. (Museum of American Folk Art, New York; Promised anonymous gift)

48. *Fraktur;* Johann Adam Eyer (1755–1837); Montgomery County, Pennsylvania; dated 1789; watercolor on paper; 7½" x 4½". Johann Ayer, one of the most outstanding of the Pennsylvania *fraktur* makers, was a *Schuldiener,* or schoolteacher, a common occupation among *fraktur* artists. The elegant calligraphy provides a measured counterpoint to the simply but charmingly drawn deer, angels, and flowers, all motifs that have symbolic meaning and appear in a variety of combinations in Pennsylvania *fraktur.* The inscription on this devotional *fraktur* reads, "As a deer pants for water, so cries my soul, oh Lord, for thee." (Museum of American Folk Art, New York; Promised anonymous gift)

46. (OPPOSITE PAGE) *The Crucifixion;* Antonio Esteves (1910–1983); Brooklyn, New York; 1978; acrylic on wood; diameter 35½". Antonio Esteves, born in Brazil, came to America as a young child and spent part of his youth fending for himself on the streets of New York. After an accident in 1970 left him in severe pain, he began painting as a mechanism to take his mind off his injuries. He soon found that painting fulfilled a need for creative expression and once referred to it as a "hobby that got out of hand." Esteves's subjects ranged widely from fantasy and religion to the mundane. In this painting, his interpretation of the crucifixion of Christ is dramatic and vivid, with a sense of personal immediacy that characterizes much of his work. (The Robert Bishop Collection)

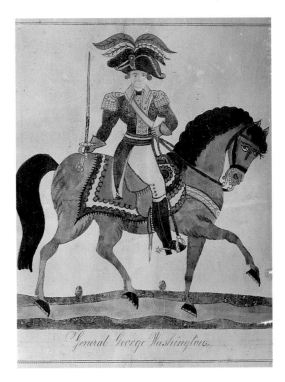

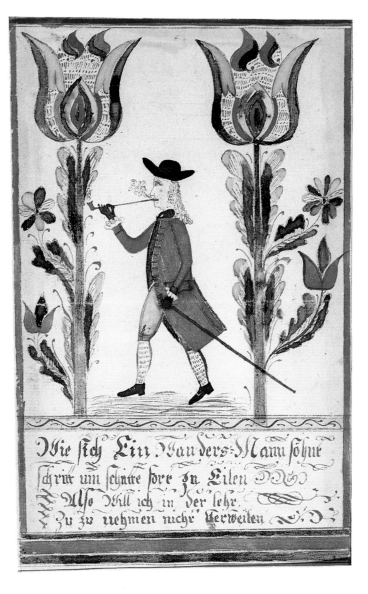

49. (RIGHT) *Fraktur;* artist unknown; ink and watercolor on paper; c. 1810; southeastern Pennsylvania; 8¹/₂" x 4³/₄". This wonderful *fraktur* fantasy portrays a pipe-smoking gentleman walking among giant tulips. Like the later drawing of Washington (fig. 50), it is the work of a *fraktur* artist in a lighthearted, even whimsical, mood. (Rare Book Department, Free Library of Philadelphia)

50. (ABOVE) *General George Washington on Horseback;* attributed to Henry Young (1792–1861); Lycoming County, Pennsylvania; 1825–1835; pen and ink, pencil, and watercolor on wove paper; 13⁵/₈" x 9³/₄". Washington personified the American ideals of freedom and democracy, and the hero worship accorded him is well reflected in folk art, including the work of the *fraktur* artists. "Every American considers it his sacred duty to have a likeness of Washington in the home just as we have images of God's saints," wrote the Russian diplomat Paul Svinin in an 1829 article on the liberal arts in America that he published as a postlude to his memoirs of travels in the United States from 1811 to 1823. "He would fain keep before his eyes the simulacrum of the man to whom he owes his independence, happiness and wealth! Washington's portrait is the finest and sometimes the sole decoration of American homes. Citizens of the first two classes go out of their way to have these portraits painted by Stuart, and pay a hundred dollars for it." Those less affluent had to content themselves with prints or, as in this case, turn to humbler artists in their own communities who could give them the image desired. (Museum of American Folk Art, New York; Promised anonymous gift. P79.102.1)

After the 1830s, art manuals and instruction books were published with increasing frequency and, as the various branches of artistic endeavor proliferated, numerous publications dealing with specific types of painting reached the booksellers. Books on theorem painting, watercolor painting for young ladies, ornamental painting, graphic art, flower painting, and drawing for children flooded the marketplace. Art instruction was first introduced into the public schools in New England by *An Introduction to Linear Drawing Adapted to Use of Public Schools in the United States,* written by William B. Fowle and published in Boston in 1825. This book was so successful that subsequent editions were issued in 1828 and 1830. By the close of the nineteenth century, elementary art classes had become fairly standard for students in the public-school systems of major cities, but even at this late date Fowle's publication may have still been reaching the hands of country artists and influencing their artistic endeavors.

As the nineteenth century drew to a close and made

way for the twentieth, some folk painters began to look back to the world of their childhood and early adult years, one that, in spite of its often-strenuous day-to-day demands, now appeared simpler and perhaps innocent of the many complexities and tensions that modernization brought along with its benefits. Many of the works of these artists who bridged the centuries have a nostalgic element, while others document the gradual disappearance of a way of life and work that once predominated. Olof Krans (1838–1916), for example, working from photographs and his memories, captured the verve and communal spirit of the inhabitants of the Bishop Hill Colony in Illinois in its earlier years, while Joseph Pickett (1848–1918) marked the gradual encroachment of industrialization on the rural lifestyle to which he was born.

Certainly the most popular of this century's self-taught artists are the memory painters, and it was their work that first brought twentieth-century folk painting to the public at large. Memory painters frequently select personal incidents from their own childhood as the subjects of their pictures, often combining into a single picture several experiences that enliven the visual composition in unusual and interesting ways. Among the best-known of the memory painters are Grandma Moses and Mattie Lou O'Kelley. Anna Mary Robertson Moses (1860–1961), better known today as Grandma Moses, was born in and spent much of her life in eastern New York State, except for a brief period when she and her husband had a farm in Virginia. Throughout her life she tended to the daily chores and activities that are so often depicted in her paintings. Grandma Moses did not began painting in earnest until she was in her seventies. She acquired an awareness of organization and rendering ability by examining Currier and Ives prints; when she coupled this knowledge with her memories of rural family life and her own innate talent, her creations took on a quality all their own. Her work exemplifies the essence of folk art during the first half of the twentieth century, and, when she died in 1961, Grandma Moses was, perhaps, the best-known of all American folk painters (fig. 65).

In more recent years, Mattie Lou O'Kelley has risen to prominence with her rich and charming memory paintings. Born in the small southern town of Maysville, Georgia, in 1908, she was the seventh of eight children. Her oils on canvas reflect childhood memories of family gatherings and farm activities such as sowing and harvesting; they all include a wealth of detail that delights the eye (fig. 75). Other twentieth-century painters have also captured some of the mystical sense of the lost years of innocence of the past (fig. 71).

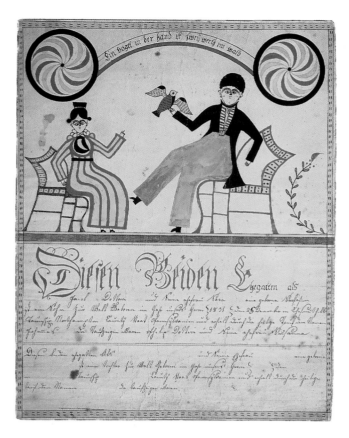

51. *Birth and Baptismal Certificate for Johannes Dottern;* artist unknown; Northampton County, Pennsylvania; c. 1831; watercolor on paper; 15" x 11⅞". The inscription above the couple's heads in this charming *fraktur*, created to document the birth of Johannes Dottern on December 25, 1831, reads: "One bird in the hand is worth two in the forest." The dates given on *fraktur* such as this one are not always the date the piece was created; sometimes *fraktur* artists drew the illustrated part of birth and baptism certificates and sold them to families who then filled in the pertinent information when needed; other times, a certificate might be done several years after the birth, if an artist were not available when a child was born. (Museum of American Folk Art, New York; Promised anonymous gift)

The first half of the twentieth century also saw black folk artists begin to come into their own. The deceptively simple drawings of Bill Traylor (fig. 66), the dramatic and often introspective renderings of Horace Pippin (fig. 67), the vivid and mysterious paintings of Minnie Evans (fig. 69), and Clementine Hunter's colorful and beguiling depictions of everyday life on a southern plantation (fig. 71) have all contributed to and expanded the concept of American folk art. The works of these artists have provided enrichment, inspiration, and instruction, and, in their own way, helped to set the stage for those who followed.

Much of the folk painting of the twentieth century has been inspired by the same motivations as those of earlier periods. Portraiture has continued to flourish, and

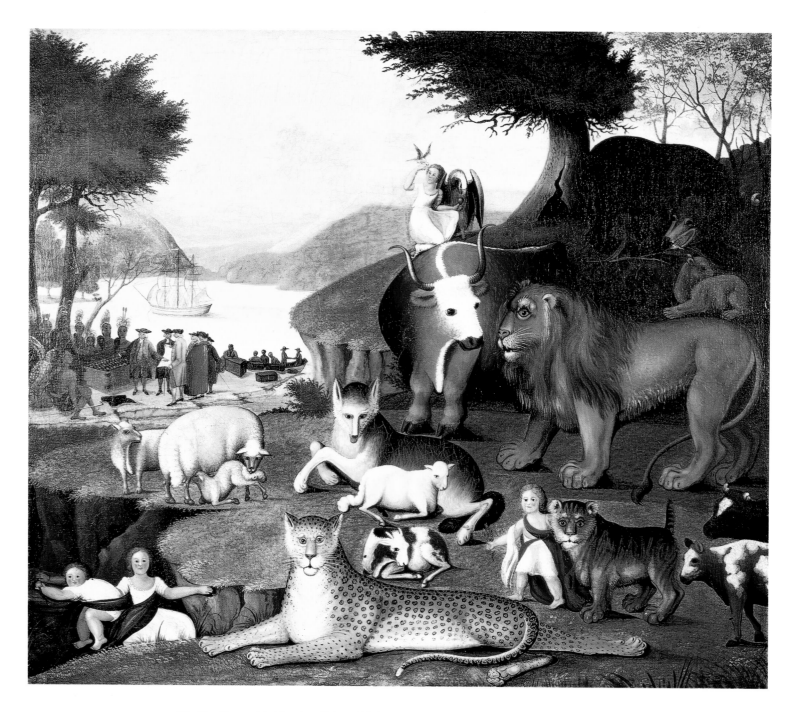

52. *The Peaceable Kingdom;* Edward Hicks (1780–1849); Newtown, Pennsylvania; 1846; oil on canvas; 26" x 29³/₈". Edward Hicks, a deeply religious Quaker, found an outlet for many of his beliefs in his depictions of religious and historical scenes. This lovely painting illustrates Isaiah's words from the Old Testament, "The wolf also shall dwell with the lamb, and the leopard shall lie down with the kid, and the calf and the young lion and the fatling together; and a little child shall lead them," and it is one of the many variations on this theme (about sixty versions are known) that Hicks created. Hicks included a depiction of William Penn's treaty with the Indians in several versions of his *Peaceable Kingdom* (as seen here) because he considered that event to be a manifestation of the possibility of a peaceable kingdom on earth. Like many artists of his time, Hicks used prints and biblical illustrations both as sources of inspiration and of compositional elements for his work. The Penn scene, for example, is based on an engraving after Benjamin West, and the foreground scene of animals and children is adapted from an engraved illustration of a painting by Richard Westall. (Museum of American Folk Art, New York; Promised anonymous gift)

naïve artists still attempt to record the world that surrounds them, although today's depictions may be more likely to reflect the problems and difficulties of a life than the more romanticized scenes that once held greater sway. Patriotism remains a frequently expressed theme, although now more often overlaid with social comments as well (John Orne Johnson Frost, fig. 63, was an early commentator on the ravages of war), and popular media figures are depicted as often as political ones. The decoration of utilitarian, functional objects that can be embellished and made more beautiful with paint has certainly been of concern to the modern-day folk artist, and recent immigrants and descendants of immigrants are still utilizing transplanted exotic designs and motifs that continue to infuse America's artistic heritage with a unique blend of the old and the new.

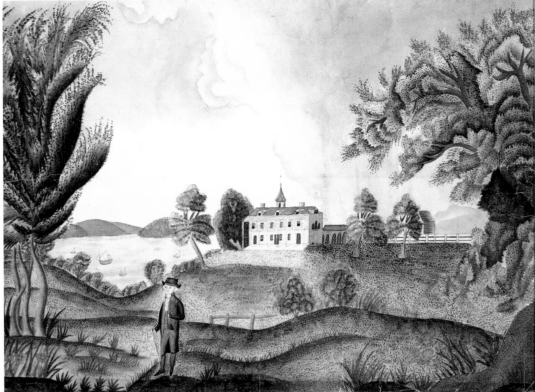

Often the question is asked "Will there be an American folk art in the twenty-first century as well?" It seems almost certain that the answer is yes. "Visionary" and so-called "outsider" artists have increased in number and their paintings speak powerfully to us today. Just as prints and engravings once helped form and inspire folk artists' images, today magazines, newspapers, and, perhaps most important, television, have provided contemporary folk artists with an expanded visual point of reference, but most still ignore the formal lessons of the contemporary art world. With inner vision and burning zeal, self-taught painters like Joseph Yoakum (1886/8–1972; fig. 74), Sister Gertrude Morgan (1900–1980; fig. 70), Nellie Mae Rowe (1900–1984; fig. 78), Jack Savitsky (1910–1991; fig. 76), the Reverend Howard Finster (b. 1916; fig. 72), Thornton Dial, Sr., (b. 1928; fig. 80), and many others "make" pictures that bring their private worlds to the public eye. Although sometimes difficult to understand, these are the folk painters of our time. Their work is today's folk legacy for the future. The portrait of America continues and grows.

53. *George Washington at Mount Vernon;* signed on the back "Painted by A.M. Tredwell at Mrs. Willards School Middlebury, Vermont 1814"; watercolor on paper; 14¹⁄₂" x 19¹⁄₄". The latter part of the eighteenth century and the early nineteenth century saw an increase in education for girls, and it was not unusual for young women of upper-class and rising middle-class families to attend female seminaries and academies. In addition to a limited academic curriculum, they received training in the "polite arts," including painting. Watercolors depicting national heroes—most especially George Washington—were popular, and they often used prints as sources for the basic composition. This painting by a student at Mrs. Willard's Academy probably had such a source, for several similar examples are known, including one painted in 1842 by Sarah Whitcomb, also a schoolgirl, but without the figure of Washington. Photograph courtesy Stephen Score, Inc., Boston, Massachusetts. (Private collection)

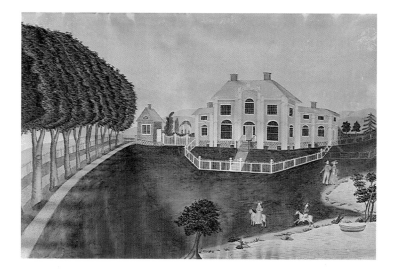

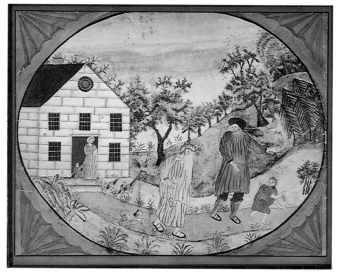

54. *Yellow House in a Landscape;* artist unknown; c. 1820; probably New England; size unavailable. Houses and landscapes were also among the favored topics depicted by schoolgirls in their painting exercises. Although nothing is known about the creator of this charming composition, it reflects many traces of schoolgirl art, including subject matter, the use of watercolor, the possible use of stencils for creating some of the elements, and tiny brushstrokes that resemble needlework in certain areas of the painting, as in the foliage of the trees. Photograph courtesy America Hurrah Antiques, New York City. (Private collection)

55. *Ishmael Driven Out;* Emeline Dowe; 1825–1840; probably Connecticut; watercolor on paper; dimensions unavailable. Biblical stories were favorite subjects for the needlework pictures and watercolors done by young women in female academies and seminaries, and the story of Ishmael was among the most popular. Both the subject and execution of this watercolor clearly show that the artist was trained in an academy. One of the most delightful parts of this watercolor is the depiction of a New England house in this biblical scene. It was not unusual for such contemporary elements to be included in a classical or biblical subject. (Present whereabouts unknown)

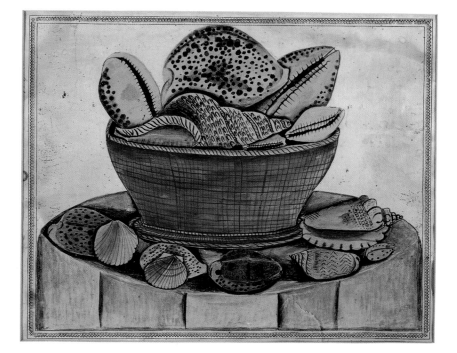

56. *Basket of Shells;* artist unknown; New England; 1825–1840; watercolor on paper; 10½" x 13¾". Still-life painting became fashionable in the mid-1820s for well-bred young ladies who learned their painting skills at female academies and seminaries; the genre was also practiced by professional artists as well. Careful arrangements of shells or fruit and vegetables were favorite subjects, but romanticized rural or castellated landscapes were also popular. This watercolor possesses an aesthetic power that is most unusual given its prosaic subject. (Private collection)

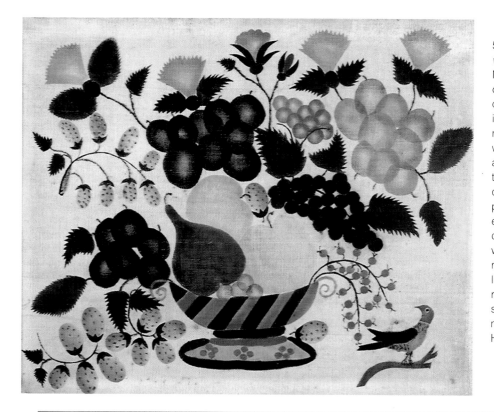

57. *Theorem: Fruit and Flowers with Bird;* artist unknown; probably New England; 1825–1850; watercolor on velvet; 8" x 11¼". Theorem, or stencil, painting came into fashion in America soon after the technique became popular in England, where it was introduced from China at the close of the eighteenth century. Most theorem paintings required several stencil sheets, which provided the basic shapes of the elements making up the painting's compositions. Theorem stencils were similar to those used to decorate furniture, tinware, and walls (in lieu of wallpaper). This lively theorem contains a bright array of shapes that belie the mechanistic method used in its creation. (America Hurrah Antiques, New York City)

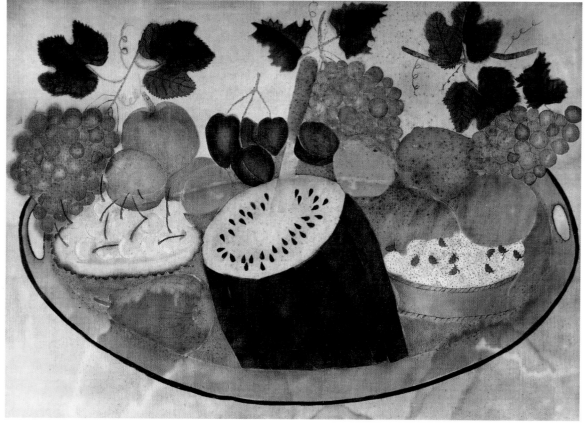

58. *Theorem: Tray of Fruit;* artist unknown; probably New England; 1830–1850; watercolor on velvet; 16½" x 23". Still lifes were the favorite subjects of theorem paintings, and velvet was the fabric of choice because its napped surface gave an appealing softness to the stencil demarcations, although paper was also used with pastels or watercolors. Theorem stencils were cut from heavy paper or cardboard and then shellacked or oiled to create a strong, stiff surface. (Museum of American Folk Art, New York; Gift of Mrs. William P. Schweitzer. 1983.23.1)

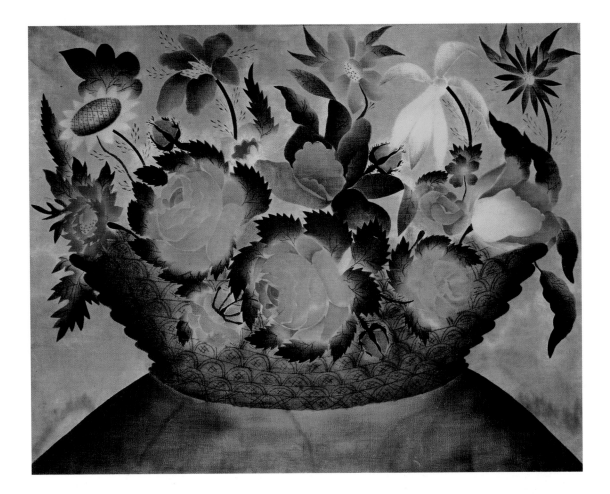

59. *Theorem: Basket of Flowers;* artist unknown; possibly Delaware; c. 1825; watercolor on velvet; 18" x 24". Although they provided an almost foolproof way for anyone to create an interesting picture, many theorems overcame the limitations of the form to produce colorful and charming compositions. Theorems were an especially popular form of art among young women attending finishing schools or academies, and works created at the same schools are often similar because the girls frequently used the same stencils. An almost identical version of this brimming basket of bright flowers, for example, is known to have been executed at Mrs. Maul's School in Wilmington, Delaware. Photograph courtesy America Hurrah Antiques, New York City. (Private collection)

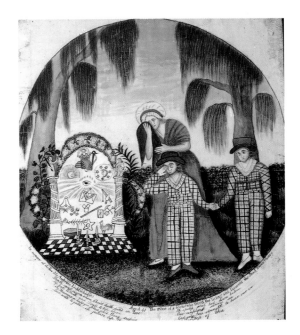

60. *Masonic Memorial Picture for the Reverend Ambrose Todd;* Eunice Griswold Holcombe Pinney (1770–1849); Windsor or Simsbury, Connecticut; 1809; watercolor on laid paper, pen and ink inscription; 14" x 11⅞". Eunice Pinney, a well-educated woman who took up painting as a hobby in the early years of the nineteenth century, had been married to her first husband by the Reverend Todd in 1797, and the touching inscription makes clear her regard for him. The Masonic motifs included on the gravestone give some indication of the importance of Todd's affiliation to this fraternal organization. Pinney, although best known for her many light-hearted depictions of children playing, courting couples, or women enjoying themselves, painted several other memorial/mourning paintings, including one for herself (with the dates left blank). (Museum of American Folk Art, New York. 1981.12.7)

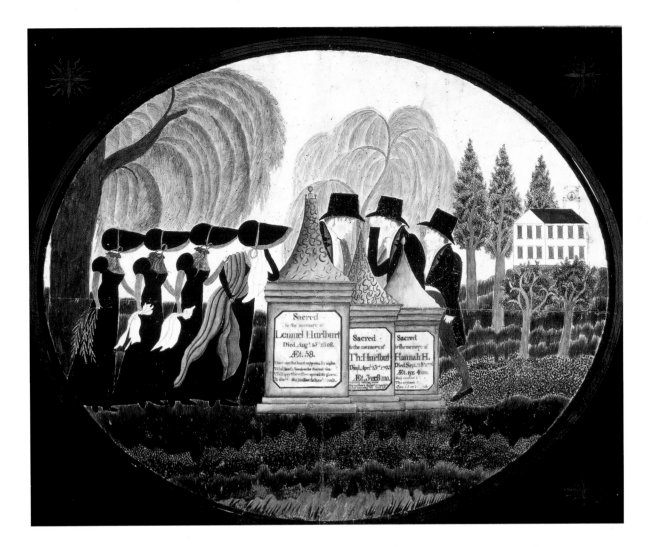

61. *Hurlburt Family Memorial;* Elizabeth Hurlburt; Connecticut; c. 1808; watercolor on paper; 16½" x 20¼". The mourning picture became a popular art form for schoolgirls in the early years of the nineteenth century. Although in many cases they were true expressions of grief and remembrance created by the newly bereaved, many were made as memorials to long-gone relatives or friends or to popular heroes like George Washington. Each element in a mourning picture has symbolic meaning; weeping willows symbolized mourning, evergreens stood for resurrection and life everlasting, the urn for the spirit of the departed, deciduous trees for transitory life, the church or cathedral for faith and hope. In this elegant memorial painting, the grass and foliage have been painted to resemble needlework. (Museum of American Folk Art, New York; Promised anonymous gift)

62. *Pile Driving;* Olof Krans (1838–1916); Bishop Hill, Illinois; 1896; oil on canvas; 35" x 37". Olof Krans (then named Olsson) came with his parents from Sweden to America in 1850. They settled in the Bishop Hill Colony in northern Illinois, a utopian community started by Swedish religious dissidents. He worked in the colony's blacksmith and paint shops and, as his talents became evident, became known as "Painter Krans, the Wizard with the Brush." After a tour of duty as an infantryman in the Civil War, he became a painter of theater backdrops and curtains and hand-lettered road signs. Crippled in later life, he turned to painting memory scenes of his

past experiences at Bishop Hill as well as portraits of its members. Krans painted this picture in honor of the fiftieth anniversary of the founding of the Bishop Colony, an event that saw the first meeting of the Bishop Hill Old Settlers Association, a group now nearing its centennial reunion. Photograph by Soren Hallgren. (Bishop Hill Heritage Association)

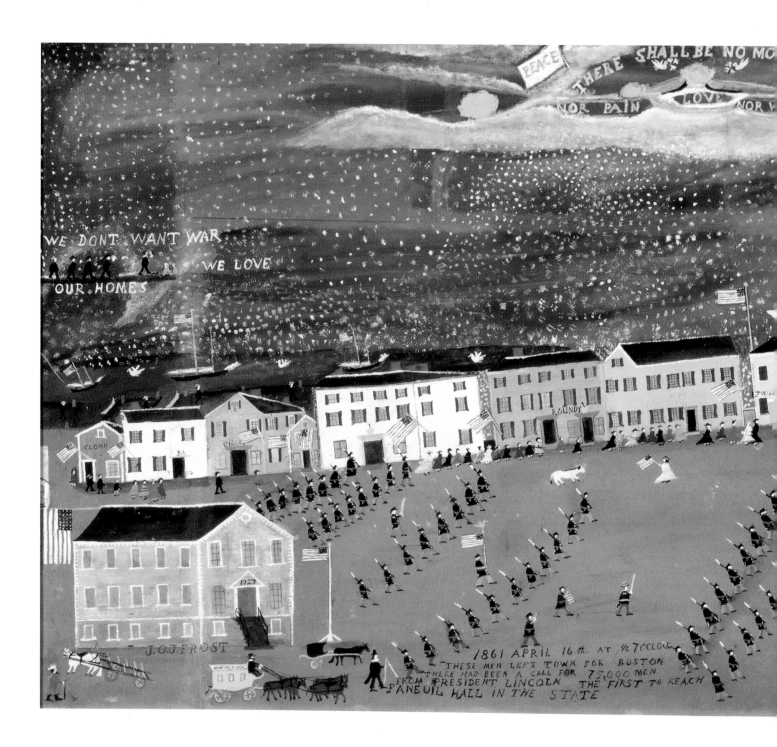

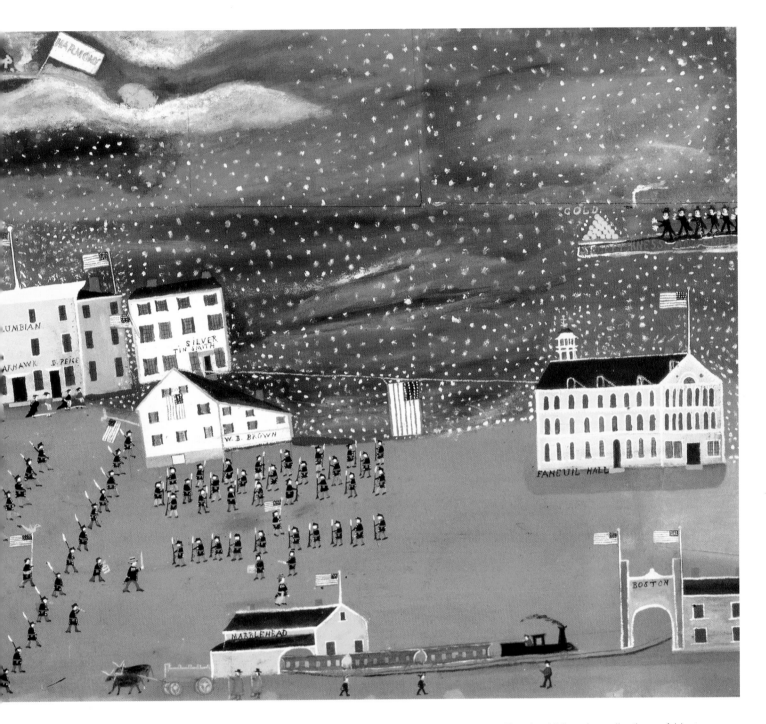

63. *The March Into Boston From Marblehead April 16, 1861: There Shall Be No More War;* John Orne Johnson Frost (1852–1928); Marblehead, Massachusetts; c. 1925; oil on masonite; 31½" x 72". Frost, a native of Marblehead, began to chronicle the history of the town in paint and words starting around 1922. Although a large group of his paintings deal with the seafaring life and the marine industries of Marblehead, another dominant theme is the history of the area from the earliest days of its settlement through the Civil War. This dramatic depiction of troops preparing to head off to war, one of his most potent and penetrating works, incorporates Frost's childhood recollections of his father's departure for the Civil War (from which he did not return) as well as powerful textual reminders of the human costs and suffering of war. Although largely unappreciated in his lifetime—especially by other Marblehead residents—Frost's work eventually gained the recognition it deserved. By 1952, when renovations to the house in which he had lived revealed more than thirty additional paintings nailed in the walls, his unique works were at last receiving critical acknowledgment. Photograph courtesy Sotheby's. (Property of a private collection)

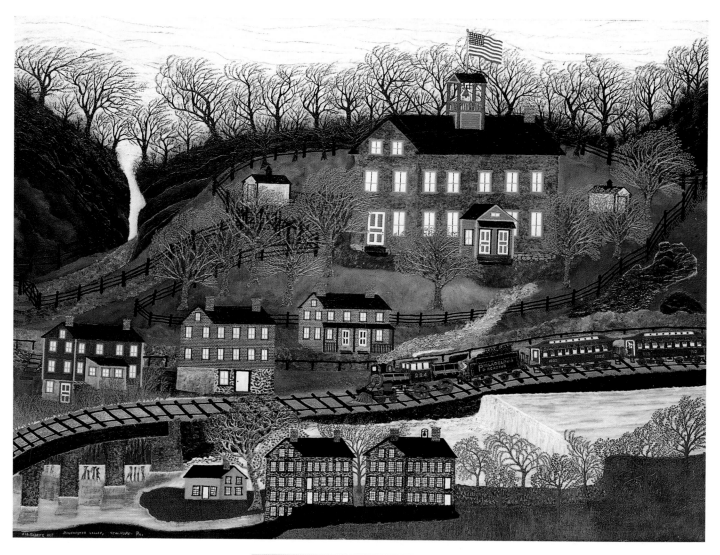

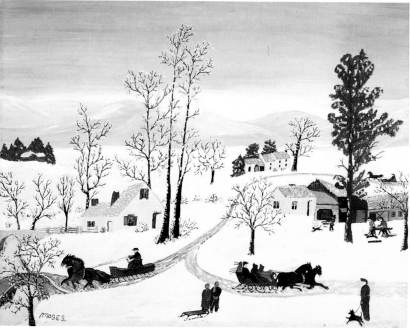

64. (OPPOSITE PAGE, TOP) *Manchester Valley;* Joseph Pickett (1848–1918); Pennsylvania; 1914–1918; oil with sand on canvas; 45½" x 60⅝". Joseph Pickett, an artist whose work bridges the nineteenth and twentieth centuries, documented the passing of a way of life in his paintings, in which he reflected the impact of the Industrial Revolution on rural America. Pickett is known from a very small body of work, only four pieces of which still exist. He was a migrant carnival worker until the age of forty-five, when he returned to settle in New Hope, Pennsylvania, the town of his birth. He started painting in the late 1890s and often labored for several years on a painting. Pickett worked in oils on canvas, but he often textured his paint with sand, earth, rocks, and shells, creating varied surfaces that add character and depth to his work. (The Museum of Modern Art, New York; Gift of Abby Aldrich Rockefeller. Photograph © 1995 The Museum of Modern Art, New York)

65. (OPPOSITE PAGE, BOTTOM) *Dividing of the Ways;* Anna Mary Robertson (Grandma) Moses (1860–1961); Eagle Bridge, New York; 1947; oil and tempera on masonite; 16" x 20". Of all the twentieth-century American artists, Grandma Moses, who did not begin to paint seriously until she was in her seventies, is probably the best known worldwide, for her nostalgic but lively portrayals of rural life in the late nineteenth and early twentieth centuries have a universal appeal that few can resist. This work encapsulates both the landscape and the memory-painting styles for which Moses is so well known. Her paintings were often inspired by prints such as those of Currier and Ives, by greeting cards, and by calendars, as well as by clippings from magazines and newspapers (of which she had a file of thousands). Many of her winter scenes contain mica, sprinkled on the paint while it was still wet, to give sparkle to the snow. (Museum of American Folk Art, New York. Copyright © 1987, Grandma Moses Properties Co., New York. Gift of Galerie St. Etienne, New York, in memory of Otto Kallir. 1983.10.1)

66. (RIGHT) *Figures and Construction with Blue Border;* Bill Traylor (1854–1947); c. 1941; Benton, Alabama; poster paint on cardboard; 15½" x 8". Bill Traylor was born a slave on an Alabama plantation and continued living there until the age of eighty-four, when his wife having died and his children gone, he moved to Montgomery, Alabama. There, after working briefly until he was disabled by rheumatism, he spent his days on the sidewalk and his nights in the back room of a funeral parlor. It was during this period that he began to draw; "It just come to me," he once said. He used mostly found materials at first, but later a young local artist befriended him and brought him paper and paints. This painting is one of the more complex of Traylor's works; many of his works depict only single subjects, often animals such as the ferocious dog-like figure at the bottom of this piece. Although simple in subject and composition, Traylor's painting is always powerful in its aesthetic impact. (Museum of American Folk Art, New York; Gift of Charles and Eugenia Shannon. 1991.34.1)

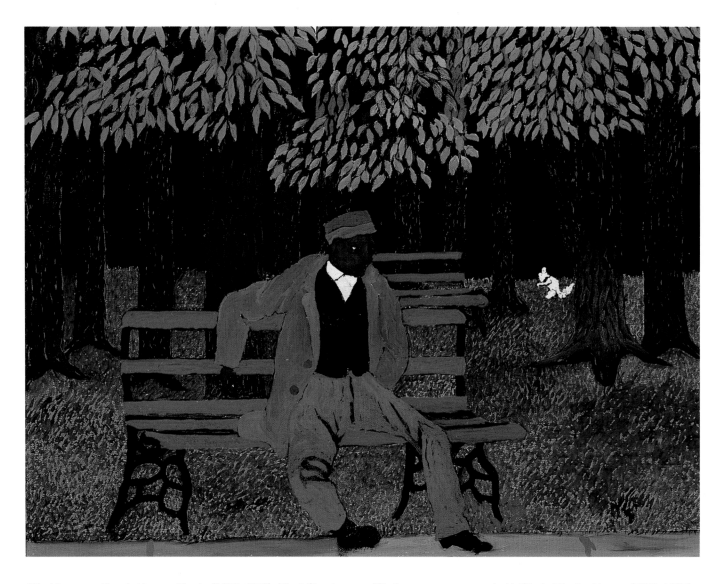

67. *Man on a Bench;* Horace Pippin (1888–1946); West Chester, Pennsylvania; 1946; oil on canvas; 14" x 18". Horace Pippin, one of the most celebrated black artists of this century, once said, "My opinion of art is that a man should have love for it because my idea is that he paints from his heart and mind," a belief that is clearly reflected in his thoughtful yet emotional paintings that reach into the soul of the black experience in America. Pippin had sketched since he was a child and kept a moving diary of drawings of his World War I army experiences. A battle wound left him with a partially paralyzed right arm, and he gradually learned to accommodate his injury in order to continue drawing and painting. His paintings range from nostalgic though perceptive depictions of a turn-of-the-century black lifestyle to penetrating illustrations of social concern and injustice. This painting, one of his last, is a masterful portrayal of mood and color and splendidly exemplifies Pippin's work. Photograph courtesy Janet Fleisher Gallery, Philadelphia, Pennsylvania. (Collection of Mr. and Mrs. Daniel W. Dietrich II)

68. (OPPOSITE PAGE, TOP) *Untitled;* Minnie Evans (1892–1987); Wilmington, North Carolina; c. 1946; pencil, crayon, ink on paper; 12" x 9". Minnie Evans created her first drawings in 1935 and then did not draw seriously again until the 1940s, when she became the gatekeeper at Airlie Gardens. She was profoundly influenced by her surroundings there, and her love for the lush flora of the gardens is reflected in her paintings, which overflow with colorful, if often imaginary, horticultural bouquets. Evans's work is often composed of fantastic visions that combine religion and mythology; many of her works include penetrating eyes or mystical faces, all wrapped in glowing rainbows of rich color. She was a prolific artist and left nearly one thousand exuberantly complex paintings and drawings. Photograph courtesy Luise Ross Gallery, New York City. (The Anthony Petullo Collection of Self-Taught and Outsider Art)

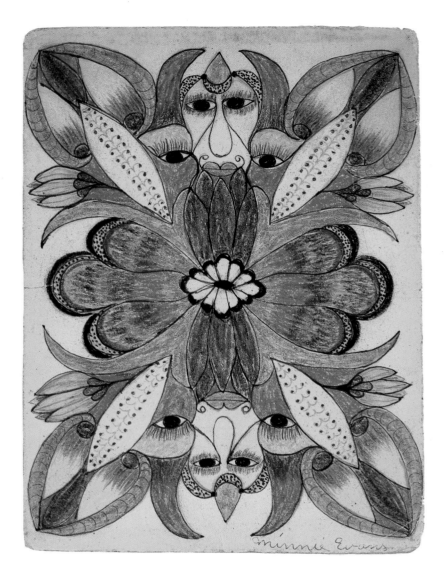

69. (BELOW) *The Art Gallery;* Gustav Klumpp
(1902–1980); Brooklyn, New York; c. 1970; oil on
canvas; 19½" x 25½". Gustav Klumpp, a German
by birth who came to America in 1923, had a
keen sense of humor and an unabashed enthusi-
asm for the female figure that is directly reflected
in his paintings. He worked in the printing indus-
try and took up painting after his retirement in
1964, but by 1971 he had stopped painting, say-
ing only that he did not feel well. He once said of
his work, "If you notice, almost all my paintings
speak for themself. There is some kind of action,
comical or something interesting in it. I am not
fond of dull paintings of landscapes or other-
wise." (Museum of American Folk Art, New York;
Gift of Mr. and Mrs. William Leffler. 1979.34.1)

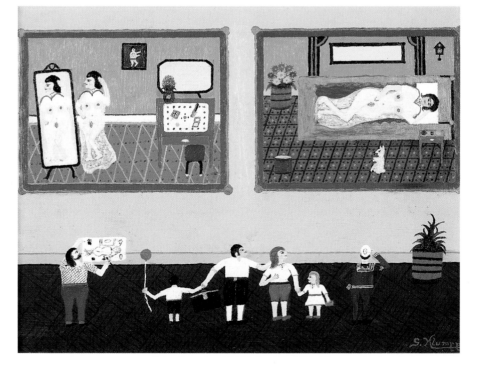

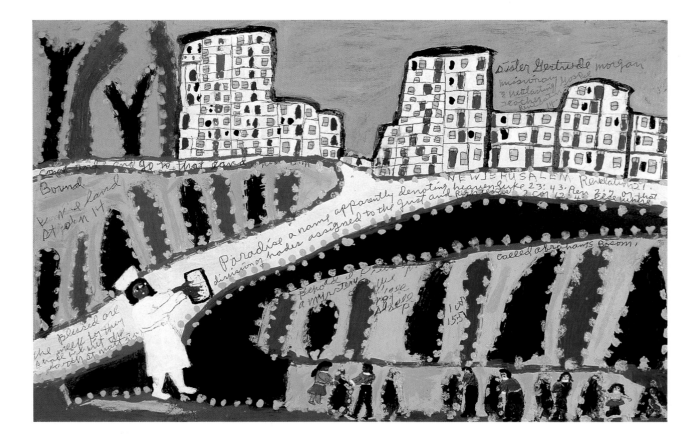

70. *New Jerusalem;* Sister Gertrude Morgan (1900–1980); New
Orleans, Louisiana; c. 1970; acrylic and tempera on cardboard;
12" x 19". Sister Gertrude Morgan was a self-styled street-corner
Gospel preacher and evangelist who, about 1956, began
expressing her religiosity through painting after receiving a vision
from God. She dressed in white and frequently depicted herself in
her work, as here (at the lower left, holding a tablet). Her paintings
almost always include writing, often being text from the Scriptures
(or her variations thereof) or references to the Promised Land.
(Museum of American Folk Art, New York; Gift of Sanford and
Patricia Smith. 1986.21.1)

71. (OPPOSITE PAGE, TOP) *Saturday Night;* Clementine Hunter
(1886/87–1988); Melrose Plantation, Natchitoches, Louisiana; c.
1968; acrylic on board; 16" x 24". Clementine Hunter is among the
best-known of twentieth-century southern black painters. An illiter-
ate field hand and house servant who started to paint in the late
1940s after discovering some paints that a plantation guest had
left behind, she depicted her peers at work and at play, in life and
in death. Her simple portrayals of everyday plantation and domes-
tic activities capture the essence of life in the rural South, and her
use of brilliant color makes her paintings glow like a southern sun-
rise. (Museum of American Folk Art, New York; Gift of Mary Bass
Newlin. 1989.9.1)

72. (OPPOSITE PAGE, BOTTOM) *There Were Just Enough;* Reverend
Howard Finster (b. 1916); 1970s; Summerville, Georgia; enamel on
Plexiglas; 20" x 26". The Reverend Howard Finster had been a min-
ister for forty years when, in 1976, he began to create artworks in
response to a vision in which, he said, God told him to "Make
Sacred Art." He has been extremely prolific as well as versatile,
creating a major environment, the "Paradise Garden" (see Chapter
Five), in addition to his work as a painter, sculptor, singer, poet, and
performance artist. Most of Finster's works carry written messages
expressing his religious, ethical, and moral concerns. Although
Finster's paintings most often reflect his doomsday preachings,
this one represents something of a departure, for it reads: "A LITTLE
TOWN WHERE SOME HAD MUCH AND GAVE TO THEM WHO HAD LITTLE AND
AMONG THEM ALL THERE WERE NONE WHO WERE IN WANT, THERE WERE JUST
ENOUGH." Photograph by Bill Buckner. (Present whereabouts
unknown)

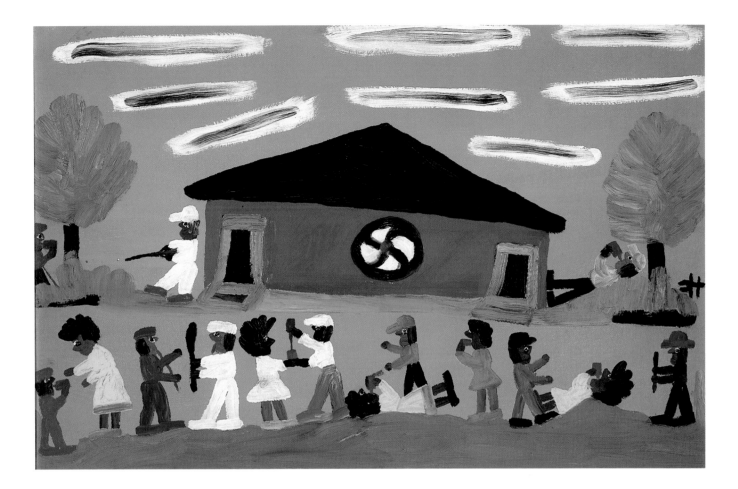

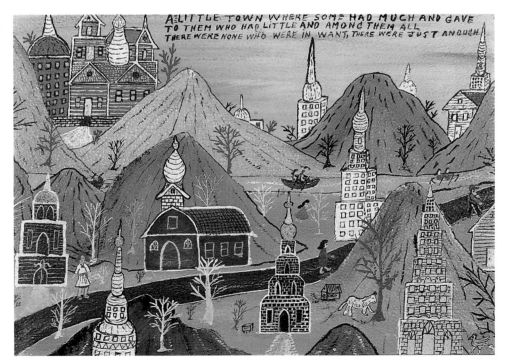

A LITTLE TOWN WHERE SOME HAD MUCH AND GAVE
TO THEM WHO HAD LITTLE AND AMONG THEM ALL
THERE WERE NONE WHO WERE IN WANT, THERE WERE JUST ANOUGH

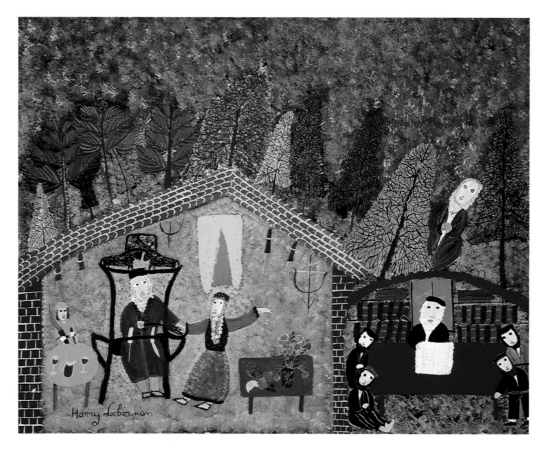

73. (ABOVE) *Whosoever Reports a Thing;* Harry Lieberman (1880–1983); Great Neck, New York; c. 1976; acrylic on canvas; 24" x 30". Harry Lieberman was born to a family belonging to a Hasidic Jewish sect in Gnieveshev, Poland. He began rabbinical studies but was never ordained. He emigrated to America in 1906, where he operated a successful candy business in New York City for many years. He began painting at the age of eighty, after attending an art class at a senior-citizens center. His early religious training is reflected in his paintings, many of which illustrate religious tales or raise moral and ethical questions; other works depict stories from Jewish folklore and literature. He wrote the story of each of his paintings in Yiddish on the back of the canvas so that people would understand them; this glowing painting recounts the story of Queen Esther. Lieberman notes that: "If you tell a thing that helps another person, you bring honor to yourself. I use the story of Purim to show this." (Museum of American Folk Art, New York; Gift of a friend of the Museum. 1988.15.1)

74. *Mt Olympus of Cumberland Mtn Range Near Winchester Kentucky;* Joseph Elmer Yoakum (1886/8–1972); date-stamped "Mar 7 1971"; colored pencil, ballpoint pen on paper; 12" x 19". Although Joseph Yoakum claimed to have traveled to all the places he depicted in his flowing landscapes, the visits may have been part of the visionary experiences that encouraged him to produce the colorful and turbulent scenes for which he is best known. He was a great storyteller, and fact and fiction were often blurred in his discourses, leaving much of the information he provided about himself a matter of conjecture. Yoakum called his painting a process of "spiritual unfoldment," and he said that the images were revealed to him by God as he worked. Yoakum had a passion for documentation and frequently wrote a descriptive title, his name, his address, and a date (sometimes with a date stamp) on his work. His few portraits of famous people exhibit a much simpler and more childlike style, lacking the powerful contained energy that sets his landscapes apart. Photograph by Norinne Betjemann courtesy Janet Fleisher Gallery, Philadelphia, Pennsylvania.

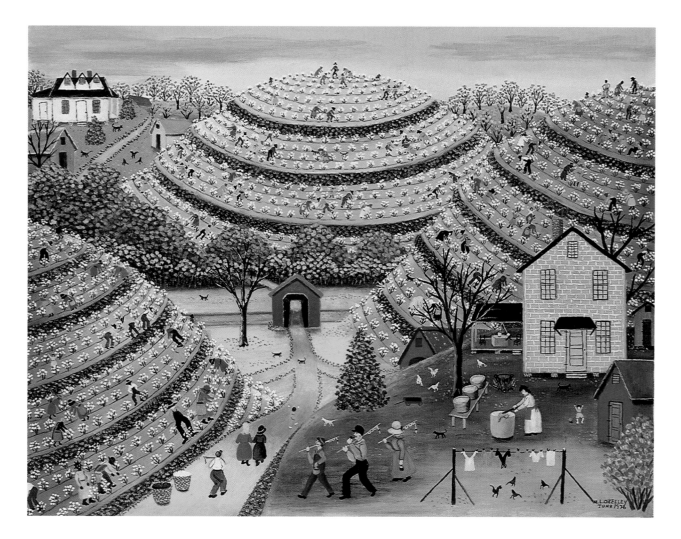

75. *Off to Fish in the Cotton Picking Season;* Mattie Lou O'Kelley (b. 1908); Georgia; 1976; acrylic on canvas; 24" x 30". This delightful scene is typical of the memory paintings that have made Mattie Lou O'Kelley's work so popular. Her nostalgic depictions of an idyllic rural lifestyle revel in the minute details of everyday life, drawing the viewer deeply into an appreciation of the past. The rounded hills and vegetation done in an appealing pointillistic style are characteristic of O'Kelley's landscape scenes. Photograph courtesy Museum of American Folk Art, New York. (From Mattie Lou O'Kelley, Folklorist by Mattie Lou O'Kelley. Copyright © 1989 by Mattie Lou O'Kelley. By permission of Little, Brown and Company.)

76. *Train in Coal Town;* Jack Savitsky (1910–1991); Landsford, Pennsylvania; c. 1975; oil on board; 25" x 33". Jack Savitsky's bold and vibrant paintings recall his years as a coal miner and offer a sharp contrast to the dangers of the miner's life. His work, which at first appears to impart a light-hearted and cartoon-like mood, exhibits a darker side on closer study. In this one, for example, the drudgery and anomie inherent in the miners' work is captured in the repetitive figures that trudge around the border. (Museum of American Folk Art, New York; Gift of Mr. and Mrs. Gary J. Stass. 1982.15.3)

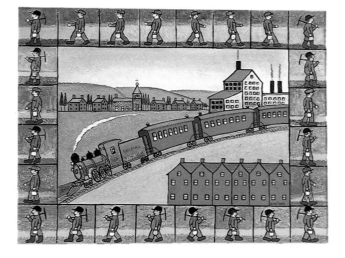

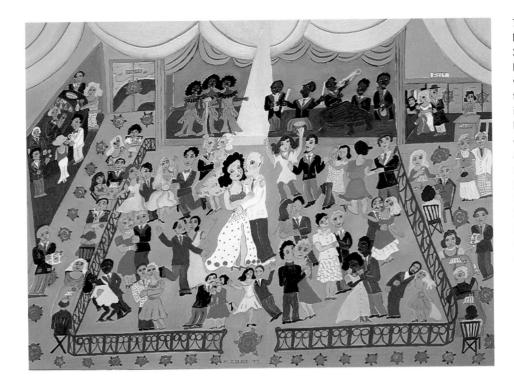

77. *Roseland;* Malcah Zeldis (b. 1931); New York City; 1977; acrylic on canvas; 30" x 40". The paintings of Malcah Zeldis brim with energy and color, and her canvases often seem too small to contain all that is happening. Zeldis creates paintings in vivid primary colors that celebrate her life, her heroes (she is a great admirer of Abe Lincoln), religion and history, and the urban scene. She often uses herself as the model for the major character in a painting; here, she is shown dancing in a red-and-white dress at the center of the painting. She does not mix her colors but uses them straight from the tube; she also is not concerned whether or not the color is necessarily realistic. As she notes, "If I can't get a tube of green open, I'll use a blue one." She has completed several hundred oils and the same number of drawings since she started painting seriously in the 1970s. (Museum of American Folk Art, New York; Gift of the artist. 1978.7.1)

78. *Black Fish;* Nellie Mae Rowe (1900–1982); Vinings, Georgia; 1981; acrylic on wood; 16¹/₂" x 37". Nellie Mae Rowe began to decorate the terrace and yard of her small house in Georgia with leftover and found objects when she was widowed in 1948. She also began to spend time drawing when she was not decorating the house. Much of her art is purely imaginative; other pieces show remembered scenes or common things—such as pigs, dogs, or fish—in innovative and intriguing ways. As she once said, "I just draw things the way I sees them." (Museum of American Folk Art, New York; Promised gift of Robert Bishop. P1.1982.1)

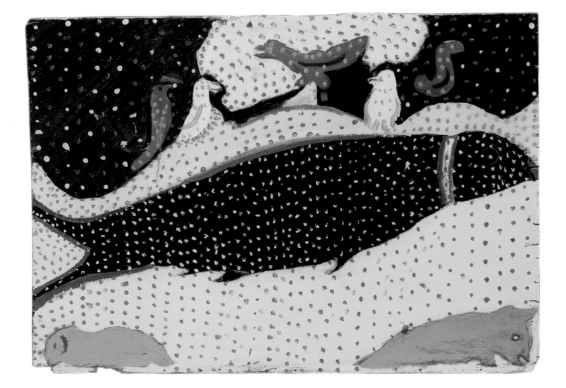

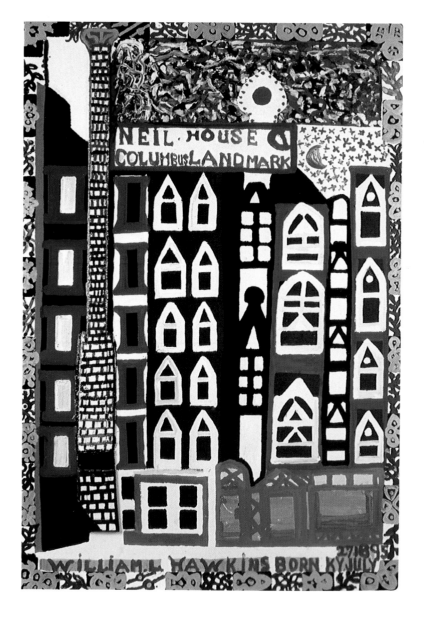

79. *Neil House with Chimney;* William Hawkins (1895–1990); Columbus, Ohio; 1986; enamel and composition material on masonite; 72" x 48". William Hawkins recorded his birthplace and birth date—Kentucky (Madison County), July 27, 1895—on all of his paintings, although he had left Kentucky as a young man in 1916 and moved to Columbus, Ohio. There he drove trucks for a construction company, which may have influenced his continuing fascination with architecture and provided the inspiration for many of his paintings in later years, such as this one. Hawkins also painted animals, landscapes, and genre scenes, for which he used postcards, advertisements, and magazine pictures for inspiration. (Museum of American Folk Art, New York; Gift of Warner Communications, Inc. 1988.19.1)

80. *A Basket Is Like a Man's Mind;* Thornton Dial, Sr. (b. 1928); Bessemer, Alabama; 1989; oil-based paint on enamel; 36" x 48". Thornton Dial, Sr., born and reared in Alabama, is the patriarch of a highly talented clan of black artists known for their dramatic and colorful works. Dial's work expresses his deep convictions about race relations, the black struggle, and the relationship between men and women. His pieces are as important for their social comment as for their aesthetic value. (Museum of American Folk Art purchase made possible with grants from the National Endowment for the Arts and the Metropolitan Life Foundation. 1990.3.4)

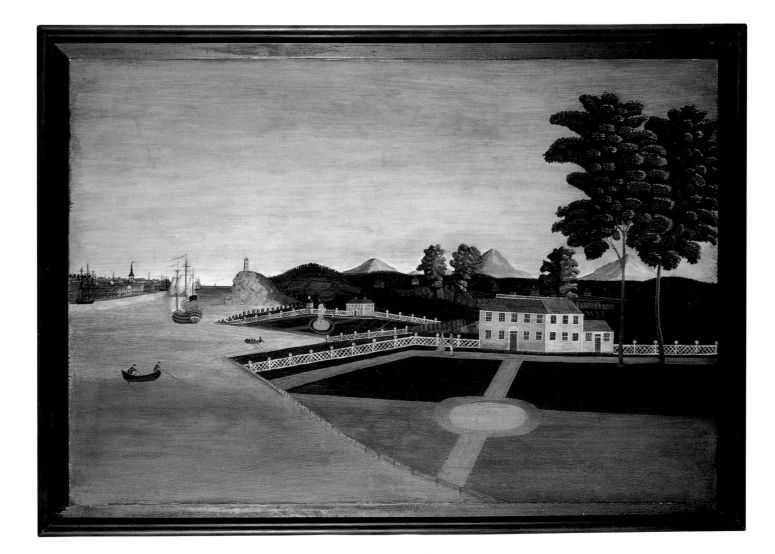

81. *Kendall Tavern Overmantel;* Winthrop Chandler (1747–1790); Leominster, Massachusetts; c. 1780; oil on pine panel; 28" x 40". Although Winthrop Chandler was best known for his stylishly elegant portraits of friends and neighbors in Connecticut and Massachusetts, he also had considerable ability as a landscape painter, as evidenced in the several remarkable overmantels that he is known to have done. This one, painted for a tavern, offers an enticing glimpse of several fashionable houses of the time. Chandler, considered one of the foremost folk artists of the Revolutionary period, painted houses to supplement his income as an artist. Landscapes were popular subjects for overmantels and fireboards, and some view them as the forerunners of landscape painting in New England. Photograph courtesy America Hurrah Antiques, New York City. (Private collection)

2

House and Home

The first rough shelters that constituted pioneer housing in colonial America quickly gave way to more elaborate structures as the early colonists became established in their adopted land. The ties to their homelands remained strong, however, and architectural inspiration at first was understandably limited to what the settlers were already familiar with, whether or not it was appropriate to the new location. Thus, frame houses proliferated in New England, brick and stone were the preferred building materials in the Dutch settlements of New Amsterdam and the Hudson River Valley, Scandinavian immigrants recreated the log construction of Sweden and Norway, and the French and Spanish settlements along the Mississippi and in the West leaned toward stucco or local equivalents that gave a comparable appearance.[1] These local and regional styles were entrenched for a period, but they gave way over time to a unique American "no-style" architecture, where design and form reflected the functional needs of the daily lives of a segment of a population that even until the present day remains predominantly self-sustaining. Regional or local characteristics still prevail in some areas, however, especially where indigenous materials such as adobe or limestone play a role.

Whatever the style of their house, whether it sat amid the bustling streets of a town or city, or in the isolated splendor of a rural landscape, Americans were proud of their homes and their property and enjoyed having them recorded. These house and farm portraits have helped to provide a clear picture of the homes and environs of our ancestors. Although such house portraits are less common today, there are still those who take enough pride in their homes to wish to document them for posterity (fig. 84).

Almost from the day of its first settlement the economy of New England was derived from the sea. The colonists had found that much of the soil was rocky and harsh and the growing season precariously short, and so they turned to the ocean for their livelihood. And a good livelihood it provided—fishing, shipping, and shipbuilding all contributed to the prosperity of the area. By 1675, over two hundred and twenty-five vessels with a fifty-ton capacity traveled between New England, the West Indies, and Europe in a triangular trade pattern that brought cities like Boston and Providence the latest in English tastes and fashions. As aggressive and astute merchants became rich and powerful, they filled their houses with imported luxuries such as fine fabrics, porcelains, and furniture that represented the very latest London styles. Not all could afford such splendor, however, and local craftsmen adapted some of these objects for the larger population of more modest means. Architecture followed this same pattern; those who could afford to emulate the grand English style did so, but most lived in more prosaic homes with few elaborate architectural details.

Gradually, from fishing villages on the coast to small towns on the interior frontier, a practical and simple architecture developed, and many paintings of the eighteenth and early nineteenth centuries reflect the domestic architecture of the time. In a painting of his father-in-law's house, *A View of Mr. Joshua Winsor's House Etc.* (fig. 83), Dr. Rufus Hathaway, a New England folk painter who produced a substantial body of work during the late-eighteenth and early-nineteenth centuries, not only documents this architecture but also illustrates New England's dependence on shipping and trading as a source of ready wealth. Joshua Winsor had extensive commercial interests in the fishing industry, and although he is depicted in the foreground of the paint-

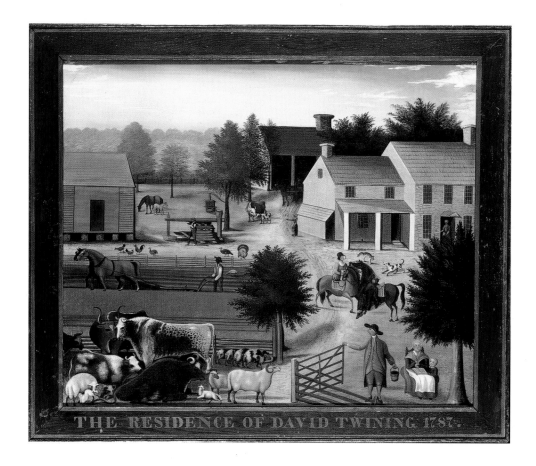

THE RESIDENCE OF DAVID TWINING 1787.

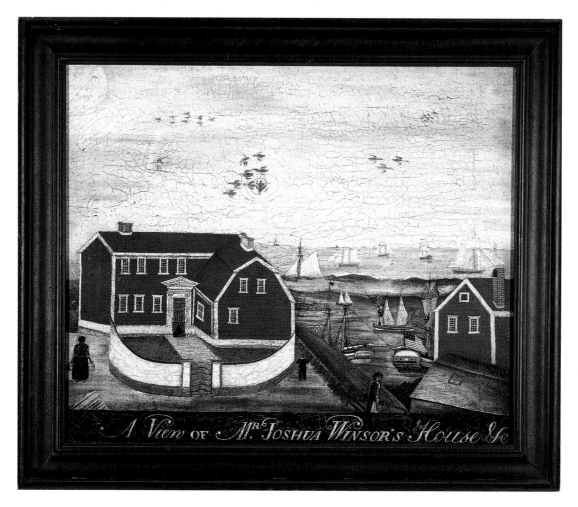

A View of Mr JOSHUA WINSOR'S House &c.

ing, he is of secondary importance to his ships, his counting house, his wharfs, and his home.

Other representations of the exterior domestic scene of this period are also often found in painted overmantels, which were scenes painted on wood panels that were then set over the mantelpiece to dress up the chimney in the parlor, usually the most formal room in a house. The scenes that made up these important pieces of household decoration occasionally would be done on canvas and set into the woodwork. Frequently rendered by itinerant artists who viewed themselves as specialists in household decorative art, the paintings were often detailed and lively and more likely to depict a specific setting requested by the householder than a flight of the artist's imagination. Landscapes, townscapes, and houseescapes were the favored subjects for these panels (see figs. 30 and 81), although some still-life and portrait overmantels are known. If so requested, these same artisans might carry their craft further and elaborately paint all the paneling surrounding a fireplace in order to provide a rich and fashionable aura and to make the fireplace wall the focal point of the room (fig. 86).

By the early-eighteenth century several major towns had been established in the South. These in time grew into cities, but until the Civil War era, the plantation, with its focus on agriculture, remained the predominant lifestyle. Settlement of one of the South's most important colonies began in 1670 at Charleston, South Carolina, where an excellent harbor proved to be one of the most defensible between Virginia and Florida. It provided security for the town, which, unlike many northeastern towns, had been systematically laid out in streets and lots as early as 1672. Throughout the colonial period, Charleston prospered and outlying plantations sprang up everywhere along the natural intercoastal waterways. By the mid-1670s, rice growing was introduced and, in time, Charleston became the center of this industry in the British outposts of the South.

English tastes prevailed in the South much longer than in other parts of the country, and the unknown artist who painted *The Plantation* (fig. 85) sometime around 1825 has provided a perfect illustration of how English tastes had been modified and simplified to serve as designs for the extensive plantation homes of the large landowners who produced tobacco and rice for the English market. The manor house shown in this painting is in the modified Georgian style of the eighteenth century; laid out below it, nearly every aspect of southern plantation life is evident. The exteriors of these "no-style" buildings that serve this self-contained social and economic unit indicate the position of their inhabitants, whether slave, overseer, artisan, or journey-

82. (OPPOSITE PAGE, TOP) *The Residence of David Twining 1787;* Edward Hicks (1780–1849); Bucks County, Pennsylvania; c. 1845–1848; oil on canvas; 26½" x 31½". The Twining family took in Edward Hicks after his mother died when he was only eighteen months old, and his father was unable to support him. Hicks, who is best known for his "Peaceable Kingdom" paintings (see fig. 52), remembered the family with affection for the rest of his life. When in his sixties, he painted at least four versions of the Twining farm as it would have looked during his early years there; the woman on horseback is one of the Twining daughters and Hicks's adoptive sister. Hicks was ordained as a Quaker minister and often found it difficult to reconcile his art with his religion, as the Quakers rejected excessive ornamentation. Although he is held in high esteem today, he considered himself only "a worthless, insignificant painter." (Abby Aldrich Rockefeller Folk Art Center, Williamsburg, Virginia)

83. (OPPOSITE PAGE, BOTTOM) *A View of Mr. Joshua Winsor's House Etc.;* Dr. Rufus Hathaway (1770–1822); oil on canvas; late-eighteenth–early-nineteenth century; Massachusetts; 23¼" x 27½". The house in this painting was built in 1768 by Joshua Winsor at Power Point, Duxbury, Massachusetts. Winsor had extensive commercial interests in the fishing industry, and the painting also shows ships from his fleet, his wharfs, and his counting house. Rufus Hathaway, the artist, married Winsor's daughter, Judith, in 1795, and the artist included a portrait of his father-in-law (holding a ring of keys in his hand) in the right foreground. The painting, a rare landscape by Hathaway, retains its original black painted frame. Hathaway's inventory of 1822 included the entry, "carved work and picture hangings," perhaps referring to frame moldings. (Museum of American Folk Art, New York; Promised anonymous gift)

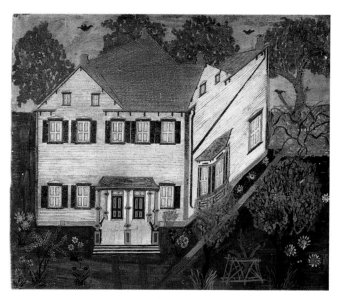

84. *White House;* artist unknown; found in Portland, Maine, area; c. 1880; painted and carved wood; 22½" x 25¾". This unusual and charming house portrait is half bas-relief, half painting, and may have been created by its proud owner. Much of the house itself— its outline (except at the base of the house), the windows, the clapboards, the doors and transoms—is carefully, if shallowly, carved, while other details, such as the drainpipe, the shutters, and the portico posts, are painted. The painted garden surrounding the house is lush with vegetation and is, perhaps, an indication of the care of the householder for the setting as well as the house. Photograph courtesy Kelter-Malcé Antiques, New York City. (Private collection)

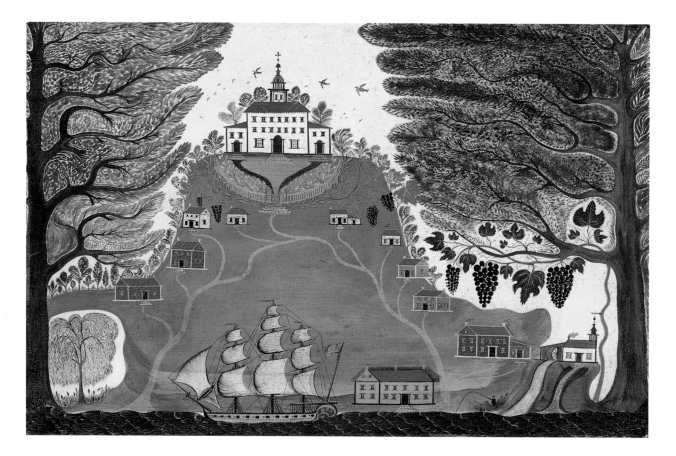

man, within the social structure. At the bottom right of the painting is a mill powered by a waterwheel, and a warehouse, where produce was stored for shipping abroad and imported goods were delivered to the plantation, stands at the water's edge. For all its technical simplicity, this striking painting conveys a wealth of information; it is one of the masterpieces of American folk art.

The Dutch in the Hudson River Valley were among the first ethnic groups to produce a unique American folk art, especially in architecture, painting, and furniture. One of the earliest Hudson River Valley genre pictures was executed sometime in the 1730s, possibly by John Heaten, on a farm owned by Marten Van Bergen

at Leeds, Greene County, New York. This painting (see fig. 31 and detail) served as an overmantel in the Van Bergen home until the house was demolished; it was then saved and installed in the new house built to replace the original. Appearing in the painting are the numerous members of the Van Bergen family, including three adults, nine young people, four black slaves, two white servants, and two Indians, probably members of either the Catskill or the Esopus tribe. Slave-holding in the Hudson Valley was occasionally encountered during the eighteenth century, and it has been documented that Mrs. Van Bergen received a slave as a wedding present from her father. It is believed that the elderly seated figure is that of a woman. The painting also illustrates the

85. (ABOVE) *The Plantation;* artist unknown; southern United States; c. 1825; oil on wood; 19⅛" x 29½". Nearly every aspect of southern plantation life is evident in this striking painting. The manor house at the top of the hill would have been maintained by the slaves and overseers who occupied the auxiliary buildings on the lower slopes. The self-sufficiency of the plantation is underscored by a waterwheel-powered mill in the lower right corner of the painting; imported goods could be delivered by ship to the waterfront warehouse. Portraits of places continued to be a staple of American folk art throughout the nineteenth century, and even into the twentieth century. (The Metropolitan Museum of Art, New York; Gift of Edgar William and Bernice Chrysler Garbisch. 1963. 63.201.3)

86. (OPPOSITE PAGE) *Fireplace Wall;* artist unknown; East Hartford, Connecticut; c. 1750; wood, marbleized with oil paint; landscape overmantel: 15" x 37½"; overall dimensions unavailable. Between 1700 and 1750 there was an enthusiastic increase in interest in painted architectural details, and buildings were enhanced with color both inside and out with a growing frequency. This painted fireplace wall, further embellished with a landscape overmantel, is a striking example of the effects that could be obtained from marbleizing and graining. The wall is from an upstairs room of the house built by Colonel Joseph Pitkin in 1723. (Wadsworth Atheneum, Hartford, Connecticut; Gift of the Atlantic Refining Company)

land, livestock, and pets belonging to the family, for the artist, in typical genre fashion, included nearly everything he saw. A farm wagon is shown standing before the mill; a hay barracks—a building peculiar to this area, constructed so that the roof and floors could be raised and lowered as necessary to protect the hay (prototypes for this ingenious device are known in Europe)—can also be seen. The Van Bergen house was constructed of stone, with a tile roof over the main structure and shingles over the kitchen wing. Small dormers and a wooden gutter, a front stoop, and windows with solid wooden blinds serve further to document the eighteenth-century architecture of the Dutch in the Hudson River Valley.

The documentation of early homes did not stop at the door, and many early portraits show carefully detailed bits of furnishings in the backgrounds or as accessories for the sitter, again providing snapshots of what domestic trappings were available in everyday life—although in the case of furnishings many examples also remain today to verify the artists' depictions. Until about 1680 all prevailing designs in colonial American furnishings were borrowed from Europe. In the majority of the colonies east of the Mississippi River—with the exception of the Hudson River Valley (settled first by the Dutch), the Delaware River Valley (with many Swedish immigrants), and those frontier settlements at the headwaters and mouth of the Mississippi River (French and some Spanish settlers)—colonists emulated as closely as possible whatever London styles dictated. By the close of the seventeenth century, international commerce had brought increased wealth and a new awareness of comfort to the colonies, inspiring a taste for foreign fashions introduced via England from Spain, Holland, India, and the Orient.[2] These foreign fashions served as a catalyst and as a source of inspiration for the American craftsperson, whether cabinetmaker, silversmith, glassblower, potter, or needleworker. Within this context there were two prevailing schemes of design: high style (or that most akin to the imported prototypes), to which everyone with pretensions and financial ability aspired, and a popular style, or one that was based on a formal prototype and then simplified and modified by self-taught craftsmen, artists, and artisans.

The Queen Anne style introduced from the English court was popular from about 1720 to 1750, when it was gradually replaced by the Chippendale style (1750–1800). This was followed, respectively, by the

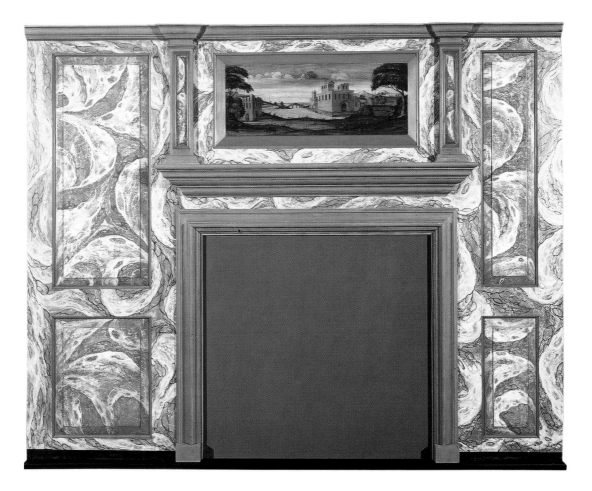

Hepplewhite and Sheraton styles (1790–1820), and the French-inspired Empire style (1800–1830), all in the Federal period; the early Victorian styles began in the 1830s and flourished through the Civil War. The so-called "pure" forms of these styles—or fine adaptations made by skilled cabinetmakers—existed largely in the cities, although after their acceptance by city-dwellers, craftsmen in small towns, tiny agrarian farming communities, and in isolated settlements on the frontier created simplified versions for their customers or incorporated elements from the prototype to enliven their own work. Consequently, it is not unusual, for example, to find elements of the Queen Anne style appearing on rural furniture throughout nearly all of the eighteenth century (see fig. 90) and even into the first half of the nineteenth century. As individual craftsmen interpreted these styles in their own way or blended elements from the different periods, a unique type of folk furnishing developed, blossomed, and, following the rise in manufacturing capabilities that enabled nearly everyone to purchase readymade furnishings that once had been crafted in rural shops or in the home, eventually faded.

Painted and decorated furniture was particularly popular in New England. Some of the earliest locally made New England pieces were heavily carved, and they would usually be painted as well (fig. 87). Paint was often used to hide the fact that a piece had been made from inexpensive wood such as pine or that several kinds of wood were used in the construction; it might also be used to disguise the simple form or rough construction of a homemade piece. A range of painting styles developed; some were almost pictorial, such as the eclectic collection of fanciful plants, sunrises, and buildings painted in red, black, and cream on the chest of drawers sometimes called the "Harvard" chest (fig. 88)—designs that bear a great similarity to some of the designs seen stitched into samplers of the time. Painting could also be as simple as that seen on the small Queen Anne–style table that is painted a bright and refreshing blue-green (fig. 89). Frequently, a *faux* grain would be attempted in order to mimic a more expensive wood, as was done on the drop-leaf dining table (fig. 96). At other

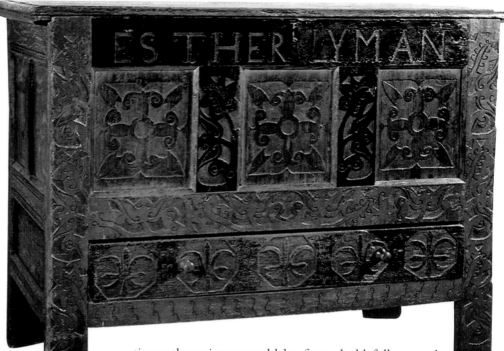

times, the painter would let fancy hold full sway; the chest attributed to Thomas Matteson, for example, combines grain painting and additional decoration in a dramatic flurry of flowing color (fig. 91). Other decorators used a variety of techniques, both freehand and controlled, to create a fantastic variety of painted decoration that was limited only by the stretch of the imagination of the artist (see figs. 92-95). Such lively and vital painted pieces as those shown must have done much to enliven and enhance the homes of the times, and these painted decorations appeared on objects both large and small.

The German groups that had settled in Pennsylvania brought with them a rich craft and decorative tradition, and this is well represented in their furniture. Color was

87. *The Esther Lyman Chest;* maker unknown; Northampton, Massachusetts; 1712–1722; 34" x 45" x 18¾". This chest, an excellent example of early eighteenth-century carved furniture of the Hadley type, is unusual both for having the full name of its owner carved on it and for having retained so much of the original red and black paint. The maker may possibly have been Erastus Banks, a name inscribed on the bottom of the drawer and across the back. The palette of red and black paint was much used on the Hadley and sunflower chests of the early eighteenth century. Several other dower chests from the same area have similar decoration and also carry the names of their owners, who were, in addition to Esther Lyman (b. 1698), Sarah Strong (b. 1698), Esther Cook (b. 1695), and Mary Burt (b. 1695). Research indicates that these girls were connected by marriage as well as by friendship. Such chests were often made as girls neared marriageable age and served as part of their "dowry," perhaps intended to hold bed furnishings and clothing that the girls would also bring with them to their new homes. Photograph courtesy Sotheby's. (Private collection)

extremely important in this tradition, and gaily painted wardrobes such as the spectacular *schrank* shown here (fig. 98) would have done much to enliven a farmhouse room. The more pictorial decorative motifs—tulips, birds, mermaids, doves, unicorns, hearts, the tree of life, and more—are all derived from early German folk art and had symbolic significance, much of it inspired by religion (fig. 97). Many similarities may be noted between the decorations on many of the

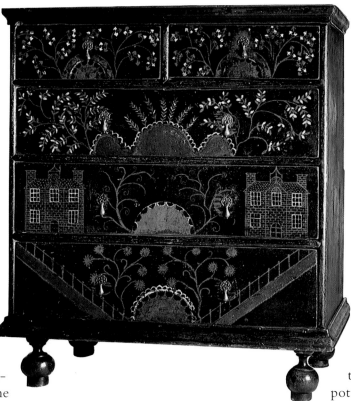

Pennsylvania chests and the *fraktur* (see, for example, figs. 48 and 49) for which this area is also well-known; this is, perhaps, not surprising, for some *fraktur* artists are also believed to have used their talents to decorate chests. Much of the Pennsylvania German decorative work is quite distinctive, and some areas have characteristic styles, allowing the origin of some pieces to be determined according to its decorative style. Berks County, for example, is associated with unicorns, horsemen, and flower patterns (fig. 100), while small, highly

stylized daisy-like motifs abound on furniture from the Mahantango Valley area (figs. 99 and 101).

The German groups who came to this country in search of relief from religious persecution did not restrict themselves to Pennsylvania; they were, in fact, voracious in their ever-widening quest for more and better land. German groups moved from Maryland down through the Shenandoah Valley to Virginia and then to North and South Carolina, and, eventually, westward as well, to Texas. They carried with them their enthusiasm for *fraktur,* pottery, and elaborate, though useful, ornamental iron. Wherever they settled, they introduced the traditional and distinctive Germanic furniture forms that recalled the lifestyle in the Old World (fig. 104).

A folk-art furniture legacy of the Dutch presence in early New York is a group of ornately painted and decorated chests that range in size from large wardrobe-like pieces of furniture called *kas* to low blanket chests (figs. 102, 103). Some are of simple flat-board construction while others are richly ornamented and sophisticated in

88. *Chest of Drawers;* maker unknown; probably rural Massachusetts; 1710–1750; painted wood; 44" x 38½" x 20½". The stylized decoration on this chest includes buildings, fences, sunrises, and leaves and flowers. Several chests with similar decoration are known, and all are thought to be from the same general area. The chests have been referred to as "Harvard chests," as the buildings were once thought to resemble those of the famous college. A comparison does not bear out this resemblance, however, so the buildings are probably simply fanciful decoration. Photograph: Ken Burris. (Shelburne Museum, Shelburne, Vermont)

89. *Tea Table;* maker unknown; Westport, Connecticut; 1740; painted cherry; 34⅝" x 27¼" x 23¾". This simple table in the Queen Anne style is an outstanding example of understatement both in its design and in its beautiful blue-green painted finish. The slight roughness in its fabrication hint at a maker who sought to emulate the high style of the time but who may have lacked the refined professional techniques it demanded. The graceful lines and glowing color, however, make this one of the great pieces of early painted furniture. Photograph by Luigi Pellettieri courtesy David A. Schorsch Company, New York City. (Private collection)

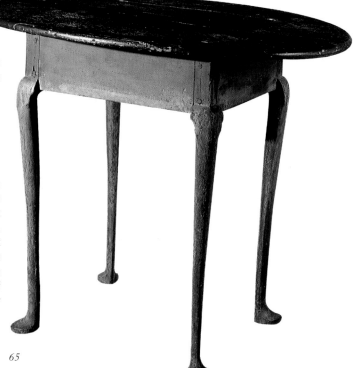

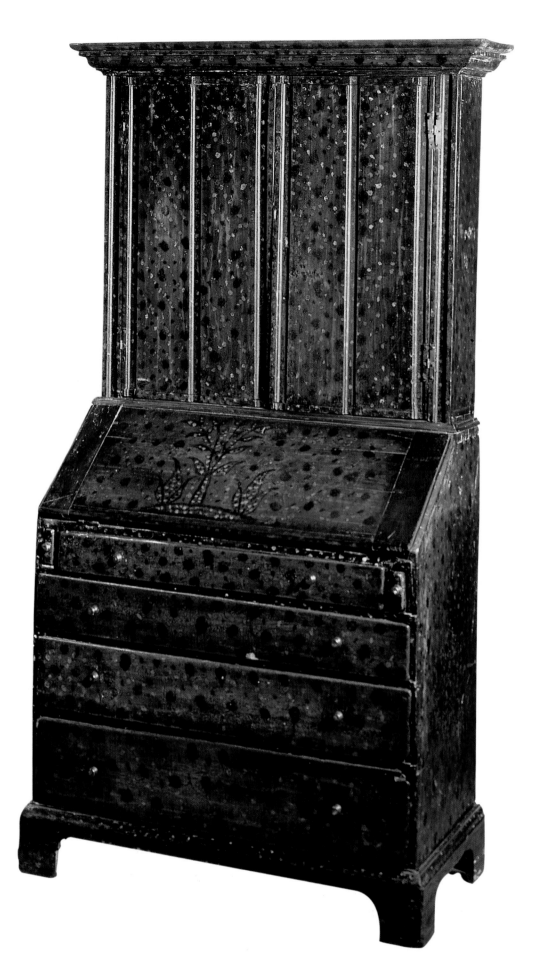

90. *Queen Anne Secretary;* maker unknown; New England; 1760– 1780; painted and decorated pine and maple; 67³/₄" x 37" x 16³/₄". The great distinction of this important rural secretary is the wonderful speckled finish highlighted by the tree and bushes decorating the fall front. (Museum of American Folk Art, New York; Eva and Morris Feld Folk Art Acquisition Fund. 1981.12.1)

construction, with, for example, a hidden drawer in a projecting cornice, complex grisaille and polychromed decoration, and stylishly turned bun feet. These pieces, found in many parts of the Hudson River Valley and other former Dutch holdings, have carefully painted architectural motifs and seem to be translations of Dutch Baroque carving into paint.[3] The sumptuous paintings of fruit and foliage on these pieces have sometimes been said to represent the earliest indigenous still-life painting in the colonies.[4]

As already noted, the South reflected English tastes for much longer than other parts of the country. Plantation homes were often full of imported English silver, furniture, glassware, and (at least through the eighteenth century) fabrics. There, as elsewhere, these objects served as models for local artisans, and for this reason much of the early Southern folk art had its roots in English style (fig. 105). A parallel development among the black population drew inspiration from African sources; there is no doubt, however, that crossover occurred, and the folk art of the South today combines many traditions of the past in its exuberant expression.

The nineteenth century brought with it what might be called the "art of the seminary." More and more young women began to attend the seminaries and the academies that started to proliferate as of the beginning of that century, and painting was one of the most popular courses taught at them. The girls were expected to demonstrate their new proficiency in such a way that their work could be shown off by proud parents, and painting on wood as well as painting on paper and canvas was taught at many schools. Often stencils like those used for theorem painting were used to create this work, which might be done on a piece of simple unpainted furniture supplied by the parents, but freehand work was frequently done by the more talented girls. Boxes and workstands or worktables were preferred for this type of decoration. A wide range of subject matter might be painted: landscapes, as on the table shown here (fig. 107); scenes from classic literature, mythology, history, or the Bible; portraits; and the perennial favorites, still lifes. Subjects of national pride and patriotism—George Washington, Andrew Jackson, the American flag, and the American eagle (fig. 108)—were also important and featured frequently on the many small boxes that seemed a ubiquitous part of the

American home.

Fireboards were other objects that young women might choose to decorate. Fireboards were used during the warmer months when fireplaces were not in use; they were used to seal off the fireplace to keep out dirt and soot—and birds! Some were decorated by the same professional artisans who did overmantels, cornices, walls, and floors, and these were likely to have elaborate subject matter, sometimes based on famous or popular prints, as in the Lion fireboard shown here (fig. 109). Vases of flowers were among the most commonly depicted subjects on fireboards (fig. 110), perhaps as a carryover from the eighteenth-century custom of placing a large vase of flowers or fresh boughs in an unused fireplace.[5]

Wallpaper was a luxury item beyond the means of the general public in the late-eighteenth and early-nineteenth centuries, but creative Americans nevertheless found a way to provide the decorative elements they wanted on their walls. Stenciling and freehand paintings

91. *Blanket Chest;* attributed to Thomas Matteson (dates unknown); vicinity of South Shaftsbury, Vermont; c. 1825; painted wood; 40" high. The fluid sweeps of red and green on a yellow ground make a strong statement in this imaginative piece of decorative painting. An almost identical chest is in a private collection, making it likely that both pieces came from the same rural cabinet shop with a taste for bright paint and strong design. (Museum of American Folk Art, New York; Gift of Howard and Jean Lipman in honor of Robert Bishop, Director of the Museum of American Folk Art. 1991.10.1)

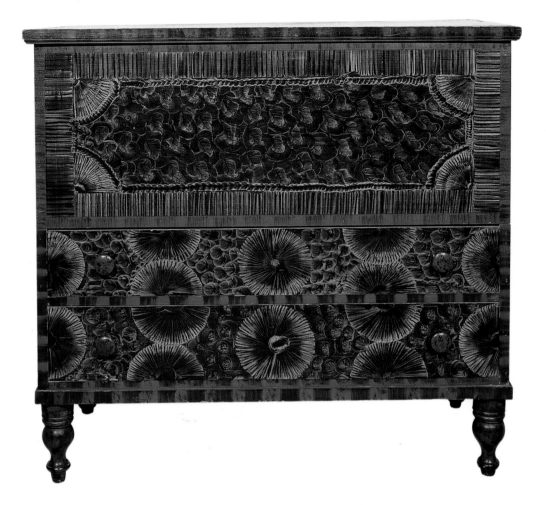

92. (ABOVE) *Blanket Chest;* maker unknown; Massachusetts; 1825–1835; painted wood; 39³/₄" x 42¹/₄" x 18¹/₄". Regular painting is combined with sponging and crinkled-paper work in a palette of red, black, and cream to create one of the most striking painted chests known. (Museum of American Folk Art, New York; Gift of Jean Lipman in honor of Cyril I. Nelson. 1994.5.1)

93. *Chest with Drawer;* maker unknown; New England; 1825–1840; painted wood; 35" x 40¹/₄" x 19". The painting on this chest has a fantastic, almost dreamlike, quality in its flowing curves, while the restrained spotting adds a lighter touch. To create this unusual effect, the skillful painter added a solvent when applying the red paint over the yellow, a technique similar to vinegar painting. (Museum of American Folk Art, New York; Promised gift of Jean Lipman)

94. (ABOVE) *Chest;* maker unknown; New England; 1830–1845; painted wood; 32¼" x 41¼" x 18½". Box; maker unknown; New England; 1830–1845; painted wood; 6¼" x 16" x 9". The carefully ordered swirls on this dramatically decorated chest sing with color; they may have been created with the help of crinkled paper. The box on top, which may well have been decorated by the same artist, is a perfect complement to the painted decoration on the chest and shows that such a bold technique need not be limited to larger pieces of furniture. (Collection of Jean Lipman)

95. *Chest;* maker unknown; New England; 1830–1845; painted wood; 39" x 37¾" x 18½". The second quarter of the nineteenth century saw furniture decoration in New England go far beyond simple graining or sponging, and many pieces were painted freehand by professionals and amateurs alike to create a wide variety of dramatic finishes. (Collection of Jean Lipman)

96. *Drop-leaf Table;* maker unknown; probably Maine; 1830–1840; painted maple; 41" wide. This beautifully proportioned table is a superior example of Maine rosewood grain painting. It bears a strong resemblance to some of the tables seen in the watercolor paintings of Joseph H. Davis. (Private collection)

97. *Dower Chest with Mermaid Decoration;* maker unknown; Pennsylvania; dated 1790; painted and decorated pine, iron; 24³/₄" x 50¹/₂" x 23³/₄". The mermaid decoration on this chest, an early German folk-art motif, symbolizes the duality of Christ; the flower designs are also common themes found in the artwork of the Pennsylvania German communities. Chests such as this were often made as gifts for brides or other young women of marriageable age—thus the name "dower chest"—and the woman's name and the date of presentation or marriage were often inscribed on the chests. (Museum of American Folk Art, New York. 1981.12.4)

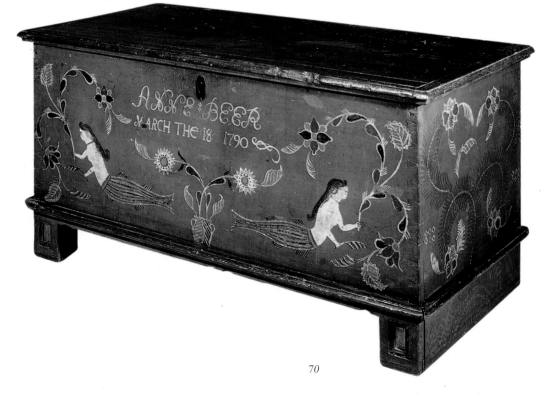

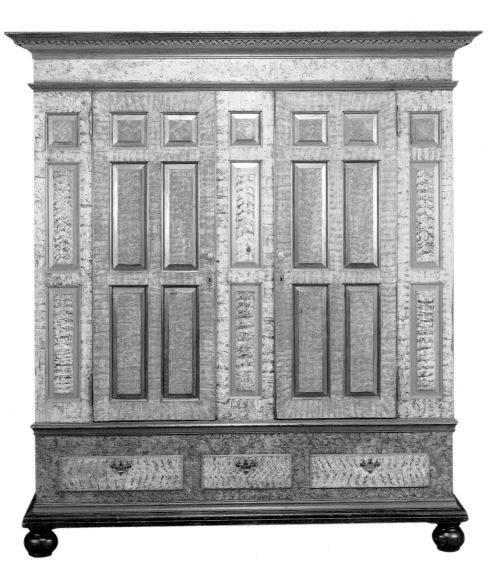

98. *Schrank;* attributed to John Bieber; Berks County, Pennsylvania; c. 1800; painted wood; dimensions unknown. This magnificent paneled and painted schrank (wardrobe) displays the vibrant colors favored by the Pennsylvania Germans in the late-eighteenth and early-nineteenth centuries. Although most of these communities were known for their simple and devout manner of life, imagination was clearly given full and colorful rein in the decoration of their household goods. Photograph courtesy Sotheby's. (Collection of Burton and Helaine Fendelman)

were commonly used substitutes for wallpaper, with the stencil idea being taken directly from the technique then used to create wallpaper. Stenciled and painted walls have been found in houses from New England to Texas, the wide range showing the importance and popularity of such decoration. Stenciled floors were also in fashion in the days before floor rugs were widely used (or even widely affordable). Very few such decorated floors exist today; the hard wear that is only to be expected of the surface would quickly take its toll on such art. The paintings of Joseph Davis and others, however, give an indication of the types of patterns—usually large-scale, bold, and colorful geometrics—that would have appeared on painted or stenciled floors; these same patterns would also have been used on floorcloths—made of a tough, durable fabric and then decoratively painted—and were later translated into designs for woven rugs. By the early nineteenth century, landscape wallpaper had come into vogue, and house-proud

housewives yearned to see their walls portraying such scenes. Around 1825, Rufus Porter, an itinerant painter who later founded the still-existing magazine *Scientific American,* developed a quick and cheap method of painting murals on walls and did not hesitate to advertise his talents:

Rufus Porter is desirous that every person in town should be informed speedily as possible, that he has taken residence for a very few days at Wesson's Coffee-House, and offers to paint walls of rooms, in elegant fall colors, landscape scenery, at prices less than the ordinary expence of papering. Those gentlemen who are desirous of spending the gloomy winter months amidst pleasant groves and verdant fields, are respectfully invited to apply as above, where a specimen of the work may be seen, and where he will also paint "correct likenesses in full color for two dollars."[6]

99. *Chest of Drawers;* possibly Johannes Mayer (1794–1883); Mahantango Valley, Pennsylvania; dated 1830; painted and decorated pine and poplar; 47½" x 43⅜" x 22". A distinctive group of decorated furniture was produced over about a forty-year period, starting at the end of the eighteenth century, in the Mahantango Valley of southeastern Pennsylvania. The tiny stenciled daisies used as outline trim on this chest also appear on other Mahantango pieces, and *fraktur* represent an obvious source for other decorative motifs used. (Museum of American Folk Art, New York. 1981.12.3)

100. (BELOW) *Dower Chest;* maker unknown; Pennsylvania; 1787; painted wood with metal lock; 22½" x 52" x 22". This painted dower chest is typical of the artistry of the Pennsylvania Germans. The decoration is beautifully done and many motifs associated with this culture are included in the overall design. The horseman waving a sword is especially interesting; it bears a striking resemblance to figures appearing on the famous "Unicorn" chest owned by The Metropolitan Museum of Art in New York. Both chests are of similar size and date, and the decorative designs on both might point to a common area of origin, if not the same maker. Photograph by Ken Medd. (Everhart Museum, Scranton, Pennsylvania)

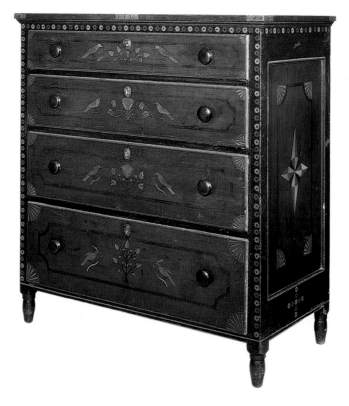

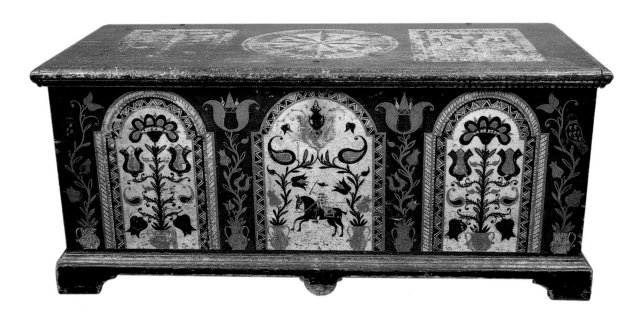

In a book on painting Porter also gave instructions on how to do murals, including guidelines for content. The creator of the mural shown here (fig. 111) may have taken his or her inspiration from Porter in creating this fascinating landscape that covered all four walls of the room in which it was painted. The mural tradition has been brought into the twentieth century in a somewhat different but nevertheless fresh and delightful mode by Clementine Hunter, who had never heard of Rufus

Porter and simply wished to brighten up the interior of her small plantation cabin (fig. 112).

Chairs were often heavily painted decorated pieces of home furniture. Like other large furniture, styles were originally influenced by popular styles in Europe, but American craft and comfort soon took over. In rural areas and small villages farmers and local carpenters might craft their own chairs, but assembly-line-like manufactories were quickly established and commer-

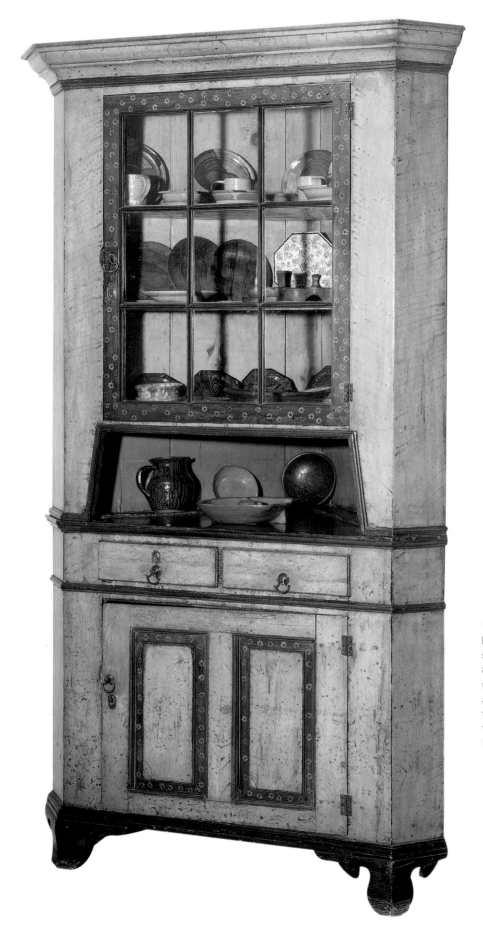

101. *Corner Cupboard;* maker unknown; Mahantango Valley, Pennsylvania; 1830–1845; painted wood; 87¼" x 35" x 37½". This elegant piece, unusually painted in salmon, blue, and red-orange, is highlighted with the stenciled daisies that are often found on Mahantango pieces. (Collection of Jean Lipman)

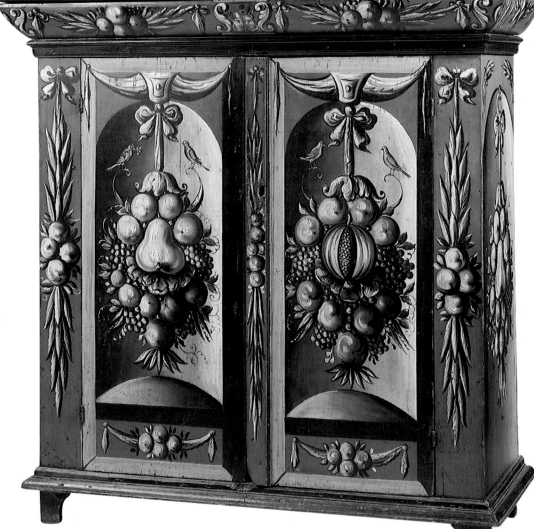

cially made chairs became widely available. Not only were the chair styles and their variations extensive but their decoration was even more so. The Hitchcock-type chair proved to be ideal for decorating, and both stenciled and freehand patterns were done (for example, fig. 113).

Some specialized local styles, such as the twig furniture found in parts of the South and, later, the Adirondack furniture of New York State, have attempted to push the form of the chair in some different directions, but, for the most part, the chair's basic function precludes much change. The chair has been an object of some fascination for folk artists in this century, and some have created unique versions that make a very personal statement yet remain useable (fig. 114). Other artists, such as Richard Dial, use the chair as a take-off point for stating their own agendas, but these pieces fall more into the realm of the sculptural than the functional.

102. *Kas;* maker unknown; American, probably New York City; 1690–1720; painted yellow poplar, red oak, and white pine; 61½" x 60⅜". An important early form of painted furniture in the Dutch-settled Hudson River Valley was the *kas*, or wardrobe. Inspired by the heavily carved pieces known from Holland, simpler versions were soon made here with grisaille decoration substituted for the more time-consuming elaborate carving seen on the originals. The grisaille decoration represents a local interpretation of the Dutch Baroque style, with painted niches recalling the carved architectural details that formed an integral part of the earlier pieces from the motherland. The meticulously painted still lifes seen on this and on the blanket chest that follows (fig. 103) give some indication of the Dutch appreciation for handsome, sumptuously decorated furnishings. (The Metropolitan Museum of Art, New York City; Rogers Fund, 1909)

Many of the most aesthetically pleasing of functional folk objects were created by members of communal societies that established communities in America. Some were utopian in nature, others were testaments to religious zeal, although often of a sectarian nature. Many of these groups set restrictions on their world view and lived within tightly prescribed but socially conscious boundaries. The Shakers are among the best-known and most long-lived of such groups (founded near the end of the eighteenth century, the group is only now seeing the passing of its last members), and they unconsciously made a number of significant contributions to the American aesthetic. Shaker architecture, furniture, and utensils reflect one of their basic beliefs—that creativity and work were forms of worship and a way of praising God. Strict doctrines governed the manufacture of fur-

niture and accessories within the Shaker community. Only meetinghouses could be white, only movable furniture could be varnished, and only oval boxes—known as "nice" boxes—could be stained or painted (fig. 115). A purity of design was stressed, untainted by embellished superfluities, which the Shakers fervently believed added neither to an object's goodness nor its durability. The paring away of the nonessential in design, be it in tools, furniture, or household accessories, resulted in sharp, spare creations of stunning simplicity, beauty, and efficiency that few other such groups have been able to match. The craftsmanship within the community was extraordinary, and their religious code that encompassed celibacy, equality of the sexes within the communal life, and the implicit belief in the closeness of God may have been contributing factors to their artistic expression.

The Shaker physical community comprised a well-built, organized gathering of simple, unadorned buildings surrounded by cultivated vineyards, orchards, and farmland. Garden seeds and processed and prepared foods, including sweet corn, lima beans, tomatoes, and various preserved fruit—the products of their work—were packaged with colorful, handsomely designed labels and widely distributed beyond the community. Hard goods like furniture, fabrics, boxes, baskets, and objects made of leather were also marketed to the outside world. One of the few artists to record the "plans" of the Shaker communities was the Elder Joshua Bussell, who drew his detailed depictions of Alfred, Poland Hill, and New Gloucester, Maine, from 1845 to 1855. A cobbler by trade, he had no formal artistic training, yet so faithful to the actual layout of the communities were his portrayals that all the various dwellings of the communities—along with inhabitants, visitors, animals, and vehicles—could easily be identified. He made no attempt to render the drawings in perspective or from a single vantage point; typically, the scenes are aerial views, and some give the illusion of a topless-bottomless map. Employing a finely cut pen, he included such intricate amenities as apple trees and individual panes in the window sashes; these cartographic pictures were often finished with watercolors with the same attention to detail as the drawing. As his proficiency grew, Bussell developed the ability to render perspective more accurately. He also solved the problem of distance by making paintings six feet long.

In his later work, Elder Joshua added to his community scenes three-dimensional contouring of the surrounding landscape, embellished directional arrows, and labels explaining the views and buildings (fig. 116). To

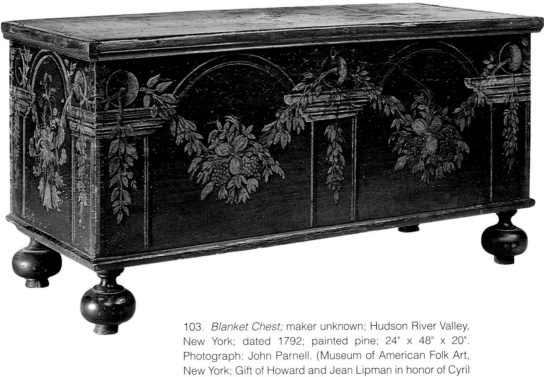

103. *Blanket Chest;* maker unknown; Hudson River Valley, New York; dated 1792; painted pine; 24" x 48" x 20". Photograph: John Parnell. (Museum of American Folk Art, New York; Gift of Howard and Jean Lipman in honor of Cyril I. Nelson. 1983.25.1)

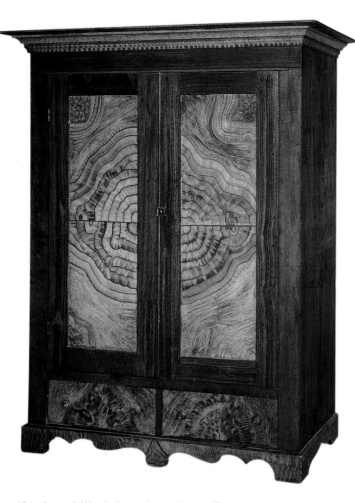

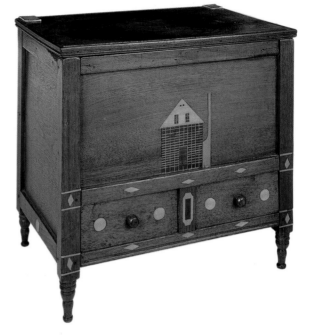

104. (ABOVE) *Wardrobe;* maker unknown; Texas; 1860–1870; cedar with painted graining; 76½" x 61" x 23". This armoire is handsomely grained in dark brown paint over yellow ochre; appearing on the back in chalk are the initials "CW." Cut nails were used to assemble the case, while the interior fittings have screws. During the nineteenth century numerous German immigrants left the communities they had established in the eastern United States, and along with new immigrants from Europe, moved to Texas, bringing their furniture traditions with them. Southern pine was especially popular for the construction of furniture because it was the most abundant wood, but cedar was also used. (Private collection)

105. *Miniature Chest with Inlay;* maker unknown; eastern Tennessee; 1820–1830; walnut with poplar and cherry inlay; 16¾" x 16⅞" x 11¼". This small but elegant chest is difficult to attribute to any one town or county; the inlay relates it to other Tennessee furniture, but its construction hints of a rural mountain origin, especially in the primitive nature of the inlay and the nailed leather straps for hinges. The construction of the chest is more typical of eighteenth-century work, and indicates the cultural lag that can be found in southern mountain furniture. The design of the inlaid house is reminiscent of embroidered samplers of the time. (Museum of Early Southern Decorative Arts, Winston-Salem, North Carolina)

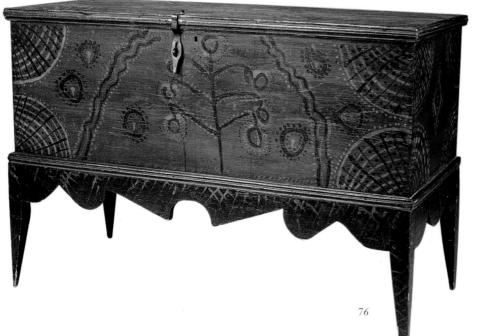

106. (AT LEFT) *Blanket Chest on Legs;* maker unknown; North Carolina; 1830–1840; painted yellow pine; 30¼" x 44½" x 19⅞". The simple construction and colorful, freehand painting make this chest an entrancing example of American folk furniture. The chest is unusual in that it is mounted on legs. Photograph courtesy Deanne Levison American Antiques, Atlanta, Georgia. (Private collection)

date, these works remain virtually the only accurate visual records historians have of these self-contained communities, and because Bussell did several drawings of each community during his period of production, it is also possible to identify changes in the physical plant of each one. Though he continued to draw for many years, Bussell's work changed and he later sought to create beautiful landscape paintings, leaving the precise pragmatic detail of his early work far behind.

The Shaker communal experiment was not unique in America, although it was one of the more successful. Social and religious reformers of many persuasions attempted to establish communities of their own, and several others have produced cohesive decorative folk art styles, among them the communities at Zoar, Ohio, Bishop Hill, Illinois, several of the Moravian communities in the South, and Amish communities from Pennsylvania and New York through the Midwest (fig. 117). None, however, has had the far-ranging impact of the Shakers.

During the seventeenth century, almost as soon as settlements were permanently established, ambitious colonists sought to establish a domestic ironworks, and by the 1640s John Winthrop, Jr. (1606–1676) had established one at Saugus, Massachusetts, that was equal to almost any similar English ironworks. By the 1650s, it was in full operation and capable of casting a variety of ironware, including pots and holloware, some of the chief products of most early American ironworks. Although Winthrop's scheme for a mill town failed, others in New England enjoyed enviable success. Rich deposits of ore had been discovered in Pennsylvania, and over eighty ironworks were operating there at the start of the Revolutionary War, producing iron for any number of necessary household items as well as guns. As a result of their production, America was able to arm herself for her struggle for independence.

The iron industry in Pennsylvania continued to grow rapidly in the nineteenth century. Most iron household goods were fashioned by blacksmiths, and

some of them were quite creative. Lighting devices, roasters, toasters, trivets, and trammels were all integral elements of every kitchen hearth that were supplied by blacksmiths, and the candle stand with an unusual finial is a wonderful example of the kinds of objects that skillful and imaginative blacksmiths could craft for themselves and others (fig. 118).

The French also possessed a keen interest in ironwork and craftsmen created and decorated all types of utilitarian objects. Metal as a medium for sculpture and decorative ornaments required different skills than either wood or stone. There were two major metalworking techniques used by the French in the South: casting and wrought-iron work. Casting involved pouring molten metal into a mold, with the most creative aspect of the process being the crafting of the pattern used to make the mold. Prototypes could be fashioned from any suitable medium—wood and clay most frequently, for they

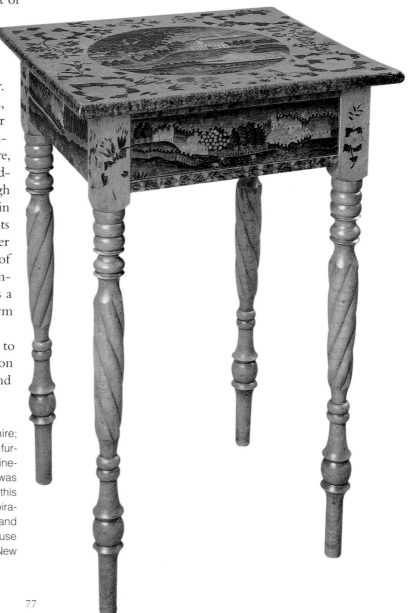

107. *Lady's Worktable;* maker unknown; New Hampshire; 1810–1825; painted tiger maple; 29" x 19" x 18". Young ladies furthering their education at seminaries and academies in the nineteenth century were often taught decorative painting, and it was not unusual for them to show off their skills on a table such as this one. Drawing manuals and prints often provided design inspiration, and stencils were sometimes used in addition to freehand work. The building shown on the top of this table is the State House in Concord, New Hampshire. (Museum of American Folk Art, New York; Promised anonymous gift)

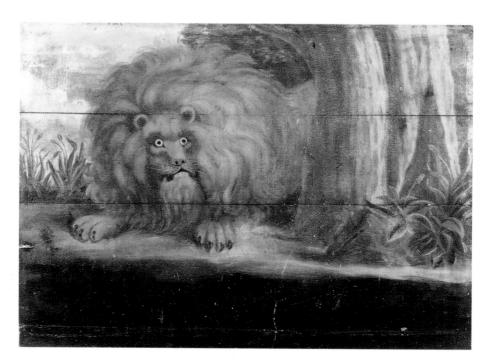

were easiest to shape. Cast-iron objects were, in effect, mass-produced art, and laborers other than the men responsible for the prototype could perform the actual work (fig. 121).

Wrought-iron products were produced with an entirely different technique. French blacksmiths in the South saw in a bar of iron the same possibilities that a cane carver might find in a wooden shaft. By heating, splitting, and bending various parts of an iron bar, a blacksmith could create a durable gravemarker, an ornamental fireplace crane, andirons for the fireplace (fig. 120), a protective lacy grill for a window or door, or simply a whimsey (fig. 119).

Iron also played its part in the making of tinplate, which was a practical material made of native iron and imported tin that was rolled into sheets and then cut and hammered into an extensive array of utensils for the home, including pots, pans, trays, trunks, canisters, and even lanterns and candelabra. Tinware had its roots in Europe, but it was being made here by the 1700s in Connecticut; by the end of the eighteenth century, it was in widespread use in many parts of this country. Tin was a boon to the colonial householder, as it could replace heavier and bulkier everyday items of iron, wood, or pewter. Its affordability, lightness, and brightness brought it the soubriquet of "poor man's silver," but its popularity escalated when painted decorations began to be applied. The range of decoration was almost as broad as the type of items to be decorated, from the colorful floral-painted spontaneity of the amateur to the highly sophisticated japanning (a type of lacquering) done by the most skilled artisans; these latter might feature the use of powdered bronze, gold and silver leaf, and inlaid mother-of-pearl in their elaborate designs. Regional and shop-related styles of decoration can be found, as well as decoration that may have been done by a handy individual at home. Decorated tinware also offered employment opportunities to women, and

109. *Fireboard:* The Fierce Lion in the Forest; attributed to Harvey Dresser; Charlton, Massachusetts; c. 1830; oil on pine panel; 33" x 45½". This wonderful and ferocious beast was based on the lion that appears in the Thomas Kensett engraving, "Let The Weapons of War Perish" (1825). This fireboard once graced the fireplace of the main room of Dresser House in Charlton, Massachusetts, a home once used as a coaching inn. Photograph courtesy Sotheby's. (Private collection)

108. (ABOVE) *Document Box;* maker unknown; New York; early nineteenth century; painted wood, brass; dimensions unavailable. Small boxes were in common usage in American households in the nineteenth century and served a myriad of functions. Some were sold already decorated by professional artisans, others were bought plain (or sometimes made at home) and then decorated by the owner. Boxes such as this were also favorite objects for schoolgirls to use as surfaces to show off their painting skills. The painter of this dome lidded box has made this golden American eagle and flag shield the stunning highlight of a complex and effective design. (Private collection)

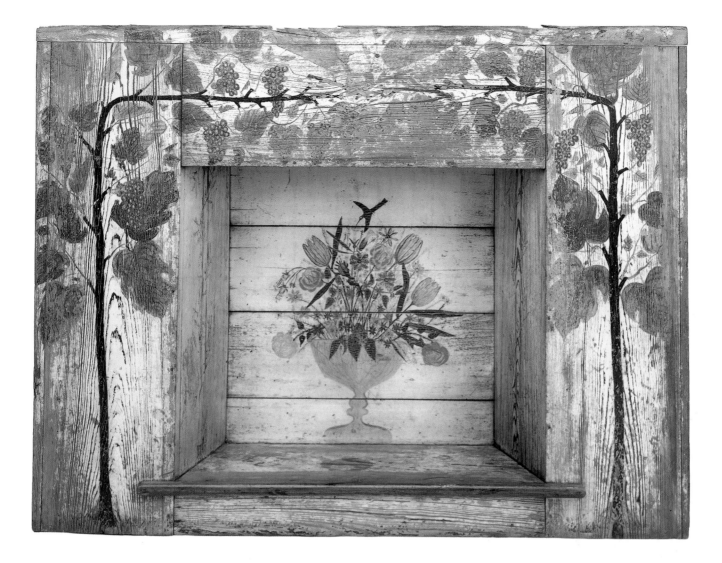

it is known that women were employed as painters by some of the many tin workshops that appeared in the nineteenth century during the period of greatest interest in this work. The Butler workshop in Greenville, New York, is one especially known for women's work as Anne, Marilla, and Minerva Butler, the three daughters

110. *Painted and Decorated Fireboard;* maker unknown; probably Maryland; c. 1830; oil on wood; 35" x 46". Fireboards were a decorative way of closing a fireplace opening during the warmer parts of the year, thus limiting drafts and at the same time preventing birds and wild animals such as raccoons and squirrels from entering the home. This fireboard is of particular interest because it was built with a recessed inset to match the size of the fireplace opening rather than a *trompe l'oeil* inset painted on a flat panel, as is often seen on other fireboards. The polychrome decoration, although now somewhat worn, is unusually elaborate, with its depiction of twining grapevines and birds surrounding a compote of flowers visited by a hummingbird. Photograph courtesy Olde Hope Antiques, Inc., New Hope, Pennsylvania. (Collection of Mr. and Mrs. George J. Dittmar, Jr.)

of the owner, all painted in their father's shop; it is likely that there were women painters in every tin family.[7] Other shops, such as that run by the Filley brothers, hired local women to help out with the painting (fig. 122); an 1824 letter from Oliver Filley to his brother mentions one woman who he thought could learn to "paint handy" and wanted to paint "the greatest part of the time."[8] All these painted pieces added their bit to the aesthetic ambiance of the American home.

During the early colonial period, nearly every ship that docked at an American port brought with it elegant ceramics from England, Holland, and several other European countries, and affluent residents wishing to demonstrate their taste and wealth to their friends and neighbors filled their cupboards with these showy imports. By the middle of the eighteenth century, advances in technology had encouraged a major expansion in the English potteries, especially around the Staffordshire area. A newspaper advertisement of

the time indicated the vast array of imported goods that were available:

> Copper plated and plain Queen's ware, white stone ware, collyflower, tortoise shell and agate ware and Delph ware. Items included: dishes, plates, tureens, fruit plates and dishes, bread and fruit baskets, sauce tureens, sauce boats, butter tubs, bowls, mugs, tea, coffee, milk, mustard, chamber, flower and potting pots, cups and saucers sugar dishes, porrengers, forms and even toys.[9]

Most of these precious ceramic forms could be had in several wares; especially popular were tortoiseshell and agateware. Despite the availability of such fineries, however, many basic utilitarian pieces were still produced at home or in local potteries. For the most part, they were plain earthenware made waterproof through glazes applied in handsome colors and designs.

By 1635, there were three professional potters working in New England: Philip Drinker at Charlestown, Massachusetts, and William Vinson and John Pride in Salem, Massachusetts. Dirck Claesen was active in New York by 1655 and by 1700 nearly every settlement on the coast boasted at least one potter. Almost all of the early colonial potters were of European origin and many of them had worked in large factories where sophisticated designs and refined raw materials were common. In the colonies, however, conditions were significantly more difficult. Kiln bricks were expensive, and specialized tools and glazes a luxury. These craftsmen built small, barrel-shaped ovens where they diligently produced "dirt dishes" for common use; jugs, storage crocks, and plates were among the most popular forms. Most American folk pottery appears to have been hand-thrown rather than shaped in molds, but there were exceptions. In the late-eighteenth and early-nineteenth centuries, Gottfried Aust and Rudolf Christ, well-known potters within the Moravian settlements in North Carolina, fashioned numerous molded pieces and many of their molds still exist.

One of the easiest raw materials to obtain was common brick clay, which turned red when fired. The resulting redware was extremely porous and had to be glazed to make it truly useful; mineral oxides and salts in various colors were nearly always used for this purpose. Because of the great popularity of imported wares, local craftsmen attempted to create competitive products. As soon as they could afford them, cobalt, manganese, iron oxide, and copper salts were mixed with lead glazes or applied beneath lead glazes to produce a rich visual array of unusual beauty. In New England, and especial-

ly in Pennsylvania during the eighteenth and nineteenth centuries, folk potters working under primitive conditions created a ceramic art that in shape and decoration rivaled the best of the imports. New England pieces are most typified by abstract free-flowing glazes, while the potters in North Carolina and Pennsylvania, chiefly of German origin, used decorative schemes that were more ordered. Sgraffito (the Italian word for "scratch"), a technique that involves cutting through a layer of slip glaze to expose the basic red clay, was especially popular in these latter regions, and often elaborate pictorial designs of personal or historic significance

were created using this technique. The ware might be further embellished with verses, names, and dates (fig. 124); many such pieces were commissioned as gifts.

Because redware was fragile, stoneware pieces—heavy, durable, nonporous, and resistant to acids—were far more desirable to early American homemakers. Stoneware clay was found mostly in the Atlantic coastal states and in Ohio. The fine white soil used for stoneware required a much higher firing temperature than redware and, after firing at approximately 2300° Fahrenheit, a ceramic body was produced that was virtually impervious to water. Although stoneware had

111. *Scenic Wall: One of Four Walls in Twelve Sections*; attributed to the "Bears and Pears" artist; Thornton, New Hampshire; 1800–1825; limestone, plaster, horsehair, tempera; approximately 96" x 144". Scenic views painted on walls were an attractive addition to the home, and much less expensive than the imported wallpapers of the time. Itinerant artists could be hired to paint walls as well as portraits, and they might have been helped in their work by the chapter "Landscape Painting on Walls of Rooms" from a book called *Curious Arts*, written by Rufus Porter (1792–1884), an itinerant artist (as well as an inventor, journalist, and the founder of *Scientific American* magazine), whose work took him from New England to Virginia. (Museum of American Folk Art, New York; Gift of William Bernhard and Catherine Cahill. 1988.10.1)

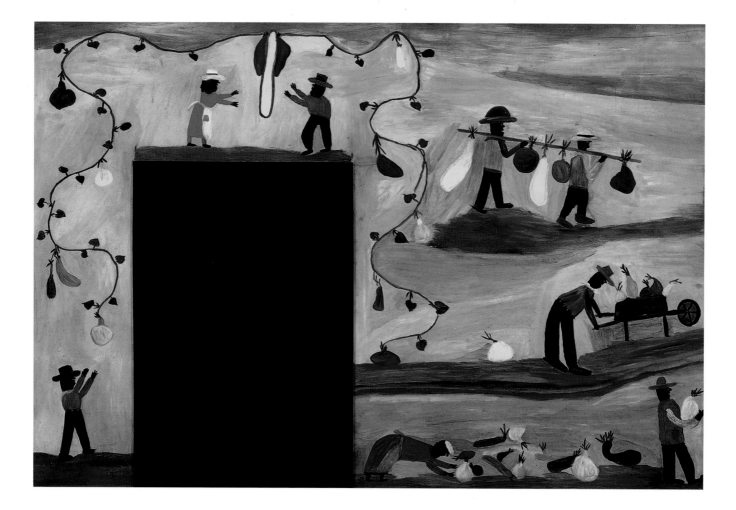

been made for several centuries by European artists, American potters seemed not to have been able to construct kilns stable enough to produce the ware before the eighteenth century. William Rogers crafted stoneware pieces at Yorktown, Virginia, from about 1720 to 1745, and in New York City, Crolius and Remmey were active prior to 1835 (fig. 125).

At first stoneware, like redware, was relatively plain and, for the most part, unadorned. At the opening of the nineteenth century, however, stoneware pieces began to be coated with a glass-like film that resulted when salt was thrown into the kiln and vaporized by the intense heat. Cobalt and manganese were also used extensively, for they, too, could survive the high temperatures required for stoneware. In time, plain surfaces were highlighted with incised decorative designs; floral motifs, birds, and human figures were among the most popular. Wood and metal stamps were also developed so that designs could be pressed on the wet surface of an unfired pot. In the early nineteenth century, the earliest methods of incising and impressing decoration had all but dis-

appeared and in its place cobalt slip, applied with a brush or slip cup, was used to make a variety of informal decorations. During the last half of the nineteenth century, a seemingly endless variety of designs using blue slip on stoneware satisfied the storage needs of every American household (fig. 126). By the end of the century, however, advances in technology had brought the price of fine ceramics within the reach of most of the population and so folk redware and stoneware became obsolete.

Figural and sculptural pottery also became popular in the nineteenth century, and a kiln that produced some of the most interesting work was that of the Kirkpatrick brothers, Cornwall, who served as business manager for the pottery, and Wallace, who was chief designer. The Kirkpatrick Anna, Illinois, pottery produced a variety of utilitarian wares as well as a series of novelty pieces that reflected the personal and political interests of the owners, both of whom belonged to two fraternal lodges and supported the temperance movement (fig. 127). Most of the folk pottery from Anna is signed by or attributed to Wallace; his most famous pieces—intricately crafted jugs

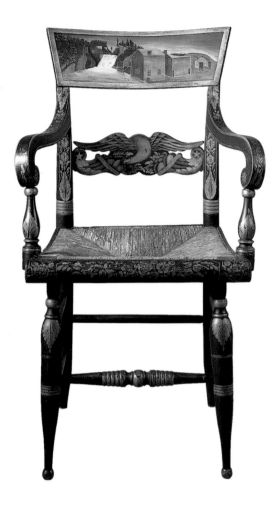

112. (OPPOSITE PAGE) *Wall Mural: Gathering Gourds*; Clementine Hunter (1886/87–1988); Melrose Plantation, Natchitoches, Louisiana; 1955; house paint on wood; 70½" x 48". Murals have remained popular into this century, as witness this lively example by Clementine Hunter, a celebrated southern painter (see also fig. 69) who is well-known for her vibrant paintings that capture vignettes of life on a southern plantation. This mural, said to have once formed part of a wall in her house, is a colorful depiction of field hands harvesting gourds. The rambling gourd vine makes even the opening an integral part of the composition in this wonderful work. (Gitter-Yelen Folk Art Collection, New Orleans)

113, 113a. *Hitchcock-type Armchair;* maker unknown; New England; c. 1825; painted and stenciled wood, woven rush seat; dimensions unavailable. The so-called Hitchcock chair, which borrowed elements from both Windsor and fancy chairs, was named after Lambert Hitchcock (1795–1852). Although Hitchcock may not have been the original inventor of this type of chair, his enthusiastic production and marketing of the style has tied his name to it forever. The popularity of the Hitchcock chair can be seen in many folk paintings, where the painter carefully detailed the chair the sitter was in. This variation on the Hitchcock chair has several unusual features. The complex and elegant pierced eagle back is of a style not frequently seen, and the free-hand polychrome painting of a mill complex is unique. (Private collection)

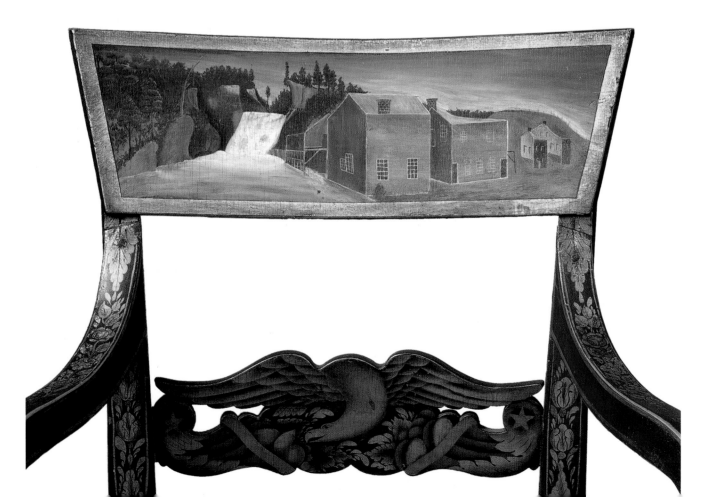

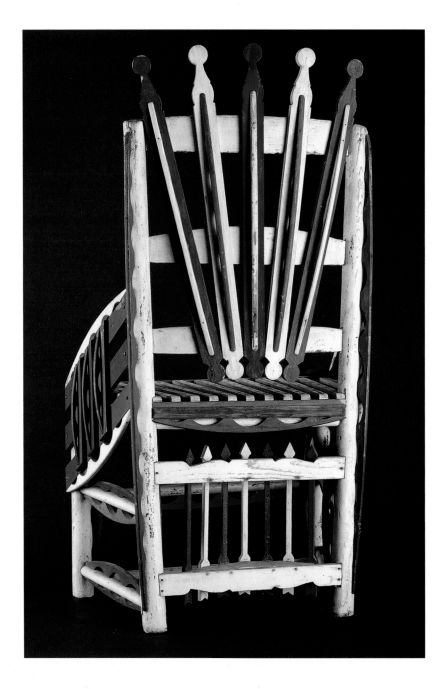

114. *Eccentric Chair;* maker unknown; Northeast; early twentieth century; painted wood; 36" high. Roughly speaking, this is a ladderback chair, but it seems obvious that its creator was determined to create a kind of chair that had never been seen before by applying a dazzling array of decorative slats and arrows in patriotic red, white, and blue. Photograph courtesy America Hurrah Antiques, New York City. (Private collection)

that incorporate snakes in the design—reflect his views on the evils of drink and its association with political corruption.

Other potters also used their work to make social and political comments, and figural and sculptural pots proved ideal for this purpose. Figural pottery was most popular in Pennsylvania and throughout the Shenandoah Valley, reaching as far south as Virginia, and the Eberly family of Virginia ran one pottery famous for such work. Face jugs are another form of figurative pottery, and the pieces can vary from the purely whimsical to the satirical (figs. 128, 129); in this century, some potters who create face jugs have used caricatures of political figures in order to make social comments.

Ornamental carvings were a popular method to add architectural detail to a home. Although many of these were carved

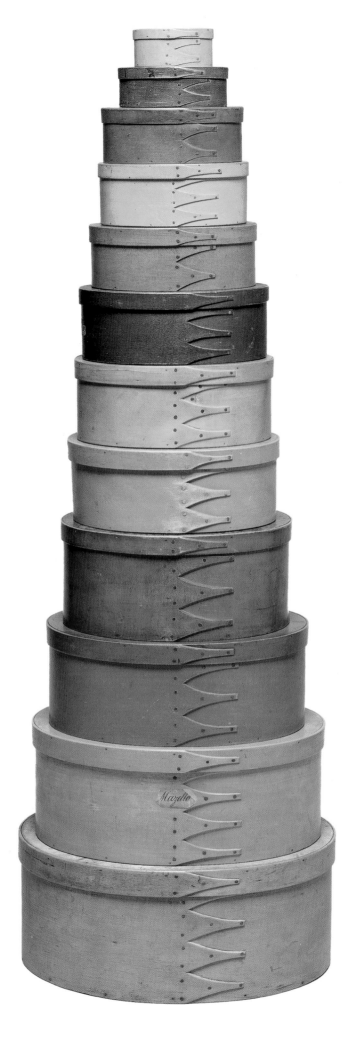

115. *Twelve Nesting Boxes;* maker unknown; probably Mount Lebanon, New York; first half of nineteenth century; painted wood; various dimensions. The oval boxes made by the Shakers had exceptionally fine workmanship and finishes. They were made in graduated sizes and had innumerable household uses. Boxes like the ones in this exceptional collection were being produced at the Mount Lebanon community by about 1800 and in most other Shaker communities by about 1830; they were made for sale to customers on the outside as well as for use within the Shaker community. Photograph courtesy Thos. K. Woodard: American Antiques & Quilts, New York City. (Private collection)

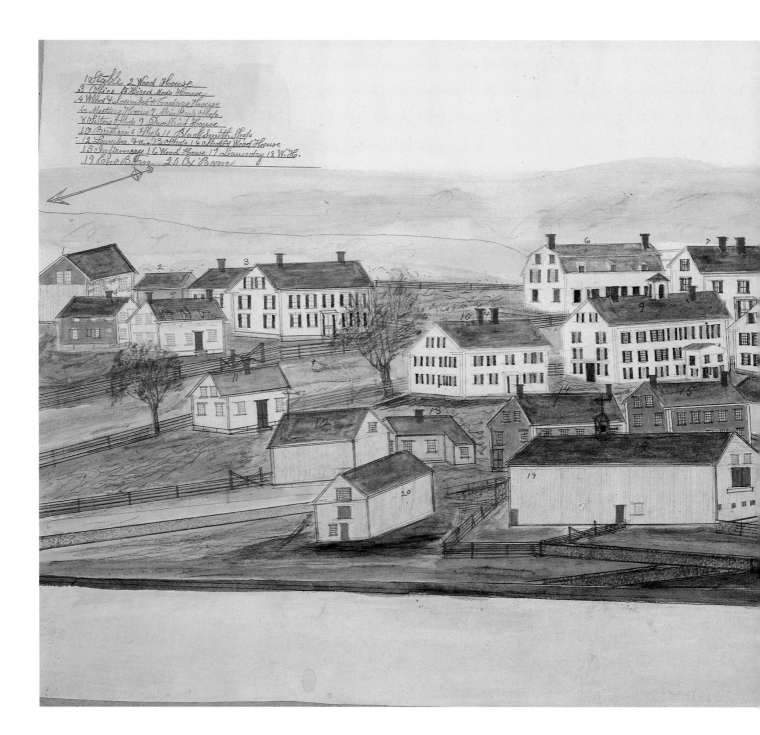

1 Stable 2 Wood House
3 Office 5 Hired Men's House
4 Wood & Lumber & Coach House
6 Meeting House 7 Ministry's Shop
8 Sisters Shop 9 Dwelling House
10 Brethren's Shop 11 Black Smith Shop
12 Launches &c. 13 Shop 14 Shop & Wood House
15 Infirmary 16 Wood House 17 Laundry 18 W.H.
19 Cow Barn 20 Ox Barn

by professional journeymen carpenters and, in the case of the more well-to-do, might be created and incorporated into a house when it was built, other carvings, such as the very solemn penguin shown here (fig. 131), were added later, probably often made by the homeowner. Although this carving decorated a gatepost, others might be placed over a front door or in other prominent positions on the house. Sometimes even the gate itself might serve as an artistic and personal statement—one of the finest examples of folk expression is the American Flag gate (fig. 130), a visible and bold statement to the world of its maker's patriotism.

Perhaps nowhere does the skill of the individual folk carver have greater scope for personal expression than in the embellishment of ornamental canes, and both handles and shafts were frequently intricately carved and sometimes painted. These practical objects not only provided an excellent means by which a carver could show off his ability, but they also provided a glimpse into the maker's personality, interests, profession, political or patriotic sentiments, and even fantasies. A carver might take advantage of the whole piece of wood, from tip to top, to create a complex and intertwined scenario for the cane, or lavish attention might be paid to the handle

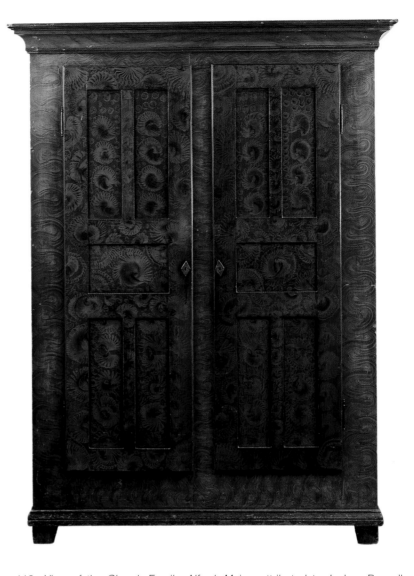

116. *View of the Church Family, Alfred, Maine;* attributed to Joshua Bussell (1816–1900); c. 1880; Alfred, Maine; pencil and watercolor on paper; 17³/₄" x 28". Shaker village views first appeared in the early nineteenth century and served as maps to document a community. By the 1840s, they began to draw more heavily on the landscape rather than the map tradition and became more decorative, although no less functional. Elder Joshua Bussell of the Shaker Community in Alfred, Maine, was a cobbler by trade as well as a popular depictor of Shaker villages within the community. He had drawn views of the Alfred settlement both in its earlier years and later in the century, thus providing a clear sense of development and change over the years. His interest was to paint, in precise detail, a complete record of what buildings existed and their condition at the time. It is not unusual to find a numbered key to the buildings in these drawings, and a directional signal is always provided. (Private collection)

117. *Amish Wardrobe;* maker unknown; possibly Michigan; 1830–1840; painted wood; 84" x 56" x 20". The design of most Amish furniture is borrowed from earlier periods, and this wardrobe is a rare form that has been made exciting by its outstanding decorative grain painting. The piece belonged to the Neuenschwander family of Adams County, Indiana, and is thought by family members to have originally been made in Michigan and moved with the family when they resettled in Indiana. (Photograph courtesy Olde Hope Antiques, Inc., New Hope, Pennsylvania)

alone (fig. 132), with the shaft left austere and smooth, a simple counterpoint to set off the elegance of the carving. Oddly shaped roots (fig. 133), knots, and burls could play into a master carver's hands, making the finished piece even more powerful. And sometimes a cane might be made for purely whimsical reasons, simply for the amusement of the maker and his friends (fig. 134). Whatever the image chosen, a carefully carved cane became far more than a practical walking stick; it made a public statement about its owner, sometimes subtle, sometimes blatant, but never ignored.

Numerous other painted, decorated, and otherwise embellished items served to brighten the lives and homes of Americans throughout the country's history, and many of these, although perhaps not unique in their everyday utilitarian personification, were made unique by some innovative person who decided to go that one step further and move from the common to the uncommon. Everything from yarn winders to gameboards to papercuts might be used as vehicles of artistic expression. Homes today may have easier access to a wide variety of readymade decorative items, but the creative urge remains strong; although it may be revealed in ways more in keeping with the present time and place, the home remains a focal point for creative folk expression.

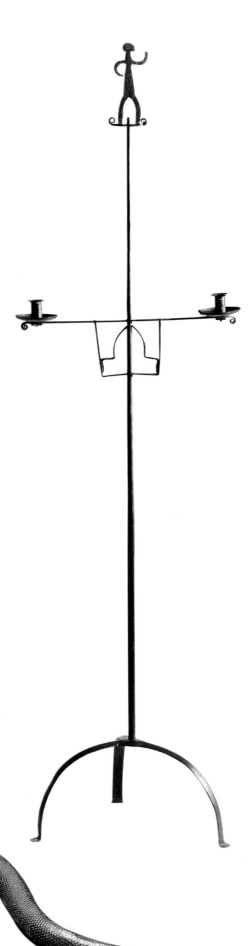

118. *Candlestand;* maker unknown; probably Hudson River Valley area; 1740–1780; iron; 67" x 19³/₈". The jaunty human figure that serves as a finial on this candlestand is believed to be unique. It is a noteworthy early example of a playful—and very skillful—hand at work. (Courtesy Winterthur Museum, Winterthur, Delaware)

119. *Snake;* maker unknown; probably Pennsylvania; late nineteenth century; approximately 12" long. This iron snake was forged from an old rasp, probably as a blacksmith's whimsey. Several other similar pieces are known, each slightly different, and all are thought to have been made by the same hand. Photograph courtesy America Hurrah Antiques, New York City. (Private collection)

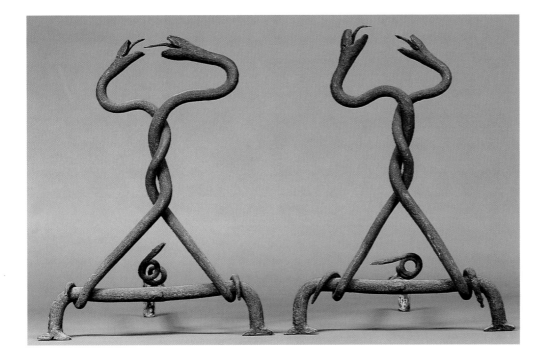

120. *Andirons;* maker unknown; probably Southern in origin; late nineteenth century; wrought iron; 21½" high. The fascinating snake design of these andirons uses a design motif that was especially popular in the rural South throughout the eighteenth and nineteenth centuries. They were obviously fashioned by an imaginative and skilled iron worker. Photograph courtesy M. Finkel & Daughter, Philadelphia, Pennsylvania.

121. *Cat Bootscraper;* maker unknown; United States; c. 1900; cast iron; 11³/₈" x 17½" x 3". The widespread popularity of cast iron in the nineteenth century made possible the multiple production of whimsical versions of very utilitarian objects, such as this bootscraper. Wooden patterns for cast iron objects were carved, then metal molds made from them; the final products were often hand painted by the consumer rather than at a factory. (Museum of American Folk Art, New York; Gift of the Friends Committee of the Museum of American Folk Art, New York. 1979.22.1)

122. (BELOW) *Dome-Top Document Box;* Filley Shop; probably Lansingburgh, New York; c. 1830; painted tinplate; 6³/₁₆" x 9⁵/₈" x 7⁹/₁₆". Decorated tinware became widespread toward the end of the eighteenth century and remained popular until well after the middle of the next century. Several workshops in New England and New York were noted for their tinware, and the workshops were often identifiable by details of the painted decoration on their products (for example, the white band on this document box). (Museum of American Folk Art, New York; Gift of the Historical Society of Early American Decoration. 73.14)

123. (RIGHT) *Tea Canister;* maker unknown; Pennsylvania; c. 1830; painted tinplate; 5¹/₈" x 3¹/₂" x 2³/₄". Painted tinware was an inexpensive, durable, and decorative solution to the many container needs of the nineteenth-century household. The decoration could take many forms and sometimes reflected the artistic traditions of the surrounding culture. The paint work on this tea canister is a fine example of Pennsylvania German decoration. (Museum of American Folk Art, New York; Gift of the Historical Society of Early American Decoration. 76.1.7)

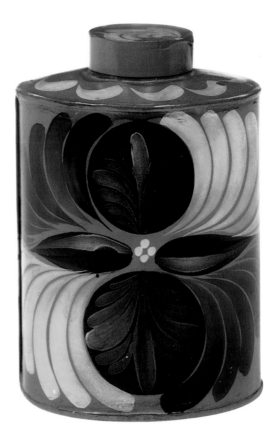

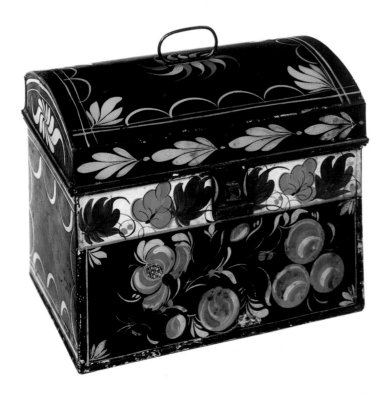

124. (OPPOSITE PAGE, TOP) Sgrafitto Plate; Johannes Neesz (1775–1867); Tylersport, Montgomery County, Pennsylvania; dated 1805; redware; 12" in diameter. Inscribed on the border of this plate is: "I have ridden many hours and days and yet no girl am able to have." The sword-waving rider appeared to be a favorite motif among the Pennsylvania Germans and is also seen on painted furniture (see fig. 99). The sgraffito technique involves laying one color of slip glaze atop another and then producing a decorative design by scratching through the outer layer of slip to expose the lower. Because sgraffito was time-consuming and expensive to produce, these wares were generally decorative rather than functional; often they were given as presentation pieces. (Museum of American Folk Art, New York; Promised anonymous gift)

125. (OPPOSITE PAGE, BOTTOM) *Presentation Punch Bowl;* attributed to John Crolius, Jr. (1755–1853); New York City; 1811; incised, cobalt-blue decorated salt-glazed stoneware; 7³/₄" x 15¹/₂". This unusual footed bowl combines simplicity of shape with an elegant incised and painted design to transcend the ordinarily mundane aspect of stoneware. The incised inscription, "Elizabeth Crane, May 22, 1811, C. Crane," implies that the bowl was commissioned for a special occasion such as a wedding, anniversary, or birth; the flowing floral design on the outside and the fish motif inside suggest a Dutch source of inspiration. Photograph courtesy David A. Schorsch Company and America Hurrah Antiques, New York City. (Private collection)

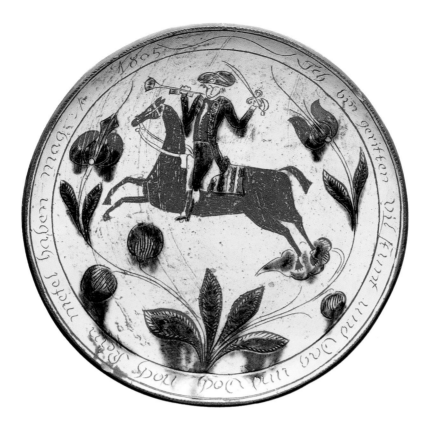

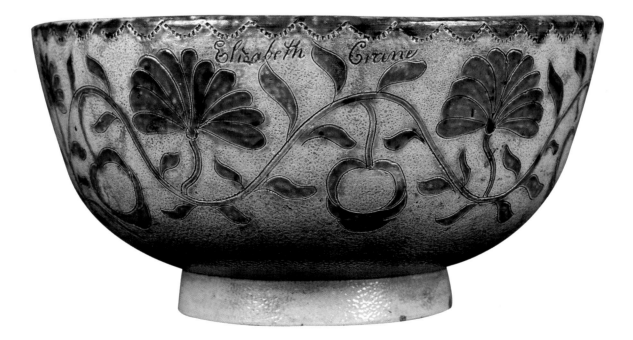

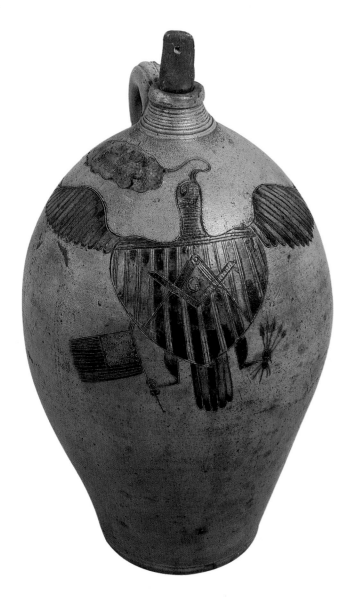

126. *Masonic Jug;* Absalom Stedman (active 1822–1831); New Haven, Connecticut; incised, cobalt-blue decorated salt-glazed stoneware; 19¼" high. Masonic symbols often vied in popularity with patriotic symbols in the early nineteenth century, and this artist combined both in a bold and striking design on this jug. The eagle holds a banner inscribed: "Made by A Stedman." Photograph courtesy David A. Schorsch Company and America Hurrah Antiques, New York City. (Private Collection)

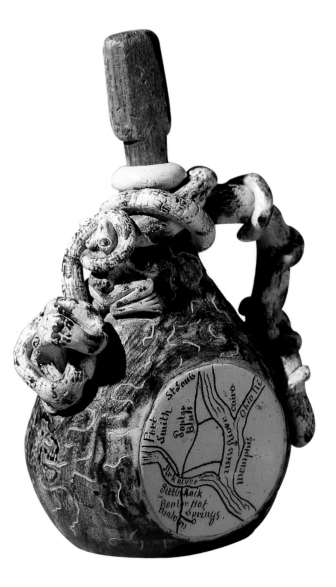

127. *Civil War Jug;* Wallace Kirkpatrick (1828–1896); Anna, Illinois; 1862; incised, sculpted, and modeled polychromed salt-glazed stoneware; 10⅝" high. The Kirkpatrick pottery is well known for the ceramic pieces that reflected the personal and political interests of the owners as well as for the more utilitarian pieces produced there. Wallace Kirkpatrick, one of the pottery owners and its chief designer, collected snakes as a hobby; many of his jugs incorporate snakes in the design, a reflection of his views on the evils of drink (he was an ardent temperance supporter) and its association with political corruption. This jug has a further connection with the events of the time, as it may have been made in honor of Civil War soldiers; it is incised with various names, as follow: "SGT BARNES GOING IN, WATSON AT CAMP DUBOIS, CAPT DAVISON, LIGHT SHORT, FOR CAPT WATSON USA." On the underside of the jug is "Kirkpatrick Anna Pottery, Anna Union Co, Illinois, Jan 17th, 1862, Camp Dubois." Photograph courtesy David A. Schorsch Company and America Hurrah Antiques, New York City (Private collection)

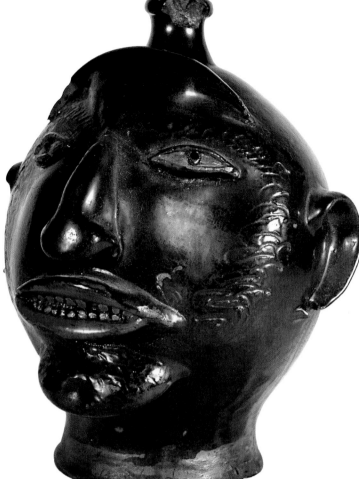

128. *Mask Jug;* attributed to a Long Island potter; Long Island, New York; late nineteenth or early twentieth century; glazed clay; 10½" x 5⅛". Face jugs, sometimes called effigy, mask, or grotesque jugs, are startling and sometimes disquieting examples of the potter's art. Some early examples are known from the 1800s, and they seem to have been made in all parts of the country. Some of these strange pieces were whimsical works created at the end of the day for the potter's private amusement, while others were commissioned, often as presentation pieces. Most examples were glazed, and sometimes the exaggerated teeth might be given a coating of bright white to provide more contrast—or, for a more shocking effect, even made by insetting bits of broken pottery or other materials into the mouth of the face. Although face jugs are found throughout the country, many seem to be associated with southern potteries. (New York State Historical Association, Cooperstown, New York)

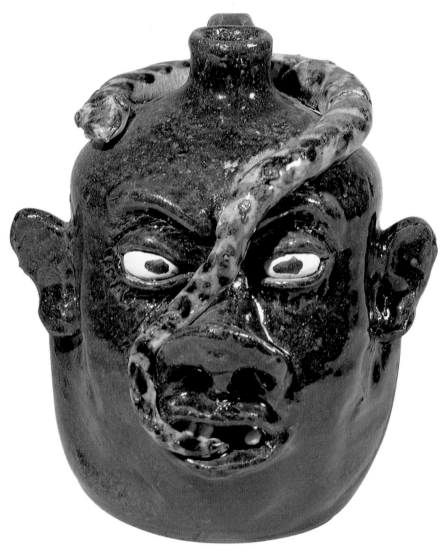

129. *Grotesque Face Jug;* Quillian Lanier Meaders (b. 1917); Georgia; 1976; glazed stoneware; 8⅝" x 7⅝" x 7½". Lanier Meaders makes sculptural heads, commonly known as face or grotesque jugs, in a continuation of a nineteenth-century tradition, but he adds his own contemporary twist. Some of his jugs are portraits of popular figures or political leaders, others are simply images he was inspired to make. In a sardonic bit of social commentary, he has been known to make two-faced "congressmen and senators" jugs, which have a face on each side. Meaders often uses porcelain for the teeth or the whites of the eyes of his faces, offering a striking contrast to the surrounding glazes. (Museum of American Folk Art, New York; Gift of Charles B. Rosenak. 1980.3.12)

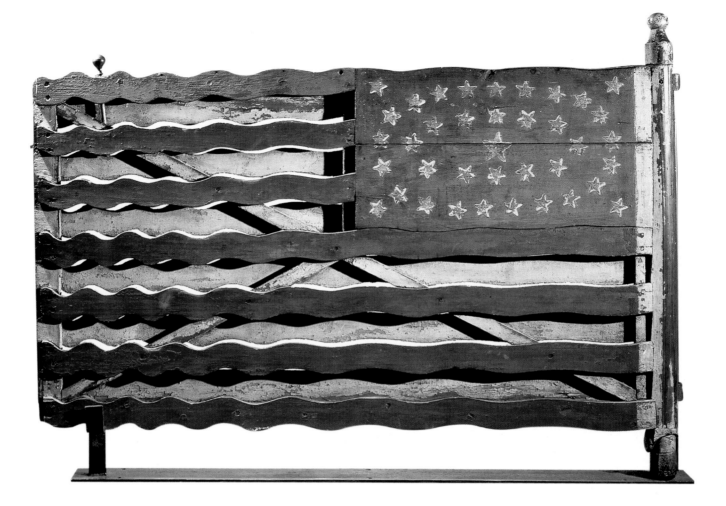

130. *Flag Gate;* maker unknown; Jefferson County, New York; c. 1876; polychromed wood, iron, brass; 39½" x 57" x 3¾". Originating on a farm in upstate New York, this gate is a glorious piece of public patriotism. Painted on both sides, it was probably made in recognition of the American Centennial celebration, which inspired many folk artists to create works with a patriotic theme. (Museum of American Folk Art, New York; Gift of Herbert Waide Hemphill, Jr. 1962.1.1)

131. *Penguin Gatepost Ornament;* maker unknown; Nantucket Island, Massachusetts; c. 1890–1920; wood, paint; 37" x 18" x 21". While most fence decorations are conservatively formal, some bold householder decided to be brash and decorate his or her gatepost with this solemn painted penguin, which was probably one of a pair. (Museum of American Folk Art, New York; Gift of Mrs. Winifred F. Eichler. 1992.7.1)

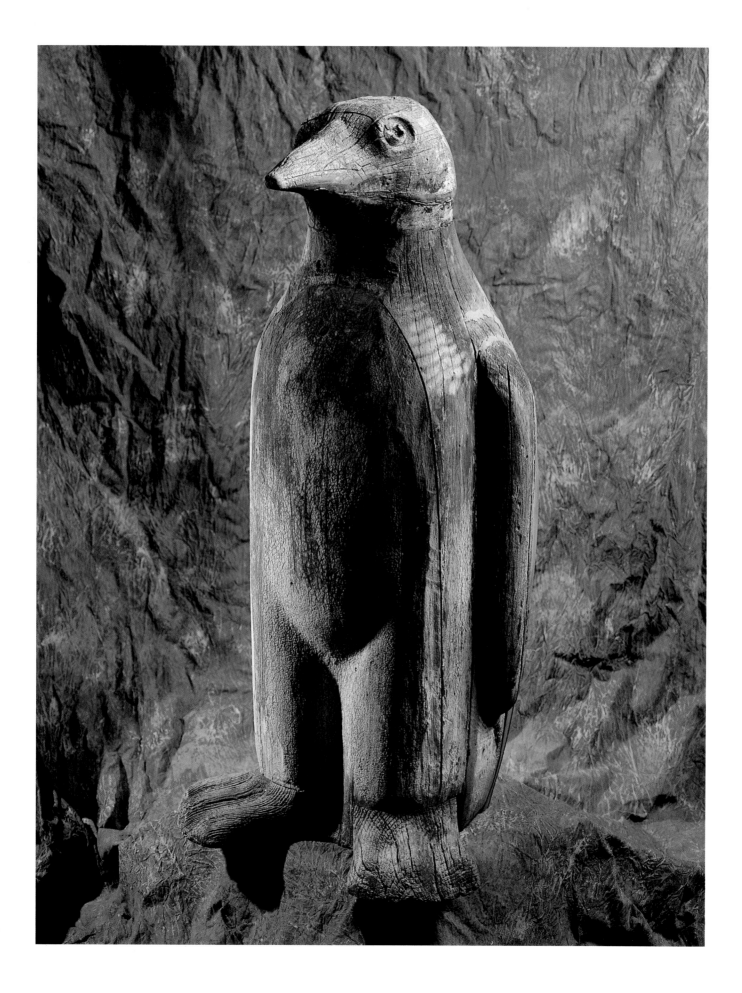

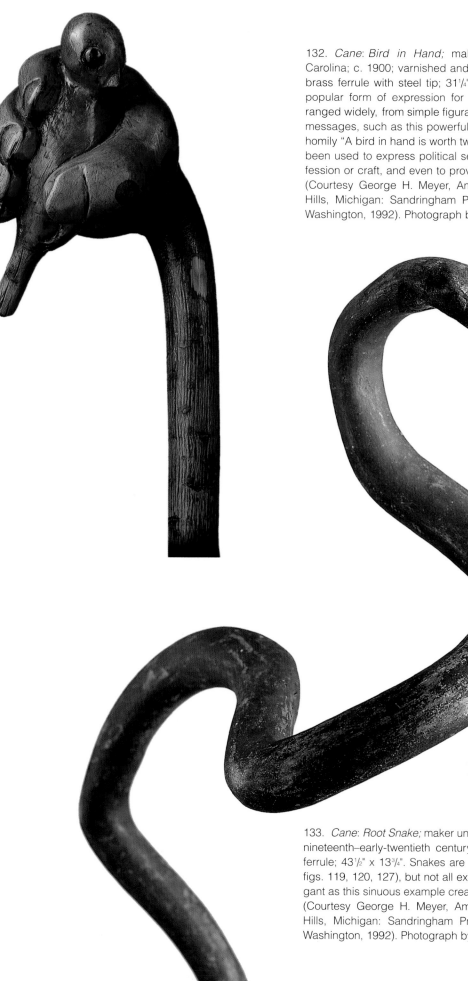

132. *Cane: Bird in Hand;* maker unknown; probably North Carolina; c. 1900; varnished and painted white pine, glass eyes, brass ferrule with steel tip; 31¼" x 4". Canes have long been a popular form of expression for folk artists. Subject matter has ranged widely, from simple figurative depictions to more complex messages, such as this powerful yet graceful rendition of the old homily "A bird in hand is worth two in the bush." Canes have also been used to express political sentiment, advertise a user's profession or craft, and even to provide satirical social commentary. (Courtesy George H. Meyer, American Folk Canes, Bloomfield Hills, Michigan: Sandringham Press, and Seattle: University of Washington, 1992). Photograph by Charles B. Nairn.)

133. *Cane: Root Snake;* maker unknown; probably Maryland; late-nineteenth–early-twentieth century; painted root, nail eyes, lead ferrule; 43½" x 13¾". Snakes are a common motif in folk art (see figs. 119, 120, 127), but not all examples are as graceful and elegant as this sinuous example created from the root of a small tree. (Courtesy George H. Meyer, American Folk Canes, Bloomfield Hills, Michigan: Sandringham Press, and Seattle: University of Washington, 1992). Photograph by Charles B. Nairn.)

134. *Cane: Mermaid;* Ralph Buckwalter (1906–1990); Lancaster County, Pennsylvania; c. 1983; clear-finished polychromed wood, nail eyes; 34" x 9¾". Canes could be bold, imaginative, humorous—even slightly risqué—and all these elements are summed up by this curvaceous and bright-eyed mermaid. (Courtesy George H. Meyer, American Folk Canes, Bloomfield Hills, Michigan: Sandringham Press, and Seattle: University of Washington, 1992). Photograph by Charles B. Nairn.)

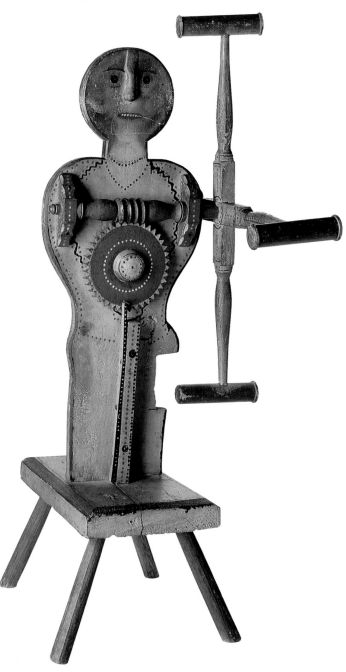

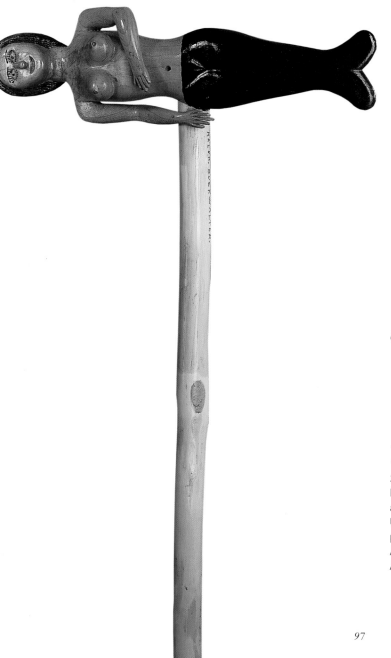

135. *Yarn Reel;* maker unknown; probably Connecticut; 1825–1850; carved, turned, and polychromed wood; 39¼" x 16" x 26⅛". Yarn reels, which were used to wind yarn into skeins or hanks, were staple fixtures in many American homes until the availability of factory-made yarn made home spinning obsolete. Until that time, yarn reels were made in a variety of fanciful and personal forms such as this extraordinary example. (Museum of American Folk Art, New York; Eva and Morris Feld Folk Art Acquisition Fund. 1981.12.10)

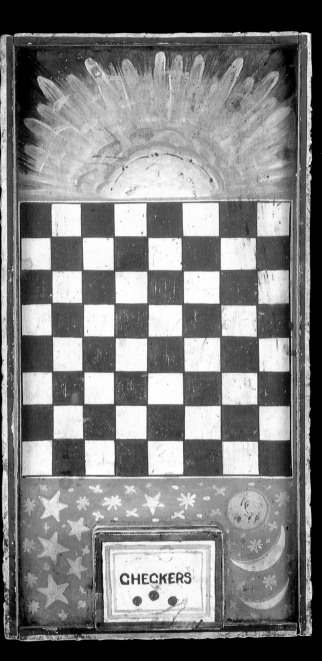

136. (OPPOSITE PAGE, LEFT). *Checkerboard with Tin Checker Box;* maker unknown, signed "Osgood"; northeastern United States; late nineteenth century; painted wood and tin; 21" x 10¼". (Museum of American Folk Art, New York; Promised Gift of Patty Gagarin. P1.1985.1)

137. (OPPOSITE PAGE, RIGHT). *Checkerboard;* maker and location unknown; painted wood; 35" x 18¾". Photograph courtesy Thos. K. Woodard: American Antiques & Quilts, New York City. (Private collection) Gameboards were often made at home and decorated at the whim of the maker. The two examples seen here are both functional and splendidly painted.

138. *Papercut for Eliza Earp;* maker unknown; Philadelphia, Pennsylvania; dated 1830; pen and ink on paper; 12½" x 14¼". The art of making intricate, lacy papercuts, or scherenschnitte, was brought to this country by the German immigrants who settled in Pennsylvania. Although the technique spread rapidly and became popular in many parts of the country, it remained especially popular in Pennsylvania. Often these skillfully wrought pieces were used as love tokens, such as for Valentine's Day or other sentimental occasions, or were given as expressions of special esteem, such as to a favorite teacher. This elegant example of filigreed paper was most probably made as a special token of affection for Eliza Earp. (Museum of American Folk Art, New York; Gift of W. B. Carnochan. 1983.22.1)

139. *Sampler;* Lydia Hart; Boston, Massachusetts; 1744; silk on linen; 11½" x 9". This sampler, showing Adam and Eve in the Garden of Eden, is one of a large number of similar pieces created in Boston, Massachusetts, in the 1740s and 1750s. It is perhaps the most elaborate example of the samplers in this group and is unusual in that it has a border. Its naïve charm is enhanced by the small goatee with which Lydia Hart thought to endow Adam. (Museum of American Folk Art, New York; Promised anonymous gift)

3

The Work of the Needle and the Loom

Needlework was an integral part of every woman's education and life in America until well into the nineteenth century, when the progress of the Industrial Revolution finally made available many of the necessities of everyday life that once had to be produced in the home. Throughout the colonial period every young girl was required to learn the basic needlework skills that would enable her to create and care for nearly all of the textiles in daily use. Clothing, linens, bedcovers, towels, bags, personal pockets, and the myriad of other textile-based items so crucial to daily life required vigilant and frequent attention, and plain sewing, spinning, knitting, and embroidery were expected lessons in the proper education of any young woman, rich or poor.

The needle was a woman's constant companion; it was at the core of her domestic chores, it provided many of her opportunities for socialization, and it offered an outlet for her creativity. Sewing was a tool of all the classes, although it should be noted that while plain sewing was knowledge that no woman could be without, only those with some leisure time and disposable income could indulge very often in ornamental needlework, which encouraged the decorative but nonutilitarian embellishment of many of the same items made by plain sewing as well as the creation of elaborate stitched pictures.

Many learned simple sewing at home, starting as soon as they could hold and thread a needle, but fundamental sewing skills, including very basic embroidery stitches, could be acquired in dame schools—which some-times also taught the rudiments of literacy—by the youngest of children, both female and male. Once the elementary classes were mastered, nearly every young woman whose family could afford it received some further education at boarding schools, seminaries, or academies, where she would be instructed in:

Reading, Writing & Arithmetic, Grammar, Geography & History, with Rudiments of the French language. All kinds of Needlework, Tambour, Embroidery & Drawing, upon very moderate terms. [The headmistress] presumes, that by an unremitting diligence she shall merit the favor of all those who honor her with the care of their children. The terms are from Three to Six dollars per quarter. All kinds of Needlework and Millinery shall be done in the newest taste, and with elegance and dispatch.[1]

Although simple needlework was part of the basic curriculum in these schools, fancy needlework cost extra, as it was considered an "accomplishment" rather than a basic skill, thus limiting its study to those who could pay. Although some schools, like the Litchfield Female Academy, preferred to attempt to "ornament the minds" of the students rather than teach only the ornamental arts, needlework remained a significant part of the curriculum until the second quarter of the nineteenth century. At most schools, a needlework piece was often the requirement for graduation and would be a girl's crowning achievement of her time at school.

140. *Sampler;* Mary Russell; Bristol, Rhode Island, or Marble-head, Massachusetts; 1791; silk on linen; 18" x 21". This remarkable black-background sampler, inscribed "Mary Russell Work in the 13th year 1791" bears a relationship to other pieces worked by young women in Bristol and Marblehead in both composition and technique. The sampler is divided into three planes, each teeming with a complex configuration of people, flora, and fauna. The central plane focuses on a young man bowing to a lady carrying a yellow parasol; another couple, with a lady holding a green parasol, is nearby. Just below is a depiction (based on a popular print of the time) of Venus in her chariot pulled by doves, with Cupid at her side. A young gentleman plays a flute on the steps of the house, while workers carry out their tasks in an elaborate farm scene in the foreground. The upper plane shows a romanticized scene of deer at play. Mary Russell was a descendant of Lewis Russell, a French immigrant who came to Marblehead in 1717; her father rowed the boat in which Washington rode during his famous crossing of the Delaware River. (America Hurrah Antiques, New York City)

For many women, the earliest complete piece of needlework they would do was the sampler. The sampler codified the virtuous life that women were expected to adhere to—it represented needle wisdom, literacy, and piety. That the girls themselves recognized the importance of samplers and sewing is seen again and again in sampler verses, some of which also spell out the place of women as viewed by society at the time:

Of female arts in usefulness
the needle far excels the rest
In ornaments there's no device
Affords adornings half so nice.
(From an 1802 sampler)

With cheerful mind we yield to men
The higher honors of the pen
The needle's our great care
In this we chiefly wish to shine
How far the arts already mine
This sampler does declare.
(From an 1817 sampler)

That some girls accepted their lot without complaint does not necessarily mean that such acceptance was universal; one young girl was clear on her preferences when she stitched this message on her sampler: "Patty Polk did this and she hated every stitch she did in it. She loves to read much more. 10 yrs old, c. 1800, MD." For most girls, however, the sampler was of major importance and often treasured until death, when it might be bequeathed to a favorite child. In this respect, samplers provided women with some sense of immortality, a fact recognized by more than one:

The Gracious God did give me time
To do this work you see that others
May learn the same when I shall cease to be.

[When] gredy worms my body eat
In this you may read my name complete.

American seventeenth-century samplers were generally long and narrow, much like English ones of the same period, and intended as "samples" of needlework stitches; most carried no names or dates. American samplers from the first half of the eighteenth century are also difficult to distinguish from their European prototypes, and motifs such as reclining stags, carnations, and fleur-de-lis were used extensively here as well as abroad. In the mid-eighteenth century, an American style developed; in addition to an embroidered alphabet and numbers, samplers were

141. *Sampler;* Fanny Smith (b. 1784); Norwich, Connecticut; 1797; silk on linen; 17" x 16¼". This sampler, inscribed "Fanny Smith/ her Sampler A/ ug 23 AD 1797/ in the 14 year of her age," is an excellent example of the Norwich style. Fanny Smith dutifully stitched her letters and numbers and indentified herself, but the meaning of her pictorial vignettes is unknown to us today. Other samplers from Norwich are known to depict ships in full sail, so a teacher may have designed this pattern for the girls to follow. (Private collection)

further decorated with one or more of the following: verses, poems, or biblical quotations; the maker's name, the community in which she lived, her birthdate, the date on which the needlework was completed, and, occasionally, a teacher's name; and pictorial embellishments such as Adam and Eve, landscapes, flowers, animals, houses or public buildings, maps, family registers, and so on (figs. 139, 140, 141). The variety was infinite, and the pictorial elements often followed contemporary fads in design. Most such samplers were intended to be framed, which was in direct contrast to English and European types that were nearly always rolled up and stored to be used as a reference for stitches when needed.

Sometimes samplers were designed by a girl's teacher, and so groups of samplers from one location or one school may show many similarities in design. Sometimes the designs might even be chosen by the parents. Toni Fratto notes that samplers were not fully explored as an art form because they were too much a part of the socialization process; conformity, restraint, and sentimentality were important, and, thus, the "creativity of

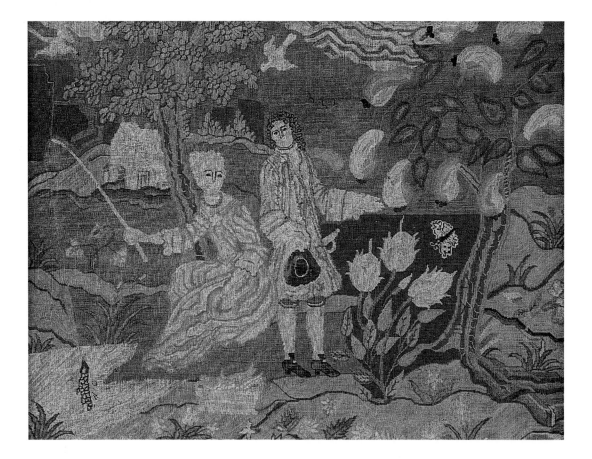

142. *Needlework Picture;* maker unknown; Boston, Massachusetts; late-eighteenth century; silk on linen; dimensions unavailable. In the mid- to late-eighteenth century young women from New England exhibited a strong predilection for needlework pictures showing idyllic pastoral landscapes filled with animals and flowers and with a Fishing Lady or Shepherdess as a major figure; often several other figures or pairs of figures would also be featured. The earliest known of these depictions was 1746, and they remained in vogue for the remainder of the century. About sixty-five versions of the so-called "Fishing Lady" pictures are now known, some being quite large, and others, such as this one, much smaller and having only a few elements of the whole composition. (Present whereabouts unknown)

143. *Needlework Picture;* Mary Lockwood; probably Newburyport, Massachusetts; late-eighteenth century; 13" x 16". This stylistically bold needlework picture is similar in color and style to others of the Newburyport area from the same period. A companion piece to this one was also done by Mary Lockwood. The scene on it comprises rolling hillocks, trees, and striking floral representations; the two together may have been intended to be displayed as a pair. (America Hurrah Antiques, New York City)

144. *Needlework Picture;* maker unknown; New England; early-nineteenth century; silk thread and watercolor on fabric; dimensions unavailable. This intriguing picture is half needlework, half painting. It was probably executed by a young lady attending a female academy or seminary, where she would have learned the fine arts of both needlework and painting. After about 1810, there was an increase of interest in painting with oils and watercolors, and needlework pictures gradually fell out of favor. However, an intermediate stage in which paint and thread were combined resulted in compositions like the one shown here. The picture is unusual in that it shows a purely contemporary setting at a time when classical scenes were the norm, especially in the academies. (Present whereabouts unknown)

145. *Mourning Picture for Mrs. Ebenezer Collins;* probably Lovice Collins (c. 1793–1847); South Hadley, Massachusetts; 1807; watercolor, silk, and metallic chenille on silk, paper label; diameter: 17". Mourning pictures were made primarily by young women; they served not only as tangible expressions of grief but as a means of memorializing the deceased. This work possesses all the typical elements of the art form: the urn set upon a tomb, weeping willows symbolizing mourning, evergreens symbolizing resurrection, a village in the distance symbolizing temporary environment, and mourning relatives. The tomb is inscribed "to the memory of Mrs. Azulab Collins, died Oct. 1, 1805, Aged 38"—probably the mother of the maker. (Museum of American Folk Art, New York; Eva and Morris Feld Folk Art Acquisition Fund. 1981.12.8)

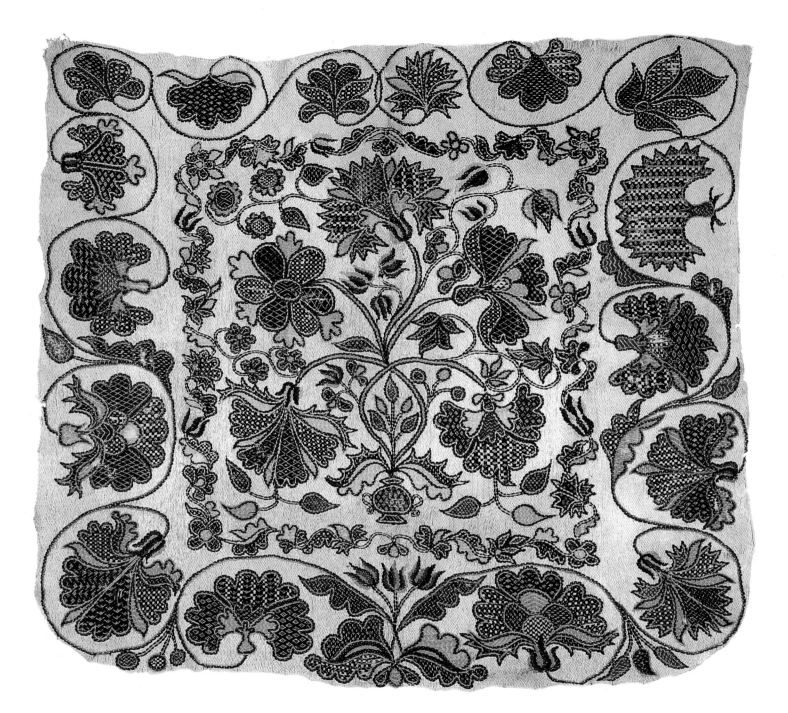

146. *Bed* Rug; maker unknown, possibly one of the Foot sisters; probably Connecticut; c. 1778; wool on wool, flat pattern-darning stitches on a tabby-weave ground; 80" x 72". The design, colors, and technique used on this bed rug bear a strong resemblance to three other rugs now in the collections of Winterthur Museum, the Connecticut Historical Society, and Historic Deerfield. These rugs, made respectively by the sisters Mary Foot, Elizabeth Foot, and, possibly, Abigail Foot, are thought to have been made at roughly the same time, possibly as dowry pieces, for Mary and Elizabeth married (on the same day) soon after. (Courtesy Kelter-Malcé Antiques, New York City; Kinnaman Ramaekers Antiques, Bridgehampton, New York; and Richard Romberg, Rochester, New York)

sampler makers and development of a powerful sampler style were inhibited."[2] Still, with all their limitations, some samplers can be very powerful works of needle-work art.

In the mid-eighteenth century needlework pictures, or "needle tapestries," began to be in vogue (figs. 142, 143), and by 1800 their popularity, which also coincided with a growth in the leisure time needed for such works, was widespread. These were the showpieces of a girl's time at an academy, her "graduation" piece—and they were often made of far more elaborate elements than were used in her everyday work. Fabric appliqués, silver and gold spangles, beads, mica, silk ribbons, and meticulously constructed rosettes added richness and depth to the designs. It was also not unusual for a girl to paint some elements of her work—such as faces—on a separate piece of silk or paper and then appliqué them to the needlework. Sometimes such additions were done by teachers or even by professional artists; T.C. Bell, Jr., for example, was a miniaturist who advertised in 1814 that he painted "the faces, etc. of Needle Work."[3] Like samplers, these works would be framed and hung—a spot of bright color and beauty in a room as well as an exhibition of skill.

The subjects of these pieces were usually allegorical, biblical, literary, patriotic, or historical, although some depicted more ordinary scenes (fig. 144). Just as the print influenced folk painting, it also had a profound influence on the designs of needlework pictures; many schools had large inventories of engravings for girls to

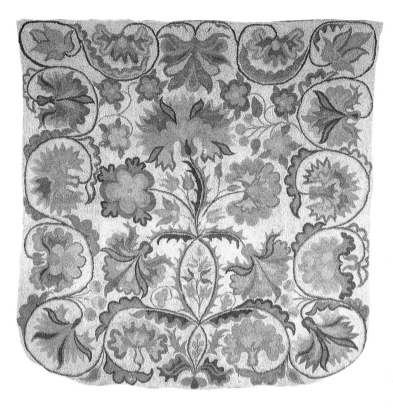

147. (ABOVE) *Bed Rug;* maker unknown; Connecticut; c. 1800; wool; 96" x 100". Complex flower motifs were the preferred design for many bed rugs, and elaborate floral-and-leaf meander patterns of the type seen in this rug were often derived from the extremely popular, but expensive, cotton coverlets known as palampores (see fig. 150) that were printed in India and imported during the late-seventeenth and early-eighteenth centuries. The deep pile that made a bed rug such a treasured object in the cold New England winters is especially evident in this example. (Museum of American Folk Art, New York; Promised anonymous gift)

148. *Harlequin Medallion Quilt;* maker unknown; New England; 1800–1820; pieced calimanco; 87" x 96". This vividly graphic quilt, made of a warm linen and wool blend, is a descendant of the early linsey-woolsey covers used by American colonists. Although most calimancos were whole-cloth constructions, the maker of this quilt, with a sure eye for color and design, created a unique piece that delighted the eye as surely as it warmed the bed. The glazing on this quilt is still very much in evidence. (Museum of American Folk Art, New York; Gift of Cyril Irwin Nelson in loving memory of his grandparents, John Williams and Sophie Anna Macy. 1984.33.1)

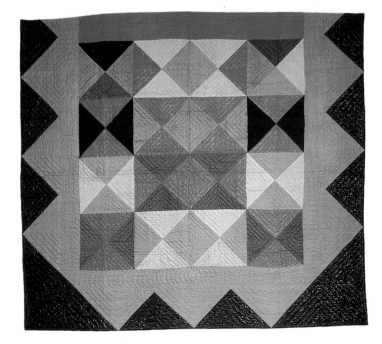

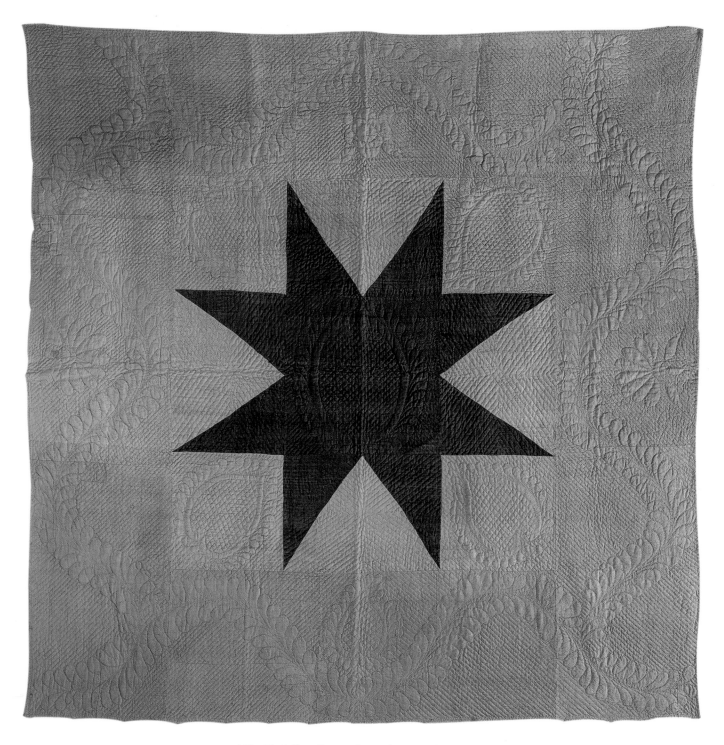

149. *Medallion Star;* maker unknown; New England; 1815–1825; pieced calimanco, wool backing; 100¹/₂" x 98". The spare, striking design and the superb quilting are enhanced by the glazing that can still be seen on this quilt. The eight-pointed star, either singly or in company with many others, was and still is a favorite design motif for quilters. (Museum of American Folk Art, New York; Gift of Cyril Irwin Nelson in honor of Robert Bishop, Director of the Museum of American Folk Art. 1986.13.1)

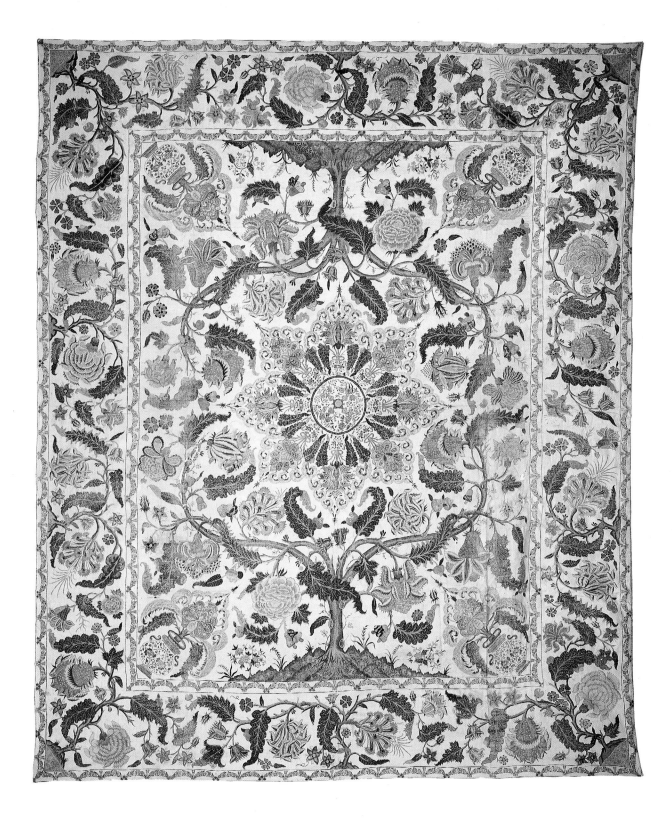

150. *Palampore;* maker unknown; probably India, made for the English trade; late-eighteenth century; printed and painted cotton; 112" x 91". Both the very large size and the highly complex double Tree of Life design on this palampore make it an unusual and rare piece. Palampores were printed by hand from wooden blocks and often, as is the case here, overpainted to bring out the color in certain areas. (Kelter-Malcé Antiques, New York City)

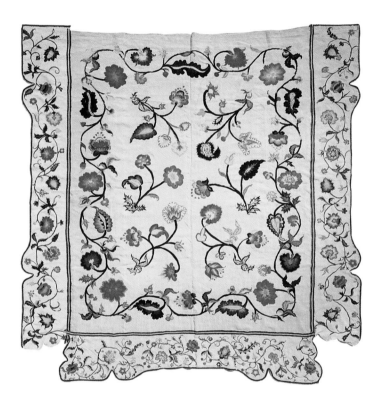

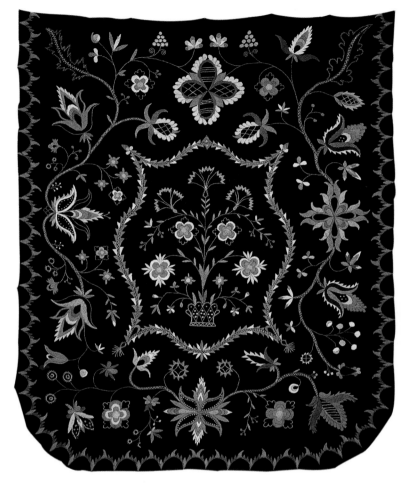

151. (ABOVE, LEFT) *Crewel-worked Floral Coverlet;* Mary Swett Bulman (1715–1792); York, Maine; c. 1745; wool crewel embroidery on unbleached linen homespun; 79" x 73". This beautiful coverlet, along with its companion bed curtains and valances, was designed and made by Mary Bulman to "occupy her mind" while her husband was serving as a surgeon under Sir William Pepperrell at the Siege of Louisburg during the French and Indian War. He died at Cape Breton in 1745. The valances (not shown here) are unusual in that verses from Isaac Watts's 1706 poem, "Meditation in a Grove" in Horae Lyricae, were embroidered on them, perhaps a mute testimony to Mrs. Bulman's loneliness. (Old York Historical Society, York, Maine)

152. (ABOVE, RIGHT) *Crewel-embroidered Medallion Coverlet;* maker unknown; New England; 1815–1830; wool crewel embroidery on wool; 100" x 84". Medallion crewel patterns were traditionally embroidered on black backgrounds. This lovely rhythmic composition features a central vase of flowers within a medallion surrounded by blossoms and leaves sinuously interconnected with tendrils. Many coverlets such as this once were edged with fringe on three sides, but it has frequently worn off with time and use. Photograph courtesy Thos. K. Woodard: American Antiques & Quilts, New York City. (Private collection)

copy, as originality was not necessarily encouraged. Teachers sometimes also augmented their incomes by creating and selling their own elaborate designs for nominal fees; the custom of purchasing a pattern was a popular one, and newspapers of the time were filled with advertisements offering a multitude of designs.

A specialized form of needlework picture was the mourning, or memorial, picture. These began to appear around 1800 and were quite fashionable until about 1830. Like the mourning paintings that eventually replaced them (see, for example, figs. 60 and 61), they were inspired by the sentimentality and romanticism of the time and fueled by an idealized vision of death. They, too, included all the traditional symbols of mourning and Resurrection, and often real hair was used to embroider the name of the person being memorialized (though not always the hair of the deceased, as fine black hair was preferred for this purpose). Many of these pictures also combine the use of needlework and watercolors or ink (fig. 145), perhaps

the transitional phase to those schoolgirl paintings in which brush strokes resemble embroidery stitches.

By the 1830s, education for women was changing and a stronger academic curriculum began to displace needlework in the schools. The careful and exquisite needlework of the eighteenth and early nineteenth centuries generally disappeared, to be replaced by something very different. New sources of needlework designs proliferated as the nineteenth century progressed, and women's periodicals such as *Godey's Lady's Book, Miss Leslie's Magazine,* and *Peterson's Magazine* encouraged the use of pre-drawn patterns that became popularly known as Berlin work, so titled because many of the first commercial designs were imported from Germany. Berlin work required some little skill but no creativity, and by the latter half of the nineteenth century, creative genius in this area was equated more with manual dexterity than with design. Again, many of the patterns available commercially were based on famous prints and paintings, but not everyone appreciated them. Mark Twain, in describing a needlework (probably Berlin work) copy of the famous painting of Washington crossing the Delaware River, noted: "[a] work of art which would have made Washington hesitate about crossing, if he could have seen what advantage was going to be taken of it." There was a resurgence of interest for working samplers during the 1920s and 1930s, when popular magazines again focused upon the many wonderful things that the American homemaker could create to enhance the interior of her family dwelling, but it did not last long.

Of all the textiles extant from colonial times, those related to the bed constitute the largest category, and these were of extreme importance to their users. A bed might be the major piece of furniture in a frontier house; people were born in it, slept in it, and died in it. Often it was the focus of the room, especially when homes consisted of only one or two rooms. What was on the bed was on display, and what was displayed was important. Many pieces were needed to enclose the bed to keep out the cold—valances, curtains, a spread or coverlet, blankets, quilts—and these early bed furnishings in total might well be worth more than the bed itself, for textiles were expensive and time-consuming to make. Women played the greatest part in the creation of these textile works, and although their basic criteria in making a piece might be protection and warmth,

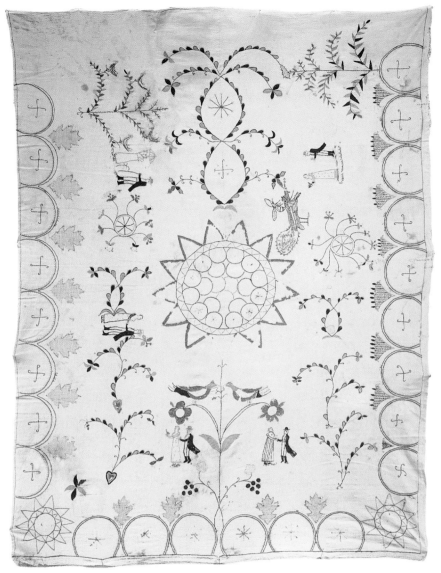

153. *The "Boo-Hoo" Coverlet;* Mary (Mrs. Elisha) Beebe Strong; Connecticut; c. 1813; wool and cotton embroidery on linen homespun; 86¼" x 78¾" (including 6¾" of cotton netting on sides and bottom, not shown). This seemingly simple coverlet is rife with symbolism and contemporary commentary. Some have viewed the five couples as illustrating various stages of love and married life while others take them to represent the five stages of man. The rather odd beast crying "Boo Hoo" while being attacked by a flying insect (at upper right) is an embroidered version of a popular satirical political cartoon of the time—"The Hornet and Peacock, or, John Bull in Distress," designed and engraved by Amos Doolittle. The cartoon refers to an event that took place during the War of 1812, the sinking of the British ship Peacock by the American ship Hornet (February 24, 1813); in the cartoon, Great Britain is represented by a fanciful creature that is part bull (as in John Bull), part peacock, who cries "Boo Hoo" as it is stung on the neck by a giant hornet. Photograph courtesy America Hurrah Antiques, New York City. (Private collection)

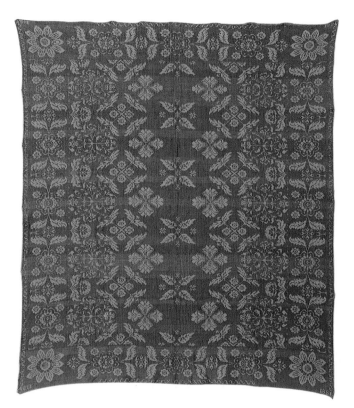

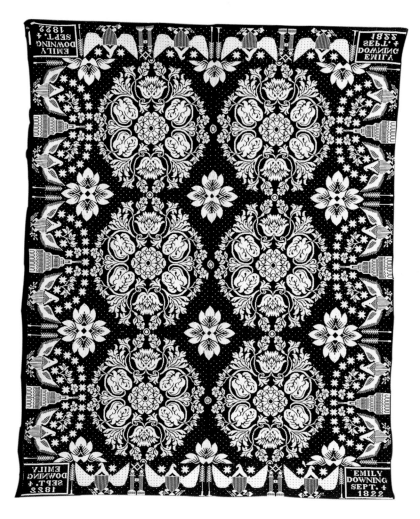

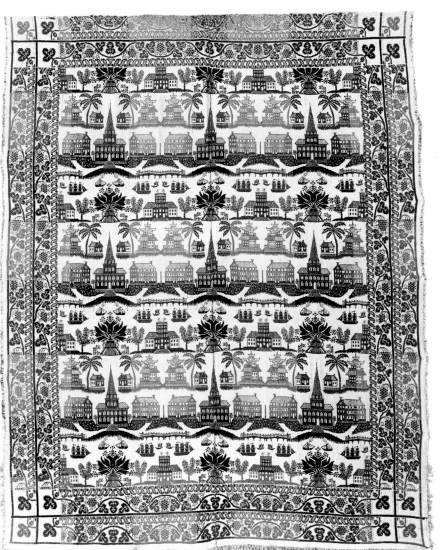

154. (OPPOSITE PAGE, TOP LEFT) *Coverlet: Single Snowball and Four Roses Pattern with Pine Tree Border;* maker unknown; New York, Ohio, or Indiana; 1820–1840; wool and cotton; 77" x 73". Block doublecloth, the weaving technique used in this coverlet, was a popular style from about 1810 to 1840. It is reversible and woven of two planes of cloth, each a different color; the crossing of the planes yields the patterns known as snowball and roses. Many coverlets using this pattern also have stylized Pine Tree borders on three sides, as shown here. A loom of at least eight harnesses is required for this pattern, making it unlikely that the average housewife would have made it. (Museum of American Folk Art, New York; Gift of Margot Paul Ernst in memory of Susan B. Ernst. 1989.16.12)

155. (OPPOSITE PAGE, TOP RIGHT) *Coverlet: Jacquard-type Double Weave;* maker unknown; possibly New York State; 1826; wool; approximately 74" wide. This unusual blue-on-blue fancy-weave coverlet may slightly predate the introduction of the Jacquard head for a loom in the late 1820s, and so it was probably made on a draw, cylinder, or barrel loom—cumbersome types that only a professional weaver would use. These looms allowed individual warp threads to be raised, thus creating floral patterns, such as here, and other patterns with swirls or curves. It is reversible. (Museum of American Folk Art, New York; Gift of Margot Paul Ernst in memory of Susan B. Ernst. 1989.16.16)

156. (OPPOSITE PAGE, BOTTOM) *Coverlet: Multiple Rose Medallions with Eagle and Independence Hall Border;* James Alexander (1770–c. 1870); Orange County, New York; dated Sept. 4, 1822; wool and cotton; 93" x 74". This coverlet, made for Emily Downing and one of two double-weave examples that can be positively identified as the work of the well-known weaver James Alexander, is a tour-de-force of the weaver's art. The complex floral center is bordered in a patriotic motif; it is a superb example of what could be achieved by a talented weaver before the advent of the Jacquard loom. (Museum of American Folk Art, New York; Gift of Margot Paul Ernst in memory of Susan B. Ernst. 1989.16.12)

157. (ABOVE) *Coverlet: True Boston Town and Christians and Heathens;* maker unknown; probably Ohio; c. 1840; wool and cotton; 92" x 73". The advent of the Jacquard loom brought about a revolution in weaving design. Now a weaver could depict houses, people, trains, buildings, ships—the motifs limited only by the weaver's access to Jacquard cards or his or her imagination, for some weavers made their own cards. This stunning example is unusual in that the pattern used as the main motif—Christians and Heathens—was normally used only in borders. The addition of the sailing vessels also appears to be an innovation of this weaver. The rainbow coloration has been found in other Ohio coverlets. (Museum of American Folk Art, New York; Gift of Margot Paul Ernst in memory of Susan B. Ernst. 1989.16.17)

close behind were almost certainly creative expression and beauty.

Bedclothes in the seventeenth through the nineteenth centuries included bed rugs, linsey-woolsey coverlets (sometimes quilted), printed whole-cloth spreads, hand-embroidered or loomed candlewick spreads, woven coverlets, and the more familiar quilts of three basic types: whole cloth, pieced, and appliquéd.

The bed rug (sometimes called bed rugg) is the rarest and earliest type of American bedcover (figs. 146, 147). They are found almost exclusively in New England, and especially in the Connecticut River Valley. At one time their size and weight caused them to be mistaken for floor rugs, but they were clearly not intended as such. Although no examples of such textiles are known from England, they apparently existed there; Nathaniel Bailey's *Dictionarium Brittanicum: Complete Universal Etymological English Dictionary* (London, 1730), a book often found in homes of the well-to-do in the eighteenth century, defines "rugg" as a shaggy coverlet for a bed, and several pieces of correspondence refer to items that might fit this definition. Governor John Winthrop of Massachusetts, for example, wrote to his son in England to ". . . bring a store of Coarse Rugges, bothe to use and to sell," and about the same time Lord Baltimore warned those considering emigration to the American shores to "Take one rugg for a bed" and a "course Rugg to use at sea."[4] The earliest reference in this country to something that may be what we now call a bed rug are in two seventeenth-century references, one that mentions a "Yearne courlead," and the other to an "embroadured couerled."[5]

Bed rugs were often signed and dated, probably as testament to the great amount of time and effort that went into their making, from the shearing of sheep and dyeing of the wool, to the completion of the elaborate design. Bed rugs were completely a home product. Unlike quilts, which blossomed in an infinity of designs, bed rugs appear in a limited range of design—although there are extensive and innovative variations. The basic range includes variations on the Tree of Life, bold and dramatic florals, wandering vines, and, occasionally, an abstract design based on a clamshell-like motif (perhaps taken from a common quilting pattern). Most known bed rugs date from the late-eighteenth century and the early nineteenth; they are, for the most part, executed in warm colors and bold designs.

Linsey-woolsey is a coarse, loosely woven fabric generally made with a linen warp and a wool weft. Linsey-woolsey is derived from Middle English "lynsy wolsye," a term that refers to the village of Lindsay, a small village in Suffolk, England, where the fabric is said to have orig-

inated. The coarse and durable linen thread that was used in the linsey-woolsey covers was a local product, as flax was one of the first crops planted after the first colonial settlements were established. Linsey-woolsey was not always woven of linen and wool, however; sometimes a combination of cotton and wool was used. Because of their extreme warmth, linsey-woolsey bedcovers are nearly always found in the colder regions of the country, and they are almost always quilted; other than that done on clothing, they probably represent the earliest quilting done in the colonies. This durable fabric, which could be woven at home on a simple two-harness loom, was also used for curtains, aprons, and even upholstery throughout much of the eighteenth century.

The calimanco coverlet is very closely associated with linsey-woolsey (and often confused with it), but it is a worsted that is usually glazed. Many of the calimanco spreads that have survived are indigo blue; this dark color did not show soil, and it was one that held up well. However, the only limitation on color was the dyes that a housewife might be able to obtain; when spreads wore out, the frugal housewife would cut out the salvageable parts and then piece them into bold designs of triangles or squares of two or three shades (fig. 148). Calimanco coverlets were often elaborately quilted, as the glazed surface was ideal for showcasing fine stitching (fig. 149). The quilting designs used were many, with the basketweave, waffle, and pineapple motifs being among the most popular.

Quilting as a technique dates back thousands of years, perhaps almost to the beginning use of needle and thread. It became known in Europe during the Crusades, when it was learned that the Turks wore several thicknesses of fabric quilted together under their armor. In northern Europe, where the climate is often harsh, it was quickly recognized that this technique offered warmth as well as protection, and it was rapidly extended to bedcovers and various forms of clothing,

158. (OPPOSITE) *Stencil Spread;* maker unknown; probably New England; c. 1830; cotton; 102½" x 88". A talented stenciler created this charming pattern of cornucopias bursting with delicate blooms. Of special interest are the two bowls of fruit at the top of the spread—they are perfect prototypes for the theorem paintings so popular at the time (see figs. 57, 58, 59), and make it likely that the artist learned her skill in a female academy, where the art of stenciling would be part of the curriculum. The most usual method of applying the colored design was to use a stencil mordant composed of ground pigment and oil. An alternate mixture, made from concentrated dye mixed with gum arabic, was preferred by some because it was less likely to run under the edges of the stencil design and thus create fuzzy edges. Photograph courtesy America Hurrah Antiques, New York City. (Private collection)

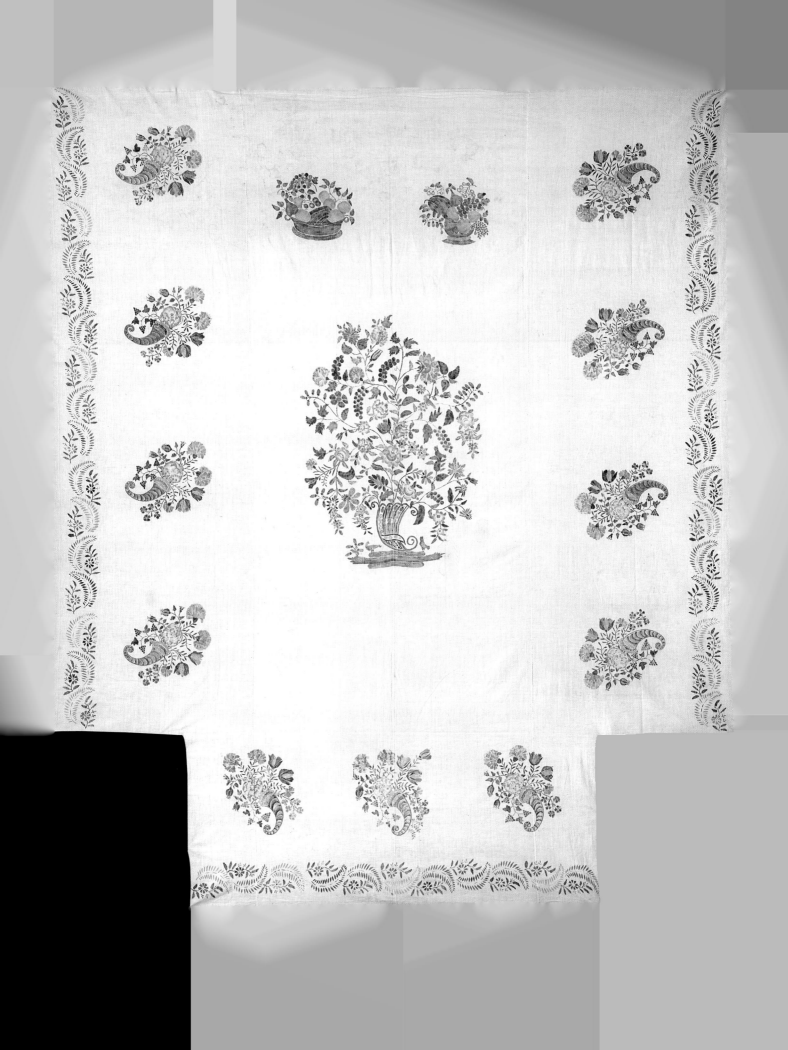

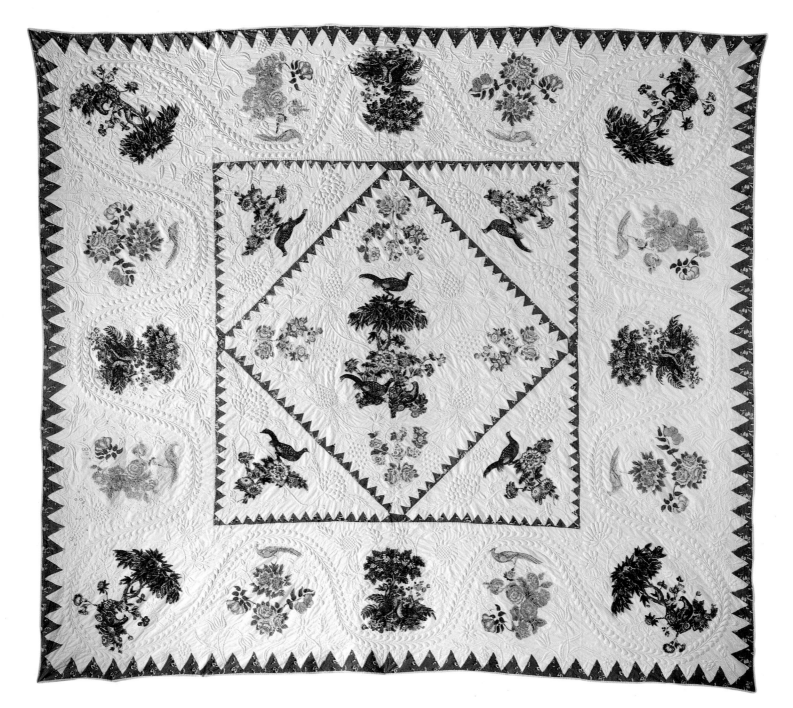

159. *Broderie Perse Center Medallion Quilt;* maker unknown; Pennsylvania; 1800–1815; pieced, appliquéd, and stuffed work, cotton; 120" x 107". This coverlet beautifully combines fine stuffed work with design elements cut from chintz cloth printed to be used as appliqués. The undulating band of feather work as well as other parts of the exquisitely stitched quilting has been stuffed to give a dramatic sculptural element to the quilt. Such stuffed work, or "trapunto" as it is sometimes called, is thought to have come to England from Italy in the seventeenth century and thence to the colonies. Photograph courtesy Kelter-Malcé Antiques, New York City. (Private collection)

such as petticoats, linings, and overcoats. From that point, it was but a short step to stitching the layers of fabric together in a decorative pattern rather than with a simple running stitch, and the future path of quilting as a decorative as well as utilitarian technique was set.

The use of quilted bedcovers eventually became widespread in this country, and more will be said about them shortly. Lighter-weight spreads were also used on beds, especially in the southern colonies, where the favored—though expensive—choices were those made from palampores (fig. 150). These cotton fabrics, with spectacularly complex designs blockprinted and over-painted by hand, were products of the East Indies. During the late-seventeenth and early-eighteenth centuries, these textiles were strikingly popular both in England and here, and English and Dutch trading ships could be sure that their cargoes of these vibrant fabrics would be rapidly sold. Although the mother country had, at first, actively discouraged and, later, forbidden textile manufacture in the English colonies in order to protect her own manufacturing interests, textile makers in England could not match the character and brilliance of the Indian printed cottons, and so both countries looked to India for their supply. It should be remembered, however, that England still controlled the Indian trade to the colonies, so it is likely that fewer palampores made it here than to England. The Tree of Life and elaborate floral designs seen on many palampores provided the inspiration for the designs of some bed rugs and many crewel-embroidered coverlets, as well as later bedcovers (figs. 161, 163).

Crewel, a major creative outlet for the colonial woman, was usually done with wool thread "workt" or embroidered on a base of linen homespun. The term *crewel* derives from the name of an English town that produced fine loosely twisted wools in a variety of rich colors used in embroidery. English crewel is usually far more complex in design than American, and the decorative elements almost always cover a larger area on the finished piece than do American examples, perhaps because of the necessity for a colonial woman to make all the thread that was needed—a time-consuming process.

Floral designs done in crewel (fig. 151) were especially popular in America during the eighteenth century, and many show the influence of older Jacobean embroidery as well as of the imported Indian fabrics. Pattern books such as Richard Schorleyker's *A School-House for the Needle*, published in London in 1632, also provided information for those who needed to "live by the needle and give good content to adorne the worthy."[6] This publication was profusely illustrated with

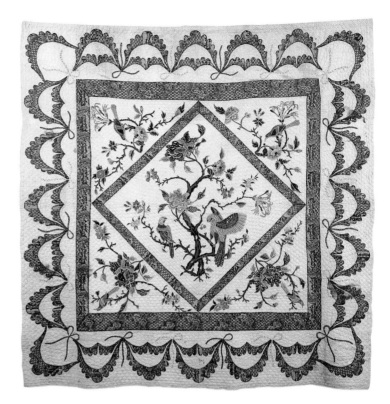

160. (ABOVE) *Broderie Perse Quilt with Tree of Life Variation;* possibly Elizabeth Gramby; Hertford/Perquimmans County, North Carolina; c. 1800; appliquéd cotton; 90" x 90". The Tree of Life featured on the East Indian palampores (fig. 150) inspired women in this country to create their own designs based on that important motif. This example was created with the broderie perse technique in which elements were cut from printed fabric and then recombined into a design of the maker's choosing. (Museum of Early Southern Decorative Arts, Winston-Salem, North Carolina)

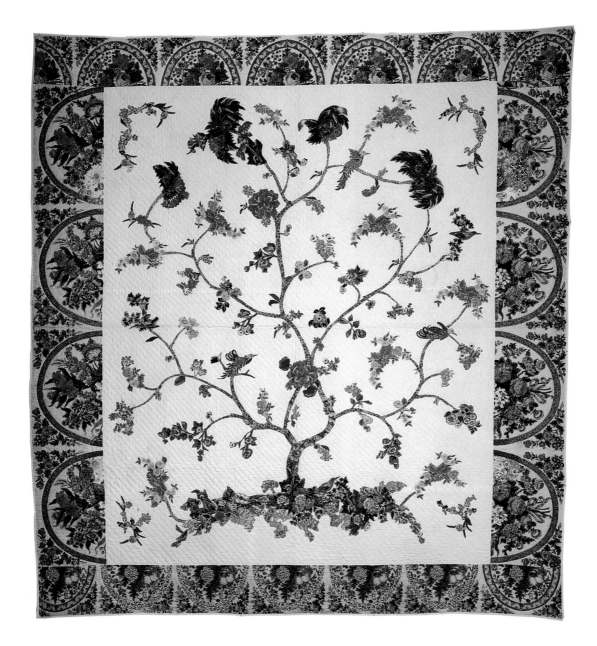

motifs that are frequently seen in American crewel work. During the late-eighteenth and early-nineteenth centuries, a taste for elaborately embroidered floral designs on a black wool background developed (fig. 152). These handsome bedcovers were much treasured, for the dyes required to color them were expensive, and, even following the Revolution, America had to look to Europe to obtain them. By the mid-nineteenth century, crewel work was also used to embellish handwoven woolen blankets or lighter-weight linen coverlets; this work tended to be somewhat more idiosyncratic than the earlier pieces (fig. 153).

Other types of embroidered bedcovers have also enjoyed great popularity. Candlewick bedspreads, for example, could be either hand-embroidered or loom-woven. The hand-embroidered spreads have a linen or cotton background that is embellished with elaborate floral or stylized designs picked out with candlewicking—a coarse cotton thread or roving. They demonstrate a freedom of design (fig. 164) that was unachievable by the weaver, who made the loomed examples that became popular about 1820. Presumably, most of the woven candlewick spreads were made by professional weavers; this is also true of many of the loomed woolen coverlets.

The spinning and weaving skills of the early colonists were crucial to their survival, for only a small number of coverlets were brought with them. As those wore out, they were replaced by pieces of domestic production, probably initially made on simple two- or four-harness looms that many households must have possessed. Weaving, however, was a slow and tedious business, and only a limited number of patterns could be created on these basic household looms; thus, many housewives

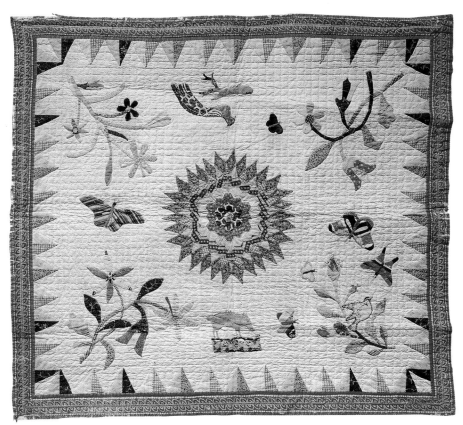

161. (OPPOSITE) *Broderie Perse Tree of Life Variation;* maker unknown; Wiscasset, Maine; c. 1925; pieced and appliquéd cotton; 96" x 90". The Tree of Life remained a favorite theme of quilters for many years, although few such elaborate examples as this one have been seen in the twentieth century. The quilt is unique in that it not only uses the broderie perse technique so popular, especially in the South, a century earlier, it also uses fabrics from both the 1830s and the 1920s. It is an excellent rendition of a classic pattern and technique by a more modern hand. Photograph courtesy America Hurrah Antiques, New York City. (Private collection)

162. *Central Medallion Crib Quilt;* Louisa Wells Fitz (1845–1908); Southold, New York; date unknown; pieced and appliquéd cotton; 35" x 32½". In the nineteenth century, crib quilts were usually just reduced versions of full-size quilts, with the designs simply scaled down as needed to fit the smaller size. It was not until the twentieth century that specific patterns geared to children were developed and used extensively. Although this crib quilt suggests a traditional broderie perse technique at first glance, the figurative appliqués such as the butterflies and the flowers are formed from random scraps of fabric rather than cut as complete images from another textile. The quilt has a charming simplicity, and the figure of the pig is particularly endearing. Photograph courtesy The New York Quilt Project, Museum of American Folk Art, New York. (Collection of James Henry Rich, Jr.)

preferred to spin their yarn and then have a professional weaver create the cloth. The early professional weavers in the colonies, most of whom had trained in Europe and owned larger multiharness looms that allowed a broader choice of patterns, traveled from town to town, collecting yarn and orders for cloth to be woven into a pattern of the buyer's choice in the weaver's home studio. Occasionally, if the amount of business could justify it, a weaver might move into a community with his loom for an extended stay, or he might even use a larger loom owned by his client or someone else in the community.

There are five main types of American coverlets: plain (or tabby) weave, overshot, doubleweave, summer and winter, and Jacquard, and the variations possible within the last four of these categories are extensive (figs. 154–157). The Jacquard head, introduced in America from France in the 1820s, dramatically altered weaving production; suddenly, coverlets could be produced much more quickly, in an astounding array of patterns that were no longer limited to the geometric. The invention logarithmically expanded the universe of potential designs, but Jacquard productions still remained luxury items for most. The advent of the powerloom and other significant advances in textile technology soon began to take a toll of individual professional weavers; the Civil War, with its thirst for factory-made goods, delivered the final blow. By the time the war ended, tastes had changed and the convenience of readymade goods was established. Handweaving had become a thing of the past and continued to be done only in the poorest rural areas or as hobbies by the well-to-do. In the twentieth century, weaving has resurfaced as a well-recognized craft, although the products of today's looms are more likely to be only decorative rather than practical.

During the first half of the nineteenth century a fashion developed for painted and stenciled walls, floors, furniture, fabrics, and paintings, and stenciled bedspreads (fig. 158) became popular at this time. Most stenciled cotton spreads were made of one layer of fabric, without a backing or lining. They were, for the most part, homemade pieces undoubtedly inspired by the theorem paintings (see figs. 57, 58) so popular among the young women of the time. Flower, bird, and fruit designs similar to those used for theorem paintings appear on these

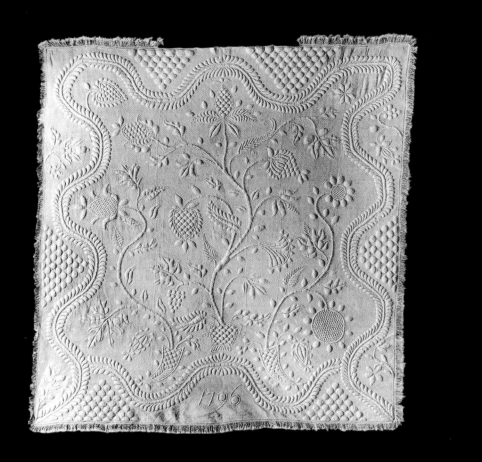

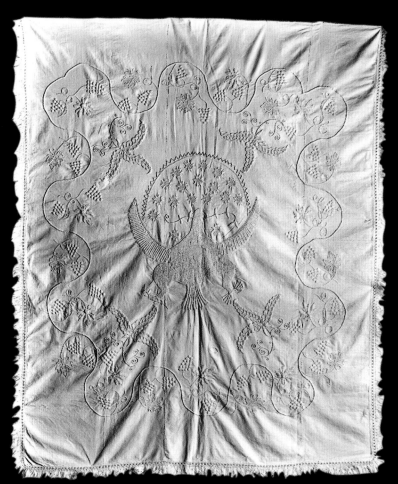

spreads, and it is possible that the same stencils were sometimes used for both a painting and a spread. Stencils provided an inexpensive and quick way to gain a colorful and decorative bedcover—no doubt a welcome alternative to time-consuming embroidery and crewel work for the always-busy nineteenth-century woman.

Of all the textiles produced for the American bed, none has fired the imagination as much as have quilts. Making quilts may have been a necessity, but it was also an area of need in which creativity could run rampant and be fully appreciated by users and viewers alike. Quilts may, in fact, be considered one of America's great indigenous art forms. Although the earliest quilt designs may have budded in Europe, the form reached full bloom here. More designs were created in America than in all of Europe together; they were lively, inventive, often sophisticated, and rarely primitive or naïve. Whether using scrap-bag remnants or specially purchased fabrics, American women stitched together an invaluable legacy that continues to be added to even today and, in the process, built a strong and wide-ranging design tradition.

The earliest references to quilts in America were in estate and household inventories in the late-seventeenth century, and all these textiles had probably come from England. The first quilts made here were probably utilitarian, for initially there was little time to spend on creating more decorative ones, even among the wealthy. The earliest-known surviving American quilt is of pieced triangles and is dated 1704; it is believed to have been made by Sarah Sedgewick Leverett, the wife of the governor of Massachusetts Bay Colony, and her daugh-

ter. An interlining of paper in the quilt has a page from the Harvard University catalog of 1701.

Regional differences in quilts began to appear quite early. Those made in New England were more likely to be made of homespun and created for warmth; they were constructed from strips of whole cloth or simple geometric pieces rather than being elaborately decorative. New England women tended to put their decorative effort into bed rugs, crewel, and handsome quilting of linsey-woolsey and calimanco spreads. In the South, with its milder climate, large plantations, and a slave population that handled more of the basic textile work, plantation mistresses and their daughters had more opportunity to create lighter and fancier work, although slave women who were skilled with a needle also contributed their share to these more elaborate pieces. *Broderie Perse*, a technique in which the forms of flowers, birds, animals, and foliage were cut from pieces of printed cotton and chintz and then stitched to a plain ground fabric, was an especially popular technique in the South (fig. 160) and resulted in many spectacular quilts.[7] Excellent examples of the style were created in other regions also (figs. 159, 162), and it has survived as a technique into this century (fig. 161).

Although some styles remained prevalent in certain regions of the country for many years, designs and techniques quickly spread and often it is difficult to pinpoint their origins. Also, patterns and how they were executed did not stay the same; quilt patterns, in fact, may be said to present an excellent example of tangible cultural evolution. Quilters of the eighteenth and nineteenth centuries rarely blindly followed inherited patterns; innovation was the order of the day, and there was little concern with departure from tradition. It was not until after the middle of the nineteenth century that standardization in patterns started via women's magazines (and newspapers in the twentieth century), and creativity in quilting began to lessen. A revival that began in the 1970s gave new life to the art, however, and quilting is now being revitalized in a whole new direction—that of the "art" quilt per se rather than as an embellished functional object.

Quilted bedcovers are generally divided into three main groups: whole-cloth quilts, pieced quilts, and appliqué quilts. Both pieced and appliqué quilts are referred to as patchwork. Several theories have been advanced toward establishing pieced quilts as the predecessors of the appliqué examples, but equally convincing evidence has been used to show that appliqué quilts predate pieced ones. It seems likely, however, that both types developed about the same time and have coexisted through the years.

163. (OPPOSITE PAGE, TOP) *Tree of Life Whitework Coverlet;* maker and origin unknown; dated 1796; stuffed and corded cotton; 92¹/₄" x 87³/₄" (including woven cotton string fringe). Whitework flourished in America well into the nineteenth century, but it was at its most popular between 1790 and 1840. The design of this rare eighteenth-century piece was probably inspired by the East Indian palampores, such as the one shown in figure 150, that often took the Tree of Life (sometimes called Flowering Tree) as their theme. The complexity of design in this coverlet is comparable to that of bed rugs of the period. Photograph courtesy America Hurrah Antiques, New York City. (Private collection)

164. *Eagle Whitework Spread;* maker and location unknown; c. 1815; candlewick-embroidered cotton; 96" x 78". This is a fine example of candlewicking that makes use of an unusual combination of design elements. The eighteen sunflower-like stars above the eagle's head may symbolize Louisiana's acceptance into the Union in 1812. The very folky American Eagle brings to mind Benjamin Franklin's suggestion that the turkey and not the eagle was the more appropriate bird to represent the new country. (Private collection)

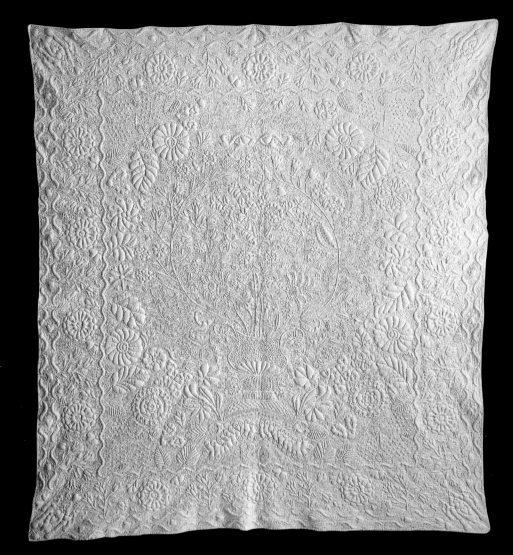

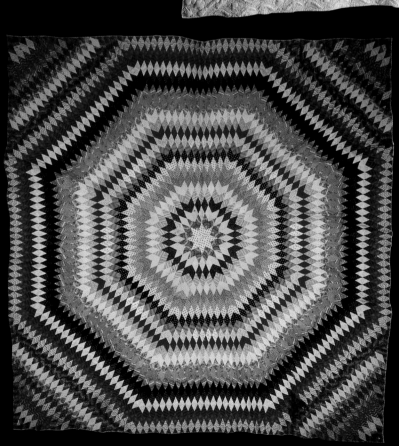

122

Whole-cloth quilts are usually made from several lengths of one or two fabrics only—the lengths of one sewn together and used as the top and the lengths of the other, usually a lesser or coarser fabric, used as the backing—and the front and back held together with extensive and elaborate quilting. The linsey-woolsey and calimanco quilts discussed earlier are types of whole-cloth quilts. In the late-eighteenth century printed fabrics were also used to create whole-cloth quilts; the well-known *toiles de Jouy* from France—and their copies—were notable among the fabrics used for this purpose. By the end of the eighteenth century, all-white whole-cloth quilts, sometimes called whitework, had become popular (fig. 163). The plain white ground proved an effective backdrop for decorative stitching such as embroidery, candlewicking (fig. 164), or stuffed work (now sometimes called "trapunto"; fig. 165), and these quilts, frequently completely covered with one or more of these decorative techniques, became popular as trousseaux and wedding gifts.

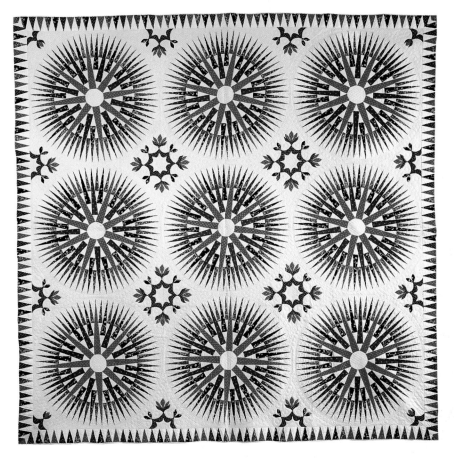

165. (OPPOSITE PAGE, TOP) *Floral Whitework Quilt;* Sarah C. Stern; Maryland; 1861; stuffed and corded cotton; 87" x 78¹/₂". This highly sophisticated and complex design would seem to indicate a very experienced needlework artist. The stuffed work is extraordinary, and tiny stuffed hearts and hands have been worked into the outside border. The maker used cording to sign her name and the date. (America Hurrah Antiques, New York City)

166. (OPPOSITE PAGE, BOTTOM) *Sunburst;* possibly Rebecca Scattergood Savery (1770–1855); Philadelphia, Pennsylvania; 1835–1845; roller-printed cottons; 118¹/₂" x 125¹/₈". This vivid quilt is very similar to several other Sunburst quilts believed to have been made by Rebecca Scattergood Savery or other members of the Savery and the Scattergood families, who were prominent among the Orthodox Quakers of Philadelphia and New Jersey. The maker, whether Rebecca or a relative, was extremely skilled, as can be seen not only in the precise cutting and stitching of the many pieces, but also in her effective use of color and fabric. (Museum of American Folk Art, New York; Gift of Marie D. and Charles T. O'Neill. 1979.26.2)

167. (ABOVE) *Mariner's Compass;* Emeline Barker (1820–1906); New York City; date unknown; pieced and appliquéd cotton; 98" x 98". Mariner's Compass is a favorite quilting pattern, thought to have been inspired by the compass designs on early sea charts. It is also a pattern that requires great skill to do properly. In this outstanding example, each radiating spike comes to a perfect point, and the stitches throughout are tiny and carefully executed. (Museum of the City of New York, 44.31.8; Gift of Mrs. Marian Place Hildrith)

Pieced quilts were time-consuming but economical in times when fabric was scarce as well as expensive. The earliest pieced quilts were made from remnants; it was not until the nineteenth century that fabric began to be bought just for the purpose of making them (purchased fabric was used in appliqué quilts by the late-eighteenth century, especially in the elaborate *broderie perse* examples that made such good use of textile-printer John Hewson's wonderful chintzes). Pieced quilts were fashioned by sewing straight-edged bits of scrap fabric—often thousands of such pieces—together either randomly or in an orderly and well-thought-out manner to form a patterned top. The remnants that appear in these quilts yield their own story, telling both of necessity and the history of a woman's life, as scraps recall a favorite dress, a special occasion, a remnant of a dead relative's favorite fabric, and so on. Pieced quilts were, for the most part, considered utilitarian and represented the everyday bedcover; their designs were usually limited to the geometric—actually to say "limited" is incorrect, for the variety seems infinite, and designs can be bold and dramatic, even shocking and disturbing. Many pieced quilts pulse with energy, their surfaces visually active, with lots of implied movement (see, for example, figs. 166–169).

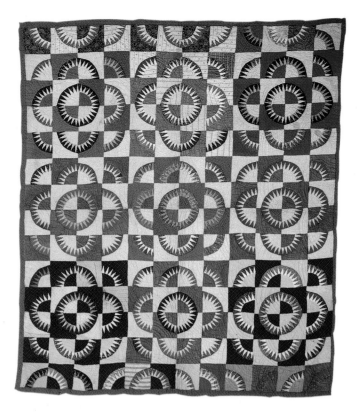

The appliqué technique involves cutout shapes stitched to a ground fabric; in essence, appliqué tops are composed of a double layer of fabric, and thus are more costly to make than pieced quilts. The blank spaces left between the appliquéd designs provided an ideal area to showcase elaborate quilting and stuffed work in decorative patterns. Appliqué quilts did not come into common use until the mid- to late-eighteenth century, when factory-made fabrics began to be more easily obtainable; the *broderie perse* appliqué quilts noted earlier are especially good examples of this technique. In spite of the greater expense implied in an appliqué quilt, many women preferred them, as they offered a greater freedom of design, whether realistic, narrative, or abstract (figs. 170–175). The South had a particularly strong appliqué tradition. Some of the finest American appliqué quilts originated in and around Baltimore, Maryland, and share an elaborate and identifiable style (fig. 172). A strong appliqué tradition is also seen in many pieces by southern black quilters (figs. 182, 184).[8]

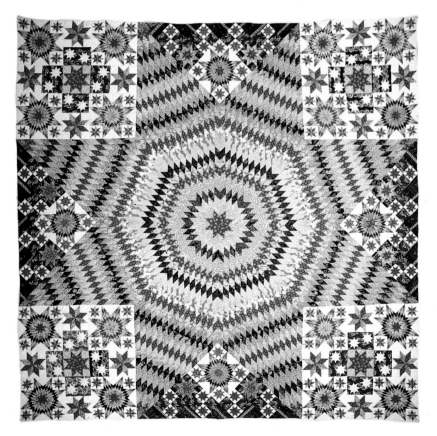

168. (ABOVE) *Pieced Quilt;* Ann Johnson Armstrong; Hickman County, Kentucky; c. 1890; cotton; 78" x 68". Although the workmanship in this quilt is somewhat casual, its dynamic design creates an extraordinary visual impact that overcomes any deficits in the stitching. One common name for this design is Rainbow, but the family's name for the pattern is Full and Change of the Moon. Variations of the basic pattern—a semicircle surrounded by sawteeth—are many, as are the names (such as Crown of Thorns and New York Beauty) by which it goes. It is not unusual to find several names for similar or even identical quilt patterns; the names might vary according to region, beliefs, or simply the whim of the maker. Photograph courtesy Kentucky Quilt Project. (Collection of Margie Lynch)

169. *Star of Bethlehem;* maker unknown; New England; c. 1850; pieced cotton; 94 1/2" x 93". The Star, either singly or in groups, has long been among the most popular designs in quilting, though few other examples can match this quilt for sheer numbers. A total of 193 stars make this piece a personal galaxy for its creator. Although five- and six-pointed stars are often seen in quilts, the eight-pointed variation remained a favorite, and that is the model used here. Photograph courtesy Thos. K. Woodard: American Antiques & Quilts, New York City. (Private collection)

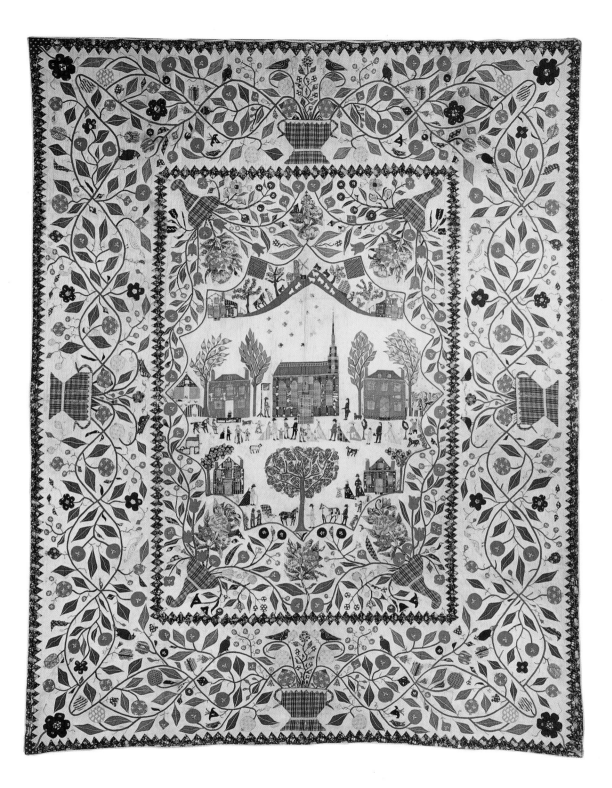

170. *Pictorial Appliqué Coverlet;* Sarah Furman Warner; Green-field Hill, Connecticut; c. 1800; embroidered cotton; 105" x 84". Although the signs of age are evident, this coverlet remains a masterpiece of early pictorial work. The maker seems to open a window through the lush vines and flowers of the outer and inner borders of the spread to allow the viewer to glimpse a busy day in the small New England village where it was created. The church is clearly the focal point and the major building, and the villagers carry on their business around it. Not forgotten are the farmers, whose activities are cameoed in the space above the church. Not only has Sarah Warner demonstrated her obvious needlework skills in this piece but she has also portrayed the affection she felt for her home in a mini time capsule that can still be appreciated today. (Henry Ford Museum & Greenfield Village, Dearborn, Michigan)

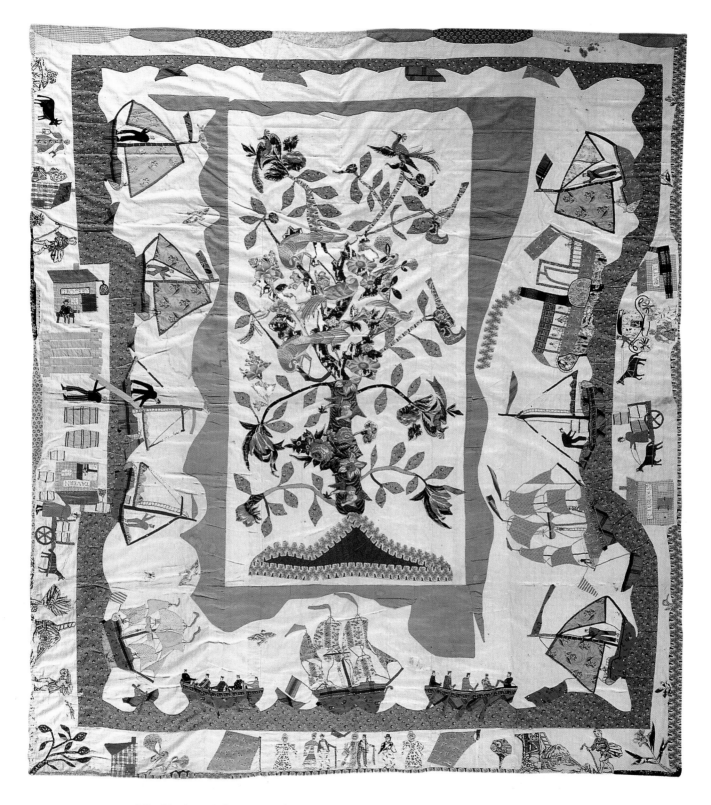

171. *"Trade and Commerce" Spread;* Hannah Stockton Stiles; Philadelphia, Pennsylvania; c. 1835; appliquéd cotton; 105" x 89". The Tree of Life motif at the center of this extraordinary piece is reminiscent of the East Indian palampores, while the highly detailed borders teem with vignettes of contemporary life. The inner and wider border depicts a surprisingly wide range of sailing vessels and even one steam vessel; the outer border shows a series of shops, draymen making deliveries, and, perhaps, customers. The group of figures at the foot of the spread may well represent the maker and her family. This glimpse into the commercial life of the times—most probably the bustling commerce along the Delaware River near Philadelphia—is what has given this spread its nickname. (New York State Historical Association, Cooperstown, New York)

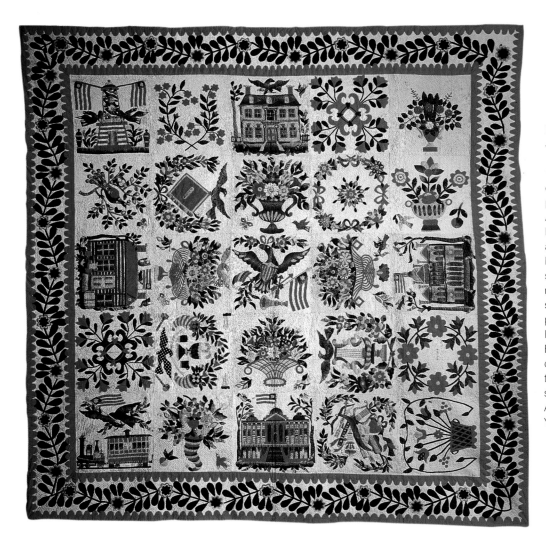

172. *Baltimore Album Quilt;* inscribed "Sarah Pool and Mary J. Pool"; Baltimore, Maryland; c. 1840; appliquéd cotton; 106" x 107³/₈". This brilliant and lavish example of the genre is a compendium of classic Baltimore Album blocks, from floral garlands to American eagles to architectural portraits. Objects of local significance were included, such as the Baltimore Monument, the State House, and a steam engine with one car, supposedly representing a steam locomotive that had its first run in Baltimore. The blocks also include a Fountain of Life, which is thought to reflect Temperance sentiments. Photograph courtesy America Hurrah Antiques, New York City. (Private collection)

After a quilt top was completed, whether it was pieced or appliquéd, it was combined with an inner lining or batting and a backing and mounted on a quilting frame that securely held the three layers and prevented them from shifting during quilting. The quilting pattern for nearly all tops was "marked" as a guide for stitching. Sometimes this difficult task was done freehand, but more often templates made from paper or tin, or even wooden or metal blocks, were used; this design would be traced on the fabric with pencil or with a water soluble ink or dye that could be washed out after the quilt was complete. Some women preferred to prick the design into the fabric with a pin or needle; when this technique was used, the pricked guide holes were covered by the quilting stitches.

Fine, intricate quilting stitches were always considered one of the most important elements of a quilt. Some women chose to do their own quilting, but many held "bees" to complete their quilts, activities that often combined the social with the functional.[9] These events took many forms, from an impromptu gathering of close relatives or neighbors to large-scale affairs that involved much of the neighborhood and were accompanied by refreshments and, often, entertainment. Frances Trollope (the mother of the well-known nineteenth-century English author, Anthony Trollope) commented on such events:

The ladies of the Union are great workers, and, among other enterprises of ingenious industry, they frequently fabricate patchwork quilts. When the external composition of one of these is completed, it is usual to call together their neighbors and friends to witness, and assist at the *quilting,* which is the completion of this elaborate work. These assemblings are called "quilting frolics," and they are always solemnised with much good cheer and festivity.[10]

Although sharp tongues may well have been plied along with sharp needles at a quilting bee, as many accounts would have us believe, the gathering mostly

offered women an often much-needed opportunity to socialize and relax—and, at the same time, accomplish a necessary chore.[11]

As the nineteenth century progressed, a growing middle class and changing technology gave rise to increased leisure time for the American woman. By mid-century, many necessities that once had to be produced by hand at home could instead be purchased, and she reaped the benefits of such new inventions as the sewing machine. Although the amount of sewing that a woman had to do was perhaps no less, it could now be done with much greater efficiency and speed. The sewing machine was wholeheartedly embraced by American women and, within twenty years of Elias Howe's 1846 prototype patent, it had gained a solid place in the American home. Now that women could concern themselves to a greater extent with the decorative aspects of their handiwork rather than with the utilitarian, even more complex and elaborate quilts began to be made, and during this period an interest in pictorial quilts developed that has not yet disappeared (figs. 176, 177).

The names of many quilt patterns reflect regional folklore. Others indicate the religious bent of the quilter, and often the Bible served as a source for pattern names. Whatever the inspiration for the naming of a pattern, it was meaningful to the maker (fig. 169). Once a pattern name was established, it might be handed down from one generation to the next, but just as often it was changed to reflect the views of the woman using it. Sometimes a pattern called by one name in the East might be known by a totally different one on the western frontier. Although quilt scholars have gathered several thousand names in their efforts to categorize the multitude of patterns used by the American quiltmaker, only about four hundred actual quilt patterns have been identified.[12]

Various ethnic and social groups have also created their own particular versions of the quilting tradition. The pieced quilts made by Amish and Mennonite quilters are distinctively designed and have their own unique palettes and quilting motifs. However, styles within these groups vary depending on whether they are in Pennsylvania or the Midwest. In the close-knit agrarian communities of Pennsylvania, the Amish have tended to produce quilts that were conservative in design, adhered to abstract patterns, and were executed primarily in wool (figs. 178, 179). In Michigan, Ohio, and Indiana, the sparser population put Amish needlewomen in closer contact with their "english," or non-Amish, neighbors and were thus subject to more outside influences;

although solid colors and geometric patterns still prevailed, their quilt designs began to reflect a greater diversity and complexity and the preferred fabric became cotton rather than wool (fig. 180).

Some researchers have postulated that quilts made by some southern black quilters represent a unique African-American style and a continuation of the textile traditions of several West African groups; they also say that these traditions, including the strip technique (fig. 181), strong color contrast (fig. 182), asymmetry, large designs, improvisation, multiple patterning, and symbolic forms, were brought to this country by slaves.[13] Others say there is no identifiable African-American style but rather a diverse body of work influenced by many factors (fig. 184).[14] The two points of view are not mutually exclusive, however, and it will be interesting to see where further research leads.

The Log Cabin pattern blossomed in popularity just after the close of the Civil War and it is a particularly graphic example of the quilter's art.[15] A Log Cabin quilt rarely has an inner lining and consequently is seldom quilted; if it is, the quilting often follows the lines of the "log," or individual pieces. Perhaps no other single pattern allows for the range of expression that the Log Cabin does, and quilters through the years have taken full advantage of this flexibility. The organization of the "logs" as well as the blocks and the use of color in each of these elements can dramatically change the look of a

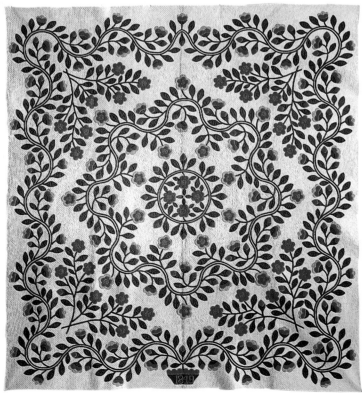

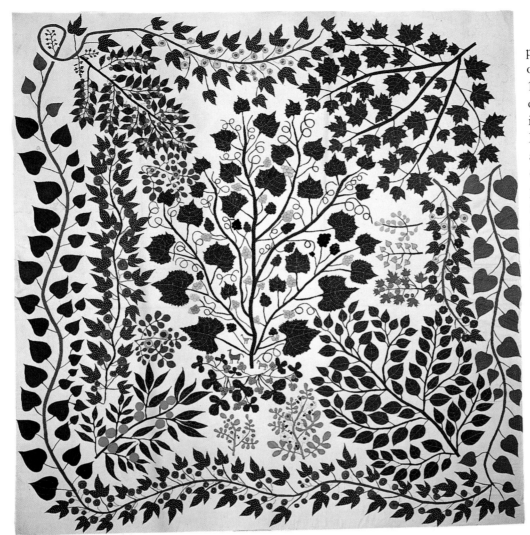

piece, giving the possibility of a single large design (fig. 183) or a series of smaller ones (fig. 185). Barn Raising, Pineapple, Windmill Blades, Courthouse Steps, and Streak o'Lightning are only a few of the many possible variations using the Log Cabin technique; the creative range possible through simple variation of color and shade alone is quite astonishing and gives a broad scope for artistic expression.

Like Log Cabins, Crazy quilts were seldom quilted; they were sometimes secured by tieing or "tufting." There are several theories regarding the origin of the term "Crazy," and one of them is purely descriptive, relating to the seemingly random combination of irregularly shaped pieces of fabric and often excessive embroidery that made up these eccentric creations. Another theory holds that the style may have been inspired by an exhibit at the Philadelphia Centennial Exposition of 1876, where a Japanese display—especially a screen described as "covered with textured gilt paper ornamented with patches of various materials that had painted, embroidered, or quilted designs"[16]—sparked a taste for anything and everything Oriental. The fad for Crazy quilts reached its peak during the last quarter of the nineteenth century and almost every household seemed to have one, whether done in the fancy fabrics preferred, such as silks, satins, and velvets, or in a more prosaic wool or cotton with remnants from the scrap bag. They also perfectly suited the nineteenth-century love of sentiment—for treasured hair-ribbons, bits of a wedding dress, men's neckties, even campaign and commemorative ribbons could be incorporated into a piece—and excessive decoration (fig. 186). They also seemed to satisfy a basic need, for as one woman noted, "I think it is a pleasant variety after the coarser work and unending array of plain sewing which is always confronting the housekeeper, to take up the soft materials whose bright colors refresh the eyes, and

173. *Pot of Flowers Quilt;* maker and location unknown; dated 1849; appliquéd cotton; 91" x 84". Red, white, and green was a popular color combination in quilts from around the 1830s until late in the century. It is perhaps worth noting that the fashion for this palette more or less coincided with the wider availability and lower prices of factory-made fabric; these were not quilts that could have been easily made from scrap-bag remnants. The designs chosen for such quilts were predominantly floral, and are notable for being infinitely varied. The patterns used for these quilts are highly decorative, and the quilting impressively elaborate, giving rise to the probability that they were often created as "best" quilts and also used for trousseaux and wedding gifts. (Thos. K. Woodard: American Antiques & Quilts, New York City)

174. *Appliqué Quilt;* Ernestine Eberhardt Zaumzeil; Chandlerville, Illinois; c. 1865; appliquéd cotton; 88" x 86". Although this quilt appears to be a marvel of spontaneous exuberance, it must have taken the maker many hours of careful planning to fit in all she wished to show. The abundance of flowers, foliage, and berries almost obscures the three tiny animals near the center. (Present whereabouts unknown)

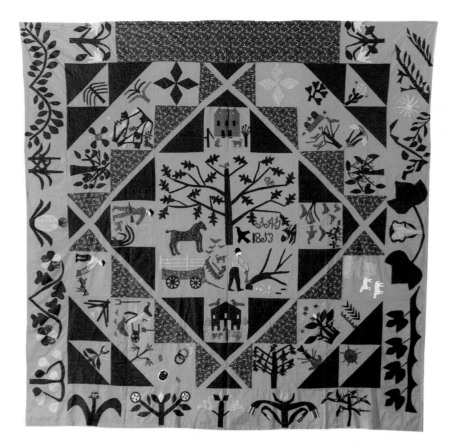

turn them into tasteful ornaments for the home."[17]

Quilts were not only utilitarian objects symbolic of home and hearth, they also served as symbols of religious (figs. 187, 188), patriotic (figs. 189, 192), and political expression, and as celebrations of or demands for reform and change. Sooner or later almost all significant historical events show up, in one way or another, in quilts—war (fig. 190), peace, politics (fig. 191), elections, temperance, suffrage, emancipation, the environment, centennials, civil rights, assassinations, the National Recovery Act, the Red Cross, concentration camps, famous people, and on and on. It may be said not only that the history of quilts is embedded in our culture but also that the history of our culture is embedded in quilts.

Although the vast majority of quilts were made by women, some stunning examples by men are known. Most of these were created by tailors, often from the leftover scraps of their daily work (fig. 193). Boys were once taught many forms of sewing, and some were even encouraged to assist in making a quilt. Calvin Coolidge pieced a Baby's Block quilt at the age of ten, and Dwight D. Eisenhower and his brother helped their mother fashion a quilt. Mary Schenck

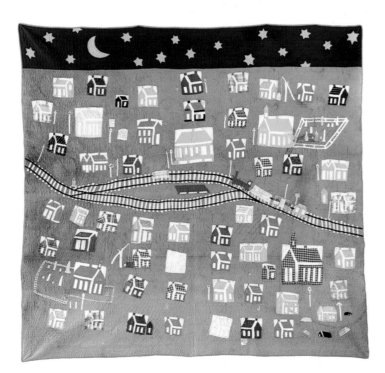

175. *Farm Scene Summer Spread;* Sarah Ann Gargis (c. 1834–c. 1887); Feasterville or Doylestown, Pennsylvania; 1853; pieced and appliquéd cotton, silk, and wool; wool embroidery, muslin back; 96" x 98". This charming appliquéd summer spread depicts significant activities that are part of farm life: plowing, hunting, and even cutting down trees in addition to many farm implements and buildings and a multitude of animals and plants. It may be that Sarah Ann Gargis intended this piece to be a gift for or in honor of her fiancé—according to family tradition, the date of 1853, stitched on the quilt just below Sarah Ann's initials, is the year of her engagement. (Museum of American Folk Art, New York; Gift of Warner Communications, Inc. 1988.21.1)

176. *Schoolhouse Variation;* maker unknown; Pennsylvania; 1891; appliquéd cotton; 78" x 80". In this unique and fascinating use of the Schoolhouse pattern the maker, rather than follow the traditional repetition of the Schoolhouse motif, has taken the basic block and created many variations to build a whole town. Of special interest is the train line that divides the town and the several churches—two with graveyards—which, along with the railway station, are the largest buildings in this very special place. Photograph courtesy America Hurrah Antiques, New York City. (Private collection)

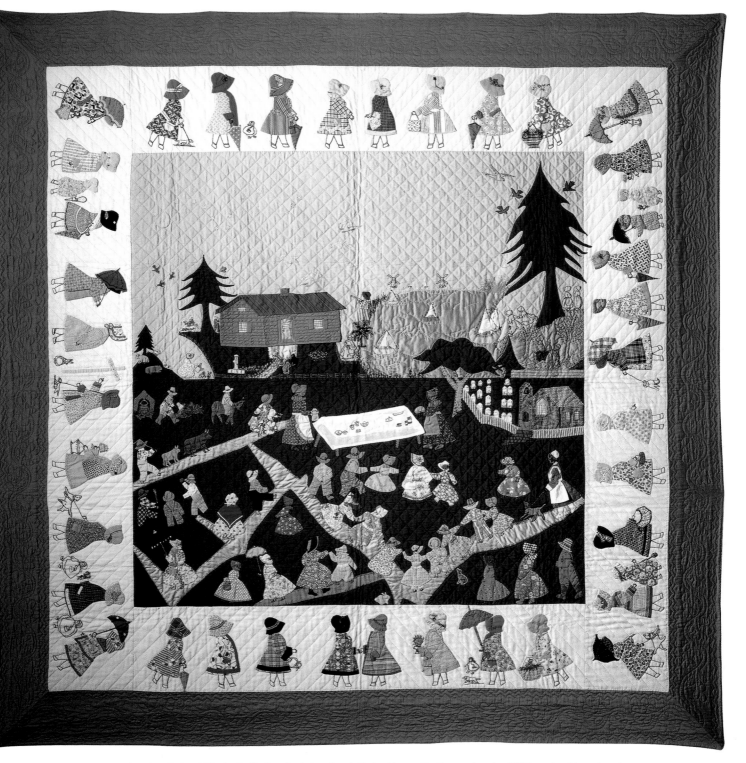

177. *Sunday School Picnic Quilt;* Jennie Achenbach Trein; Nazareth, Pennsylvania; 1932; embroidered and appliquéd cotton; 82" x 84". Although the ostensible theme of this quilt is a simple country picnic, a letter left by the maker tells a far more ambitious tale. Not only has she included many family members in the quilt—her mother and mother-in-law flank the picnic table, one daughter in nurse's uniform has her dog on a leash, and the maker and her young twin daughters (not dressed alike) are part of the border parade—she has also included a number of intriguing vignettes that make it clear there is more here than meets the eye. To the left of the house, for example, a couple elope by horseback; a boy shoots at geese flying above the house; two boys play ball and ignore a third who wishes to join in; and "a city lady . . . so disgusted with these country Rubes—that she went home." The border figures themselves are unique, apparently Jennie Trein's more fashionable interpretation of the ubiquitous Sunbonnet Sue quilt pattern so popular in the 1930s. Perhaps she herself says it best: "I can truly say my own designing of this Picnic Quilt is the only one in the whole wide world and therefore very special." Photograph courtesy Thos. K. Woodard: American Antiques & Quilts, New York City. (Collection of Shelly Zegart)

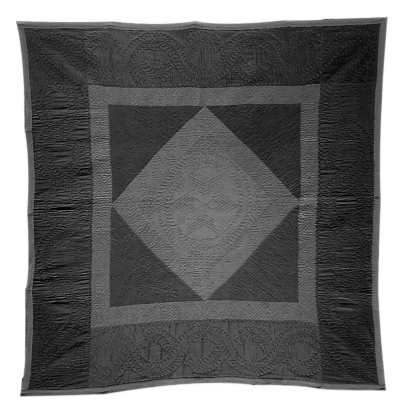

178. *Diamond in a Square;* maker unknown; Lancaster County, Pennsylvania; c. 1920; pieced wool; 77" x 77½". All traditional Amish quilt designs are variations of geometric patterns because their religion forbade the use of naturalistic decoration. Diamond in a Square (sometimes called Center Diamond) is an early pattern that has continued to be made by the Amish even today. It may have originally been inspired by the leather-bound hymnals used by many Amish families, which were often trimmed with diamond-shaped brass bosses at the center and square ones in each corner; the quilts reflect this central diamond-corner squares motif. Photograph courtesy Thos. K. Woodard: American Antiques & Quilts, New York City. (Private collection)

179. *Bars Quilt;* maker unknown; Lancaster County, Pennsylvania; 1895–1900; pieced wool; 80" x 80". Bars, another of the classic Amish patterns, is dramatic in its simplicity. The special sensibility of the Amish palette is also evident here in a combination of colors that may run counter to mainstream color theory yet works together beautifully to create a subtle appeal that gives additional depth to the simple design. As in many Amish quilts, the decorative quilting shows to best advantage against the stark pieced design; this maker allowed her imagination free rein in the exquisite quilting, going so far as to include a basket-of-fruit motif that would never have been acceptable had it been done as an appliqué. Photograph courtesy America Hurrah Antiques, New York City. (Private collection)

180. (OPPOSITE PAGE) *Stained Glass Quilt;* Mrs. Yost Miller; Wisconsin; 1920–1930; pieced cotton; 69" x 60". As the Amish moved West, they ceased to live in as homogeneous communities as they had in Pennsylvania, and so were more exposed to the "english," or non-Amish, world and its influences. This inevitably had its effect, and Amish women began to borrow quilt patterns, such as this one, from their non-Amish neighbors. The palette, however, remained identifiably Amish, with brilliant colors fairly flying out of the dark background. Photograph courtesy America Hurrah Antiques, New York City. (Private collection)

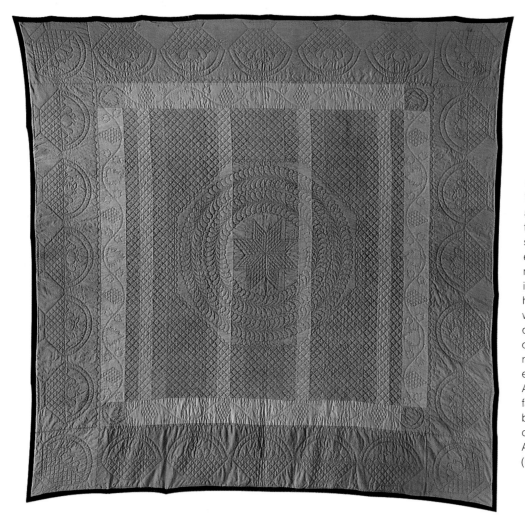

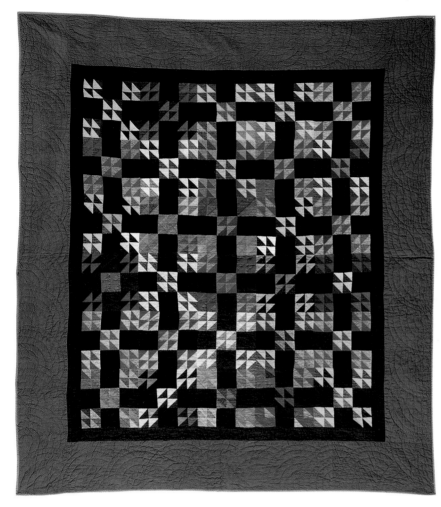

Woolman, a progressive teacher during the early-twentieth century, recommended sewing for all schoolboys:

> In the first three or four years . . . it is well for the boys and the girls to be taught the same kinds of handiwork. . . . Experience has proved that boys are greatly interested in sewing when it is connected with their pursuits. . . .[18]

Because textiles were among the most valuable of all possessions in the colonial American home, the family that could boast of several kinds was considered rich indeed. Imported carpets (usually from the East via England or Holland) during the seventeenth century and for most of the first half of the eighteenth century were valued too highly and were too expensive to be used on the floor. During the 1720s, Nathan Bailey's *Universal Etymological Dictionary* defined the word "carpet" as "A Covering for the Table," although in subsequent editions the definition was changed to "A Covering for a Table, Passage, or Floor." Numerous paintings by artists of the period show carpets in use almost exclusively on the tops of tables and chests, while floors remain all but bare.

What was used on floors in many early homes was sand, swept each morning into a series of graceful designs. The use of sand as a means of decorating floors continued well into the eighteenth century, as evidenced by John Trumbull, a noted American artist born in 1756, who wrote that as a child he had attempted to imitate some paintings done by a sister: "These wonders were hung in my mother's parlor and were among the first objects that caught my infant eye. I endeavored to imitate them and for several years the nicely sanded floors were constantly scrawled with my rude attempts at drawing."[19]

By the mid-eighteenth century, rush matting and painted floorcloths were in use and continued to be used into the nineteenth century. Floorcloths, made of closely woven canvas decorated with smooth, durable designs created by the application of numerous coats of colorful paint, were popular in concept but often beyond the budget of most families because they still represented a sizable investment. Ingenious Americans attempted to develop inexpensive alternatives, however; the September 3, 1822, edition of the Middlebury, Vermont, *National Standard* announced:

> A new carpeting substance has been invented in Philadelphia. It consists of paper, highly varnished and painted after any pattern. It is called "prepared varnished paper," and when finished has the appearance of the best and most elegant oil cloth. A pattern for an ordinary room which would take $50 worth of oil cloth may be covered by this material for $12.50 and at the end of 5 years you can lay down a new pattern for the interest of the sum which the oil cloth cost. It is cool and very pleasant, and will wear handsomely for five years at least.

As carpets slowly moved from the table top to the floor, they began to acquire specific uses. Imported carpets, as well as carpets for the bedside, entry, and tables are recorded among the inventories of ships arriving in the port of Boston, and references to such floor rugs—other than Oriental carpets—began to appear in home inventories of wealthy people in the late eighteenth century.[20] Throughout all of the eighteenth and much of the nineteenth century, purchased carpets remained too

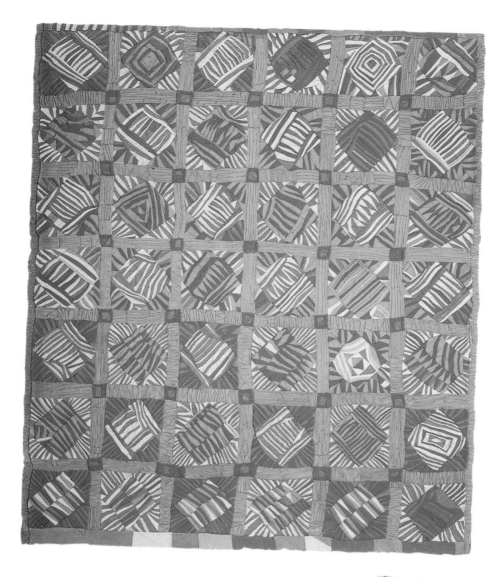

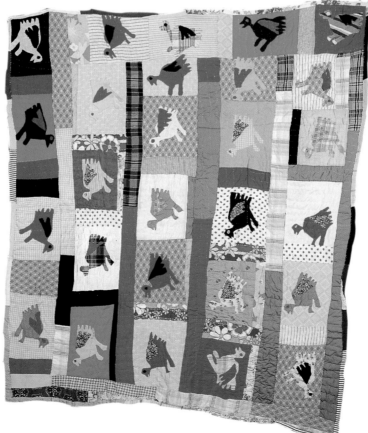

expensive for use in the interiors of most homes, and this spurred the development of homemade, handmade rugs of a surprisingly rich variety. Generally, but not always, these rugs were made by the women of the household. Yarn-sewn rugs, shirred rugs, embroidered and braided rugs, hooked rugs, rag rugs, and woven rugs of both freehand and pattern designs provided colorful accents to the American home (figs. 194, 195). The custom of using rugs to cover tables and chairs persisted, however, and many of the homemade yarn-sewn rugs continued to be used extensively as protective covers for the flat surfaces of furniture (fig. 197).

Embroidered rugs were made from the beginning of the nineteenth century. They were sometimes created by stitching together small squares of embroidered pieces richly embellished with floral and decorative motifs. One of the greatest examples of this type is the rug known as the Caswell Carpet (not illustrated), a dazzling example of American needlework art fashioned by Zeruah Higley Guernsey Caswell in Castleton, Vermont, during the 1830s. It is made up of seventy-six embroidered wool squares (the wool was from Zeruah's own sheep), each with a unique design. The carpet shown in figure 196 is rather similar to the Caswell carpet, and, like it, has a black background, but it is somewhat later and made up of floral motifs only rather than a combination of the floral, animal, and human figures used on the Caswell carpet. Both these carpets were extraordinary creations for the period in terms of their monumental size and their elegance of design, and are pieces that their makers must have labored long and hard over.

Yarn-sewn rugs were among the more prevalent type of small, decorative rug prior to the advent of hooked rugs (fig. 198). They are done with a technique quite similar to that used on bed rugs, but are smaller and lighter. Yarn-sewn rugs are sometimes mistaken for hooked rugs from the front, but a look at the backs, which show spaces between the stitching, quickly distinguishes them. Shirred rugs are a variation on the yarn-sewn type.

Hooked rugs have been called "America's one indigenous folk art."[21] It is a technique that was conceived and developed in North America (including both the United States and Canada), and the design associated with these rugs reached its greatest heights here. They started to be made around 1850 or a little earlier, when burlap, which made an ideal base for hooking, became widely available, and by the 1860s the technique was widespread throughout the Northeast and along the Atlantic coast. By the end of the century, hooked rugs were made throughout the country. There were both regional and individual styles, and the variety of design was phenomenal, ranging from the floral to the pictorial to the abstract (fig. 199). They were also made in all shapes and sizes, including room size.

By the 1860s, although many women continued to create their own designs, an extensive array of predrawn patterns were available to the rug hooker, making it easy for even the least artistic to take up the craft; the more adventuresome could modify the pattern and still create a unique piece of needlework art. Edward Sands Frost, a Maine peddler, was a leader in producing and selling predrawn patterns, and his patterns were so popular that some are still used today. The easy availability of commercial patterns may have contributed to the decline of original design in hooked rugs, but they did much to further interest in hooked-rug making and it remains a widely practiced technique today.

Textiles of many kinds continue to provide outlets for folk expression in the twentieth century, and, if the motivations that drove women to create the earlier examples as seen here are no longer the same, new ideas and equally valid motivations have replaced them. What remains the same is the imagination, personal innovation, and, above all, desire for expression that lies at the basis of the best of this aspect of folk art.

181. (OPPOSITE PAGE, TOP) *String Quilt;* maker unknown; Kentucky; 1920–1930; pieced wool, muslin binding; 75¼" x 65". This singular quilt of African-American origin is stunning in the sensibility of its palette as well as in its design conception. It exhibits several characteristics of African-American quilts, such as a tendency toward organization in strips, strong contrasts of color, and the allowance of multiple patterns or rhythms within a single piece—all traits that have their basis in African aesthetics. It is a brilliant testimony to the creativity inherent within the African-American culture as well as to the persistence of African traditions in a different medium. (Museum of American Folk Art, New York; Gift of Jolie Kelter and Michael Malcé. 1988.26.1)

182. (OPPOSITE PAGE, BOTTOM) *Hens Quilt;* Pearly Posey (1894–1984); Yazoo City, Mississippi; 1981; pieced and appliquéd cotton and synthetics; 71" x 69". This colorful quilt also exhibits the characteristics of many African-American quilts, such as strong contrast and organization in strips, but Pearly Posey also shows a lively sensibility of her own in her delightful design. Posey learned to piece and quilt from her grandmother; she did not learn to appliqué until 1980, when her daughter, a skilled quilter in her own right, taught her. (Museum of American Folk Art, New York; Gift of Maude and James Wahlman. 1991.32.2)

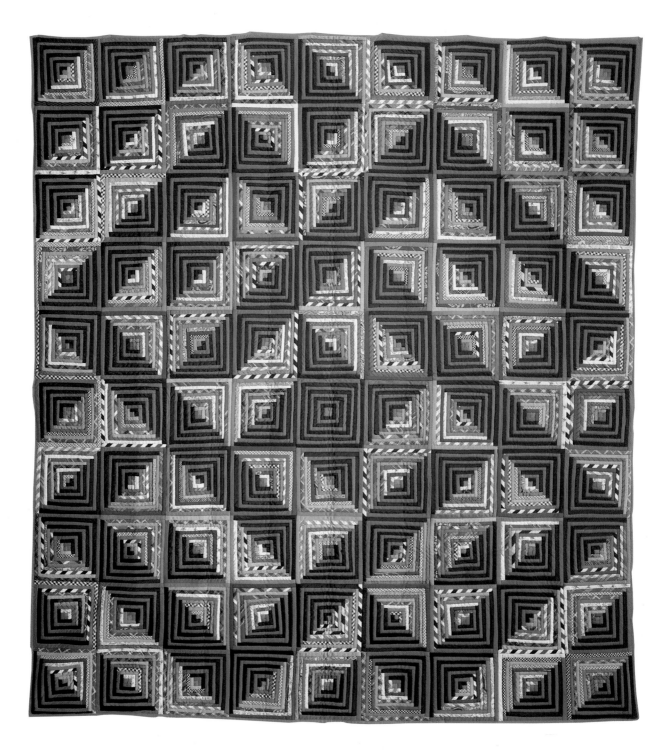

183. *Log Cabin, unique design;* maker unknown; Hornby area, Steuben County, New York; date unknown; pieced cotton, wool, and serge; 81" x 72". The Log Cabin pattern became extremely popular immediately following the Civil War, and it is one in which the variations seem endless. This quilt is an outstanding example of an original design, and it makes a powerful visual statement. The background was pieced from scrap fabrics, but the red and blue used in the dominant design was most likely purchased for this purpose. Photograph courtesy New York Quilt Project, Museum of American Folk Art, New York. (Collection of Rheon Williams)

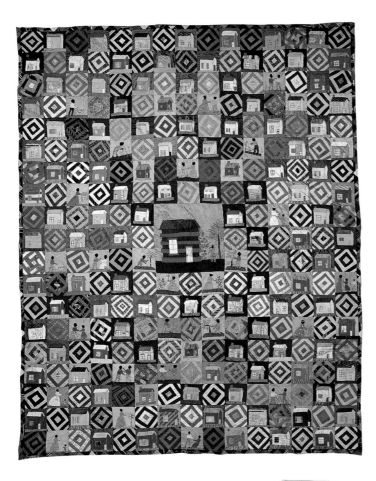

184. *Log Cabin Pictorial Quilt;* maker unknown; found in New Jersey; c. 1870; pieced, appliquéd, and embroidered silk; 76" x 62". Thought to be the work of an African-American quilter, this is an important and imaginative example of folk art using a variation of the Log Cabin style. Many of the pictorial blocks show black figures at work and play, and over one hundred houses are portrayed. The maker of this quilt was possibly a dressmaker who thus would have had easy access to leftover scraps of silk for this work. Photograph courtesy Thos. K. Woodard: American Antiques & Quilts, New York City. (Private collection)

185. *Log Cabin, Pineapple Design;* Cornelia Van Wyck (1839–1912); Dutchess County, New York; c. 1875; pieced silk; 68" x 48". The Log Cabin pattern lent itself well to a variety of fabrics, and it was not unusual to find it executed in silks, satins, and velvets. This version, done in silk, shimmers with jewel-like tones; only one block seems particularly out of sync, so much so that one must wonder whether it was by intention rather than by accident. Photograph courtesy New York Quilt Project, Museum of American Folk Art, New York. (Private collection)

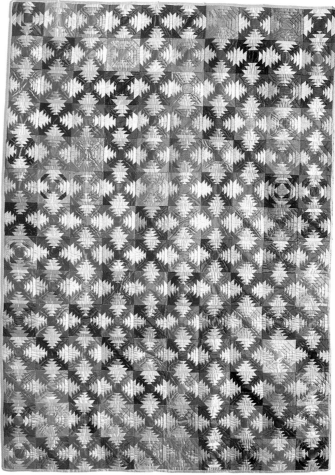

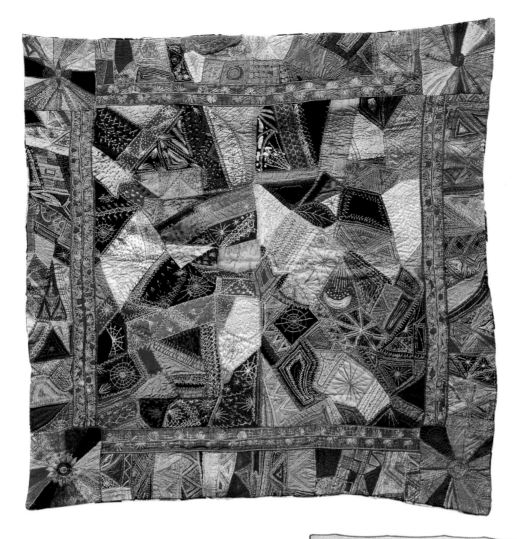

186. *Crazy*; Josephine Cashman Hooker (1860–1912); New York City; 1880; velvet, satin; 48" x 50". This dazzling piece, the epitome of the late-nineteenth century Crazy quilt, was made with scraps from the quilter's gowns. Embroidery made so dense that the fabrics below were almost obscured was quite typical of the Crazy quilt style, of which this is such a fine example. Photograph courtesy New York Quilt Project, Museum of American Folk Art, New York. (Collection of Margaret Hooker Kirkland Musil)

187. *Pieties Quilt;* Maria Cadman Hubbard (b. 1769); probably New York State; 1848; hand-pieced and quilted cotton; 88½" x 81". In quilts such as this one, the effort expended in the making is obviously far more than is needed simply to provide warmth; often a quilter used her fabric as a canvas on which she could paint a broader picture, regardless of the extra effort involved. Maria Cadman Hubbard clearly was such a devoted quilter; she was not ashamed of her moral and religious beliefs and took a very public way to make them known. The inscriptions on this quilt are done in pieced lettering and cover a full range of pious sayings and common homilies, all contained within a strong, handsome design of sawtoothed triangles, squares, and diamonds. (Museum of American Folk Art, New York; Gift of Cyril Irwin Nelson in loving memory of his parents, Cyril Arthur and Elise Macy Nelson. 1984.27.1)

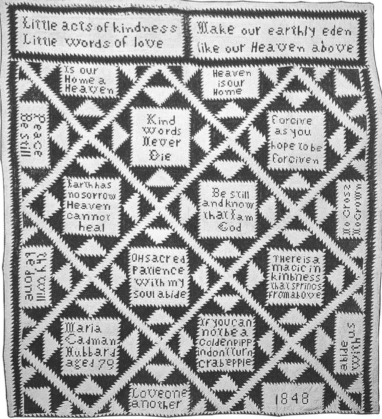

138

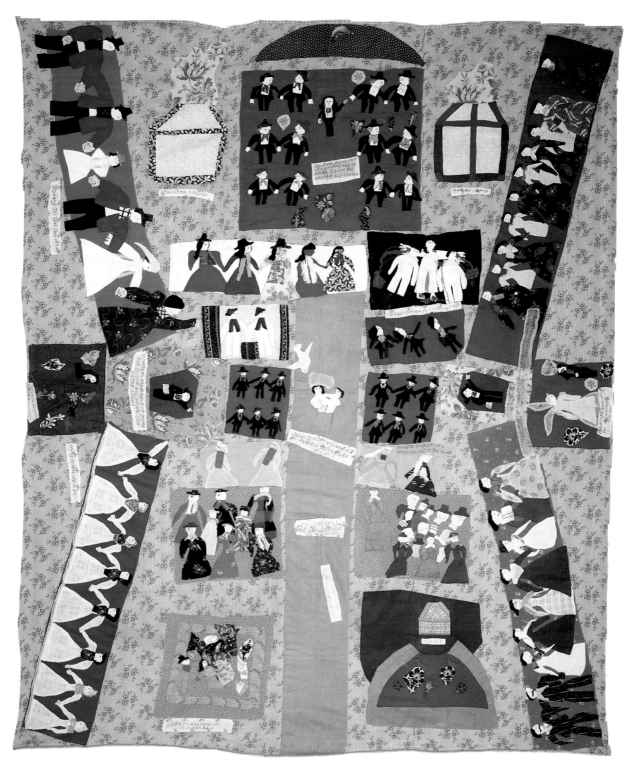

188. *"Sacret Bibel Quilt";* Susan Arrowood; West Chester, Pennsylvania; 1875–1895; appliquéd and embroidered cotton, silk, and wool; inked inscriptions; 88½" x 72". This quilt, like the two well-known Harriet Powers Bible quilts in the collections of the Smithsonian Institution and the Museum of Fine Arts, Boston, is a reflection of the deep religious convictions of the maker. The quilt depicts stories from the Bible, and Arrowood helpfully sewed labels (in her spelling) on the quilt explaining the different scenes. At the center, for example, is "John Baptizing Jesus in the river off Jorden"; at top center, "Jesus on the mountain sending his desiples threw the world to preach"; at far left center, "Jesus in the garden praying"; and at the lower left, "Adam and eav in the Garden." (Museum of American Folk Art, New York; Gift of the Amicus Foundation, Inc., and Evelyn and Leonard Lauder. 1986.20.1)

139

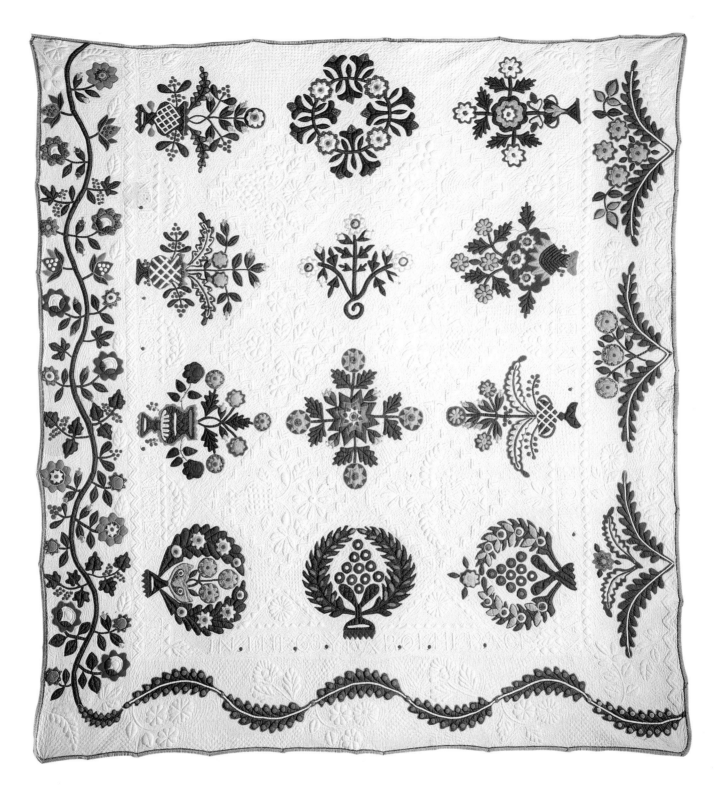

189. *Appliqué Album Type;* Mrs. C. Bartlett; dated 1860; appliquéd cotton with stuffed work; 82" x 73". Sometimes patriotism may be expressed in subtle ways. An inscription, with the words separated by tiny red dots, forms the inner border of the stuffed work in this quilt; it reads: "1860. Done by Mrs. C. Bartlett in the 63 year of her age. Name true American." This wonderful and whimsical quilt has extraordinary stuffed work both in the appliqué and in the quilting. Photograph courtesy America Hurrah Antiques, New York City. (Private collection)

190. (ABOVE) *Floral Appliqué Quilt;* Martha Jane Singleton Hatter Bullock (1815–1896); Selma, Alabama; c. 1861; silk, cotton chintz, wool challis appliqué with stuffed work; 66½" x 65½". The Civil War saw women forming an army of their own, with needles and thread as their weapons, as they moved to support their respective alliances. Martha Bullock was a loyal daughter of the Confederacy and decided to serve her country in the way she knew best. She made two spectacular quilts, of which this is one (the other is now in the collection of the White House of Alabama), to be auctioned to raise money to pay for a gunboat from Alabama that would serve the Confederate cause. The quilts were auctioned, redonated by the buyers, and auctioned again, thus raising a substantial amount of money for the gunboat effort;

today these two quilts are called the "Alabama Gunboat Quilts" in recognition of the purpose for which they were made. In the North, women made thousands of quilts for the U.S. Sanitary Commission. Some were used as fundraisers, but most went to the soldiers on the front. The work of women on both sides is eloquently captured in this quote by Wm. Howell Reed: "The women of the land could not follow those they loved in battle but . . . [they] had enlisted for the war, and there was nothing intermittent or spasmodic about their labor. As long as the need lasted they were ready for service."[1] (Collection of the Birmingham Museum of Art, Birmingham, Alabama; Museum purchase with partial funding provided by the Quilt Conservancy)

191. *Civil War "Reconciliation" Quilt;* maker unknown (initialed W.B.); probably New York State; dated Nov. 18th, 1867; appliquéd and embroidered cotton; 100" x 88". Women played a strong supporting role both before and after the Civil War, especially in New York State, which had been a stronghold for the Abolitionist movement. The forty blocks of this outstanding pictorial album quilt serve as a visual and historical expression of scenes and sentiments related to the Civil War and its aftermath—not the least of which was the imprisonment and later release, in 1867, of Jeffer-son Davis. Davis was met by his daughter when he was released from Fort Monroe, Virginia, and a block in the quilt (second row from top, third block from left) takes note of that event, portraying two figures with the legend "Jeff Davis & Daughter." One block with a black man facing a white man on horseback is inscribed "Master I am Free"; 1867 was also the year that blacks were given the right to vote. In all, this quilt is an excellent example of the use of a textile as an expression of political ideology. (America Hurrah Antiques, New York City)

192. *Commemorative Patriotic Quilt;* Mary C. Baxter; Kearny, New Jersey; c. 1898; pieced, appliquéd, and embroidered cotton; 76" x 78". The Spanish-American War in 1898 brought forth a wild burst of patriotic enthusiasm, perhaps because it was the first war in which the North and South were once again united in common cause. Oral tradition has it that the war inspired the making of this quilt; it is also an exuberant and highly successful example of the patriotic and flag-quilt genre. (Museum of American Folk Art, New York; Gift of the Amicus Foundation, Inc., Anne Baxter Klee, and Museum Trustees. 1985.15.1)

193. *Unique Design;* Carl Klenicke; Corning, New York; c. 1900; pieced silk, faille, taffeta, satin, 72¹/₂" x 60". Although women were always the primary quiltmakers, from time to time men also tried quilting. This spectacular quilt, part Crazy, part pictorial, part Log Cabin, was made by Carl Klenicke, a tailor, as a wedding gift for his daughter. Although the meaning of some of the various motifs, such as the dove at center, seems fairly clear, and for others, such as the birds on posts, obscure, the quilt can still be appreciated as a joyous celebration in fabric. Photograph courtesy New York Quilt Project, Museum of American Folk Art, New York. (Collection of Bessie P. Holmes)

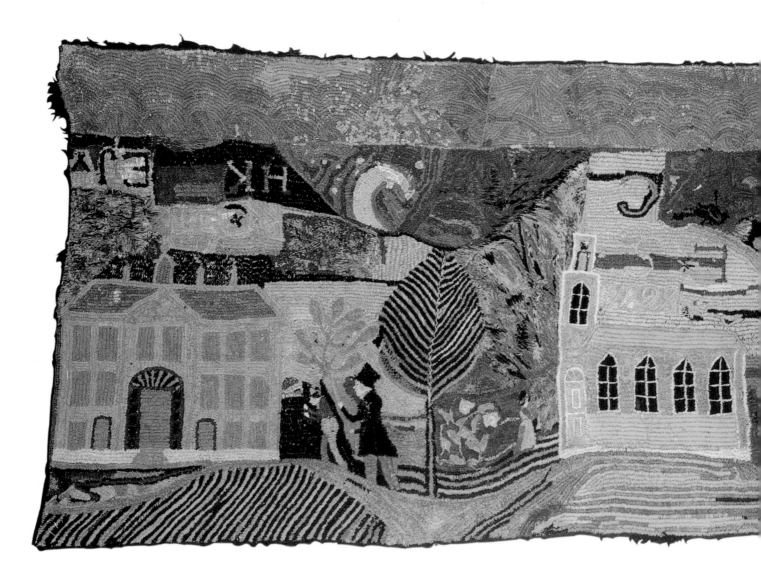

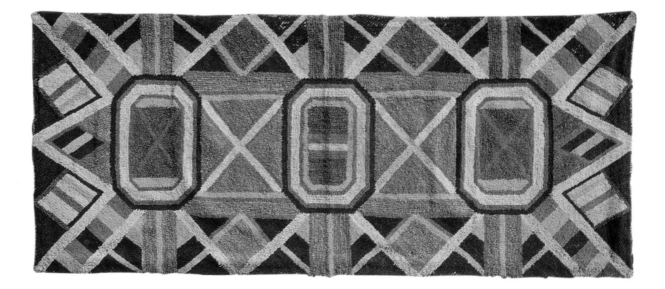

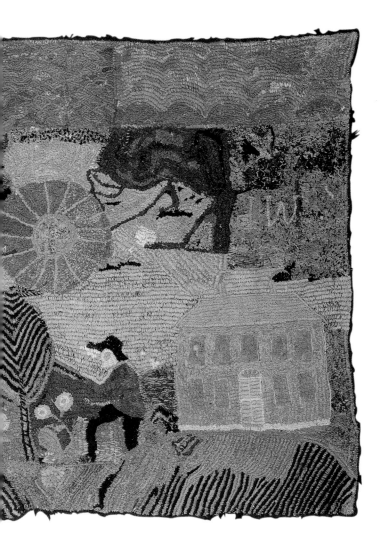

194. (LEFT) *Townscape:* Yarn-Sewn Rug; maker unknown; found in southeastern Massachusetts; dated 1828; yarn-sewn wool on linen; 32" x 72". The rendition of buildings and figures in this splendid unconventional rug is reminiscent of the style used in samplers and needlework pictures. Depicted are several aspects of life, both the good and the bad, in a Massachusetts town. At right, a schoolmaster reprimands a student with a rod, while at center a woman walks toward the church; on the right side, a hunter shoots at birds on the church roof. The sun floats in a sky filled with indecipherable shapes. The pairs of letters are probably initials, perhaps those of the people depicted. (America Hurrah Antiques, New York City)

195. (OPPOSITE PAGE, BOTTOM) *Geometric:* Yarn-Sewn Rug; maker unknown; southern Maine; 1800–1825; yarn-sewn wool on linen; 32¹/₂" x 76". The pure geometry seen in this design is extremely rare in early rugmaking, although it is seen in some of the painted and decorated furniture and boxes made in Maine at the time. The clarity of the design and the strong color combine to give a markedly modern feel to this rug. (Society for the Preservation of New England Antiquities, Boston; Cogswell's Grant, Essex, Massachusetts. Gift of Bertram K. and Nina Fletcher Little.)

196. (OVERLEAF) *Monumental Carpet;* probably Maine or New York State; c. 1860; appliquéd wool and wool embroidery on a wool ground; 112" x 158". This is the largest known appliquéd American carpet, and its size, as well as its liveliness of design and concept, rank it among the finest pieces of work of its kind. In terms of scale and pictorial elements it bears some resemblance to the unique embroidered carpet made by Zeruah Higley Guernsey Caswell in the 1830s that is now in the collection of The Metropolitan Museum of Art, New York. Photograph courtesy David A. Schorsch Company and America Hurrah Antiques, New York City. (Private collection)

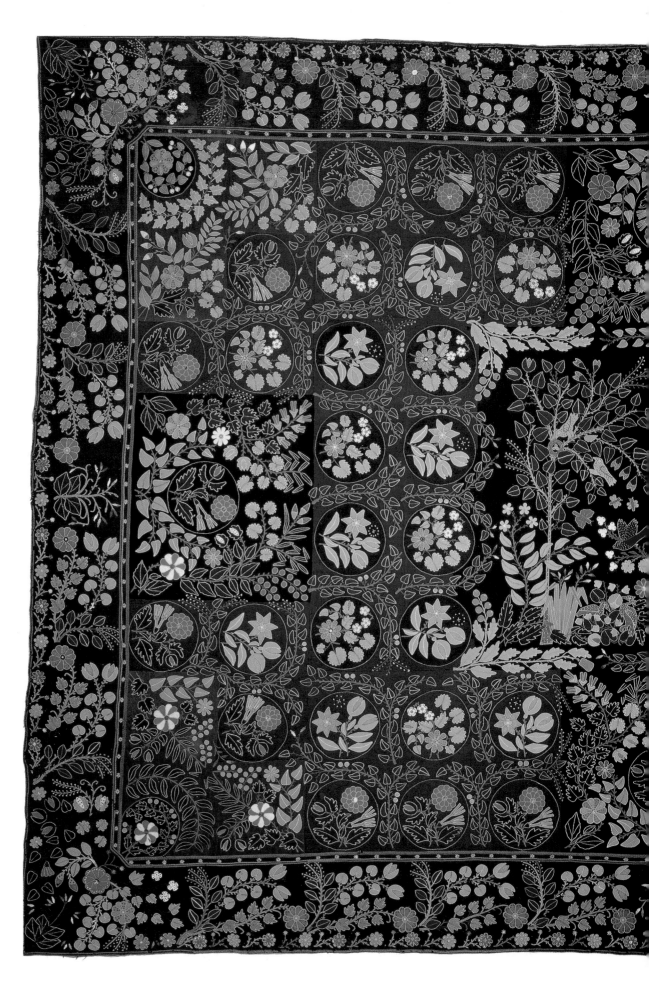

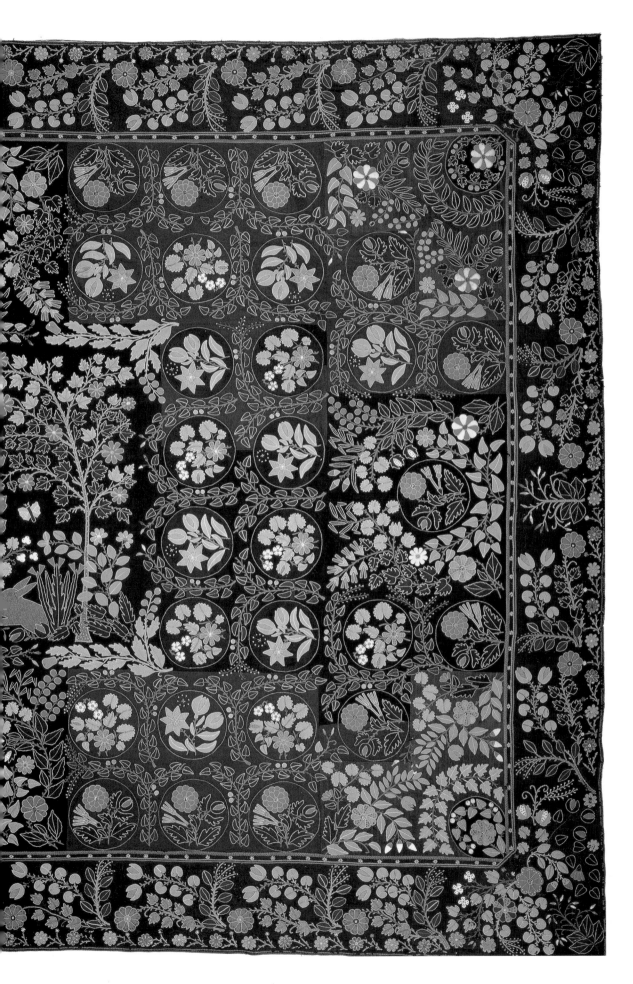

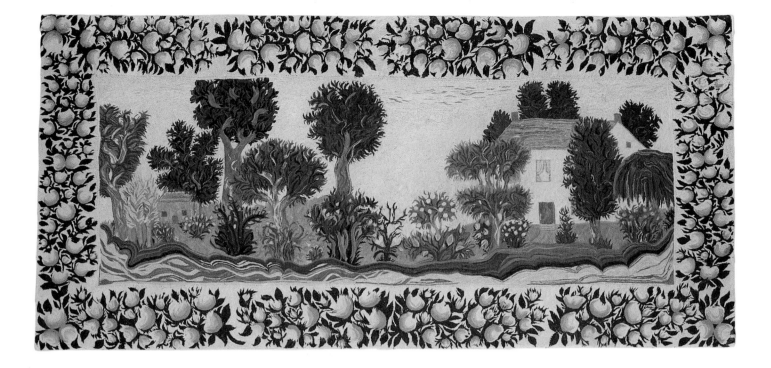

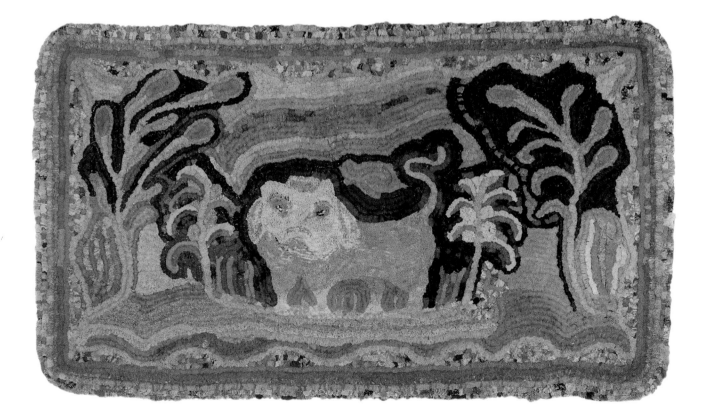

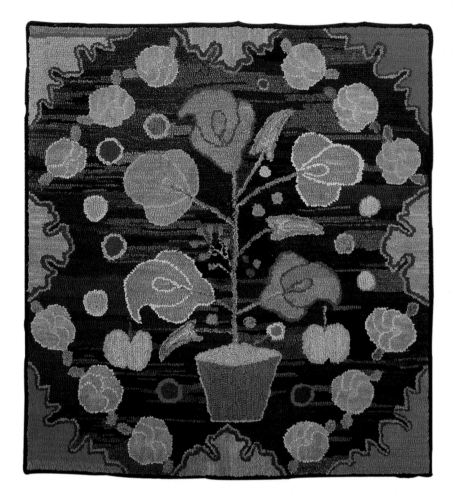

199. *Floral Hooked Rug;* maker unknown; northeastern United States; 1885–1895; wool on burlap; 41½" x 37½". Hooked rugs had become common in America by the middle of the nineteenth century, and their popularity has continued into this century. Although an extensive array of commercial patterns were available by the end of the nineteenth century, the maker of this lovely pot of flowers relied on her own imagination to create an almost surreal still life that glows with subtle color. (Private collection)

197. (OPPOSITE PAGE, TOP) *Landscape: Embroidered Table Rug;* maker unknown; northeastern United States; 1825–1835; crewel-embroidered wool on linen; 28" x 59". In the eighteenth century, rugs were considered too valuable to put on the floor and were used as coverings for tables and chairs. Even after floor rugs became more common, table rugs continued to be used extensively as protective covers for flat furniture surfaces. This superbly executed landscape, a testimony to both the maker's mastery of crewel embroidery and her artistic vision, was most probably intended for this purpose, as the crewel work would not have held up to the wear it would receive as a floor rug. The landscape itself, with its lush, flowering bushes and border of swirling roses, has elements common to many of the schoolgirl paintings of the time, and the maker may have received some art training in a female academy or seminary. (America Hurrah Antiques, New York City)

198. (OPPOSITE PAGE, BOTTOM) *Lion: Yarn-Sewn Rug;* maker unknown; New England; 1850s; shirred and yarn-sewn wool on linen; 32½" x 54". The lion was a favorite subject of rug makers, and somewhat later in the century commercial patterns became widely available. The best-known Lion design was created for hooked rugs and was one of the many pre-drawn designs produced by Edward Sands Frost—some of which are still in use today—in the late-nineteenth century. Many makers at mid-century, however, still relied on prints and engravings for their depictions of exotic fauna, although some might have seen such animals in traveling menageries. What actually inspired this rug maker is not known, but the result that shows a distinctly unthreatening king of the forest (the Cowardly Lion from The Wizard of Oz comes clearly to mind) has a charming folk quality that is hard to resist. Photograph courtesy Kelter-Malcé Antiques, New York. (Private collection)

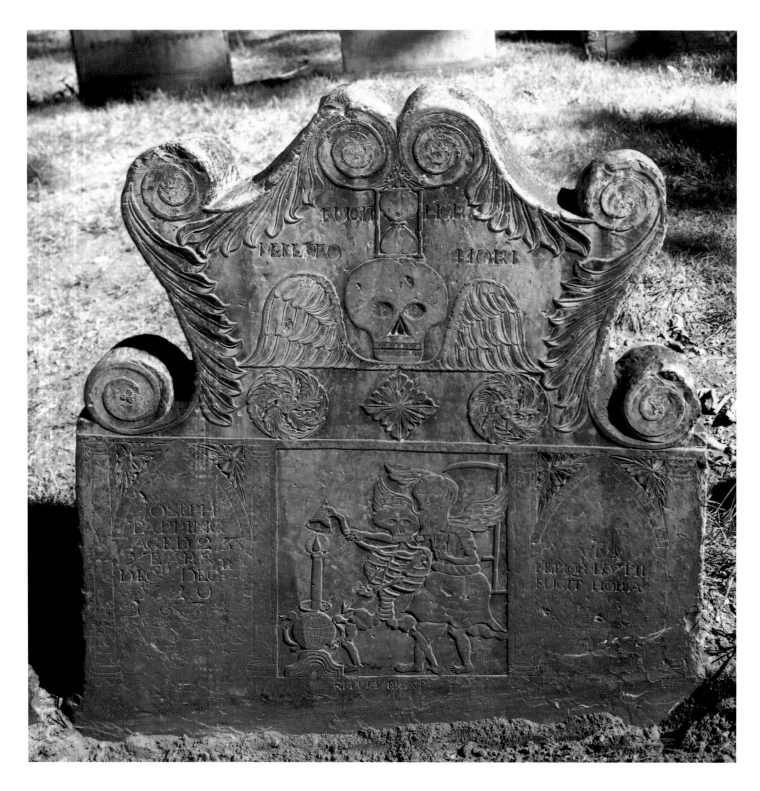

200. *Gravestone of Joseph Tapping;* maker unknown; King's Chapel, Boston, Massachusetts; 1678; slate; dimensions unavailable. Some of the earliest gravestones made no attempt to glorify life after death, but the skulls, skeletons, and depiction of Father Time with his scythe that today are all too bleak reminders of what one might expect were, to the early colonists, a symbol of departure from the grim realities of everyday life and an entrance into a world of eternal peace. The skeleton on this stone is shown snuffing out a long candle, an obvious symbol of the brief span of one's life. Photograph by Daniel Farber, courtesy Museum of American Folk Art, New York. LR1987.1.12.

4

Carvers, Metalworkers, and Artful Eccentrics

Death was a familiar companion of the early colonists, and it may be said that American sculpture was born in the graveyard and nourished by death. Gravestones are among the earliest pieces of dated sculpture, and some of the finest examples are from New England. Although the New England Puritans displayed an intense fear of idolatry—in sharp contrast to the Spanish colonists in other parts of the country, where carved religious figures were prevalent—this did not prevent stonecarvers from infusing their gravemarkers with an overlay of dark passion and mystical symbolism that their outward lives lacked. When compared to similar work in Europe, the results of American stonecarvers' efforts seem somewhat simplistic; yet, over time, they developed and perfected a symbolic lexicon that was used throughout the seventeenth and well into the eighteenth centuries.

By the end of the seventeenth century, several recognizable schools of gravestone carving had emerged, and it is clear from the numerous groups of gravemarkers with stylistic similarities that craftsmen borrowed from one another. It is possible, for example, to trace through time several of the symbolic motifs first seen on stones originating in coastal workshops to a general later usage by artisans carving in the interior of the country. Just as there is a time lag in the dissemination of fashion, so, too, did the iconic language of death follow this path.

The symbols of death most frequently used on gravestones in colonial America were the grim and forbidding effigies of winged skulls, underworld demons carrying darts of death, hourglasses with the sands of time quickly running out, and fire- and scythe-bearing skeletons (figs. 200, 201). Yet these representations, however dire and intimidating, conveyed a much different meaning in those earlier centuries than they do today; their intent was not to portray a threatening message of eternal damnation for the commission of sins; rather, they were intended to herald the entrance of the spirit into a world of eternal peace, far from the daily trials and difficulties of the all-too-human world. Eventually, these forbidding images began to be replaced with more visually congenial winged cherub heads or angels, and these images were used extensively (fig. 202); a 1772 Boston newspaper, for example, noted that a local carver, one Henry Christian Geyer, had executed a gravestone in the "Composite Order with twisted Pillars, and other proper ornament, having a Cherub's Head on Wings with a label flowing from the mouth inscribed 'Robert Sandeman who died at Danbury, Conn. Apr. 2, 1771.'"[1] In some areas, portrait effigies of the deceased also began to appear on tombstones.

Although the need was always there, many rural communities in the seventeenth century were too small to support a stonecutter or gravestone carver; instead,

151

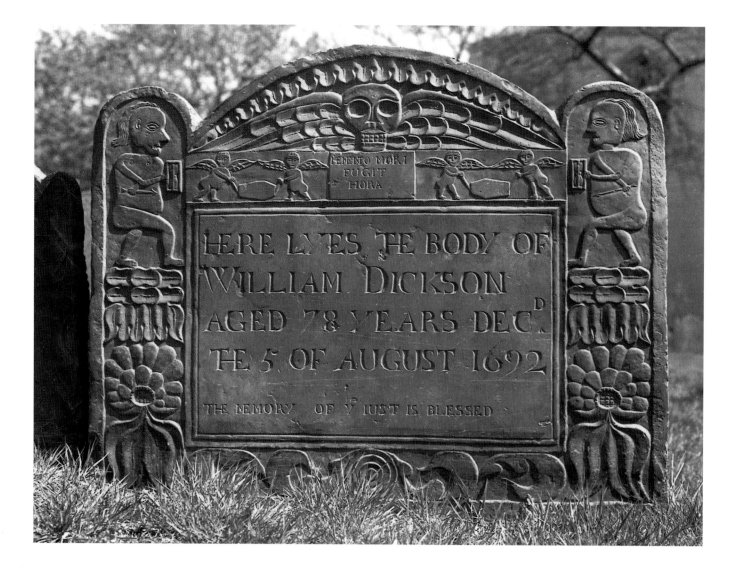

HERE LYES THE BODY OF
WILLIAM DICKSON
AGED 78 YEARS DEC:^D
THE 5 OF AUGUST 1692

THE MEMORY OF Y IUST IS BLESSED

201. (ABOVE) *Gravestone of William Dickson;* maker unknown; Bainbridge, Massachusetts; 1692; slate; dimensions unavailable. The winged skull and cavorting winged cherubs—here shown helping to carry coffins—were popular motifs with New England stonecarvers in the late-seventeenth and eighteenth centuries. The hourglass containing the sands of time, held by naked figures (perhaps representing demons of the underworld) flanking the central image, was another common symbol referring to fleeting life and the approaching drama of death. Photograph by Daniel Farber, courtesy Museum of American Folk Art, New York. LR1987.1.17.

202. (OPPOSITE PAGE) *Gravestone of Mary Cutler;* probable work of Jos. Lamson; Charlestown, Massachusetts; 1703; slate; dimensions unavailable. A cherub's head on wings was another favored gravestone image and may have symbolized the innocence of life in the hereafter. Mary Cutler's family had her stone further enhanced with scrolls and floral motifs. Photograph by Daniel Farber, courtesy Museum of American Folk Art, New York. LR1987.1.16.

this service was frequently provided by those in related businesses. The above-mentioned Geyer apparently also did stonework for the home as well as for the grave, as indicated by this 1767 advertisement: "That he has by him a considerable assortment of Connecticut Free Stones fit for architect Work Tomb-Stones, Hearth and Fire Stones, some Frontice-pieces, work'd in with some of the compleatest Moldings of any in this Town."[2]

The dawn of the nineteenth century saw a shift in attitudes as the advent of the Romantic movement, an export of England and France, produced an about-face from the simple though rigid Puritan outlook of our forebears through its tendency to romanticize and sentimentalize death. Death came to be seen as a gentle, romantic release from earthly life; personal loss was magnified and emphasized, and gravestone iconography changed accordingly. Angels, weeping willows, funeral urns, laurel garlands, and other softer images—in short, all those symbols so beloved of the makers of mourning pictures—replaced the darkly dramatic carving of the earlier years. Mourning customs became institutional-

ized through a "cult of memory,"[3] and a preoccupation with the grave and life in the hereafter became marked. Gravemarkers and mausoleums increased in size, elegance, and importance, for they were viewed as status symbols by an ever-growing middle class that wished to demonstrate its newfound wealth. An early example of the importance the trappings of death took on may be seen in the last will and testament of the Reverend William Smith, Provost of the College, Academy, and Charitable School of the City of Philadelphia, drawn in 1802, in which he included very specific notes about the building of his mausoleum, which was to be executed by William Rush (a well-known carver who also fashioned figureheads, three-dimensional signs, and ornamental decorations):

I do hereby direct . . . that my body may be conveyed and deposited in the middle grave prepared by me in the small mausoleum and Cenotaph, which I have erected in my garden, near my dwelling house at the Falls of Schuylkill. . . . I do further direct that the figure of the Angel coming down from heaven having in one hand a little Book open, and setting his right foot on the Sea and his left foot on the Earth with the other hand lifted up to heaven in the Act of Swearing or Proclaiming (as in Rev. Chap. X) proposed for the top of the Mausoleum be not forgot and that Mr. Rush the Carver be expedited to finish and put up the same according to his promise.[4]

Especially popular as grave markers in the Victorian period were three-dimensional symbolic figures that expressed the popular attitudes toward death; these were imbued with a sentimentality of far-reaching dimensions. The symbolic carving of a young girl by Asa Ames (fig. 203), said to represent two young sisters who died within nine days of each other, and the representation of the lamb and cup included in it depict the concept of a sacrifice of innocence. As the nineteenth century progressed, many Americans continued to document their earthly life, or that of those close to them, through the creation of extremely complex and elaborate three-dimensional vignettes and gravemarkers; the life-size stone representations installed in the cemetery in Mayfield, Kentucky, of Colonel Henry G. Wooldridge (d. 1899) mounted on his favorite horse and attended by his favorite dog as well as by relatives and friends are especially impressive and indicative of some of the excesses of the day in regard to death (not illustrated here).

Not all graves were attended by such elaborate markings, however. During the eighteenth and nineteenth centuries, in settlements where iron was plentiful and where Catholicism predominated, graceful metal grave crosses (fig. 204) shaped by blacksmiths were often used; some examples remain from former French settlements in the lower Mississippi Valley and Spanish settlements in the Southwest. More recently, in the mid- to late-nineteenth century, improved mining techniques put the purchase of iron within easy reach of almost everyone, and a great number of metal gravemarkers were produced in this period, especially in parts of the Midwest and the South.

By the late-nineteenth century a large number of Russian and German-Russian immigrants had settled in

North Dakota, where they created remarkably decorative, handcrafted, iron grave crosses (fig. 205). These wrought-iron markers were forged, pounded, twisted, beveled, bent, tapered, cut, and rounded into often elaborate patterns that remained popular until the 1940s, when the worldly tastes of the twentieth century dissipated and ultimately buried many of these historical artistic conventions. The wrought-iron crosses fashioned by these Catholic and Russian Orthodox settlers initially were versions of much earlier European folk forms; some of the later examples were further embellished by found metal objects such as ball ornaments, cast-iron crucifixes, doorknobs, springs, curtain rod ends, and boiler tops. Although handmade nameplates were attached original-

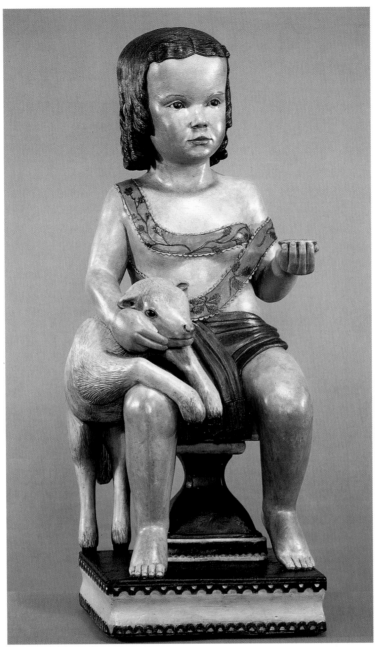

ly, time has taken its toll and only a few of the remaining gravemarkers bear legible inscriptions.

By the third quarter of the nineteenth century, machine technology gradually began to replace gravestone carvers, and by the twentieth century, except for a few very rare individuals, most stone carvers had found other areas in which to exploit their skills. One exception, however, was the celebrated black carver William (Will) Edmondson (fig. 206), born around 1870 in Davidson County, Tennessee, who lived and worked in Nashville, Tennessee, throughout much of his life. Like many twentieth-century folk artists, Edmondson was an extremely religious man and, in 1934, he experienced a vision, of which he later said: "I knowed it was God tellin' me to cut figures." Edmondson executed a prodigious number of pieces, many of which were used as tombstones for members of his church, with his ele-

mentary carving tools—a simple mallet and a steel point that he fashioned from a railroad spike. His work, executed predominantly in limestone available from local quarries, is stunning in its simplicity and power.

In the first permanent settlements on the eastern seaboard of America, where members of the colonial society often considered the most functional object to be the most beautiful, embellishments of utilitarian objects were among the early attempts at creating a domestic sculpture. Thus, weathervanes—those most functional of objects that were an intrinsic part of American life—provided an ideal mechanism and outlet for such creative expression. And they were ubiquitous—because of the importance of weather in the lives of the early colonists, farmers and sailors alike, the skyline of even the smallest settlement would reveal one or more of these wind pointers.

Although weathervanes had a long history in the Old World, there is little doubt that they reached the peak of their development in the New. One of the oldest-known vanes, dating from around 48 B.C., is from Athens. The Greek astronomer, Andronikos Cyrrhestes of Kyrrhos, had built an octagonal water clock called the Tower of the Wind, and a figure of Triton carrying a pointed arrow that indicated wind direction revolved atop it. Pre-Christian Roman villas are also known to have had decorative, though functional, vanes in the forms of their gods, and Christian churches were often capped by a cock. In the centuries after the birth of Christ, fabric banners, or "fanes," were used on castle turrets both to indicate wind direction and as ensigns to indicate rank. Vikings are also known to have embell-

ished the masts of their ships with finely gilded quadrant-shaped metal banners that were designed to indicate the ship's movements as well as the wind direction. Sir Christopher Wren, as the architect chosen to rebuild London in 1666 following the Great Fire, used vanes in cock, heraldic-style banner, and arrow forms on the new buildings. By the end of the eighteenth century, in both Europe and America, vanes had become widespread, a common fixture on shops and homes as well as atop churches, castles, and governmental buildings. Thomas Jefferson is known to have installed indoor directionals connected to a metal weathervane by means of rods and gears, an adaptation of an earlier Roman invention of Marcus Varro, a contemporary of Julius Caesar. A similar piece, though of more modest design, was found on a farmhouse in Skowhegan, Maine, dating from the early 1800s.

There are several basic types of weathervanes: handcrafted silhouette and three-dimensional vanes made of wood; handcrafted silhouette and three-dimensional vanes made of metal, and factory-made vanes, either flat or in the round. The Dove of Peace (fig. 207) is an example of a flat silhouette vane made of metal, and vanes such as this, cut by hand from a sheet of iron, zinc, or tin, continued to be made in rural areas long after factory-made pieces became widespread. Flat silhouette wooden vanes (figs. 208, 211) were also popular and frequently made, but few early ones still exist, as they are considerably more fragile then the metal vanes. They are also subject to greater damage by the wind, necessitat-

ing the need to replace them frequently and thus of less interest to a busy farmer or shopkeeper. The three-dimensional handcrafted metal vane, such as the Saint Tammany vane (fig. 210), is especially dramatic when seen against the sky. This form has always been popular with the more affluent, for they cost considerably more—in money, time, and skill—to produce than the silhouette type.[5] Three-dimensional handcrafted wooden vanes were also made, but they are especially delicate and very few remain from the eighteenth and nineteenth centuries. The Angel Gabriel (fig. 209) is a fine example of this type.

The weathervane served as a symbol of man's social and political equality, a "coat of arms" flying high above his "castle." By the eighteenth century, American vane makers had established a craftsmanship and artistry all their own, and, through them, many vanes had attained a most refined sculptural form. Deacon Shem Drowne, a famous Massachusetts weathervane maker, crafted several spectacular vanes that still survive, among them a metal rooster, the "Blew Ball and Banner," the copper grasshopper vane that still sits atop Faneuil Hall in Boston (the building for which it was originally designed), and an Indian vane, all in the Boston, Massachusetts, area.

Although a basic requirement for a vane was a bold shape that, when silhouetted against the sky, could clearly indicate direction, by the time of the American Revolution, American tin- and coppersmiths had devised a variety of weathervane forms that showed wit, charm,

203. (OPPOSITE PAGE) *Seated Female Figure with Lamb and Cup;* Asa Ames; Buffalo, New York, area; dated on the back of the stool: "carved Apr 1850"; polychromed yellow poplar; 29¼" x 12¼" x 12". Memorial art flourished in America during the Victorian era. Symbolic representations, such as the lamb, and other pastoral motifs presented a romanticized attitude toward death. This figure is said to represent Sarah Reliance Ayer and Ann Augusta Ayer, two infant sisters who died within nine days of each other in May 1849 during an epidemic in Erie County, New York. (Wadsworth Atheneum, Hartford, Connecticut; purchased with funds bequeathed by Roscoe Nelson Gray in memory of Roscoe Nelson Dalton Gray and Rene Gabrielle Gray)

204. (ABOVE) *Iron Cross;* maker unknown; southern United States; 1790–1850; wrought iron; 43½" x 30¼". Blacksmiths frequently embellished their objects just as did the cabinetmaker. It was a delicate operation, for the temperature of the fire, which is judged by the color of the molten iron, had to be just right. A skilled craftsman was able to pound, cut, and twist the iron into graceful forms, as was done with this grave marker cross that incorporates fleur-de-lis palms with a heart of bent iron at the crossing. (Louisiana State University Rural Life Museum, Baton Rouge, Louisiana)

205. *Wrought-Iron Grave Marker;* maker unknown; St. Mary's Cemetery, Hague, North Dakota; c. 1900; wrought and forged iron, cut tin; dimensions unavailable. Elaborate and unusual wrought-iron crosses were personalized reminders of the far-reaching skills of local blacksmiths in the North Dakota communities settled between 1885 and 1910 by immigrants who had moved from Germany to Russia, near the Black Sea, and then to the United States. In the background may be seen two cast-iron grave markers, which were available commercially. Many of the plaques identifying those memorialized have been lost; those still extant are often in a combination of German and English. A conscientious movement to restore and preserve the best wrought-iron markers on their original sites has been undertaken by the State of North Dakota, and the well-documented efforts have proved to be a model for environmental preservationists across the country. Photograph: Timothy J. Kloberdanz. (State Historical Society of North Dakota, Fargo, North Dakota)

206. (OPPOSITE PAGE) *Mother and Child;* William Edmondson (c. 1870–1951); Nashville, Tennessee; c. 1940; limestone; 14" high. The child of freed slaves, Will Edmondson is recognized today as one of the outstanding folk carvers—if not the outstanding one—of the twentieth century. Like many black men of his time, he was a manual laborer, working at a variety of jobs from farmhand to hospital janitor. Soon after he left the janitorial job in 1931, after the closing of the hospital where he worked, he was inspired to begin carving; the Lord, he said, had told him to take up tools and become a stone carver. His first carvings were memorials, often for members of his church, but soon he began carving other subjects as well. During his lifetime, he produced hundreds of pieces that ranged from pure abstractions to stylized representations reflecting the artistic aesthetics of the period in which he was creating. Whatever the subject, however, Edmondson's inner vision was added to and shone from the stone. In 1939 and again in 1941, Edmondson was employed by the sculpture section of the WPA (Work Projects Administration). Photograph courtesy America Hurrah Antiques, New York City. (Private collection)

and delicacy of design. The designs often also reflected their immediate locale—in rural areas, common ones might be horses, pigs, cows, sheep, or fowl; the coastal areas might show a preference for whales, fish, mermaids, and ships; and the English-influenced Southerners seemed to prefer banners and standards. Specific interests of the maker or commissioner might be indicated, too; George Washington, in ordering the Dove of Peace vane for Mount Vernon (fig. 207), was most specific about the type of vane he wanted, as his letter of 1797 to Joseph Rakestraw, the maker, shows:

I should like to have a bird . . . with an olive branch in its Mouth. The bird need not be large . . . the point of the spire not to appear above the bird. If this, that is the bird thus described, is in the execution, likely to meet with any difficulty, or to be

attended with much expence, I should wish to be informed thereof previous to the undertaking of it.[6]

The birth of the nation's independence and the ensuing patriotic fervor gave rise to such designs in weathervanes as the eagle, Columbia: the Goddess of Liberty, and George Washington on horseback. In 1876, the celebration of the nation's centennial brought a renewed wave of patriotism, and vanes representing the Statue of Liberty, newly erected in New York Harbor, also became extremely popular (fig. 212). During the late Victorian period several forms were created for special use on buildings where there was a direct relationship between the design of the vane and the purpose of the structure, further tieing the vane into the everyday business of life. In 1867, Benson J. Lossing noted:

We [passed] down by this evergreen hedgerow, and

then between the orchard and the Flower and Kitchen Garden to Lack Lawn Knoll, near the Carriage-house. It is a pretty spot, covered with grass and shaded by larches and pines. The curious little building on the right, at the corner of the garden, is the Apiary, whose vane, an enormous golden honey-bee swinging over a hive, denotes its use.[7]

Several commercial weathervane companies appeared around the mid-nineteenth century, including J. W. Fiske of New York City, Savory and Co. of Philadelphia, and J. Harris and Son of Boston. These companies offered a variety of metal vanes in different sizes and shapes, many priced as low as $6.50. Although certain manufacturing processes were mechanized at this time, much of the finish work was still done by skilled craftsmen. By the early-twentieth century, however, improved machine technology allowed weathervanes to be entirely mass-produced, with no handwork whatsoever, and individual artistic input thus totally disappeared from the process. Generally, the design of an existing vane was simplified and adapted so that stamping presses could hammer out one-half of a vane with a single thrust. Two halves were then soldered together and placed on a previously prepared mount that included a metal arrow and directionals and, occasionally, the additional refinement of a glass ball. (It was also in this century that stationary directionals were added for easier and more accurate readings.) The stamping machines used to shape the various parts of a weathervane were not unlike those used in this century in the production of automotive elements such as fenders, hoods, and doors.

Thus, the artisan-made vane could no longer compete with the simpler and more economically produced factory ones, and the handcrafted and unique pieces gradually disappeared, except for those made by individuals who wished to make their own personal statement or have a more elaborate vane than their budget would allow (see, for example, figs. 213, 214). Today, weathervanes are made primarily for decorative purposes and are almost exclusively factory made; the glory and usefulness of their earlier days has given way to the practicality of the United States Weather Service and mass-media communication. There still remain, however, a few hardy and non-conformist souls who choose to create their own, although their inventiveness is now more often expressed in whirligigs and other wind toys than in weathervanes.

A lively variation of the weathervane—three-dimensional wind-driven, articulated yard toys, once called wind toys and now popularly known as whirligigs—have long had an appeal for folk sculptors. These small, animated statues or structures were created strictly for amusement, for, unlike weathervanes, they do no more than signal that the wind is blowing or not blowing. They also allow a great deal of scope for creative expression—and expression not limited to the artistic. Whirligigs were ideal spontaneous mechanisms for a bit of social or political commentary, and many makers seemed to take full advantage of these possibilities.

The origin of the whirligig in this country is obscure; although some are thought to have been made in the eighteenth century, none of those early examples are known to exist today. One of the earliest references to a whirligig appears in Washington Irving's *The Legend of Sleepy Hollow*, written in 1819:

Thus, while the busy dame bustled about the house, or plied her spinning wheel at one end of the piazza, honest Balt did sit smoking his evening pipe at the other, watching the achievements of a little wooden warrior, who, armed with a sword in each hand, was most valiantly fighting the wind on the pinnacle of the band.

It seems almost certain that the windmill was probably the progenitor of the more complex of these wind toys, for many examples are constructed with nearly identical, if miniaturized, mechanisms. There are several

207. *Dove of Peace;* Joseph Rakestraw; Philadelphia, Pennsylvania; 1787; copper with iron strips; 42½" long. This vane was made at the request of George Washington and was installed atop Mount Vernon, his Virginia home. A 1792 painting of Mount Vernon shows the vane in place on the house. Silhouette pieces such as this weathervane, which were cut from a single sheet of metal, were nearly always braced or strengthened by the addition of iron straps. (The Mount Vernon Ladies' Association of The Union, Mount Vernon, Virginia)

208. *Sea Serpent;* maker unknown; New England; c. 1850; painted wood and iron; 16½" x 23¼". The sea-serpent image was a popular one in coastal areas and was used on scrimshaw as well as on such land-based objects as weather-vanes. This sinuous example appears to be half horse, half serpent; the artist was probably inspired by a combination of myths that had Neptune mounted on such creatures and contemporary "sightings" of fantastic animals by sailors long at sea. (Museum of American Folk Art, New York. 1981.12.13)

types of whirligigs: single figures with paddle-like arms—much like articulated dolls—such as that described in Irving's work (see fig. 215); pieces with blades and propellers that, when caught by the wind, cause various parts to move (figs. 216, 217); animal and bird-like figures, and endless other variations that nearly always amuse through their ingenuity. Because of their fragility, few whirligigs made prior to the second half of the nineteenth century have survived, but those that have give some indication of the wide range of possible images. Because many were created by impromptu carvers or carpenters, they were often casually executed, yet the roughness of the work rarely detracts from their appeal. Whirligigs have continued to be made into this century, for their value as vehicles of expression for whimsical and personal points of view, a characteristic of American folk sculpture, has not diminished.

Shipping and its companion industries were of the utmost importance to the American economy as well as to its ongoing contact with the rest of the world, and the sea played some part in the lives of almost everyone living in coastal areas. Just as the gravestone carver combined form and function in a variety of expressive ways to ease the transition of life to death, so too did the ship carver transform pragmatic needs into towering talismans of deep meaning. If American sculpture found its initial nourishment in the graveyard, it encountered a veritable feast of possibilities from the sea, and ship carvers' shops along the Atlantic seaboard flourished, from early in the seventeenth century until the relatively unadorned steamships took precedence after the mid-nineteenth century.

American figureheads first mirrored English prototypes—not surprising, perhaps, considering that English craftsmen were the first to set up shop in the colonies. "Lyons," other beasts, and classically garbed guardian figures were among the most popular forms until the 1760s, when full-length human figures—a distinctly American development—usually representing a vessel's name, became especially popular (fig. 218). After the American Revolution, enthusiasm for patriotic symbolism ran high among the general populace and this contagious fervor is reflected in the carvings of the time. While it is not, perhaps, surprising to find naval vessels lavishly decorated with carvings of eagles (fig. 220), flags, national heroes, prominent political figures, and personifications of Liberty or Columbia (fig. 219), the trend carried over to merchant and, sometimes, fishing ships as well, an indication of how strongly these sentiments permeated the population.

As the demand for figural embellishments for ships increased in the late colonial period, whole dynasties of carving families emerged. Craftsmen like Simeon Skillin, Sr. (1715–1778), and his sons John (b. 1746) and Simeon, Jr. (b. 1757), organized themselves into shops that provided not only the primary figurehead but also complete integrated schemes of three-dimensional carved ornamentation for a ship from prow to stern. The versatility of these carvers was remarkable, for they were equally competent in executing a tiny bas-relief portrait bust for the pediment of a fine piece of sophisticated furniture and, during this period, it was not unusual for craftsmen to offer the use of their talents in many areas. Stephen Dwight, for example, a former apprentice of the carver Henry Hardcastle, advertised his own new establishment as follows: "all sorts of ship and house work: also tables, chairs, picture and looking glass frames, and all kinds of work for cabinet makers, in the best

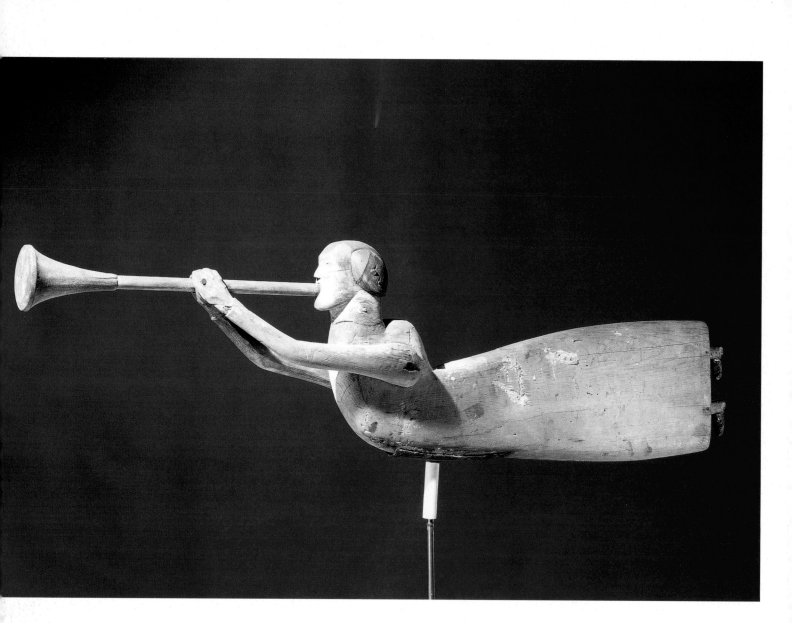

209. *Angel Gabriel;* maker unknown; United States; nineteenth century; wood; 11½" x 41" x 4". The Angel Gabriel was an especially popular weathervane figure in nineteenth-century New England and was often used for churches, where he could take his place as the messenger of God. Whether or not this Gabriel was used for that purpose is unknown, but he is a wonderful example of a three-dimensional carved vane, with a simple and stylized sculptural form that nevertheless encompasses a great deal of expression. (Collection of David L. Davies)

210. (OPPOSITE PAGE) *Saint Tammany;* maker unknown; East Branch, New York; mid-nineteenth century; molded and painted copper; 102½" x 103" x 12". Saint Tammany is unique; no other American vane of such size and workmanship is known. It stood on a lodge building, where it functioned as a symbol for the fraternal organization known as The Improved Order of Redmen. This group, along with many other fraternal societies of the time, adopted Indian customs and dress and pledged their moral and aesthetic allegiance to the ideals of "Tammany, Chief of the Delawares," a semimythical figure revered in colonial America for his eloquence and courage. During the Revolution, American soldiers called him "Saint" Tammany and carried his banner into battle as a protection against the British, who went to war protected by Saint Andrew and Saint George. Such allegiance to patron-symbols was not uncommon in the early days of the Republic. (Museum of American Folk Art, New York. 1963.2.1)

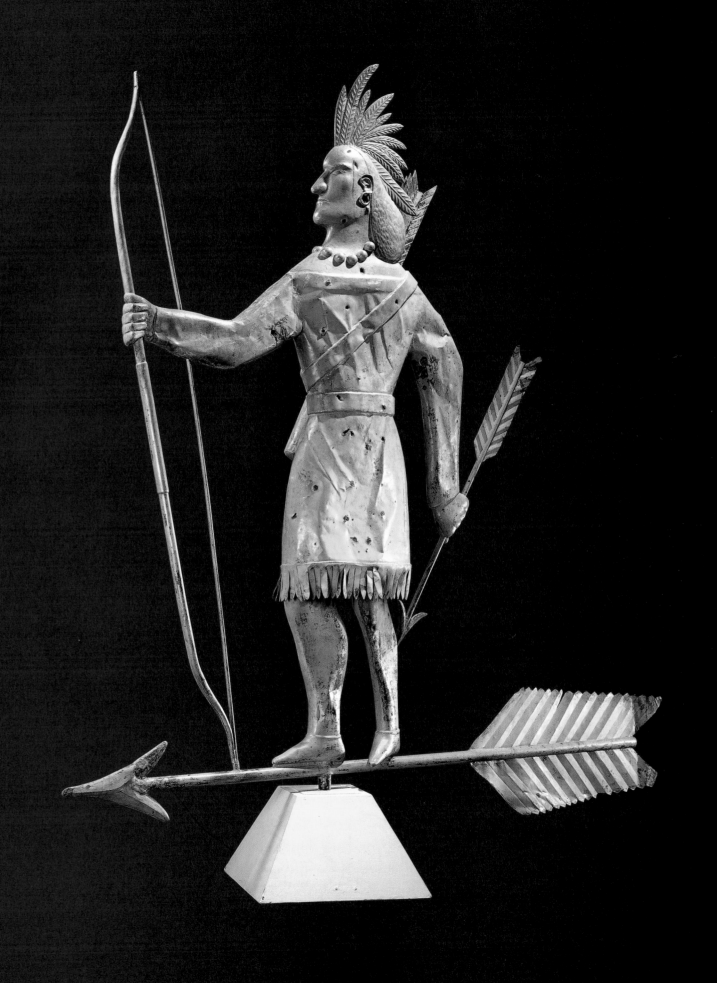

manner and all reasonable terms."[8] Eight years later he carried his versatility even further, then advertising his availability as a portrait and history painter and teacher but noted that he "also continues to Carve all sorts of House, Ship, and cabinet Work in the best Manner." In later years, John Hale Bellamy (1836–1914) was a carver who also exhibited a similar versatility (fig. 220).

The figurehead was used at the prow of the ship, generally immediately under the bowsprit where the sides converged, and may appear awkward when viewed today apart from the ship it graced; but it must be remembered that these figures would have been high above the head of the viewer when the ship was in dock, or seen from a distance when at sea, and the craftsmen who carved them were forced to consider these positions when creating the piece. Visually, these pieces were an extension of the bow, and their true beauty is only fully appreciated when seen in position and riding high above the waters.

Like most artisans, ship carvers learned their craft through a combination of apprenticeships and practical experience. Those that excelled possessed not only fine carving skills but also an artistic eye, and some, such as William Rush (1756–1833) of Philadelphia, developed reputations that far exceeded those of most of the contemporary academic artists. Rush's figurehead of George Washington for the ship *Washington* was "as large as life . . . exhibiting a capital likeness . . . in full uniform as commander in chief, pointing with his finger at some distant object and holding a perspective glass grasped in his left hand"; it caused a sensation in London where admirers saw in it "perfection manifest in all its parts and proportions."[9] Samuel McIntire (d. 1811) of Salem, Massachusetts, was another who enjoyed a wide reputation; he executed figureheads for a number of ships in the early-nineteenth century, and numerous sketches that he made for ship decorations also survive.

As technology progressed during the nineteenth century, the shipbuilding industry changed dramatically. Steamships became prevalent, iron and steel replaced

211. *Elephant;* maker unknown; Bridgeport, Connecticut; c. 1880; painted pine braced with iron straps; 48" long. Bridgeport was the home of P.T. Barnum of circus fame, so it is perhaps not surprising to find this odd choice for a weathervane subject. The vane, a hand-crafted silhouette type, may have been intended to portray Jumbo, one of the most popular and famous of the performing animals in Barnum's shows. (Private collection)

212. (OPPOSITE PAGE) *Statue of Liberty;* maker unknown; United States; c. 1886; hammered copper with original parcel gilding; 53" high. Since the day that the Statue of Liberty, or "Liberty Enlightening the World," was brought to New York as a gift from France and installed on Bedloe's Island (now Liberty Island) in New York Harbor in 1886, it has inspired the work of countless folk artists. This vane, which captures the majesty of the original in miniature, was probably made in honor of the erection of the statue. (Museum of American Folk Art, New York; Promised anonymous gift)

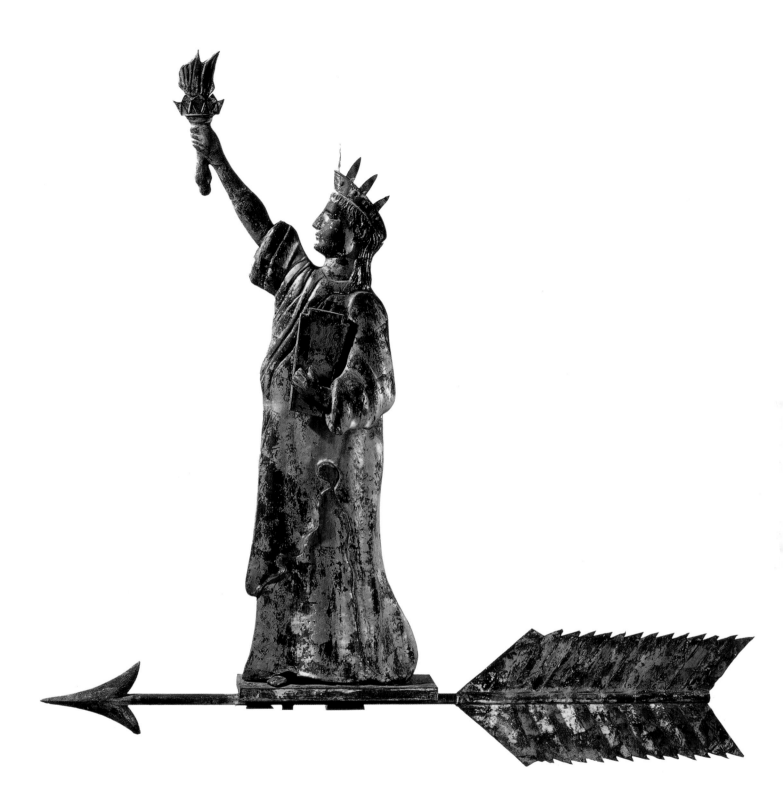

213. (OVERLEAF, LEFT PAGE) *Saint George and the Dragon;* maker unknown; probably New England; late-nineteenth century; painted sheet metal; 24" x 17½". A wonderful interpretation of an old legend and a most unusual subject for a weathervane; one can only speculate that the maker had tired of the ubiquitous horse-and-rider vanes and was determined to put his own unique spin on the subject. (New York State Historical Association, Cooperstown, New York)

214. (OVERLEAF, RIGHT PAGE) *Roadster with Driver;* maker unknown; southern Maine; c. 1920; painted metal; 16" wide. The automobile captured the mind and heart of America and, thanks to Henry Ford's "Model T," it quickly become a ubiquitous part of the landscape. The popularity of the early motor car—and its role as a vehicle of inspiration to folk artists—is captured in this one-of-a-kind weathervane that bears a strong resemblance to a 1907 Packard; its maker, who had mounted it on his barn, was referred to only as "The Old Man." (Collection of David L. Davies)

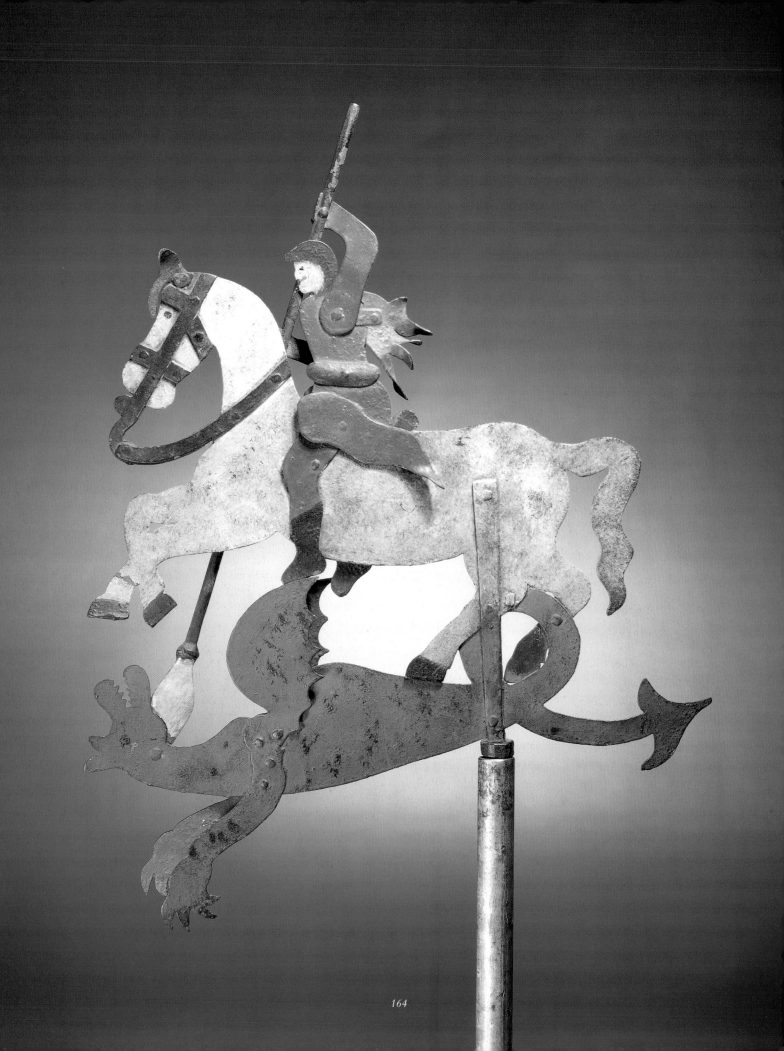

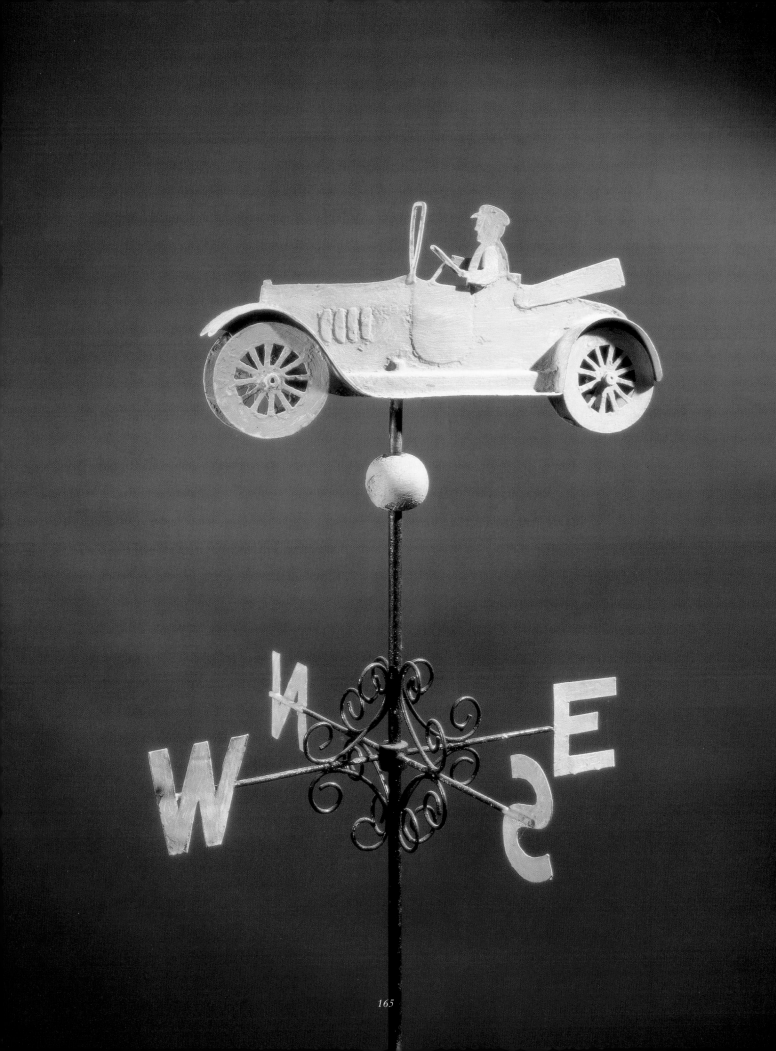

wood, and the installation of figureheads became extremely difficult, if not impossible. The death blow to the figurehead occurred in 1907, when they were ordered removed from all U.S. Navy ships. Although some ship carvers continued to make a living carving pilot-house figures and miscellaneous other inboard decorations, an era had ended, and soon they turned their talents to other areas such as trade figures and carousel carving, where their skills were still welcome.

The whaling industry, a companion industry to shipping and ship building, emerged in the early colonial period and reached a peak in the mid-1840s, when the American sailing fleet boasted some 740 ships active in the pursuit of the ever more elusive sperm whales. Unlike the sailing vessels used for trade and defense, whaling vessels were strictly utilitarian and carved decoration, other than a figurehead—often a portrait of the wife or daughter of the captain, perhaps as a reminder of the hearth and home that might not be seen for many, many months—was minimal. It is difficult today to comprehend the rigors associated with a whaler's life; whaling expeditions frequently lasted up to four years and took seamen to distant parts of the world. It was a rough-and-tumble way of life with few guarantees, but it had its appeal; not only was there the potential for good earnings at the end of a successful voyage, it also offered the opportunity to visit exotic lands, something otherwise open to few other than the very wealthy. Yet, there were many days on these lengthy voyages when the lack of activity and the monotony of the sea could make life almost intolerable.

Scrimshaw, the whalemen's art, was the answer to the boredom generated by the tedious days, weeks, or even months that might elapse between the taking of whales. An art form created and developed to a ighly refined degree by crew members aboard whaling vessels, it was both personal recreation and a social pastime—perhaps a shipboard equivalent of the quilting bees of the women at home. Scrimshaw was made from the jawbones and teeth of the whales taken, and all manner of objects were created, from items intended strictly for personal or crew amusement to lovingly crafted pieces intended as gifts for loved ones on shore. The scrimshander—or scrimshaw maker—produced articles that ranged from the simple to the complex, from the attractively functional (fig. 221) to the elaborately decorative (fig. 222). There is little doubt that the creation of these pieces also served a therapeutic purpose by providing a useful type of activity during idle hours. As one sailor indicated: "Nothing in sight and no signs of ever seeing any spirm [sic] whales around here the old man and the mate devote their time a Scrimshorning that is all they think about." Another observed: "Nothing to do but make canes to support our dignity when we are at home."[10]

The scrimshanders used the materials at hand that had little commercial value in their raw state, and an unwritten law of the sea gave the lower jaw of the sperm whale, with its teeth, to the crew. The jaw from a medium-sized sperm whale yielded approximately fifty teeth from four to ten inches long—a favorite material on which to etch pictorial scenes. White bone and pan-bone were also taken from the sperm whale's jawbone, while white and bowhead whales were the source of black bone. The tools used for carving scrimshaw were the simplest kind and often a testimony to the art of improvisation—jackknives, sail needles, files and saws made from barrel hoops, and many other similar devices. Sharkskin might be used as an abrasive, and lampblack with a varnish fixative as pigment for filling an etched design.

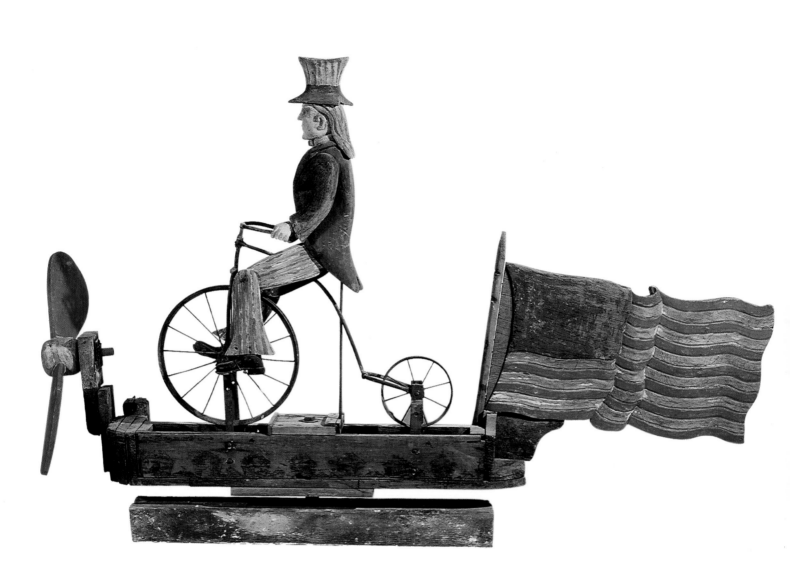

215. (OPPOSITE PAGE) *Man in a Red Jacket;* maker unknown; New England; late-nineteenth century; polychromed wood; 14¾" x 6½" x 6½". The sculptural potential of the whirligig form is fully realized in this simple but unusually graceful figure. There is more careful modeling in this example than is often found in such wind toys, but the dignity of the figure at rest goes by the board when its arms begin to flail in the wind. (Museum of American Folk Art, New York; Gift of Martha B. Groetzinger. 1978.19.1)

216. (ABOVE) *Uncle Sam Riding a Bicycle;* maker unknown; probably New York State; 1880–1920; carved and polychromed wood, metal; 37" x 55½" x 11". This amusing whirligig is unusual in that the Canadian flag is carved and painted on one side of the tail and the American flag on the other, suggesting that the maker had ties with both countries. The intricate mechanism allows the Uncle Sam figure to pedal furiously when the wind is right. The symbol of "Uncle Sam" dates back to the War of 1812, but it only gained its extensive popularity late in the century. (Museum of American Folk Art, New York; Promised bequest of Dorothy and Leo Rabkin. P2.1981.6)

Scrimshaw rose and fell with the fortunes of the whaling industry. Although it never totally disappeared, the heyday of the art was in the second and third quarters of the nineteenth century. Created by anonymous and untrained amateurs, some good and some less so, scrimshaw remains as witness to creativity under the most onerous of conditions and to the innate skill and sense of design possessed by even the most unschooled sailor.

The merchant soon followed the soldier, the farmer, the artisan, and the fisherman in the development of colonial settlements, and with the merchant came the need to let others know of the goods for sale, be they food and drink (fig. 223), general dry goods (fig. 224), or even services, such as those of a justice of the peace (fig. 225). At a time when education was a privilege and when a large portion of the population could neither read nor write, a well-conceived trade sign was a necessity to convey the nature of a business to the public. That they must be pictorial and representational was a given, although commonly recognized symbols were also used extensively; script, such as the proprietor's name, might sometimes be added, but most of the signs relied on visual depictions to make their message known. They had to capture the interest of passersby and also be totally explanatory—no mean feat even today! Some trade signs were hung at right angles to the building in which

the advertised business was lodged, and so were visible from two directions, requiring that both sides carry the intended message. Others, often carved and painted in the round, were hung or otherwise placed over the entry to the business or near the door. Many of these latter were quite notable in form and conception, evidence of a skilled craftsperson at work (figs. 226, 227).

Through the years signs continued to be one of the most popular means of publicizing business endeavors. Today, signs from the seventeenth and eighteenth centuries are very rare, and even those from the early nineteenth century are not common. Climate and insect infestation have all but eradicated early examples, especially in the South, and we are often left only with the accounts of contemporary eyewitnesses to have an indication of the variety there were, as indicated in a journal entry made by Margaret Van Horn Dwight as she recorded her observations during a trip to Ohio in 1810:

It is quite amusing to see the variety of paintings on the inn-keeper's signs. I saw one in N.J. with Thos. Jeff'ns. head & shoulders & his name above it. Today I saw Gen. G. Washington, his name underneath. Gen. Putnam riding down the steps at Horseneck. One sign was merely 3 little kegs hanging down one after the other. They have the

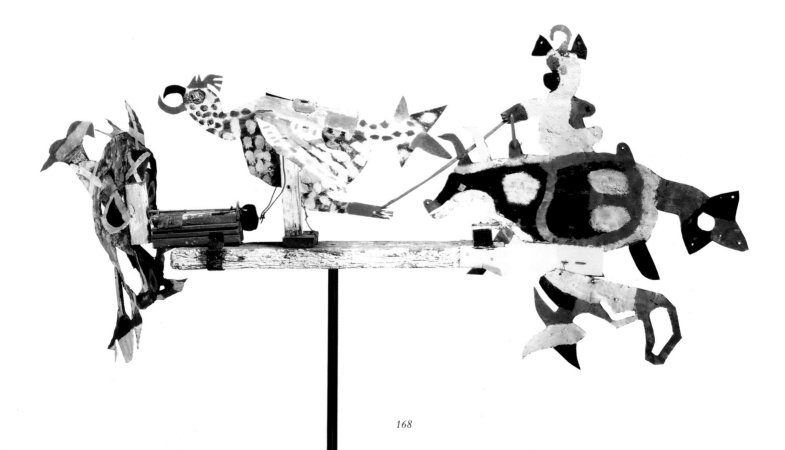

sun rising, setting, & at Meridian, here a full moon, a new moon, the moon & 7 stars around her, the Lion & Unicorn "fighting &c.," & everything else that a Dutchman has ever seen or heard of.[11]

Sign carving and painting also played an important role in the economic structure of the lives of many early craftspeople, for not only were good signs in great demand, often several people—carvers, cabinetmakers, and even blacksmiths—contributed to the finished piece.

As the nineteenth century progressed, schools proliferated, literacy became more prevalent, and pictorial signs gave way to lettering. Soon, a bewildering number of painted and lettered shop signs competed to communicate messages of business activity to an evermore-sophisticated public. As a Scottish visitor to these shores, Captain Thomas Hamilton, noted on a visit to one town:

As we passed, many of the signs exhibited by the different shops struck me as singular. Of these, "Dry Goods Store," words of which I confess I did not understand the precise import, was certainly the most prevalent. My companions informed me that the term dry goods is not, as might be supposed, generally applicable to merchandise devoid of moisture, but solely to articles composed of linen, silk, or woollen. "Coffin Warehouse," however, was sufficiently explanatory of the nature of the commerce carried on within; but had it been otherwise, the sight of some scores of these dismal

217. *Windmill Whirligig;* David Butler (b. 1898); New Orleans, Louisiana; c. 1950; painted tin, wood, and plastic; 29¼" x 49½" x 24¼". David Butler says that he began to make his colorful whirligigs after receiving directions from God; each of the assemblages was intended to form part of an overall environment that he created in the yard of his New Orleans home. Although the figures that make up his constructions appeared realistic to him, many of the images are creatures of fantasy. A number of his one-of-a-kind works are wind-driven, but he has also made a number of brightly colored stationary sculptures. (Museum of American Folk Art, New York; Gift of William A. Fagaly. 1977.15.1)

218. *Ship's Figurehead;* maker unknown; New England; nineteenth century; carved and polychromed wood; 77" x 28" x 28". This fearless buxom lady has the courageous mien admired in a figurehead. Whether a representation of a member of a ship captain's or owner's family or simply a valkyrie-like figment of the maker's imagination, she would have graced any ship admirably. (Museum of American Folk Art, New York; Gift of Mr. and Mrs. Francis Andrews. 1982.6.1)

219. *Columbia: Goddess of Liberty;* maker unknown; New York; c. 1858; carved and polychromed wood; 68" high. Along with the wives and daughters of ship captains and owners, patriotic figures were also popular among figurehead carvers. This elegant and serene figure of Liberty was intended to stand on the deck in front of the pilot house of a Great Lakes steamer. She holds the apple of knowledge in one hand while the other rests on the shield of the Union. A sheaf of wheat by her left side (not visible here) symbolizes abundance. (New York State Historical Association, Cooperstown, New York)

220. (OPPOSITE PAGE) *American Eagle Figurehead;* attributed to John Hale Bellamy (1836–1914); probably Portsmouth, New Hampshire; third quarter of nineteenth century; carved, painted, and gilded pine; 41" x 23". John Bellamy, a woodcarver who created ship figures first for the Navy Yard in Boston, Massachusetts, and later for the one in Portsmouth, New Hampshire, as well as for commercial ships, is especially well-known for his dramatically carved eagles, many of which were made to decorate U.S. naval vessels. His eagles were so popular, in fact, that they were widely copied by others along the northeast seacoast within his lifetime. Bellamy also excelled in carving many other types of objects, as can be seen from his business card, which read: "Figure and Ornamental Carver, particular attention paid to House, Ship, Furniture, Sign & Frame Carving, Garden Figures." Photograph courtesy Sotheby's. (Private collection)

commodities, arranged in sizes, and ready for immediate use, would have been comment enough. "Flour and Feed Store," and "Oyster Refectory," were more grateful to the eye and the imagination. "Hollow Ware, Spiders, and Fire Dogs," seemed to indicate some novel and anomalous traffic, and carried with it a certain dim and mystical sublimity, of which I shall not venture to divest it, by any attempt at explanation.[12]

Many of the signs noted by Captain Hamilton were flat, painted wooden signs, but trade figures in the round were also extremely popular and, more often than not, made by the same carvers who so skillfully created figureheads for ships. Although some of the earlier ones advertised taverns and other businesses, they gained their greatest use—and fame—when cigar smoking became widespread in the nineteenth century. The owners of tobacco shops immediately latched on to the image of the American Indian as the appropriate symbol for tobacco, another native of America, and they commissioned an amazing number of American Indians to be carved (fig. 228). The image proved so popular that by the mid-nineteenth century what seemed to be whole tribes of carved Indians had appeared on the walkways in front of tobacco and cigar shops.

The use of cigar-store figures increased during the last decades of the nineteenth century, the depictions ultimately extending far beyond those of American Indians to include a wide range of races, nationalities, and costume (fig. 229). The size of the figure, the richness of detail, and its sculptural quality were all viewed as a reflection of the taste and success of the tobacconist. As cities grew and the population expanded, however, the large figures proved to be hazardous obstructions to pedestrians and so local ordinances forced the removal of the wooden figures from shop exteriors in the 1890s. They took up too much room when moved indoors, and that, plus the advent of electric signs, eventually pushed these brilliant painted figures into permanent retirement. Although the heyday of sculpture as a means of advertising passed with the disappearance of these figures, the occasional inventive, individual entrepreneur still uses whatever is at hand to create a public display to draw attention to his or her business, and the elaborate animated display at Possum Trot (see fig. 263) was one such endeavor. There is also some indication that the genre may have moved from folk art to mainstream— the golden arches of MacDonald's come immediately to mind!

Most late-nineteenth and twentieth-century trade figures were the products of woodcarving shops and small factories that specialized in the production of show figures, circus figures, carousel figures, and other display pieces. There were individual carvers who executed one-of-a-kind creations, but most often several craftsmen would work on a single piece, each artisan executing the part at which he was most skillful.

As the call for ship ornaments began to decrease in the latter part of the nineteenth century, carvers who had worked in nautical specialty shops often joined crews in studios that specialized in carousel carvings. The carousel's origins appear to be in a twelfth-century Arabian horseman's game in which contestants threw fragile clay balls filled with perfume-scented water at each other. Italian crusaders brought the sport back to Italy, renaming it "carosello," or "little war." By the seventeenth century, the French had refined the game into a variation that consisted of a rotating wheel of wooden

171

221. *Pie Crimper in the Form of a Seahorse with the Head of a Unicorn;* maker unknown; c. 1870; whale ivory, black ebony mid-section and eyes; 8" long. Pie crimpers, used to seal the edges of a piecrust to prevent bubbling juices from seeping out, were often made by sailors on long and lonely whaling voyages as home-coming gifts for wives and sweethearts. The crimpers, frequently carved in elaborate and whimsical forms, were only one of the many forms that these seamen carvers created as they put almost every part of their skill to good use. (Museum of American Folk Art, New York; Promised anonymous gift)

222. (OPPOSITE PAGE) *Scrimshaw Clock Hutch;* maker unknown; New England; mid- to late-nineteenth century; whale ivory, ebony, and other wood, mother-of-pearl, purchased clock face; dimensions unavailable. Sailors on whaling ships used the materials on hand to carve and decorate often elaborate objects. Although many of these pieces were made as gifts for those left at home, there is little doubt that their creation may have also served a therapeutic purpose by providing a useful means of whiling away the long and idle hours of lengthy sea voyages. Photograph courtesy Robert Kinnaman. (Private collection)

arms from which hung carved horses. While at first only the nobility enjoyed this sport, the device was soon imitated by clever toymakers for Parisian children who used them especially on festival and religious carnival days.

In early America, similar carousels were placed at picnic areas and at lake and beach resorts. The initial devices were small, rarely containing more than a dozen swings (horses), which were hung from beams attached to a center pole, and these were pushed by hand or by mules. With the invention of the steam engine in the mid-nineteenth century, carousels began to grow in size and flamboyance. In addition to horses, the carousel carvers now fashioned ornate animals such as pigs, tigers, goats, lions, camels, deer, seahorses, giraffes, zebras, dogs, rabbits, roosters, and bears, among others (figs. 230–232).

The heyday of the carousel industry lasted only a century, from the 1820s to the 1920s, but several companies thrived during this period. The best-known are the Gustav Dentzel Company, D.C. Muller Brothers, and the Philadelphia Toboggan Company, all of Phila-

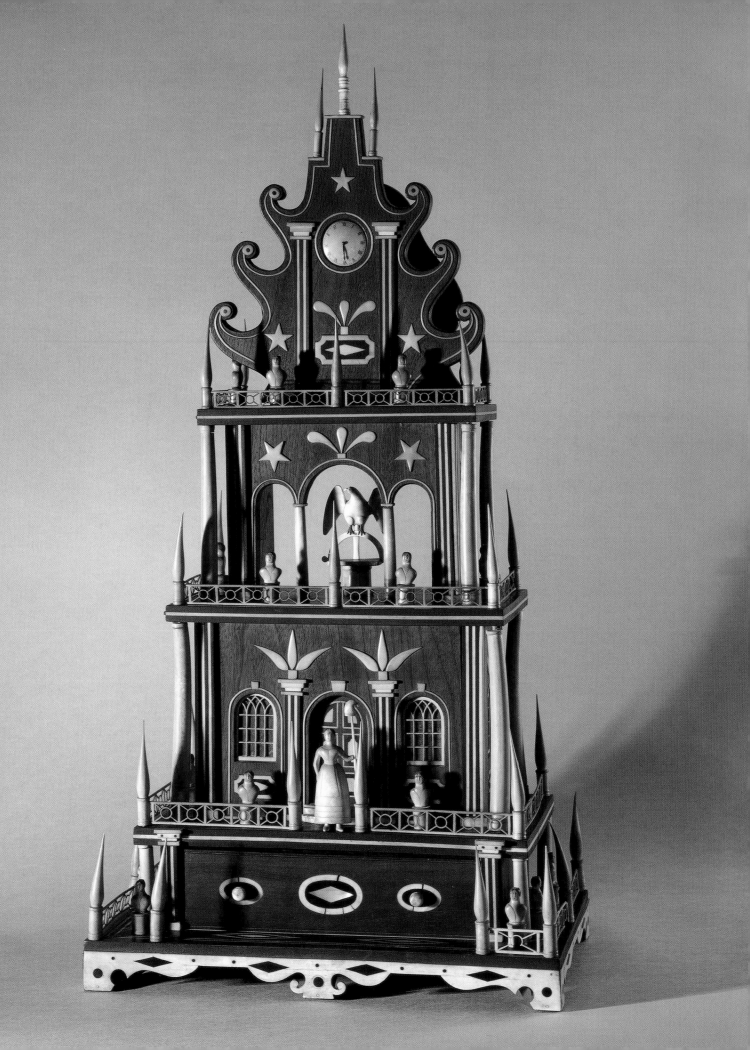

delphia, Pennsylvania; Charles Looff, Marcus Charles Illions, and Charles Carmel of New York City; Stein and Goldstein of Coney Island (fig. 231), and Allan Herschell of North Tonawanda, New York (fig. 230); and a handful of companies in various rural areas, such as C.W. Parker of Abilene, Kansas. The Great Depression forced most of these companies to close their doors, and those that did not eventually turned to metal, plastic, and fiberglass to replace the glorious hand-carved beasts of earlier years.

Three major styles for carousel animals were recognized during this period, one of them created by the Dentzel Company of Philadelphia, which was founded by Gustav Dentzel in 1867 and operated until 1929. It grew from a small shop to a complex of carving shops, carpentry shops, painting studios, and metal-working studios virtually unequaled in size by any other company. The animals it produced had an identifiable style, one now viewed as classic: a formal, classically posed horse with recognizable realistic features including muscle structure, a gently curved mane, tapered hooves with narrow carved horseshoes, short flat saddles without jewels, a low pommel, and a curved cantle.

Charles Looff's Coney Island style was developed in 1876. Primarily a furniture carver, Looff carved animals in his spare time. He erected the first carousel at Coney Island in New York City. His horses were flamboyant, with wildly flowing manes and upward-flung heads. Although the company folded in 1918, his trademarks of lavishly decorated trappings and jewels created a lasting legacy in the art of carousel making.

The third prominent carousel style, the country-fair style, is the most primitive. The carved figures in this style were usually part of portable merry-go-rounds that were moved between rural towns on a weekly basis. They were considerably smaller than their city counterparts (fig. 232) and far more rugged. Although much of carousel art is more accurately labeled "popular" rather than "folk," as so much of it was produced in factory situations, the country-fair style, in which a carousel was often the product of one carver, retains a legitimate claim to the designation of "folk."

Carousels have an undeniable appeal for children and adults alike. At a time when colorful and flamboyant entertainment for the masses was not always widely available, it is understandable that these irresistible devices, with their ostentatious appearance and "band organ" music, provided the logical entertainment for a Sunday outing in the late-nineteenth and early-twentieth centuries.

The story of decoys is tied to the history of hunting in America. When the colonists arrived in the New World, they discovered decoys already in use by American Indians, and they appear to be a uniquely American invention. Archaeologists have found remnants of what appear to be canvasback decoys made of tightly bound reeds and feathers from sites dating back some one thousand years in the American Southwest, and tribes in eastern North America of approximately the same period almost certainly stacked stones one atop another to form visual images of nesting ducks. The decoy was—and still is—a lure used to instill confidence in wildfowl, drawing them within weapon range, whether it is a bow and arrow or a gun (figs. 233–236). The word itself is derived from the Dutch word "ende-kooi," meaning "the cage" and referring to the European use of a duck cage or trap that predated the popular use of firearms and in which birds were placed to attract other waterfowl. The colonists quickly recognized the value of the decoys used by the American Indians and adopted their usage immediately. By the nineteenth century, birds were being carved from wood—more permanent than reeds and more portable than rocks—and used extensively, although the representations were often somewhat vague and abstract.

In the seventeenth and eighteenth centuries, waterfowl hunting in America was generally directly related to the procurement of food. By the mid-nineteenth century, however, the availability of improved firearms and the seemingly endless supply of birds gave impetus to the emergence of hunting as an organized sport. As hunting moved from survival to sport—and the business of sport—decoys became increasingly realistic. The earlier vague, carved representations of the waterfowl began to disappear, and several new types of decoys evolved: floating decoys, stick-up shorebird decoys, field decoys, and even flying decoys that could be rigged on a wire and used to lure birds in flight. Woodcarvers who specialized in the production of decoys began to be seen and, by 1900, well-known specialists catering to the needs of pleasure-seeking sportsmen were able to earn a substantial living through their carving skills.

Because waterfowl migrate in specific patterns on a regular timetable, regional types of decoys were developed to satisfy local conditions. Demand was so great in

some areas that groups of carvers were hired by entre-
preneurs who created carving cooperatives not unlike
the factory-studios on the East Coast where cigar-store
figures, carousel figures, and circus carvings were creat-
ed by groups of carvers in large numbers. Both the
Dodge and the Mason factories in Detroit, Michigan,
competed favorably in the marketplace, and wooden
birds could be made and sold profitably at prices rang-
ing from $9.00 to $12.00 per dozen. Again, just as in the
eastern shops, factory production also permitted carvers
to specialize; some were particularly adept at doing
heads, others excelled at making bodies; now, too, paint-
ing and decorating specialists found an outlet for their
talents. Technical innovations and mass production
intruded upon the studio system, however, and rubber
decoys, which first appeared in the late 1860s, and then
honking decoys, which were activated by rushing water,
began to crowd the field. By 1873, the patent office had
awarded many grants for decoys, including some with
metal bodies and others that could be folded easily and
transported in a box.

Even after the advent of true factory decoys, howev-
er, many hunters preferred handmade birds, so decoy
carvers continued to be in demand, especially those

223. (OPPOSITE PAGE) *Trade Figure: Good Food & Drink;* maker
unknown; New York; c. 1810; carved and painted wood; 46½".
Taverns flourished in early America, and tavern signs were famil-
iar elements of the landscape in both town and country. This
unusual figure, perhaps a forerunner of the cigar-store figures of
later in the century, was a beacon to hungry and thirsty travelers.
At one time it may have held a glass in one hand and a bottle in
the other. It probably stood on the porch or just above the door-
way of a tavern. (New York State Historical Association, Coopers-
town, New York)

224. (ABOVE) *Trade Sign: E. Fitts Jrs. Store and Coffeehouse;* maker
unknown; vicinity of Shelburne, Massachusetts; dated 1832; poly-
chromed wood, wrought iron, oval, 22⅜" x 34½". The Fitts were obvi-
ously a diversified family in their business interests, as is testified to
by this shop sign embellished with a painted depiction of a gener-
al store interior on one side and a lettered notice of a coffeehouse
on the other. The painting and the lettering are of relatively fine qual-
ity, and it seems likely that this sign was originally executed by an
itinerant artist specializing in such work. It was probably either
mounted on a pole near the road or suspended out from the build-
ing so that it could be seen by passersby from either direction.
Painted and decorated flat signs such as this were especially frag-
ile, although the maker of this piece provided additional protection
by framing it with a wrought iron band secured by skewer-like metal
rods possessing decorative "C" scrolls. (Museum of American Folk
Art, New York; Gift of Margery and Harry Kahn. 1981.12.9)

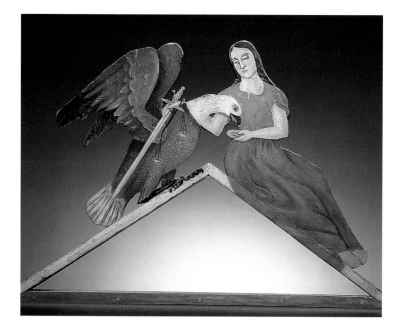

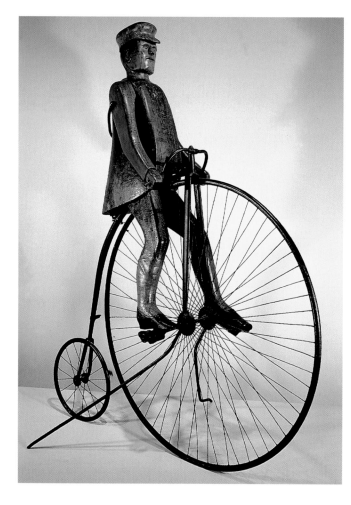

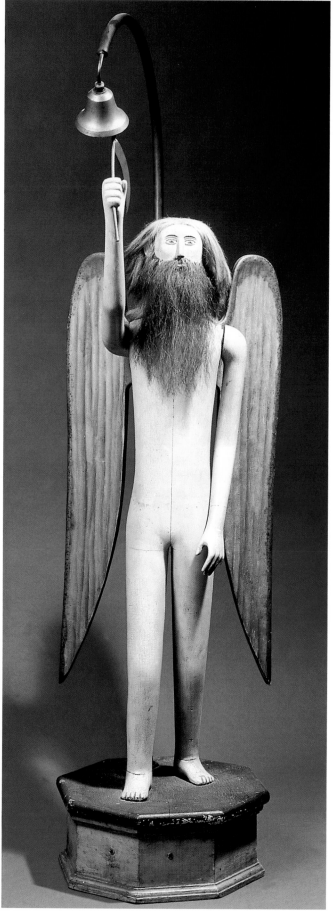

whose birds seemed to draw the best results—that is, the largest number of waterfowl. A. Elmer Crowell (1862–1951) enjoyed a well-deserved reputation as a carver of exceptional decoys and as a very witty man (fig. 234). In addition to carving working decoys, Crowell also made ornamental birds for the home, so that the fine carving and painting would be preserved. Crowell's son also became a decoy maker, and one so skillful that it is difficult to distinguish the son's work from the father's. Another decoy artist of particular note is Charles E. "Shang" Wheeler (1872–1949). This artist carved all kinds of wild ducks and geese that, when placed in the water, were said to look as real and natural in size, shape, color, and posture as if they were alive (fig. 236). He also made highly realistic fish carvings, tied alluring flies, and painted and drew wild birds and animals—as well as humans—with great skill.

The widespread popularity of sport hunting and the random slaughter of water and other wildfowl eventually had severe ramifications, however. Several species (the passenger pigeon and the Carolina parakeet, although not waterfowl, are among the best-known examples) disappeared completely, and the population of others was significantly reduced. Conservation groups seeking to set limits on hunting had formed by late in the nineteenth century, and in 1918 Congress passed legislation regulating certain aspects of wildfowl hunting. Today, wildfowl can no longer be shot for commercial purposes, and the hunting of shorebirds is outlawed. Some wildfowl may still be hunted legally, and decoys are still made and used for this purpose. Now these are almost exclusively factory or, very occasionally, homemade; the day of the great carvers of working decoys, like the day of the figurehead carvers, is past.

The use of decoys was not limited to waterfowl, however; another form—the fish decoy—was also used extensively and was a popular lure used in ice fishing. Although such decoys had their widest usage in the Midwest, especially in and around the Great Lakes, they were found throughout the northern areas—from Alaska to Maine, in upper New York State and northern New England, and in Canada. It is believed that fish decoys, like bird decoys, were also first utilized by Indians, who then taught their usage to the white settlers as they moved into what was commonly known as the Old Northwest Territory in the nineteenth century. By the mid–nineteenth century, fish decoys were being used by the new settlers on most of the Great Lakes and on some other bodies of water in Michigan, Ohio, Minnesota, and Wisconsin.

Fish decoys, which began to be made by professional carvers around 1900, are typically used for ice fishing on

225. (OPPOSITE, TOP LEFT) *Trade Sign: Justice of the Peace;* maker unknown; Appleton, Ohio; carved and painted wood; 1880s, triangular, 21¼" x 31". This creative depiction of Liberty feeding the American eagle made an eye-catching sign for a justice of the peace. It is said to have been made by the justice's young sister, who based her design on the well-known early-nineteenth-century print of "Liberty Providing Sustenance to the Eagle" by Edward Savage, a continual source of inspiration for the needlework and paintings of nineteenth-century schoolgirls of the time. Such patriotic motifs are still found in many aspects of American life and now, as in earlier years, professionals and tradesmen alike are no less hesitant to use them to their benefit. (New York State Historical Association, Cooperstown, New York)

226. (OPPOSITE, BOTTOM LEFT) *Trade Figure: Bicycle, Livery, Carriage, and Paint Shop;* Amidée T. Thibault (1865–1961); St. Albans, Vermont; 1895–1905; Columbia bicycle, painted wood; 84" x 66" x 36". This happy cyclist rides atop an actual Columbia high-wheeler. The maker, Amidée Thibault, was a native of Quebec, Canada, where he began his career as a carver of crosses and church pews. He moved to Vermont in 1895 and established a bicycle and carriage-repair shop, making this unique sign a symbol of his skills. Laminated wood was used for the figure to give it greater strength. (Museum of American Folk Art, New York; Gift of David L. Davies. 1983.24.1)

227. (OPPOSITE, RIGHT) *Trade Figure: Father Time;* maker unknown; Mohawk Valley, New York; c. 1910; carved and polychromed wood, metal, hair; 52⅛" x 13⅞" x 14½". This striking piece of folk sculpture was at one time articulated so that the right arm moved and the sickle hit the suspended bell. The original purpose of this remarkable figure is uncertain, but it remains an outstanding legacy of the unknown carver's art. (Museum of American Folk Art, New York; Gift of Mrs. John H. Heminway. 1964.2.1)

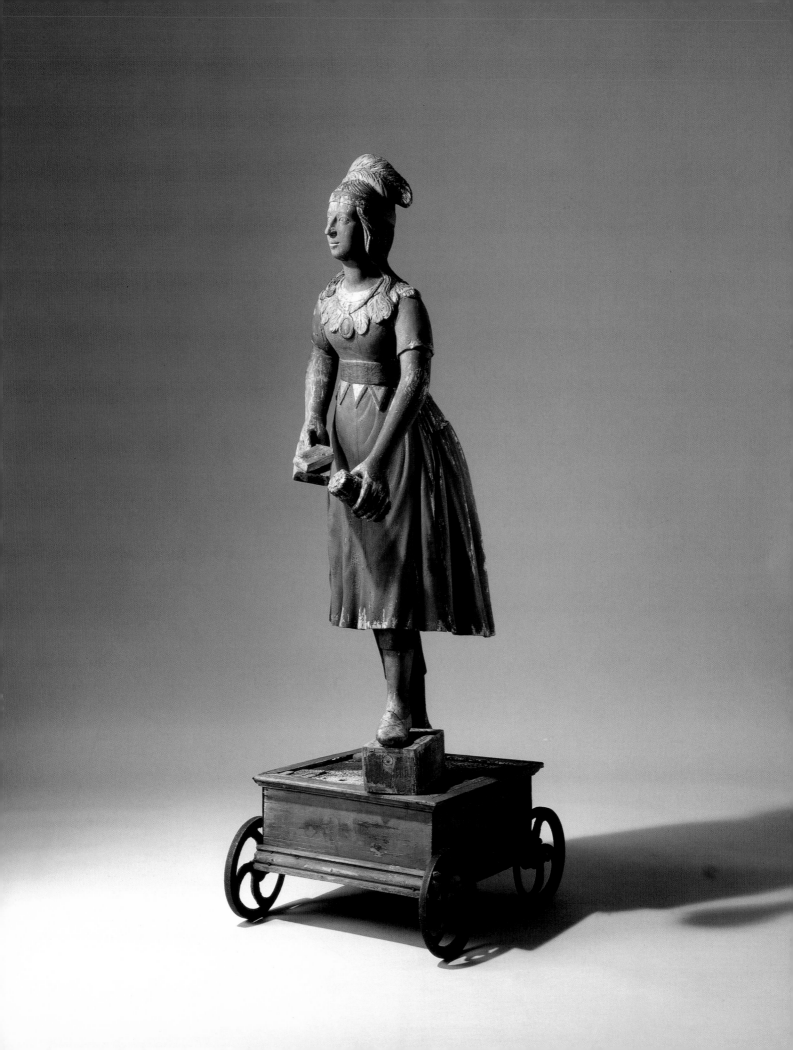

frozen lakes or streams; they have no hooks, and their primary purpose is to entice fish within reach of a fisherman's spear. Fish decoys vary in size from just an inch or two to several feet in length. Some are remarkably realistic and others only vague approximations of the prey (figs. 237, 238). While many are painted to resemble the natural coloration of the fish, some decoy carvers prefer gaudy embellishments, including mirrors set into the body, glass taxidermy eyes, and garish paint. Fish decoys are still made and used by sportsmen, but, like the waterfowl decoy, the majority today are mass-produced.

Although functional objects have formed the basis for folk sculpture in America, there have been many artists who have created sculptural objects that serve no purpose other than to satisfy the creative urge of the maker or to express a point of view. Many regions of the country had woodcarving traditions, and several of these artists worked within the local tradition but created works that carried the stamp of their own personal vision. They derived their inspiration from a variety of sources, including nature, the events of everyday life, or people they have known or would like to know; whatever the source of inspiration, its expression is highly influenced by the individual artist's outlook and feelings (figs. 239–248).

In addition to those already noted, several themes have formed a continuous running thread in folk art; they are all fundamental elements within American life and continue to inspire the folk sculptor today. These basic themes are religion, social commentary, and patriotism. Religion has always been a cornerstone in the life of America, and the visionary religious spirit that so motivated the gravestone carvers of the seventeenth century can still be found in the work of artists of this century, although expressed in unique and more personal ways (figs. 243–245). Folk sculpture has also offered an ideal outlet for social commentary, in some cases making powerful statements in whimsical ways, and twentieth-century artists have not hesitated to make use of the possibilities inherent in the form.

The third significant theme for twentieth-century folk sculptors centers around the never-ending preoccupation with patriotism—the ideals of liberty, freedom, and the American experience, and political heroes such as George Washington, Abraham Lincoln (fig. 249), and, more recently, John F. Kennedy. The present-

day extension of patriotic enthusiasm is as vibrant as it has always been, and these personal visions are still among the most powerful, poetic, and beautiful of all folk expression.

228. (OPPOSITE PAGE) *Cigar-Store Figure: Pocahontas;* maker unknown; possibly Ithaca, New York; third quarter of nineteenth century; overall height 63½". Many carvers who specialized in the production of ship figureheads occasionally produced cigar-store figures, and this splendid example, holding cigars in one hand and blocks of tobacco in the other, has the stance and forward thrust that recalls figurehead work. It retains its original finish, a rare quality, as owners frequently repainted their figures so that their brightness would attract attention. Her foot rests on a block inscribed "A.H. Platt & Co., Ithaca, N.Y." This Pocahontas was apparently used as a sidewalk figure, meaning that it was kept outside the shop during business hours and then easily rolled inside at closing time. The wheeled base, however, appears to be a later addition; the figure at one time may have been a stationary figure and was converted to a rolling one when local ordinances called for the clearing of sidewalks at night. A story handed down with the figure states that it was made in payment for a funeral, but this has never been verified. Photograph courtesy America Hurrah Antiques, New York City. (Private collection)

229. (ABOVE) *Cigar-Store Figure: Turk;* maker unknown; Eastern United States; 1860–1900; carved and polychromed wood; 77" x 28" x 28". The quality of the carving and the painting are superb in this unusually elegant and graceful cigar-store figure. At one time or another, almost every exotic nationality was represented by trade figures. (Museum of American Folk Art, New York; Gift of Mr. and Mrs. Francis S. Andrews. 1982.6.8)

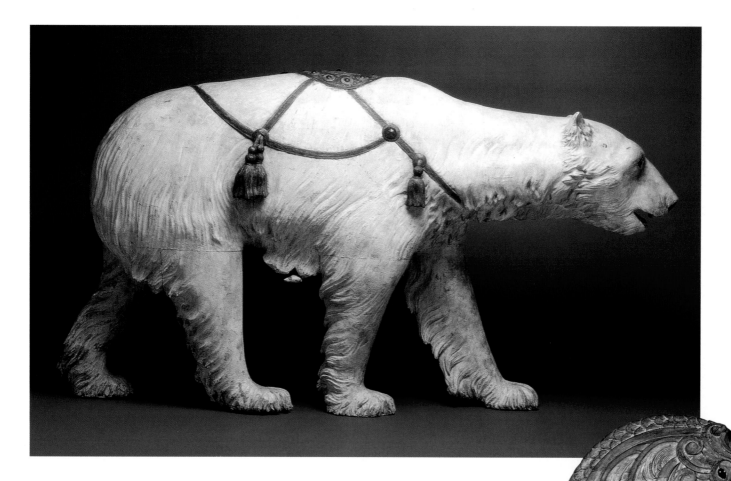

230. *Carousel Figure: Polar Bear;* Allan Herschell (d. 1928); North Tonawanda, New York; c. 1885; carved and painted wood; 64" x 42". Allan Herschell completed his first carousel in 1883 and continued producing carousel animals until his death in 1928. His company, which stayed in business until 1960, became one of the largest producers of carousels in the country. This polar bear—an unusual creature even among the wide variety of animals found in the carousel zoo—has only the barest minimum of decorative trappings; the carver's effort has been expended on the majestic beast itself. Photograph courtesy America Hurrah Antiques, New York City. (Private collection)

231. *Carousel Figure: Armored Horse;* Stein and Goldstein; Coney Island, New York City; 1912–1917; carved and polychromed wood; approximately 66" long. This prancing and colorful horse, typical of the "Coney Island Style" of carved carousel animals, reflects the flamboyance expected of that lively amusement center. The long body, the C-shaped locks of hair forming the mane, the sharply delineated leg muscles, and the aggressive expression seen here are characteristic of the Stein and Goldstein horses. (Museum of American Folk Art, New York; Gift of the City of New York, Department of Parks and Recreation. 1982.4.1.)

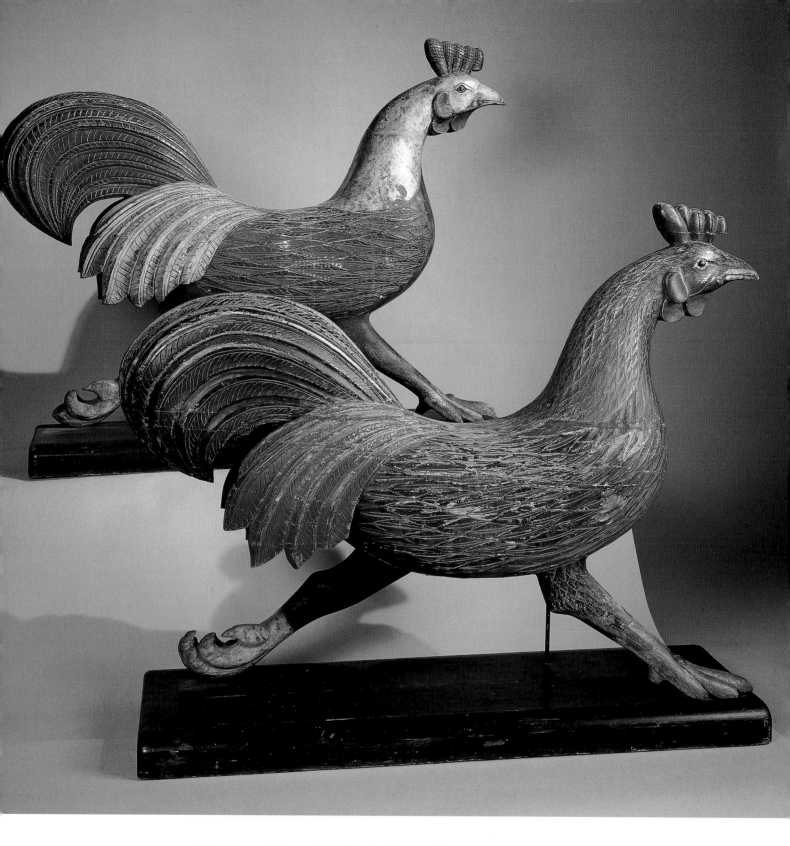

232. *Carousel Figures: Pair of Running Roosters;* Edmond Brown (1870–1940); St. Johnsbury, Vermont; c. 1900; polychromed wood; each 39" high. Edmond Brown was a cabinetmaker who carved the figures for a traveling carousel and then traveled to county fairs where he operated it. Because of the need to be as portable as possible, figures used in carousels of this type—sometimes called "county-fair style"—were somewhat smaller than those used in stationary carousels. Brown's lively roosters show a far finer degree of carving than is generally found in the animals of the county-fair type. Photograph courtesy America Hurrah Antiques, New York City. (Private collection)

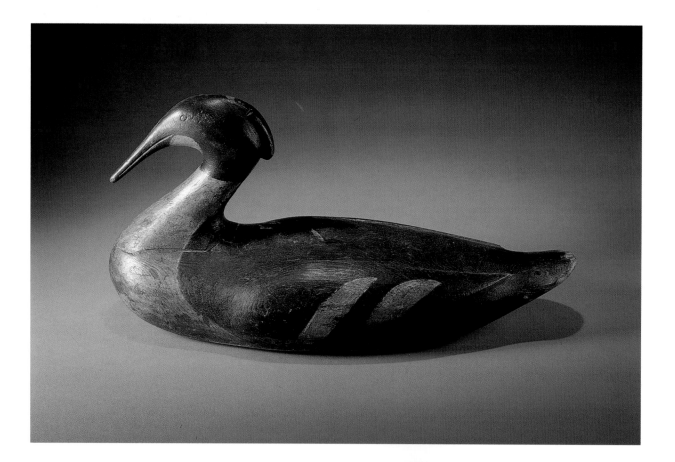

233. (ABOVE) *Red-Breasted Merganser Drake;* maker unknown; Monhegan Island, Maine; c. 1890; polychromed wood; 8½" x 16½" x 6½". This elegantly graceful decoy embodies the typical characteristics of pieces from the Maine coast. Among them are a mortised head, flat underside, and a wide beam, for it was intended to float on sea water amid swelling whitecaps instead of on a quiet pond. To be seen by birds in flight, it necessarily possesses somewhat oversized proportions. (Museum of American Folk Art, New York; Gift of Alastair B. Martin. 1969.1.25)

234. *Shorebird: Black-Bellied Plover;* A. Elmer Crowell (1862–1951); East Harwich, Massachusetts; c. 1910; painted wood, glass; 5⅝" x 9⅞" x 2⅞". Elmer Crowell was one of the acknowledged masters among American decoy artists; his painting is considered especially good. After shorebird hunting was outlawed in 1918, Crowell shifted from working decoys to carving and painting decorative decoys and other birds for display in the home. Shorebird decoys such as this one, which are placed on sticks along the beaches or marshes to lure live birds within shooting range of hunters, are often called "stick-ups." (Museum of American Folk Art, New York; Gift of Alastair B. Martin. 1969.1.94)

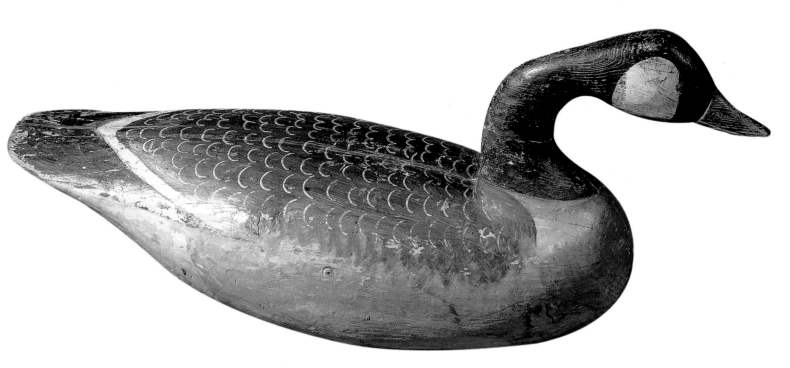

235. *Canada Goose;* Ira Hudson (1876–1949); Chincoteague Island, Virginia; c. 1920; painted wood; 11" x 25½" x 8¼". Ira Hudson, a prolific decoy maker with over twenty-five known pieces to his credit, is remembered for his exceptional duck and shorebird decoys as well as for his bird and fish carvings. Always inventive, he designed a boat, widely used by hunters, that he called a "dead rise batteau." This decoy, in exceptionally fine condition for its age, is a tribute to Hudson's skill. (Museum of American Folk Art, New York; Gift of Alastair B. Martin. 1969.1.13)

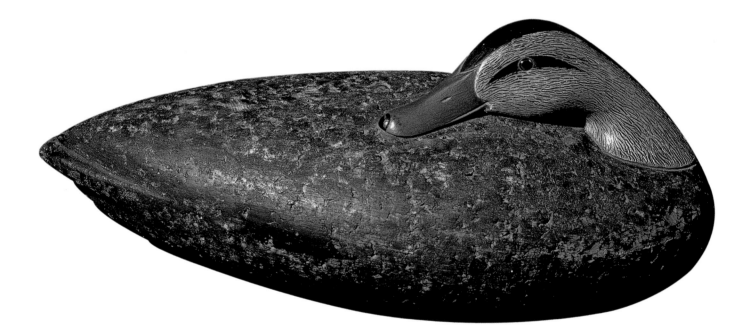

236. *Sleeping Black Duck;* Charles E. "Shang" Wheeler (1872–1949); Stratford, Connecticut; c. 1930; painted cork, wood, and glass; 5⅞" x 16" x 6¾". Charles Wheeler, although best known as a decoy carver, also carved ornamental decoys, lifelike birds and fish, and ship models. His carving was actually a sideline—his full-time job was being the manager of an oyster-farming business. This working decoy, with its elegantly shaped head resting comfortably on a cork body, was used on the exposed mud flats of Connecticut. (Museum of American Folk Art, New York; Gift of Alastair B. Martin. 1969.1.15)

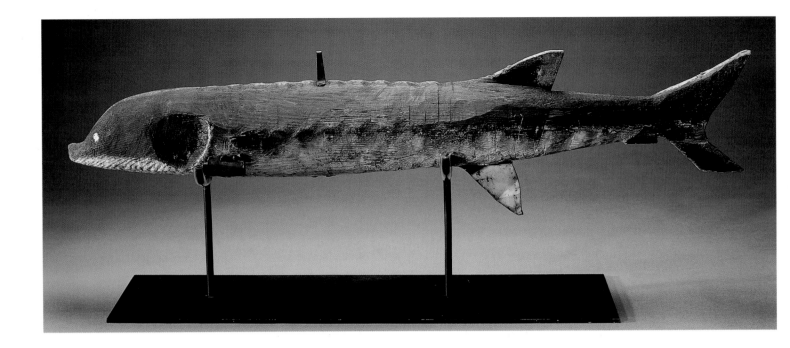

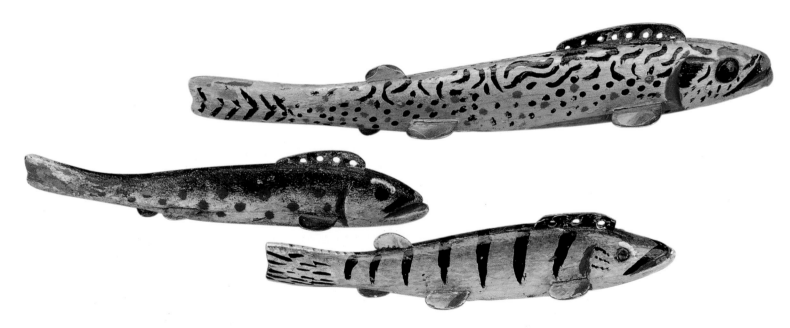

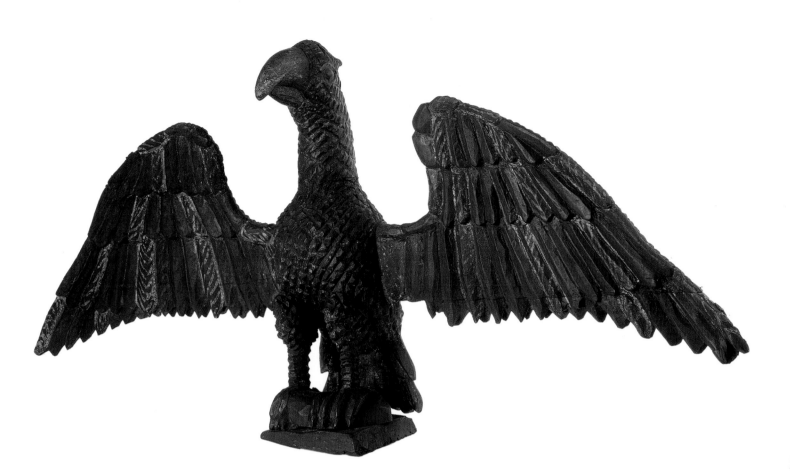

237. (OPPOSITE PAGE, TOP) *Fish Decoy;* maker unknown; midwestern United States; twentieth century; painted wood, metal; 10¾" x 41¼" x 6⅜". Fish decoys were widely used during the nineteenth and the first half of the twentieth centuries, primarily in the Great Lakes area. They were intended as lures only and so were not fitted with hooks. This fish has metal fins; some other fish decoys were fitted with leather fins and tails. (Museum of American Folk Art, New York; Gift of Robert Bishop. 1992.10.8)

238. (OPPOSITE PAGE) *Fish Decoys:* (top) Brook Trout, (middle) Brown Trout, (bottom) Perch; Oscar William Peterson (1887–1951); Cadillac, Michigan; c. 1930; carved and painted wood; metal fins; 5" to 8" long. Oscar Peterson is considered to be the master among carvers of fish decoys; his fish not only have elegant shapes and careful painting, their action in the water is said to be especially effective. Peterson began to carve decoys as a young man; he frequently worked as a hunting and fishing guide, and his carvings reflect his love for and knowledge of this work. (Museum of American Folk Art, New York; Gift of Lori Zabar in memory of Selma Segal. Brook Trout; 1991.14.4; Perch: 1991.14.5; Brown Trout: 1991.14.6)

239. *Eagle with Outspread Wings;* Wilhelm Schimmel (1817–1890); Carlisle, Pennsylvania; (1870–1890); carved, gessoed, and painted pine; 20" x 41" x 6½". Wilhelm Schimmel's carvings are highly individualistic; the eagle was one of his favorite subjects, and he carved them in various poses. Schimmel, an itinerant hobo/carver whose work falls within a genre now known as "tramp art," frequently made carvings in exchange for food, lodging, and drink; local lore has it that the saloons he frequented had shelves full of his work. His highly stylized carvings gained a great deal of local attention even in his lifetime, although Schimmel himself was not always appreciated. A local paper carried the following obituary on Schimmel's death in 1890: "'Old Schimmel,' the German who for many years tramped through this and adjoining counties making his headquarters in jails and almshouses, died at the almshouse on Sunday. His only occupation was carving heads of animals out of soft pine wood. These he would sell for a few pennies each. He was apparently a man of very surly disposition."[1] (Museum of American Folk Art, New York; Gift of Mr. and Mrs. Francis S. Andrews. 1982.6.10)

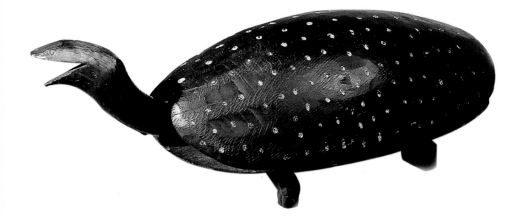

240. *Turtle;* maker unknown; American, nineteenth century; carved and painted wood; 7¼" x 20⅝" x 7⅝". Examples similar to this are known to have been made as footstools, although they have flat rather than rounded backs. This one, with a root head, was most likely made by the artist in a whimsical moment as a decorative but nonfunctional object. (Museum of American Folk Art, New York; Gift of Herbert Waide Hemphill, Jr., in the name of Neal Adair Prince. 1964.1.2)

241. *Sunburst;* John Scholl (1827–1916); Germania, Pennsylvania; 1907–1916; wood, paint, metal, wire; 71" x 38" x 24½". John Scholl, an immigrant from Germany, worked as a carpenter after settling in Germania, Pennsylvania, where he carved many pieces for a local Lutheran Church. At eighty years of age Scholl began to carve for himself and created the work for which he is best known— large snowflake-like pieces and elaborately ornate freestanding sculptures; the work shown here combines aspects of both. Scholl was so attached to his pieces that he could seldom bear to part with them; at one point, he made the parlor of his home into a museum of sorts where he could display his creations to the public. Scholl also carved small whittler's puzzles dubbed "finials" and mechanized wooden toys. (Museum of American Folk Art, New York; Gift of Cordelia Hamilton in recognition of research, work, and continued meritorious contributions in the field of eighteenth- and nineteenth-century folk art by Mrs. Adele Earnest, founding member. 1982.8.1)

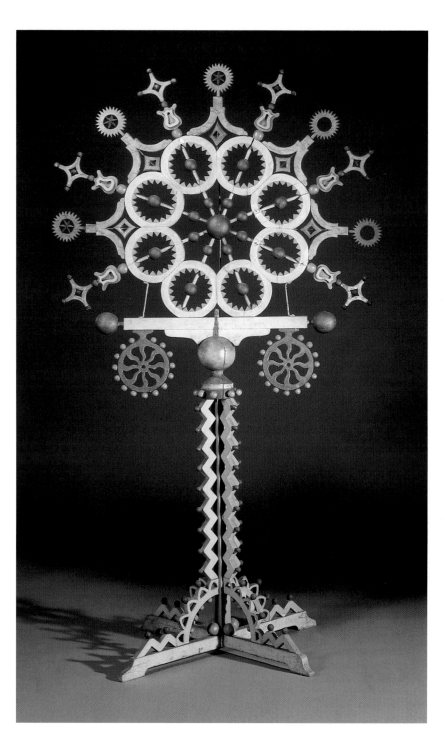

242. *Seabird;* maker unknown; Dixfield, Maine; 1850–1900; painted wood, glass eye; 18" high. This seabird, once used as a ridgepole ornament on a house, is an understated masterpiece, exemplifying the best in American folk sculpture. The bold and yet delicate details of the skillful carving by an unknown hand are further enhanced by the fine weathering of the paint. (Private collection)

Ο ΑΓΙΟΣ ΕΥΑΓΓΕΛΙΣΤΗΣ ΙΩΑΝΝΗΣ
J.S.W. PERATES

243. (OPPOSITE PAGE) *Saint John*; John W. Perates (1895–1970); Portland, Maine; 1938–1970; carved, polychromed, and varnished wood; 49¼" x 27½" x 51½". John Perates was an immigrant carver whose Greek Orthodox heritage is evident in his work. He was a cabinetmaker who began carving what he termed "furniture for the House of the Lord" when business was slow in the 1930s, and he continued to carve over the next thirty years. He is known for his iconic carved reliefs of Christ's disciples as well as for an altar piece of monumental proportions and other church-related pieces. Though he intended these works for his local church, most were never put on view, as church officials considered them too large and too strange. Perates's works have the flat, frontal aspect that characterizes much of folk art, but it only underscores the inherent power of these pieces. (Museum of American Folk Art, New York; Gift of Mr. and Mrs. Edwin C. Braman. 1983.12.1)

244. *Expulsion from Paradise;* Edgar Tolson (1904–1984); Campton, Kentucky; c. 1969–1970; wood, paint, pencil; 18" x 14½" x 7". Edgar Tolson, one of the best-known of the Kentucky carvers, is noted for his religious carvings, especially the series of eight carvings entitled The Fall of Man, of which this is one. Unusual among folk sculptors, Tolson typically painted only those portions of his pieces that he wished to accentuate in order to make a particular point in the story he portrays. Here, the painted snake is a reminder of what drove Adam and Eve from Eden. Tolson worked as a farmer, chairmaker, and, for many years, preacher; although he had always carved or whittled, he did not begin carving seriously until around 1957. Many of his works deal with the relations between men and women, often portrayed through biblical allegories. (Museum of American Folk Art, New York; Gift of Elizabeth Ross Johnson. 1985.35.17)

245. *The Devil and the Damned;* Miles Burkholder Carpenter (1889–1985); Waverly, Virginia; c. 1972; painted wood and cellophane; 19" high. Carpenter was born in Pennsylvania and moved to Virginia with his family as a child. He began carving about 1940, mostly to amuse himself during slack periods in his lumber-mill business. In 1955, when he closed the mill, he turned to carving more seriously. His carvings ranged from small to life-size, from animals to Indians to politics to religion, of which the piece shown here is an example. He was considered something of an eccentric in his town—he would fill the open back of his pickup truck with several of his carvings, and he had a nearly full-sized carved Indian with a moveable head that he would place in the passenger seat in the front, making the head move as he drove to face passersby. Perhaps his best-known carving is a large watermelon, now in the permanent collection of the Abby Aldrich Rockefeller Folk Art Center, Williamsburg, Virginia, which he used as a trade sign for his ice house, a side business that also sold soda and fruit. (Museum of American Folk Art, New York; Gift of Herbert Waide Hemphill, Jr. 1990.1.10)

246. (OPPOSITE PAGE, BOTOOM) *Seeking Gold in the West;* Elijah Pierce (1892–1984); Columbus, Ohio; c. 1950; carved and poly-chromed wood; 12" x 24½". A barber for most of his life, Elijah Pierce carved as a hobby; he is now regarded as a master of bas-relief carving. Pierce, the son of former slaves, was a highly religious man who saw himself as an instrument of God's hand. He was a sculptural storyteller, taking such subjects as historical and biblical scenes, incidents from his childhood, and his father's tales of slavery, and turning them into detailed carvings that often also included allegorical or social commentary. Although the religious pieces were his favorites, Pierce also carved reliefs of national heroes such as Abraham Lincoln and sports figures such as Joe Louis. (Museum of American Folk Art, New York; Gift of Mr. and Mrs. Charles Pendergast. 1972.2.1)

247. *The Seven Wonders of the Ancient World;* Josephus Farmer (1894–1989); Milwaukee, Wisconsin; 1970–1975; redwood, enamel paint; 30" x 50". Josephus Farmer, a black folk artist and former street preacher, has gained wide recognition for his relief carvings with historical and religious themes. Born in Tennessee, Farmer moved north to Illinois in 1917. He was ordained a Pentecostal minister in the 1920s and became a street preacher, singing songs he composed himself while preaching. In 1947, he moved to Milwaukee, Wisconsin, where he ran a storefront church while supporting himself and his family as a hotel porter. He began to carve after he retired. (Museum of American Folk Art, New York; Gift of Herbert Waide Hemphill, Jr. 1990.1.4)

248. *The Schoolmarm;* Lavern Kelley (b. 1928); Oneonta, New York; 1988; carved and painted pine; 31" high. Lavern Kelley's carvings are realistic, almost full-scale models of people and objects. His figurative carvings are often based on people he knew and are semirealistic portrayals. He carved this school-teacher in the middle of a lesson; painted on her slate is a part of the multiplication tables. Kelley has also done numerous carvings of trucks, tractors, and other farm equipment, notable for their accuracy and detail. Kelley is a farmer and one-time logger who carves what he sees around him—what he dubs "real" things and people. (New York State Historical Association, Cooperstown, New York)

249. (OPPOSITE PAGE) *Lincoln and Washington;* carved into the bottom of the frame: Stephen L. Iwasko; probably Midwest; c. 1930; relief carving in wood; 15½" x 13¼". Stephen Iwasko is said to have worked for the American Crayon Company and was laid off during the Depression. In his subsequent free time, he is known to have made at least eight bas-relief carvings of Lincoln and Washington, both singly and in pairs. This handsome carving is one of a pair, the other being a mirror image in which Lincoln and Washington face to the left, and with Washington in the foreground. Photograph courtesy America Hurrah Antiques, New York City. (Private collection)

CARVED · BY · STEPHEN L. IWASKO

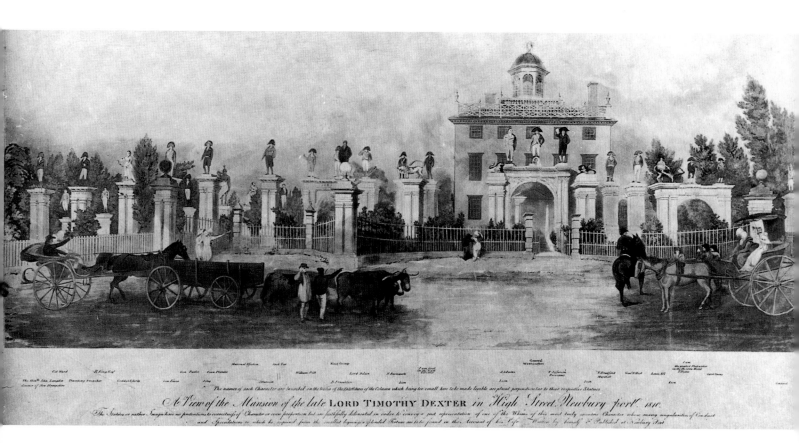

At View of the Mansion of the late LORD TIMOTHY DEXTER in High Street Newbury port. 1810.

250. *A View of the Mansion of the Late Lord Timothy Dexter in High St., Newbury Port;* artist unknown; Boston, Massachusetts; 1810; mezzotint; 26½" x 16¼". The Timothy Dexter house is one of the first recorded American efforts at environmental art. Dexter decorated his property in Newburyport with carved and painted images of Sir William Pitt, three presidents of the United States, Napoleon, the Goddess of Fame, and various other luminaries, including himself. The text on this print reads: "The Statues or rather Images have no pretensions to correctness of Character or even proportion but are faithfully delineated in order to convey a just representation of one of the Whims of this most truly eccentric Character whose many singularities of Conduct and Speculations by which he acquired from the smallest beginnings a splendid Fortune are to be found in the Account of his Life Written by himself & publ'd at Newbury Port/Boston." The sculptures were striking; one commentator of the time noted that they "were remarkable specimens in wood carving. In his work, Mr. Wilson [the sculptor] displayed the power of a sculptor; it is a pity he never aspired to works of greater durability."[1] (Henry Ford Museum & Greenfield Village)

5

Private Vision, Public Statement

The Folk Art Environment

Throughout much of American history there has been a strong inclination on the part of a few people—whom many would not hesitate to label as eccentrics—to rearrange their everyday environment in order to create a singular blend of art and architecture that uniquely expresses their own personal visions of the world. Oftentimes this expression has led to the creation of structures that are architectural in nature but not necessarily designed to produce living spaces; it may also take the form of the embellishment of an already existing space, such as Joseph Furey's colorfully personalized Brooklyn apartment (figs. 271, 272). The works vary tremendously. Some, such as the soaringly majestic Watts Towers (fig. 261), are large-scale, even monumental, and are built outdoors, becoming public presences by default whether or not the artist meant them as such, while others, such as "Lord" Timothy Dexter's flamboyant collection of figures (fig. 250) or the Reverend Howard Finster's extensive Paradise Garden (figs. 257, 258), were always intended to have a public presence, meant to be seen and admired. Still others, such as James Hampton's mesmerizing Throne of the Third Heaven of the Nation's Millennium General Assembly (fig. 256), may remain intensely private and personal statements, with public recognition often occurring only after the creator has died or, for whatever reason, abandoned the project.

These creations may be part art, part architecture, and often, part performance—as witness Calvin and Ruby Black's lively Possum Trot (fig. 263) or Clark Coe's Killingworth "images" (figs. 252, 253). Sometimes they represent an attempt to control the immediate environment and, thereby, some elements of life; sometimes they are intended to enhance the expression of strong spiritual beliefs to a larger audience, such as Father Wernerus's Holy Ghost Park that celebrates both religion and patriotism (figs. 259, 260). And sometimes they were made simply because, once started, the maker found the exercise too enjoyable to stop, as was the case with "Grandma" Prisbrey and her Bottle Village (fig. 265) and Fred Smith's eccentric collection of oversize sculptures that comprise his Concrete Park (figs. 267, 268).

Many—perhaps most—environments are created in part, if not in total, from found materials such as tin, glass, automobile parts, seashells, and bottles—the discards of daily life to some, but treasures ready for new life to others. Of the environments shown here, only a few, such as the trimmed stone for Samuel Dinsmoor's

251. *Architectural Sculpture of Sir William Pitt;* Joseph Wilson (1779–1857); Newburyport, Massachusetts; c. 1800; polychromed pine; 78" x 23". Of the forty-five larger-than-life-size statues that were created for Dexter, this, along with two unidentified arms and a hand (now in the collection of the Historical Society of Old Newburyport, Newburyport, Massachusetts), are the only pieces still in existence. This recently refurbished statue, however, gives a good idea of the skill of the artist as well as of Dexter's unconventional vision. Photograph courtesy John Wright, Historical Society of Old Newburyport. (National Museum of American History, Smithsonian Institution, Washington, D.C.)

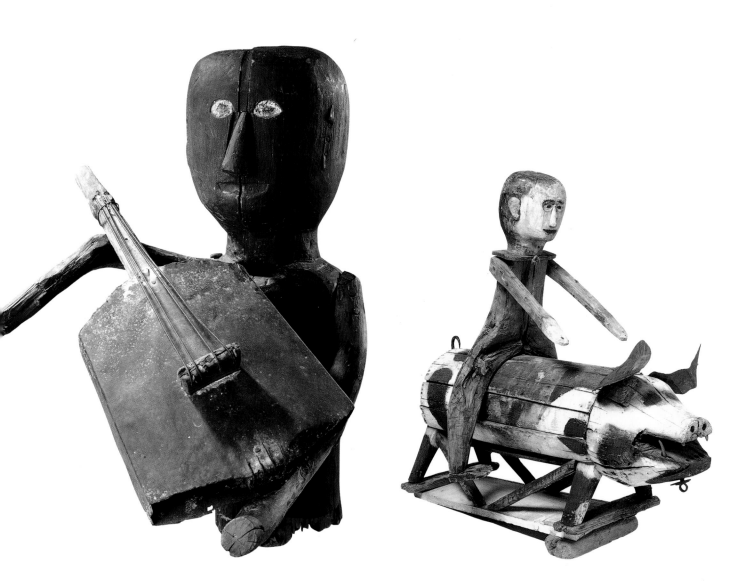

Rock Log Cabin (fig. 254) or Dexter's carved-to-order figures (fig. 251), contain significant amounts of purchased materials. Part of the challenge of building an environment, it seems, comes as much from the resourceful use of materials as from the creation itself. Some environments push materials and form to the limits, the single-minded vision of the builder often finding creative and viable solutions to what some might term impossible problems—as Edward Leedskalnin did in crafting his Coral Castle from immensely large and heavy blocks of coral (figs. 269, 270).

That environments are not always appreciated by their neighbors is true; they can become highly controversial, and some, such as Kea Tanawa's Ark (not illustrated here) in Newark, New Jersey, do not survive the debate. Yet, whatever the motivation for these creations, whether private vision or public statement, whether they survive today in fact or in memory, whether they inspire light-

252. *Musician with Lute;* Clark Coe (1847–1919); Killingworth, Connecticut; early-twentieth century; figure: wood, lute: metal and wood; 30" high. Clark Coe created an extraordinary environment of life-size figures in the early years of this century. The figures crafted by the artist were set in and near the river that flowed by his house, and many of the figures had water-powered movement of some sort. The figures are constructed of barrel staves, slats, driftwood, and tree stumps. (Museum of American Folk Art, New York; Gift of The Museum of Modern Art, New York, from the collection of Gordon and Nina Bunshaft. 1995.1.1)

253. *Man on a Hog (sometimes called Girl on a Pig);* Clark Coe (1847–1919); Killingworth, Connecticut; early-twentieth century; articulated polychromed wood and metal; 37" high. This sculpture was originally part of a life-size water-powered whirligig that Coe constructed. The giant toy was put into action by a waterwheel that was activated by a nearby waterfall. Photograph courtesy Art Resource, N.Y. (National Museum of American Art, Washington, D.C.)

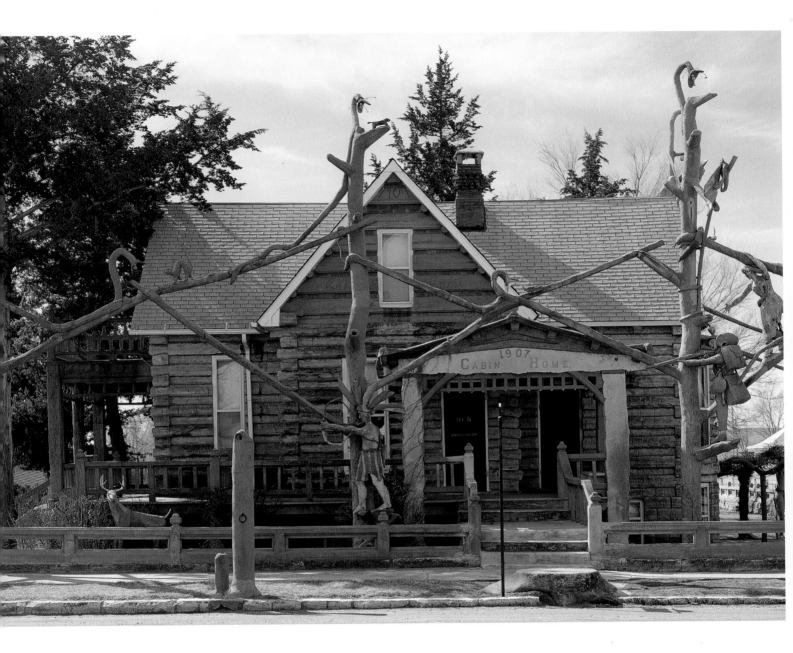

254. *Rock Log Cabin, Main Entrance;* Samuel Perry Dinsmoor (1843–1932); Lucas, Kansas; 1910–1927; limestone, reinforced concrete. Dinsmoor's Rock Log Cabin, which he called "the most unique home, for living or dead, on earth," was surrounded by groupings of aerial sculptures, part of which he called Garden of Eden and part Modern Civilization. He was an early user of electric light, and each element of the environment had its own lighting so it could be seen by night as well as by day. One of the buildings included is a mausoleum, made of notched limestone "logs" like the main house, in which Dinsmoor, in a glass-covered concrete coffin that he designed and built himself, was buried next to his first wife. Photograph © Jon Blumb, 1989.

255. (OPPOSITE PAGE) *Adam and Eve;* Samuel Perry Dinsmoor (1843–1932); Lucas, Kansas; 1910–1927; reinforced concrete, mixed media. Although many of Dinsmoor's themes are biblical, his interpretations are very much his own. He said of his depiction of Adam and Eve, which shows two snakes: "Two snakes form the grape arbor. One is giving Eve the apple. The Bible tells all about that. The other snake didn't have any apple, so Adam got hot about it, grabbed it, and is smashing its head with his heel. That shows the disposition of man. If he doesn't get the apple there is something doing. And the Bible says, the heel of the seed of the woman shall smash the serpent's head, or something to that effect." Photograph © Jon Blumb, 1989.

256. (OVERLEAF) *The Throne of the Third Heaven of the Nation's Millennium General Assembly;* James Hampton (1909–1964); Washington, D.C.; assemblage of old furniture, light bulbs, glass jars, scrap wood, and cardboard covered with silver and gold foil; c. 1950–1964; approximately 9 x 32 feet. Included within this extraordinary work are nearly 180 foil-wrapped objects representing thrones, altars, pulpits, wall plaques, and crowns. It is also embellished by inscriptions in English and a secret script resembling hieroglyphics, pen and ink geometric designs, and other drawn and painted symbols. A shimmering central throne dominates the whole, and the pulpits, crowns (of which there are a total of twenty-five), chairs, altars, and other objects are arranged symmetrically on either side. Notes left by Hampton indicate that the New Testament is represented by one side, the Old Testament by the other. Photograph courtesy Art Resource, N.Y. (National Museum of American Art, Washington, D.C.)

so, sometime between 1799 and 1801, he commissioned Joseph Wilson (1779–1857), a carver of ship figureheads, to create a large group of life-size statues, including likenesses of Dexter himself, George Washington, Thomas Jefferson, John Adams, Sir William Pitt, and Napoleon Bonaparte, among others, to be set atop columns, archways, the house roof, and fenceposts on Dexter's property. The spectacle thus created drew spectators from miles around. Unfortunately, Dexter did not enjoy his version of a neoclassical garden for long; he died in 1806 and several of the statues were sold at auction the following year. Many were destroyed in a "Great Gale" (possibly a hurricane) in 1815, some succumbed to dry rot, and others were taken down by one of the owners of the property. Only one figure and a few pieces from another remain of this imaginative site today (figs. 250, 251).[1]

Another embellishment of the New England landscape was done by Clark Coe (1847–1919), a Connecticut farmer and basketmaker who supplemented his income by making ax handles that he then sold to general stores in New Haven, Connecticut. Around 1900, as a means of amusing children in the family,[2] Coe constructed life-size figures—some of them dressed in discarded clothing and bits of ribbon—out of barrel staves,

hearted laughter or awed silence, they all reflect an underlying common thread among their creators—a strong and burning inner vision that could be translated into tangible structures that speak to a larger audience in a passionate personal language of both mind and heart.

One of the earliest demonstrations of this form of American expression was created by "Lord" Timothy Dexter (1747–1806), a wealthy merchant, at Newburyport, Massachusetts, in the late-eighteenth and early-nineteenth centuries. Dexter, never a modest man, wrote the following comment about his birth: "I was born when grat powers Rouled—I was borne in 1747, January 22, on this day, in the morning . . . I was to be one grate man. [*sic*]" Dexter was a self-styled "Lord" with a great interest in historical figures; he felt he belonged in the company of "grat" men like himself and

slats, driftwood, and tree stumps that he mounted in a waterway near his home in Killingworth. He used the flowing water to animate the figures, causing them to move in unusual and unpredictable ways. By 1915, the figures, which came to be called the Killingworth "images," had become a local tourist attraction, and visitors from miles around flocked to see these curious figures at their numerous tasks. One visitor recorded: "And suddenly we come upon them: a planked floor, partially roofed but with open sides, inhabited by a random group of life-size figures built of wood, with painted faces and makeshift hair, but garbed authentically (if somewhat out of date) in real cast-off clothes. The few that have no motion of their own are in a pair or tableau in which something is astir: an arm, a head, or some accessory." There were some forty images all together, grouped in and around a shed near a waterfall that activated a waterwheel constructed by Coe that put the figures into motion. When Coe died, the next owner of the property tried to keep the environment going, but by 1930 he gave it up and the still-existing figures were sold (figs. 252, 253).

Samuel Perry Dinsmoor (1843–1932) created a singular environment on a half-acre lot in Lucas, Kansas. In 1905, he began work on a project that he called "the most unique home, for living or dead, on earth"; it eventually became a monumental statement of his beliefs as well as his home. He surrounded his first building, an eleven-room Rock Log Cabin built of local limestone (fig. 254), with his own interpretation of the Garden of Eden and Modern Civilization. Not only does this grouping of unusual sculptures contain Adam and Eve (fig. 255), serpents, animals, birds, and Cain and Abel, it also includes the goddess of Liberty, flags, soldiers, Indians, and figures representing The Crucifixion of Labor (in which Labor is crucified by a preacher, a doctor, a banker, and a lawyer)—in all, some 150 pieces of sculpture that present a powerful visual allegory of his religious, social, and political beliefs. Dinsmoor once said of his creation: ". . . U.S. flags, Adam and Eve, the Devil, coffin, jug, labor crucified, bird and animal cages, trees eight to forty feet high are all made with cement—modern civilization as I see it. If it is not right, I am to blame, but if the Garden of Eden is not right, Moses is to blame. He wrote it up and I built it." The Garden of Eden, a tribute to this man's unique beliefs, is now included in the National Register of Historic Places.

James Hampton (1909–1964), like Dinsmoor, was an intensely religious man. The son of a Baptist minister, Hampton worked as a janitor for the General Services Administration in Washington, D.C., during the day and, at night, created an extraordinary assemblage, The

257, 258. (ABOVE AND OPPOSITE PAGE) *Paradise Garden* (details); Howard Finster (b. 1916); Summerville, Georgia; started c. 1975; mixed-media environment; covers many acres. A preacher for forty years, Finster retired from the pulpit for health reasons and began constructing a massive environmental work, the Paradise Garden, in the small Georgia town in which he lives. This work consists of walls, walkways, and various structures inset with an incredible variety of found objects, including sparkling fragments of glass, mirrors, plastic toys, photographs, hubcaps, even abandoned refrigerators. Hand-written signs are placed throughout this gigantic jeweled garden explaining Finster's religious views. His work, like his pronouncements, comes from religious fervor; it is the unorthodox visual incarnation of his doomsday preaching. Photographs © Roger Manley.

Throne of the Third Heaven of the Nation's Millennium General Assembly, in an unheated garage that he rented near this home (fig. 256). He built the Throne in almost complete isolation; only a very few people even knew of it. He himself used it for individual religious services on Sundays, and he might have intended eventually to use it for services for a larger group. Hampton believed that he was creating the work at the direction of God, and he dedicated it to the Second Coming of Christ. Although he left no explanation of the Throne, several inscriptions indicate that he may have derived some inspiration from the Book of Revelation. Hampton also developed a secret script that he claimed God had given him; a small notebook is filled with entries in this unknown language that has yet to be deciphered. The Throne of the Third Heaven, now installed in the National Gallery of American Art of the Smithsonian Institution, is an inspiring, never-to-be-forgotten composition, a transformation of mundane and discarded objects into a glittering tribute to God

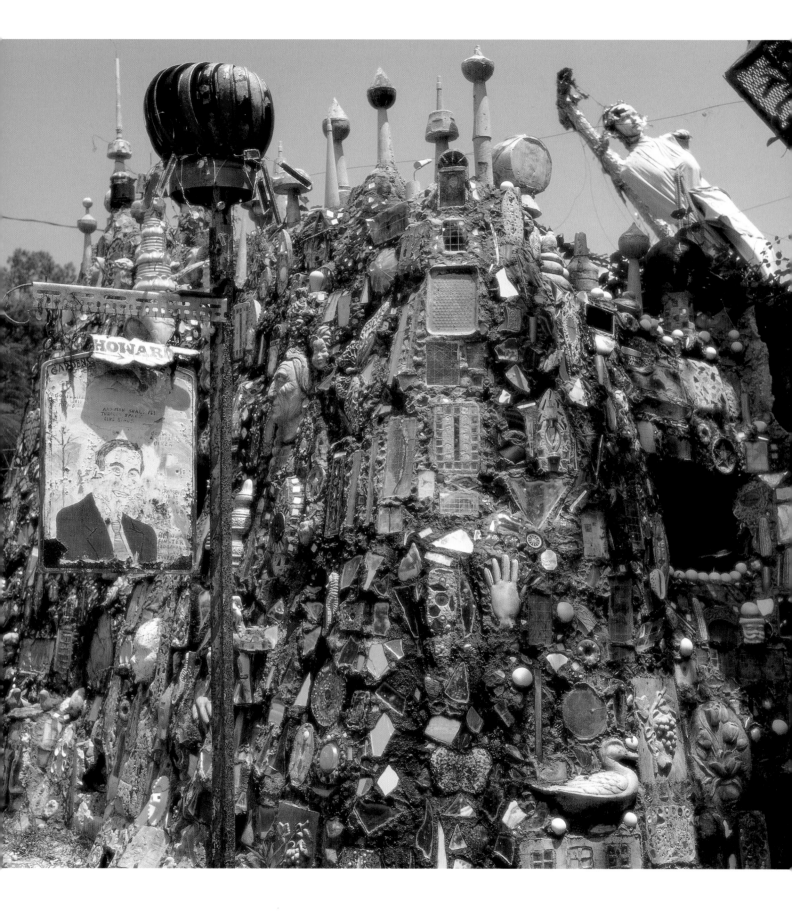

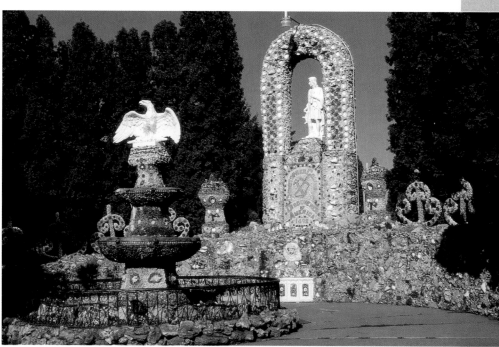

259, 260. *Holy Ghost Park* (details): *Entrance to Main Grotto* (OPPOSITE PAGE), *Patriotic Shrine* (ABOVE); Father Mathias Wernerus (1873–1931); Dickeyville, Wisconsin; c. 1924–1930; mixed-media environment (reinforced concrete, shells, glass, semi-precious stones, other found objects); on one acre. The dual themes of religion and patriotism—the organizing principles for Father Wernerus's Holy Ghost Park—are made evident in the signs flanking the entrance to the Main Grotto, which is dedicated to the Blessed Mother (the Virgin Mary). The American flag tops one sign, a flag with a cross is on the other. Statues of saints and the apostles were built in niches in the Main Grotto, the principal structure in the Park, while statues of Columbus, Washington, Lincoln, and the American eagle grace the Patriotic Shrine and accompanying fountain. Father Wernerus used many objects to decorate his work, including artifacts donated by Indians from a nearby reservation who had become interested in his work. In addition to the shells, glass, and other artifacts that appear throughout the environment, the interior walls of the Grotto are also inlaid with precious and semiprecious stones, some of which had been collected by Father Wernerus himself on local caving expeditions. Photographs courtesy Cynthia Carlson.

that effectively expresses the exceptional depths of belief of its quiet creator.

The Reverend Howard Finster (b. 1916) is, perhaps, the other end of the spectrum from the private religiosity of James Hampton. A self-proclaimed Man of Visions, Finster was a preacher for over forty years until he retired from the pulpit for health reasons. Still intending to spread the Lord's word—and his own unique view of religion and the world—in whatever way possible, he then began constructing a massive environmental work that he termed Paradise Garden in Summerville, Georgia; it is a project that is still ongoing. The early Garden was replete with paintings and signs explaining his religious ideas; today it also includes walls, walkways, and other structures inset with an incredible variety of found objects

from iridescent fragments of glass and mirrors to plastic objects to photographs to hubcaps to abandoned refrigerators, to mention only a few (figs. 257, 258). Of the many handwritten signs found throughout this gigantic jeweled garden, one best explains its essence: "I took the pieces you threw away/ and put them together by night and day./ Washed by rain dried by sun/ a million pieces all in one." Finster has said of this environment, "Just you and the Lord. And you can talk and He can tell you things to do." Finster is an amazingly prolific artist and has not limited his creativity to the Garden. All his works, like his pronouncements, come from religious fervor; they are the unorthodox visual incarnations of his doomsday preaching. His apocalyptic paintings (see fig. 72), plexiglass constructions, futuristic light boxes, and

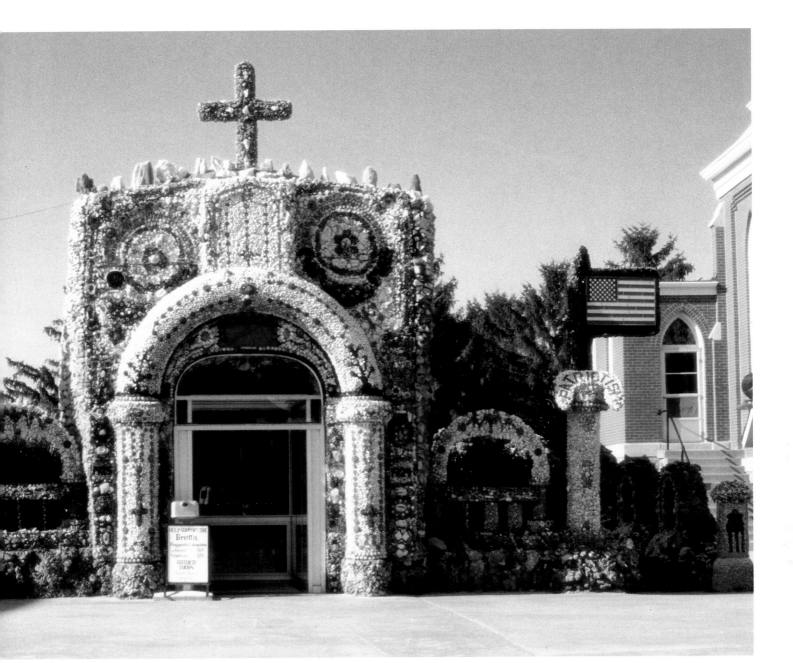

larger-than-life figures have gained him a great deal of attention throughout the world. In spare moments, Finster can be heard singing his self-composed folk songs—both religious and secular—while strumming a banjo he plays by ear.

Father Mathias Wernerus (1873–1931), a German-born Catholic priest in a small town in Wisconsin, is another artist whose environmental creation is a stirring testimony to his faith. Father Wernerus was appointed pastor of Holy Ghost Parish in Dickeyville, Wisconsin, in 1918 and soon after, in honor of parish members who had died in World War I, he created a memorial sculpture that included Christ on the cross and other figures. Its success inspired him to envision a larger project that would include a religious grotto and a series of shrines;

this grouping, which was started in 1924, became the environment now known as Holy Ghost Park (figs. 259, 260). Father Wernerus used religion and patriotism as the organizing themes for his Park, and, with some help from his parishioners, he completed the Main Grotto (dedicated to the Blessed Virgin), the Sacred Heart Shrine, the Patriotic Shrine, and a series of smaller statues of children and animals before his death in 1931 curtailed his plans for other pieces. In a 1930 document about his work, Father Wernerus noted, "I can only say that Almighty God and his Blessed Mother, in whose honor we worked, blessed us in such a way that we built better than we knew." The Park, with its blend of sincere religious belief and unashamed patriotism, still draws numerous visitors to the tiny village of Dickeyville.

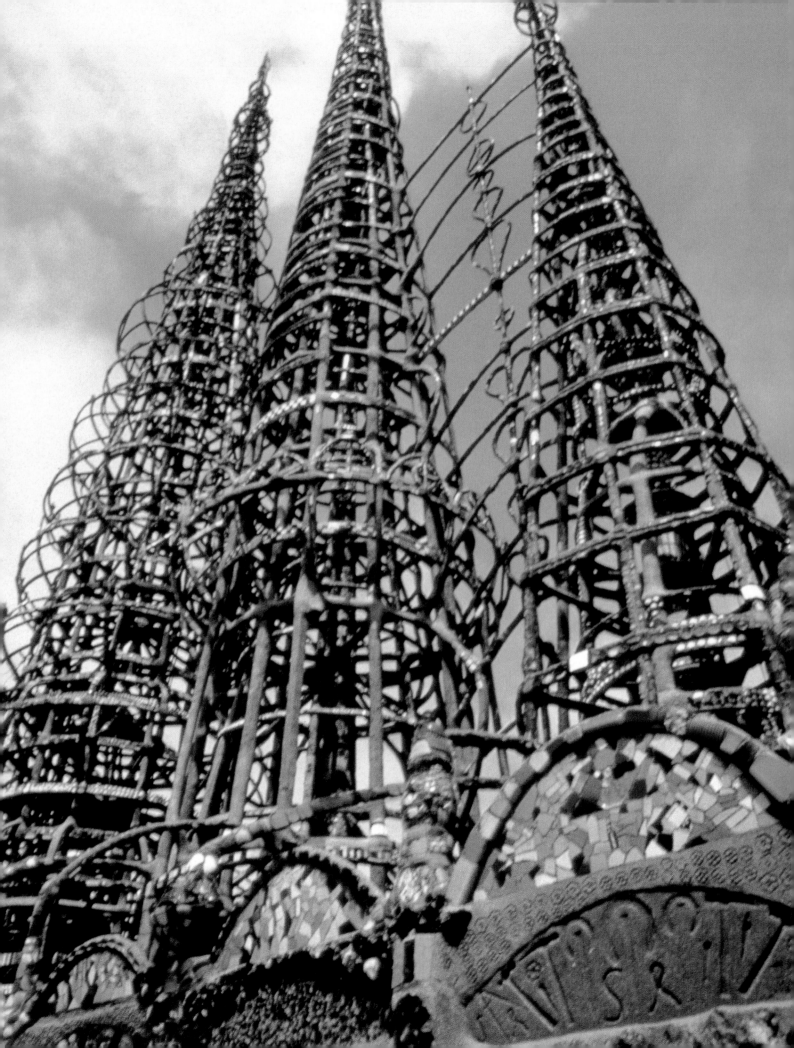

Without question, one of the most beautiful and certainly the most monumental of all outdoor environments was created by Simon Rodia (1879–1965), an Italian immigrant, in the inner-city area of Watts in Los Angeles, California. Although he worked occasionally on construction jobs, he soon devoted most of his time to building the soaring towers, now known as the Watts Towers, which he had begun in 1921. Rodia spent almost eight hours every day working on these structures until 1954, when he deeded the property to a neighbor in exchange for a bus ticket to Martinez, California, where he had some family. Rodia never explained his reasons for building the Towers or why he left; his only comment was, "I had it in my mind to do something big and I did." Although these questions remain unanswered, his legacy endures. Built by this one man, without assistance, the Towers are an amazing blend of steel rods, wire mesh, and mortar decorated with countless fragments of broken glass, dishes, ceramic tiles, and seashells (figs. 261, 262). The height of the tallest tower is approximately 100 feet, and it was conceived and built without the benefit of predrawn designs. After Rodia left, the Towers began to deteriorate and the city of Los Angeles was threatening to tear them down when a

261. (OPPOSITE PAGE) *Watts Towers;* Simon Rodia (1879–1965); Watts, Los Angeles, California; begun 1921, completed 1954; reinforced concrete decorated with broken bottles, dishes, tiles, and seashells; 99½ feet high. Rodia's soaring towers are constructed of steel reinforcing rods and wire mesh covered with cement; not a single bolt or rivet holds them together. There is some reason to believe that the inspiration for the Towers were giglios, elaborate towering structures used as part of religious celebrations in some parts of Italy that Rodia may have seen during his childhood. Except for the reinforcing materials and the cement, almost all the other materials in the Towers were discards, some gathered by Rodia, while others were brought to him by neighborhood children. Photograph © Seymour Rosen; courtesy SPACES.

262. *Detail of Arch, Watts Towers;* Simon Rodia (1879–1965); Watts, Los Angeles, California; begun 1921, completed 1954; reinforced concrete decorated with broken bottles, dishes, tiles, and seashells; 99½ feet high. This incredible structure, built without a predrawn design, machinery, or scaffolding, includes arches, fountains, pavilions, and labyrinths in addition to the Towers. The surfaces form a rainbow mosaic, with thousands of pieces of bottles, dishes, tiles, mirrors, and seashells embedded in them. Photograph © Seymour Rosen; courtesy SPACES.

group dedicated to their preservation intervened. The Towers, with their many arches, fountains, pavilions, and labyrinths, are now a protected site and listed on the National Register of Historic Places; they have been meticulously restored and visitors can enjoy the magnificent splendor of this unique folk creation.

Sometimes environments were created as part of an effort to draw attention to something else, as was the case with Possum Trot in Yermo, California. Calvin and Ruby Black moved from Georgia to California after their marriage in 1933 to prospect for gold. Eventually they settled in Yermo, California, to run a mineral and rock shop. As Yermo was in the middle of the Mojave Desert, the shop got very little business, so Calvin Black began to carve dolls, which Ruby dressed, that were put in front of the shop in the hope that they would attract customers. He also constructed several outbuildings, and soon there were enough dolls to populate the buildings as well as the outdoor area (figs. 263, 264). The Blacks used some of the dolls to create the Fantasy Doll Show in one building; the show consisted of animated "talking" dolls whose movements were controlled by an ingenious system developed by Calvin, who used to be a puppeteer. He also recorded voices for each figure, as well as songs and guitar accompaniments for his scenarios for the dolls. Eventually Possum Trot did draw visitors, and it became a popular stop for those traveling through the area as well as for some who came just for the show. Possum Trot was dismantled and most of the pieces sold after Ruby Black's death in 1980, but the vision of this odd couple lives on in the dolls that have survived and in an excellent documentary video of the environment.[3]

Tressa "Grandma" Prisbrey (1896–1988) did not set out to create a remarkable environment. All she wanted initially was a place to house her collection of tens of thousands of pencils, but once started, she just kept building because, she said, "I enjoyed it. I never thought of it as work; I was just having a good time." Although the initial motivation for building was the pencil collection, the final result, called Bottle Village in recognition of its major building material (fig. 265) is filled with mementos of Prisbrey's life. In addition to the Pencil House (fig. 266) that started it all, Prisbrey gave each of the fifteen buildings in the Village names such as the School House, Cleopatra's Bedroom, the Shell House, the Bottle House, the Doll House, and so on; each name reflects the theme of a building and its contents, all collected by Prisbrey over a lifetime. Prisbrey planned, designed, collected materials for, and constructed the Village on her own. She claimed to have used bottles—of which she reportedly included over one million—as

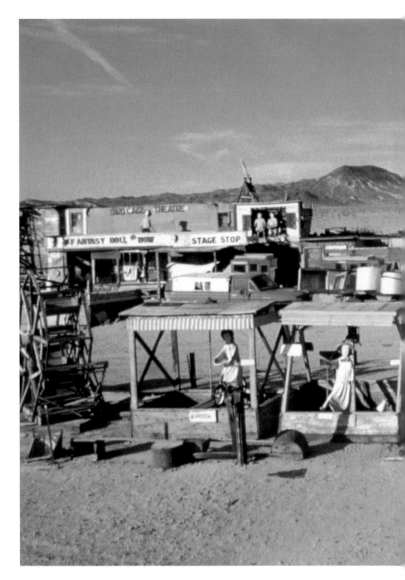

263. *Exterior View of Possum Trot as It Appeared in 1975*; Calvin Black (1903–1972) and Ruby Black (1915–1980); Yermo, California. To attract customers to their rock shop, Calvin and Ruby Black created Possum Trot, a series of rough buildings that included the Fantasy Doll Show. Most of the dolls moved, performing activities such as strumming a guitar or riding a bicycle; many of those placed outdoors were wind-operated. Ruby designed and made the costumes for the dolls, often simply slipping a new dress over an old one when the clothes showed wear, as frequently happened with the outside dolls that were constantly subjected to the harsh climate of the Mohave Desert. Photograph © Seymour Rosen; courtesy SPACES.

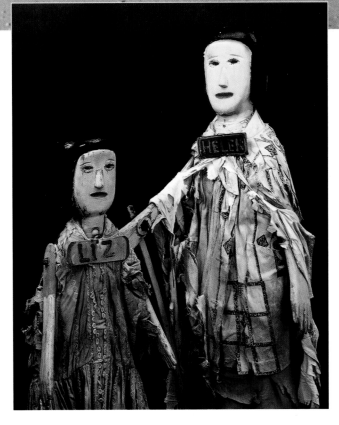

264. *Possum Trot Figures: Liz and Helen;* Calvin Black (1903–1972) and Ruby Black (1915–1980); Yermo, California; c. 1955; painted and carved redwood, clothed; each 33" x 10" x 7". The dolls made by the Blacks—carved by Calvin and dressed by Ruby—were approximately one-half to three-quarters life-size. All the dolls were female, and the Blacks gave each one its own name, providing them with name tags so visitors could identify their favorites. (Museum of American Folk Art, New York; Gift of Elizabeth Ross Johnson. 1985.35.3 and 1985.35.8)

a basic building material because they were the cheapest thing she could find; they also give a strange beauty to the whole. In 1986 Bottle Village was acquired by a preservation committee that has worked to restore it and keep it open to the public. The Village has also been designated a landmark by the State of California.

Fred Smith (1886–1976) began to create stunning concrete sculptures of animals and people (figs. 267, 268) after he retired as a tavernkeeper. "Nobody knows why I made them," he once said, "not even me." Once started, he spent almost all his time working on the Park until he was stopped by a stroke. Smith never sold any of his pieces; they were for him and others to enjoy. After his death the Kohler Foundation bought the property and carried out much-needed restoration work so that the public could continue to enjoy the Park as Smith had hoped.

The Coral Castle environment created by Edward Leedskalnin (1887–1951) was a paean to unrequited love. Leedskalnin came to America in 1912 after he was jilted by his fiancée in his native Latvia and, after several years of travel, settled first in Florida City, Florida, in 1918 and finally, in 1936, on ten acres near Homestead, Florida. Leedskalnin, however, could not forget his first love and devoted the rest of his life to building a castle in the belief that she would one day share it with him. The castle included a number of rooms, a surrounding wall, a nine-ton gate that was perfectly balanced on a pivot, chairs and tables, a sundial, a moon fountain, and several other sculptures—and everything was carved from large blocks of coral (figs. 269, 270). The immense scale of the environment made it a brilliant accomplishment for one man to create, but Leedskalnin found no happiness in it because his fantasy bride never joined him there. In 1984 the Castle was placed on the National Register of Historic Places.

Joseph Endicott Furey (b. 1906), a retired steelworker, turned his five-room Brooklyn, New York, apartment into an extraordinary painted and collaged private environment simply because he wanted it to look good. The apartment, which Furey and his wife rented in 1938, was his home for fifty years, although he did not begin decorating it in his own unique way until about 1980. He had started the project while his wife was still alive, but after her death he began working on it virtually nonstop, covering almost every available inch of wall space with neat and glowing rows of shells, painted and decoupaged geometric patterns, beads, cut-out bow ties and hearts, plaster chickens, even dried lima beans and empty thread spools until the entire apartment became a glowing jewel-box of shape and color (figs. 271, 272). When Furey went to live with his son in 1988, his landlord was left to contend with the dazzling work his tenant had left behind. Although the next tenant preserved the environment to the extent practical, the very nature of the materials and their installation made preservation problematic, if not impossible. When that tenant left, the landlord felt that no further preservation was possible and that restoration was not feasible and so, in 1994, demolished what was left of the environment in order to renovate the apartment. Furey himself has shown no inclination to repeat the process in his new home.

One of the major concerns about folk environments continues to be: "Is there realistically a body of work that can be thought of or classified in this way?" The answer is—probably not, for the religious and personal visions and three-dimensional fantasies of the artists that created environments such as those described here defy classification. Each is an intensely personal expression, regardless of whether intended for public or private view, and can fit easily only into its own unique category.

265. (OPPOSITE PAGE, TOP) *Bottle Village* (detail); Tressa "Grandma" Prisbrey (1896–1988); Simi Valley, California; c. 1956–1970; mixed-media environment; one-third of an acre. Bottle Village, one of the few still-existing environments built by a woman, is a remarkable creation. It comprises fifteen buildings and several other structures such as wishing wells, a shrine, a fountain, and a television-picture-tube fence, all made from bottles, concrete, and a mad medley of salvaged objects. Mosaic pathways edged with bottles and other found objects wind between the buildings. Prisbrey stopped work on her Village only when her third of an acre had no more space for building. Photograph © Seymour Rosen; courtesy SPACES.

266. (OPPOSITE PAGE, BOTTOM) *Pencil House* (detail), *Bottle Village*; Tressa "Grandma" Prisbrey (1896–1988); Simi Valley, California; c. 1956–1970; mixed-media environment. This is just a small portion of the extensive pencil collection—started when Tressa Prisbrey was a teenager—that provided the initial inspiration for the building of Bottle Village. Photograph © Seymour Rosen; courtesy SPACES.

267. *Concrete Park* (detail): *Man with Ox Team and Others;* Fred Smith (1886–1976); Phillips, Wisconsin; 1950–1968; mixed-media environment (concrete embedded with glass, tin, etc.); covers sixteen acres. Over two hundred figures make up the Concrete Park created by Fred Smith over a period of nearly twenty years. The figures are constructed of wooden frames covered with concrete and are embellished with broken bottle glass, telephone insulators, and mirrors. They include representations of animals and people—from rows of reindeer to an angora cat, from Paul Bunyan to Sun Yat-sen—whatever Smith felt like depicting at the time. Photograph courtesy Roger Amft.

268. (OPPOSITE PAGE) *Concrete Park* (detail): *Indian;* Fred Smith (1886–1976); Phillips, Wisconsin; 1950–1968; mixed media environment (concrete embedded with glass, tin, etc.); covers sixteen acres. Many of the figures of people in the Concrete Park are larger than life because, Fred Smith once said, "otherwise they're too small. I would have made them 100 feet tall if I could." Photograph courtesy Roger Amft.

269, 270. *Coral Castle* (details): *Telescope* (OPPOSITE PAGE), *Saturn and Crescent* (ABOVE); Edward Leedskalnin (1887–1951); near Homestead, Florida; 1936–1951; sculpted coral environment; on ten acres. The Coral Castle constructed by Edward Leedskalnin has continued to baffle engineers. About 1,100 tons of coral went into the construction of the castle, its furnishings, and the various sculptures around it, yet Leedskalnin, working alone and with only the most basic equipment—simple block tackles and homemade winches—moved and lifted huge blocks of coral. He worked in secret, and little is known of his methodology. Photographs courtesy Cynthia Carlson.

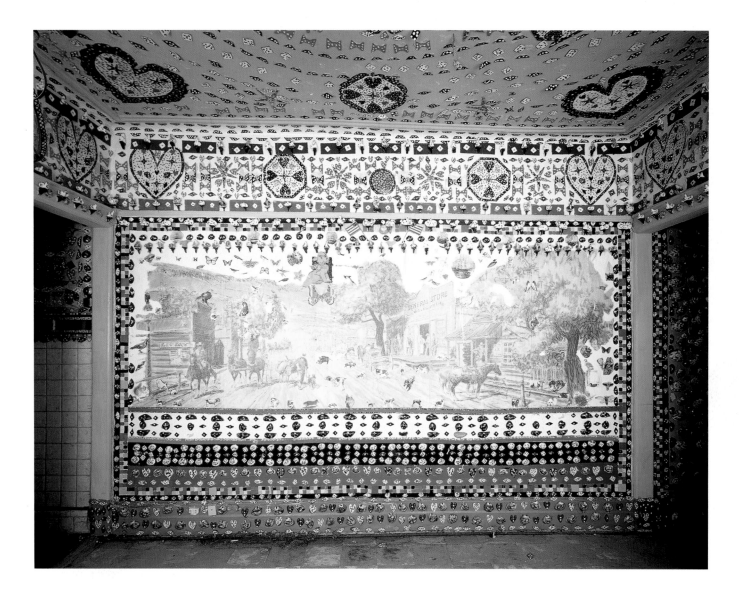

271, 272. *Apartment Environment:* (details), *Main Wall in the Living Room* (ABOVE), *and Hallway* (OPPOSITE PAGE); Joseph Endicott Furey (b. 1906); Brooklyn, New York; 1980s; mixed-media environment (paint, shells, plaster forms, spools, beads, beans, other objects). A furious collage of objects covered the walls, doors, and ceilings of Joseph Furey's Brooklyn apartment, turning the five rooms into a blaze of color and contrast. Over 70,000 shells, including some collected by Furey during his job at an oil refinery in Venezuela, as well as mussel shells from a local beach, decorate the walls; bow-tie motifs are also prominent, to honor, so Furey said, someone he had worked with called "Bow-Tie George." Photographs courtesy Addison Thompson.

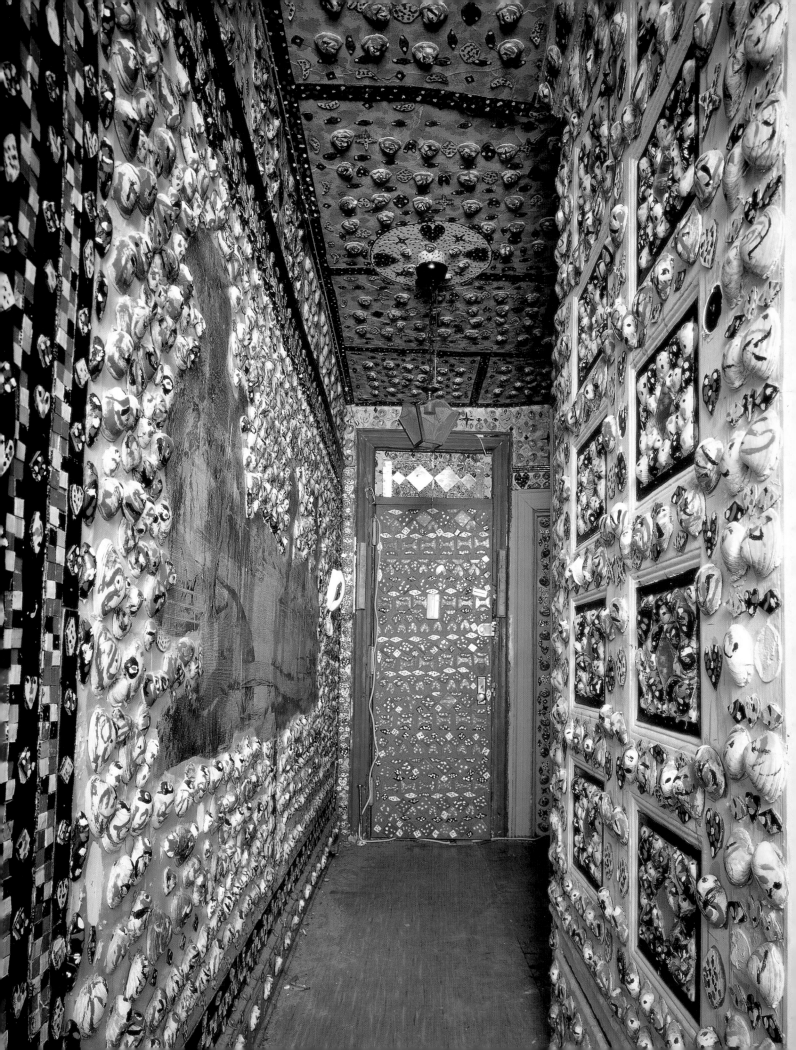

Notes

INTRODUCTION

1. Mary Black, as quoted in Robert Bishop, *Folk Painters of America* (New York: E. P. Dutton, 1979), p. 7.
2. See, for example, Frank J. Miele, ed., "Folk, or Art? A Symposium," *Antiques Magazine* 135 (March 1989), pp. 272–286; Blake McKendry, "Folk Art: What Is It?" *Queen's Quarterly* 94, 4 (Winter 1987), pp. 868–887; and "What is American Folk Art? A Symposium," as reprinted in Jack T. Ericson, ed., *Folk Art in America: Painting and Sculpture* (New York: *Antiques Magazine* Library for Mayflower Books, 1979), pp. 14–21.

CHAPTER 1

1. As quoted in an unpublished letter from Christopher Tahk to Dr. Dorothy Vaughan, June 2, 1974.
2. From the December 19, 1798, edition of the *Baltimore Intelligencer*, as quoted in Cynthia Elyce Rubin, *Southern Folk Art* (Birmingham, Ala.: Oxmoor House, 1985), p. 52.
3. From an advertisement by William Birchall Tetley in the November 14, 1774, edition of *The New-York Gazette and the Weekly Mercury*, as quoted in Robert Bishop, *Folk Painters of America* (New York: E. P. Dutton, 1979), p. 11.
4. June 30, 1840, issue of the *National Intelligencer*, as quoted in ibid., p. 13.
5. As quoted in C. Kurt Dewhurst, Betty MacDowell, and Marsha MacDowell, *Religious Folk Art in America: Reflections of Faith* (New York: E. P. Dutton in association with the Museum of American Folk Art, 1983), p. 49.
6. Albert Ten Eyck Gardner and Stuart P. Feld, *American Paintings* (New York: Metropolitan Museum of Art, 1965), p. 150.

 Caption 12—1. As quoted in Mirra Bank, *Anonymous Was a Woman* (New York: St. Martin's Press, 1979), p. 59.

CHAPTER 2

1. English settlers learned about the log cabin from the Swedes in the Delaware River Valley. Most log cabins were a simple version of the European half-timber building technique. Construction methods varied greatly, depending upon the origin of the builder; structural members were sometimes roughly shaped, notched, and set horizontally, a method that permitted the fill between the timbers to be made less visually obvious. In the eighteenth and nineteenth centuries this form of structure became universal on the frontier because the extensive virgin forests provided a natural building material. Even the most unskilled craftsperson, with only an axe and an enthusiastic spirit, could build a home for himself and his family.
2. Until the Revolutionary War England kept a grip on the imports and exports of her colonies. All goods from other countries destined for the colonies had first to pass through an English port or be shipped there via an English ship and crew; the British government intended to miss no opportunity for placing added value—that is, taxes as well as second- and third-party handling charges—on the goods, thus lining the pockets of merchants in Britain and the coffers of the government while keeping goods expensive in the colonies.
3. Dean A. Fales, Jr., *American Painted Furniture 1660–1880* (New York: E. P. Dutton, 1972), p. 50.
4. Ibid.
5. Jean Lipman and Alice Winchester, *The Flowering of American Folk Art 1776–1876* (New York: Viking Press in cooperation with the Whitney Museum of American Art, 1974), p. 191.
6. *Providence* [Rhode Island] *Patriot*, November 20, 1822.
7. Margaret Coffin, *The History and Folklore of American Country Tinware 1700–1900* (New York: Thomas Nelson & Sons, 1972), p. 27.
8. Ibid.
9. *The New-York Gazette*, 1771.

CHAPTER 3

1. Advertisement in the *Boston Independent Chronicle and Universal Advertiser*, October 17, 1799.
2. Toni Flores Fratto, "Samplers: One of the Lesser American Arts," *The Feminist Art Journal* (Winter 1976/1977), pp. 11–15.
3. As quoted in Judith Reiter Weissman and Wendy Lavitt, *Labors of Love: America's Textiles and Needlework 1650–1930* (New York: Alfred A. Knopf, 1987), p. 127.
4. Both as quoted in Carleton L. Safford and Robert Bishop, *America's Quilts and Coverlets* (New York: E. P. Dutton, 1972), p. 17.
5. As quoted in Weissman and Lavitt, *Labors of Love*, p. 34.
6. Robert Bishop, *New Discoveries in American Quilts* (New York: E. P. Dutton, 1975), p. 27.
7. Many of the elegant Southern quilts known today may have been made in whole or in part by slaves under the plantation mistress's guidance. House slaves often included highly skilled needlewomen, and it would be surprising if they had not had a part in creating some of these quilts.
8. Some researchers connect this style to African appliqué traditions, especially as found among the Fon of Dahomey. See, for example, Maud Southwell Wahlman, *Signs and Symbols: African Images in African-American Quilts* (New York: Dutton Studio Books in association with the Museum of American Folk Art, 1993).
9. Quilting bees have been extensively documented in the literature. See, for example, Jacqueline Marx Atkins, *Shared Threads: Quilting Together Past and Present* (New York: Viking Studio Books in association with the Museum of American Folk Art, 1994).
10. Frances Trollope, *Domestic Manners of the Americans*, Donald Smalley, ed. (New York: Vintage Books, 1949), p. 416.
11. Atkins, *Shared Threads*, pp. 11–16. It should be noted that many of the writings that gave rise to the popular stereotype of the quilting bee as a nest of gossip and slander were done by men!
12. Barbara Brackman, *Clues in the Calico: A Guide to Identifying and Dating Antique Quilts* (McLean, Va.: EMP Publications, 1989), p. 165.

13. Wahlman, *Signs and Symbols.*

14. Cuesta Benberry, *Always There: The African-American Presence in American Quilts* (Louisville, Ky.: The Kentucky Quilt Project, Inc., 1992).

15. Some contend that the pattern was already several hundred years old by the Civil War, having originated in Great Britain much earlier. One may, however, question why, if the pattern was not particularly obscure, it took so long to be recognized here when emigrants must certainly have brought knowledge of it much earlier. See, for example, Amelia Peck, *Quilts and Coverlets in the Collection of the Metropolitan Museum of Art* (New York: The Metropolitan Museum of Art and Dutton Studio Books, 1990), p. 65, and Janet Rae, *Quilts of the British Isles* (New York: E. P. Dutton, 1987), p. 68.

16. Penny McMorris, *Crazy Quilts* (New York: E. P. Dutton, 1984), p. 12.

17. As quoted in ibid., p. 82.

18. Mary Schenck Woolman, *A Sewing Course* (Washington, D.C.: Frederick A. Fernall, 1911), pp. 31–32.

19. As quoted in Elisabeth Donaghy Garrett, *At Home: The American Family 1750–1870* (New York: Harry N. Abrams, 1990), p. 75.

20. Two bedside carpets are noted in the 1773 inventory of Governor Tryon's home, for example. See Weissman and Lavitt, *Labors of Love*, p. 153.

21. Elizabeth Waugh and Edith Foley, *Collecting Hooked Rugs* (New York: Century Company, 1927), pp. 7–8.

> *Caption 190*—1. As quoted in Jacqueline M. Atkins and Phyllis A. Tepper, *New York Beauties: Quilts from the Empire State* (New York: Dutton Studio Books, 1992), p. 27.

CHAPTER 4

1. *Boston News-Letter*, July 30, 1772.

2. *Boston News-Letter*, August 13, 1767.

3. Martha V. Pike and Janice Gray Armstrong, *A Time to Mourn: Expressions of Grief in Nineteenth Century America* (Stony Brook, N.Y.: The Museums at Stony Brook, 1980), p. 13.

4. "The Last Will and Testament of the Reverend William Smith, Provost of the College, Academy, and Charitable School of the City of Philadelphia, July 14, 1802"; private collection.

5. One vane craftsman, Kenneth Lynch, described the method that he and his father used to make such weathervanes: "Let's discuss a craftsman who is engaged in the occupation of making weathervanes, a man who makes at least one or two weathervanes each week and sells them. Let us say that he is going to make a horse and has been inspired by a fine trotter that was famous during the period. He sees sketches of this trotter in the local newspaper and decides to enlarge them into a drawing which will serve as the basis of his weathervane. He transfers the outline of his drawing onto a stone table, a marble table, a sheet metal table, anything that is sturdy enough to stand working on. He then models the horse in clay, ordinary wet clay, until he has it looking just about the way he wants to see it in copper. This is remarkably easy and simple to do for a talented artisan. When he has it finished, and this is one-half of the horse, not both sides, he puts a dam around the outer edge five or six inches away from the clay and pours plaster over it and comes up with a plaster mold in the negative. He then models the reverse side, for the two parts must work out exactly together. He does this by leaving the clay in the mold which he had just made, turning the whole thing over, and then modeling in clay on top of it a second half of the horse which matches the original in outline precisely. Then he pours plaster over the second half of the clay body, thus creating two halves, right and left, bisecting the animal from its foreleg right down to its tail. [Sometimes this process did not involve the entire animal, but only parts, such as legs, tails, bodies, and heads, which ultimately were assembled by soldering them together.]

"The craftsman now takes the two plaster molds for the complete horse, or the various smaller parts for a horse that is going to be assembled, to an iron foundry, where he has each mold cast in iron. Once the iron molds are finished, they are clamped down to a bench firmly so that they will not move around. Next, a piece of copper is cut to a generous size so that it is much bigger than the negative in the mold. It is then roughly hammered on a sand cushion, which is nothing more than a pillow filled with sand, generally made of thick leather. After the copper has been roughly bumped down, the craftsman proceeds to hammer it into the mold with a variety of hammers that have ends shaped with balls, points, or other variations. When the copper is formed with the hammers, the craftsman hammers some lead into the copper and hits it very firmly so that it drives the copper further down into the mold. He then removes the copper and the lead from the mold and turns it over on the bench and with small tools chases up the relief so that the hair and the eyes, etc., can be seen. He does this until the piece has a satisfactory sculptural dimension. The whole process is repeated for the opposite side. Once completed, the parts are either cut out with a chisel or with a pair of tinsnips and then soldered together." Private letter from Lynch to Robert Bishop, Wilton, Conn., April 1979.

6. George Washington to Joseph Rakestraw, *Writings*, vol. 29, p. 250, The Mount Vernon Ladies' Association of The Union.

7. Benson J. Lossing, *Vassar College and Its Founder* (New York, 1867), p. 74.

8. *The New-York Mercury*, July 21, 1755.

9. M. V. Brewington, *Ship Carvers of North America* (Barre, Mass.: Barre Publishing Company, 1962), p. 33.

10. From a private journal in the collection of the Old Dartmouth Historical Society Whaling Museum, New Bedford, Mass.

11. "A Dutchman's Inn," from *A Journey to Ohio in 1810, as Recorded in the Journal of Margaret Van Horn Dwight*, Berks County, Pennsylvania, October 29, Max Farrand, ed. (New Haven, Conn.: 1913), pp. 21–22.

12. Captain Thomas Hamilton, *Men and Manners in America* (Edinburgh, Scotland: 1933), pp. 17–18.

> *Caption 239*—1. *Evening Sentinel*, August 7, 1890, Carlisle, Pennsylvania.

CHAPTER 5

1. John Hardy Wright, *Vernacular Visions: Folk Art of Old Newbury* (Newburyport, Mass.: Historical Society of Old Newbury, 1994), pp. 99–100.

2. Some sources note the environment was built to amuse a crippled nephew (Chuck and Jan Rosenak, *Museum of American Folk Art Encyclopedia of Twentieth-Century Folk Artists*, New York: Abbeville Press, 1990, p. 78); others attribute its creation to the desire to amuse two young grandsons (Linda Roscoe Hartigan, *Made with Passion*, Washington, D.C.: Smithsonian Institution Press, 1990, p. 215). Whichever the reason, the environment was a delight to all who saw it.

3. "Possum Trot," produced by Light-Saraf Films, San Francisco, Calif., 1977.

> *Caption 250*—1. Sarah Anna Emery, *Reminiscences of a Nonagenarian* (Newburyport, Mass.: William H. Huse & Co., 1879), p. 222.

Selected Readings

FOLK ART

An American Sampler: Folk Art from the Shelburne Museum (exhibition catalogue). Washington, D.C.: National Gallery of Art, 1987.

Ames, Kenneth L. *Beyond Necessity: Art in the Folk Tradition.* New York: W. W. Norton, 1977.

———— and Gerald W. R. Ward. *Decorative Arts and Household Furnishings in America 1650–1920: An Annotated Bibliography.* Winterthur, Del.: The Henry Francis du Pont Winterthur Museum, 1989.

Bank, Mirra. *Anonymous Was a Woman.* New York: St. Martin's Press, 1979.

Bates, Elizabeth Bidwell, and Jonathan L. Fairbanks. *American Furniture 1620 to the Present.* New York: Richard Marek, 1981.

Bishop, Robert. *American Folk Sculpture.* New York: E. P. Dutton, 1974.

———— and Pat Coblentz. *American Decorative Arts: 360 Years of Creative Design.* New York: Harry N. Abrams, 1982.

———— and Pat Coblentz. *A Gallery of American Weathervanes and Whirligigs.* New York: E. P. Dutton, 1981.

Black, Mary, and Jean Lipman. *American Folk Painting.* New York: Clarkson N. Potter, 1966.

Bronner, Simon J. *American Folk Art: A Guide to Sources.* New York: Garland Publishing, 1984.

Cahill, Holger. *American Folk Art: The Art of the Common Man in America.* New York: The Museum of Modern Art, 1932.

Christensen, Erwin O. *The Index of American Design.* New York: Macmillan, 1950.

Common Ground, Uncommon Vision: The Michael and Julie Hall Collection of American Folk Art. Milwaukee, Wis.: Milwaukee Art Museum, 1993.

D'Ambrosio, Paul S., and Charlotte M. Emans. *Folk Art's Many Faces: Portraits in the New York State Historical Association.* Cooperstown, N.Y.: New York State Historical Association, 1987.

Dewhurst, C. Kurt; Betty MacDowell; and Marsha MacDowell. *Artists in Aprons: Folk Art by American Women.* New York: E. P. Dutton, 1979.

———— *Religious Folk Art in America: Reflections of Faith.* New York: E. P. Dutton in association with the Museum of American Folk Art, 1983.

Dinger, Charlotte. *Art of the Carousel.* Green Village, N.J.: Carousel Arts, 1983.

Ericson, Jack T., ed. *Folk Art in America: Painting and Sculpture.* New York: Mayflower Books, 1978.

Fales, Dean A., Jr. *American Painted Furniture 1660–1880.* New York: E. P. Dutton, 1972.

Flexner, James Thomas. "Moonlit Mysteries: An American Historian Rescues an Unknown Folk Art—Monochromatic Drawings by Women." *Art & Antiques* (September 1988): 94.

Garvan, Beatrice B., and Charles F. Hummel. *The Pennsylvania Germans: A Celebration of Their Arts 1683–1850.* Philadelphia: Philadelphia Museum of Art, 1982.

Hartigan, Linda Roscoe. *Made with Passion.* Washington, D.C.: Smithsonian Institution Press, 1990.

Hemphill, Herbert W., Jr., and Julia Weissman. *Twentieth Century Folk Art and Artists.* New York: E. P. Dutton, 1974.

Janis, Sidney. *They Taught Themselves: American Primitive Painters of the 20th Century.* New York: Dial Press, 1942.

Johnson, Theodore E., Brother. *In the Eye of Eternity: Shaker Life and the Work of Shaker Hands.* Gorham, Me.: United Society of Shakers and the University of Southern Maine, 1983.

Jones, Louis C. *Three Eyes on the Past: Exploring New York Folk Life.* Syracuse, N.Y.: Syracuse University Press, 1982.

Jones, Michael Owen. *Exploring Folk Art: Twenty Years of Thought on Craft, Work, and Aesthetics.* Ann Arbor, Mich.: UMI Research Press, 1987.

Lipman, Jean, and Tom Armstrong, eds. *American Folk Painting of Three Centuries.* New York: Hudson Hills Press in association with the Whitney Museum of American Art, 1980.

Lipman, Jean, and Alice Winchester. *The Flowering of American Folk Art 1776–1876.* New York: Viking Press, 1974.

Lipman, Jean, Elizabeth V. Warren, and Robert Bishop. *Young America: A Folk-Art History.* New York: Hudson Hills Press in association with the Museum of American Folk Art, 1986.

Livingston, Jane, and John Beardsley. *Black Folk Art in America 1930–1980.* Jackson, Miss.: University Press of Mississippi and Center for the Study of Southern Culture for the Corcoran Gallery, 1982.

Muto, Laverne. "A Feminist Art: The Memorial Picture." *Art Journal* 35, 4 (Summer 1976): 352–358.

Patterson, Daniel. *Gift Drawing and Gift Song: A Study of Two Forms of Shaker Inspiration.* Sabbathday Lake, Me.: United Society of Shakers, 1983.

Pike, Martha V., and Janice Gray Armstrong, eds. *A Time to Mourn: Expressions of Grief in Nineteenth Century America.* Stony Brook, N.Y.: The Museums at Stony Brook, 1980.

Quimby, Ian M.G., and Scott T. Swank, eds. *Perspectives on American Folk Art.* New York: W. W. Norton, 1980.

Rosenak, Chuck, and Jan. *Museum of American Folk Art Encyclopedia of Twentieth-Century Folk Artists.* New York: Abbeville Press, 1990.

Rumford, Beatrix T., ed. *American Folk Portraits: Drawings and Paintings from the Abby Aldrich Rockefeller Folk Art Center.* Boston: Little, Brown; a New York Graphic Society Book published in association with the Colonial Williamsburg Foundation, 1988.

————, and Carolyn Weekley. *Treasures of American Folk Art from the Abby Aldrich Rockefeller Folk Art Center* (exhibition catalogue). Boston: Little, Brown in association with the Colonial Williamsburg Foundation, 1989.

Schorsch, Anita. *Mourning Becomes America: Mourning Art in the New Nation* (exhibition catalogue). Clinton, N.J.: Main Street Press, 1976.

Sellen, Betty-Carol. *20th Century American Folk, Self-Taught, and*

Outsider Art. New York: Neal-Schman Publishers, 1993.

Through a Woman's Eyes: Female Folk Artists of the Twentieth Century (exhibition catalogue). Tokyo: Isetan Museum of Art, 1988.

Vlach, John Michael. *Plain Painters: Making Sense of American Folk Art.* Washington, D.C.: Smithsonian Institution Press, 1988.

————, and Simon J. Bronner. *Folk Art and Art Worlds.* Ann Arbor, Mich.: UMI Research Press, 1986.

Waingrow, Jeff. *American Wildfowl Decoys.* New York: E. P. Dutton in association with the Museum of American Folk Art, 1985.

Warren, Elizabeth V., and Stacy C. Hollander. *Expressions of a New Spirit: Highlights from the Permanent Collection of the Museum of American Folk Art.* New York: Museum of American Folk Art, 1989.

Watkins, C. Malcolm. "Lord Timothy Dexter and the Earl of Chatham," *The Magazine Antiques,* December 1962.

Wright, John Hardy. *Vernacular Visions: Folk Art of Old Newbury.* Newburyport, Mass.: Historical Society of Old Newbury, 1994.

NEEDLEWORK AND TEXTILES

Allen, Gloria Seaman. *First Flowerings: Early Virginia Quilts.* Washington, D.C.: DAR Museum, 1987.

Atkins, Jacqueline Marx. *Shared Threads: Quilting Together Past and Present.* New York: Viking Studio Books in association with the Museum of American Folk Art, 1994.

Benberry, Cuesta. *Always There: The African-American Presence in American Quilts.* Louisville, Ky.: The Kentucky Quilt Project, Inc., 1992.

Bishop, Robert. *New Discoveries in American Quilts.* New York: E. P. Dutton, 1975.

———— and Carter Houck. *All Flags Flying: American Patriotic Quilts as Expressions of Liberty.* New York: E. P. Dutton in association with the Museum of American Folk Art, 1986.

Bowman, Doris. *Smithsonian Quilts.* Washington, D.C.: Smithsonian Institution Press, 1991.

Brackman, Barbara. *Clues in the Calico: A Guide to Identifying and Dating Antique Quilts.* MacLean, Va.: EMP Publications, 1989.

Christopherson, Katy, commentator. *The Political and Campaign Quilt.* Frankfort, Ky.: The Kentucky Heritage Quilt Society and The Kentucky Historical Society, 1984.

Clark, Ricky. "The Needlework of an American Lady: Social History in Quilts," pp. 65–77. In Jeannette Lasansky, ed., *In the Heart of Pennsylvania: Symposium Papers.* Lewisburg, Pa.: Oral Traditions Project of the Union County Historical Society, 1986.

Cooper, Patricia, and Norma Bradley Buferd. *The Quilters: Women and Domestic Art.* New York: Doubleday, 1977.

Ferrero, Pat; Elaine Hedges; and Julie Silber. *Hearts and Hands: The Influence of Women and Quilts in American Society.* San Francisco, Calif.: Quilt Digest Press, 1987.

Finley, Ruth E. *Old Patchwork Quilts and the Women Who Made Them.* Newton Centre, Mass.: Charles T. Branford, 1929, reprinted 1970.

Fisher, Laura. *Quilts of Illusion.* Pittstown, N.J.: Main Street Press, 1988.

Fox, Sandi. *Wrapped in Glory: Figurative Quilts and Bedcovers 1700–1900.* New York: Thames and Hudson and the Los Angeles County Museum of Art, 1990.

Fratto, Toni Flores. "Samplers: One of the Lesser American Arts." *The Feminist Art Journal* (Winter 1976/1977): 11–15.

Fry, Gladys Marie. *Stitched from the Soul: Slave Quilts from the Anti-Bellum South.* New York: Dutton Studio Books in association with the Museum of American Folk Art, 1990.

Haders, Phyllis. *Sunshine & Shadow: The Amish and Their Quilts.* Pittstown, N.J.: Main Street Press, 1984.

Hall, Carrie A. and Kretsinger, Rose G. *The Romance of the Patchwork Quilt in America.* New York: Bonanza Books, reprint of 1935 edition.

Holstein, Jonathan. *The Pieced Quilt: An American Design Tradition.* Greenwich, Conn.: New York Graphic Society, 1973; Boston: Little, Brown, reprinted 1982.

Houck, Carter, ed. *The Quilt Encyclopedia.* New York: Abbeville Press and the Museum of American Folk Art, 1991.

Ice, Joyce and Linda Norris. *Quilted Together: Women, Quilts, and Communities.* Delhi, N.Y.: Delaware County Historical Association, 1989.

Irwin, John Rice. *A People and Their Quilts.* Exton, Pa.: Schiffer Publishing, 1984.

Katzenberg, Dena S. *Baltimore Album Quilts.* Baltimore, Md.: The Baltimore Museum of Art, 1981.

Kiracofe, Roderick. *The American Quilt: A History of Cloth and Comfort 1750–1950.* New York: Clarkson Potter, 1993.

Klimaszewski, Cathy Rosa. *Made to Remember: American Commemorative Quilts.* Ithaca, N.Y.: Herbert F. Johnson Museum of Art, Cornell University, 1991.

Kopp, Joel and Kate. *American Hooked and Sewn Rugs: Folk Art Underfoot.* New York: E. P. Dutton, 1985.

Mainardi, Patricia. "Quilts: The Great American Art." *The Feminist Art Journal* 2 (Winter 1973): 1, 18–23.

Orlofsky, Patsy and Myron. *Quilts in America.* New York: McGraw-Hill, 1974; Abbeville Press, 1992.

Peck, Amelia. *Quilts and Coverlets in the Collection of the Metropolitan Museum of Art.* New York: The Metropolitan Museum of Art and Dutton Studio Books, 1990.

Peto, Florence. *Historic Quilts.* New York: American Historical Company, 1939.

Rae, Janet. *Quilts of the British Isles.* New York: E. P. Dutton, 1987.

Ring, Betty. *Girlhood Embroidery: American and Pictorial Needlework, 1650–1850.* 2 vols. New York: Alfred A. Knopf, 1993.

———— . *Let Virtue Be a Guide to Thee: Needlework in the Education of Rhode Island Women 1730–1830.* Providence: The Rhode Island Historical Society, 1983.

Ruskin, Cindy. *The Quilt: Stories from The NAMES Project.* New York: Pocket Books, 1988.

Safford, Carleton L. and Robert Bishop. *America's Quilts and Coverlets.* New York: E. P. Dutton, 1972.

Swan, Susan Burrows. *Plain and Fancy: American Women and Their Needlework 1700–1850.* New York: Holt, Rinehart and Winston, 1977.

Treschel, Gail Andrews. "Mourning Quilts in America." *Uncoverings 1989,* vol. 10, 1990, pp. 143–144.

Wahlman, Maud Southwell. *Signs and Symbols: African Images in African-American Quilts.* New York: Dutton Studio Books in association with the Museum of American Folk Art, 1993.

Waldvogel, Merikay. *Soft Covers for Hard Times.* Nashville, Tenn.: Rutledge Hill Press, 1990.

Webster, Marie D. *Quilts: Their Story and How to Make Them.* New York: Doubleday, Page, 1915.

Weissman, Judith Reiter, and Wendy Lavitt. *Labors of Love: America's Textiles and Needlework. 1650–1930.* New York: Alfred A. Knopf, 1987.

Woodard, Thomas K. and Blanche Greenstein. *Twentieth-Century Quilts: 1900–1950.* New York: E. P. Dutton, 1988.

GENERAL BACKGROUND

DePauw, Linda Grant and Conover Hunt. *"Remember the Ladies":* *Women in America 1750–1815* (exhibition catalogue). New York: Viking Press, 1976.

Deutsche, Davida Tenenbaum. "The Polite Lady: Portraits of American Schoolgirls and Their Accomplishments, 1725–1830." *Antiques* 135 (1989): 742-753.

Earle, Alice M. *Home Life in Colonial Days.* Stockbridge, Mass.: Berkshire Traveler Press, 1974, reprint of 1898 edition.

Emery, Sarah Anna. *Reminiscences of a Nonagenarian.* Newburyport, Mass.: William H. Huse, 1879.

Garrett, Elizabeth Donaghy. *At Home: The American Family 1750–1870.* New York: Harry N. Abrams, 1990.

Larkin, Jack. *The Reshaping of Everyday Life 1790–1840.* New York: Harper and Row, 1988.

Lynes, Russell. *The Tastemakers: The Shaping of American Popular Taste.* New York: Dover Publications, 1980.

Nylander, Jane C. *Our Own Snug Fireside: Images of the New England Home, 1760–1860.* New York: Alfred A. Knopf, 1993.

Richards, Caroline Cowles. *Village Life in America, 1852–1872, as told in the Diary of a Schoolgirl.* Williamstown, Mass.: Corner House Publishers, 1972, and New York: Henry Holt, 1913.

Sizer, Theodore and Nancy, et al. *To Ornament Their Minds: Sarah Pierce's Litchfield Female Academy 1792–1838.* Litchfield, Conn.: The Litchfield Historical Society, 1993.

Spruill, Julia Cherry. *Women's Life and Work in the Southern Colonies.* New York: Russell and Russell, 1969.

Sutherland, Daniel E. *The Expansion of Everyday Life 1860–1876.* New York: Harper and Row, 1989.

Trollope, Frances. *Domestic Manners of the Americans.* Donald Smalley, ed. (New York: Vintage Books, 1949)

Index